THE BATTLE OF VERSAILLES

THE BATTLE OF VERSAILLES

The Fashion Showdown of 1973

Mark Bozek

Photographs and Diary by Bill Cunningham & Jean-luce Huré
Contributions by Liza Minnelli, Pat Cleveland & Diet Prada

RIZZOLI
NEW YORK

New York · Paris · London · Milan

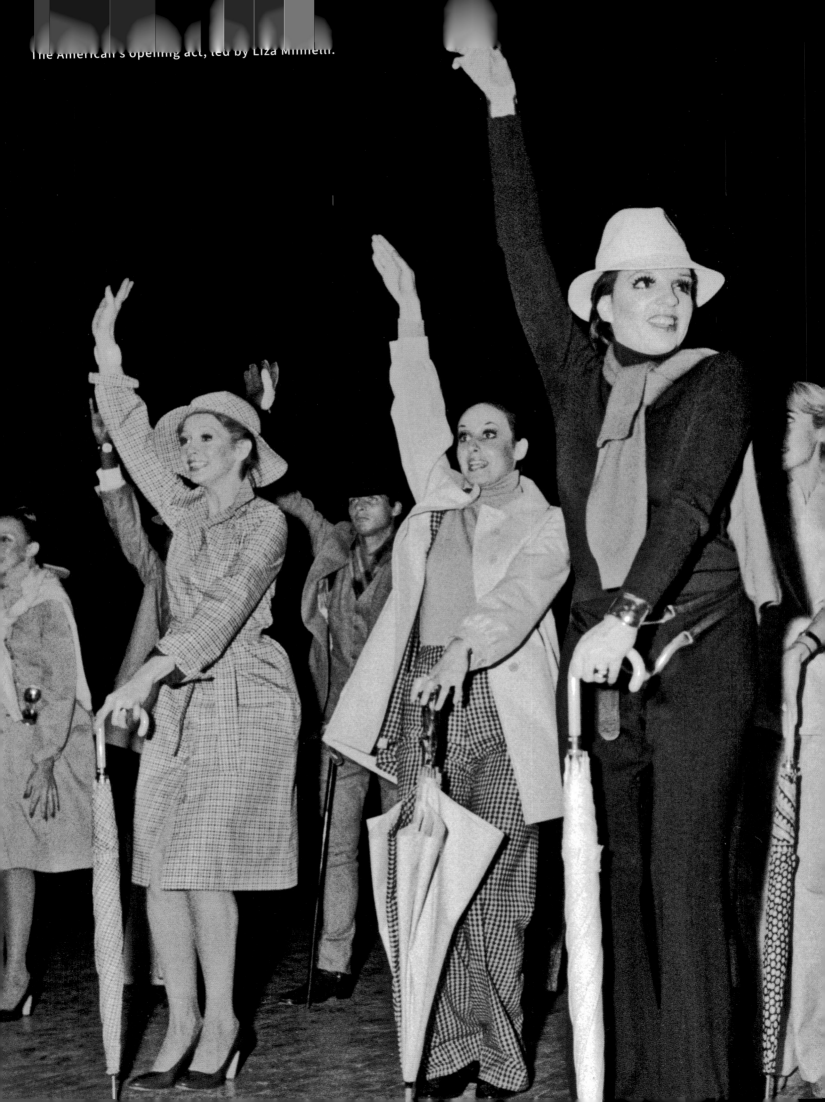

The American's opening act, led by Liza Minnelli.

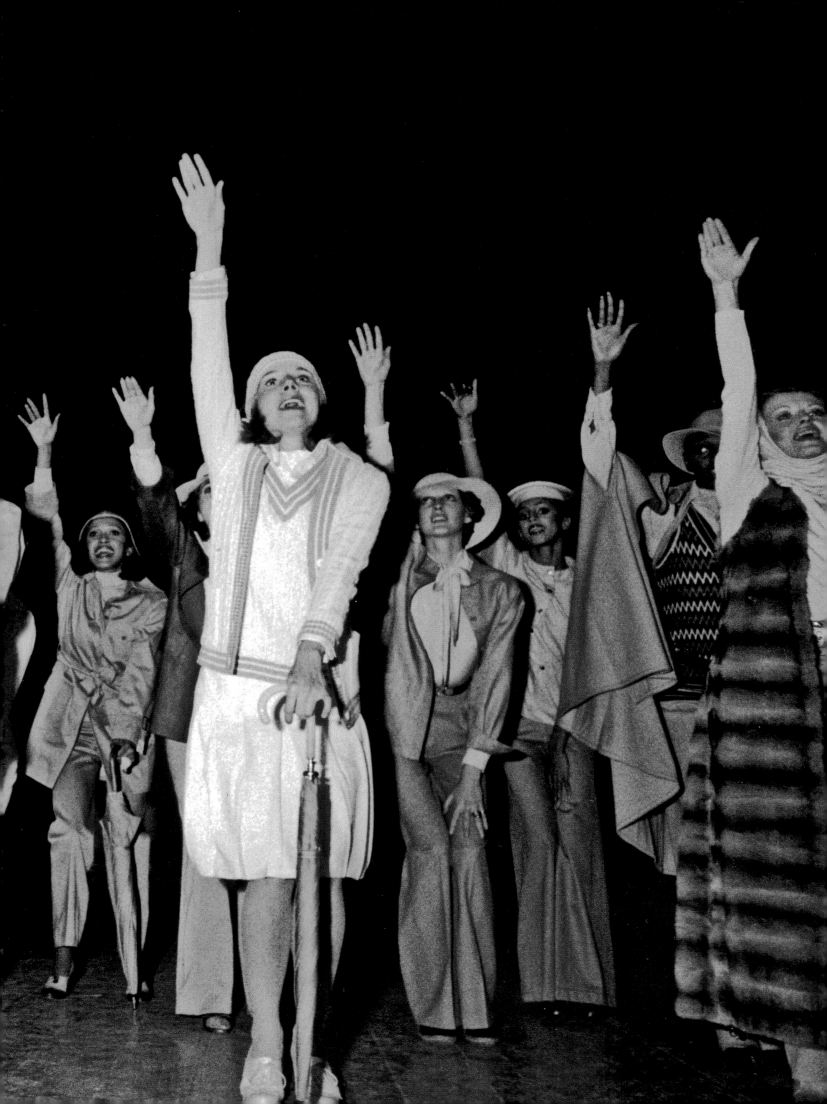

Grand Divertissement à Versailles

Contents

8 Preface by Mark Bozek

11 Dedication

12 Foreword by Liza Minnelli

17 Introduction by Pat Cleveland

22 Arrivals

42 Maxim's

62 The French

 Pierre Cardin

 Marc Bohan for Christian Dior

 Hubert de Givenchy

 Yves Saint Laurent

 Emmanuel Ungaro

112 The Americans

 Bill Blass

 Stephen Burrows

 Oscar de la Renta

 Halston

 Anne Klein

214 Gala

266 Epilogue by Jean-luce Huré

268 Bill Cunningham's Diary

284 Afterword by Diet Prada

286 Acknowledgments

Opposite: The program cover.

Preface

Mark Bozek

In 1950, at age twenty-one, Bill Cunningham was proudly drafted into the United States Army during the Korean War. His first crossing of the Atlantic was via an Army transport ship. It should come as no surprise that Private Cunningham would be chosen to serve his military time in Rochefort Sur Mer, a military outpost on the west coast of France, and a mere five-hour train ride to Paris. He would discretely make women's hats in the middle of the night. His military leave was spent attending the French Couture Shows of Jean Dessés, Christian Dior, Jacques Fath, and the new house of Hubert de Givenchy. By the time he covered the Grand Divertissement a Versailles in November of 1973, some twenty year later, his keen eye and interest in all things women wore was, even then, amongst a most rarified group of fashion historians.

I think it's best to simply begin this book with Bill Cunningham's own words on the Versailles Fashion Show of 1973, captured in a long dormant interview I had done with him in 1994. Please note that although one should refer to their subject formally, i.e., "Mr. Cunningham," or "Cunningham," everyone always knew him as just plain Bill.

Therefore, here are Bill's own words from my documentary, *The Times of Bill Cunningham*: "Incidentally, earlier you asked me what my one of the most important fashion memories were. It was the [fashion battle between] French and Americans at Versailles. That was a once in a lifetime event. You had five of the top French designers at the peak of their career...and [five] Americans at the peak. Especially Stephen Burrows. Here came this young black fella, with dresses like you've never seen...on models like the French had never seen. And when they walked out onto that stage—their hair pulled up tight, and a stripped ostrich bone going through [it]—the audience nearly went crazy. And [then] Bethann Hardison shot them her policewomen look. And that's when they went bananas. It was just at the time of Watts. The French were all aware of the American trouble. And here were these empresses, these marvelous black models. Ziegfeld would've put a show together right there."

There was no need for me to probe further in the interview—Bill was on a roll:

"It was all there for the making. There's no question about it. And the Stephen Burrows. It was fabulous. Everything about it. Kay Thompson, the way she choreographed the show. And Liza Minnelli singing 'Bonjour, Paris' with no sets, no props. The French were all covered with props and everything else. Oh, it was fabulous. It was pure, raw talent pressing on the raw nerve of the time, which was the social change on the streets of America. It was right there. And that's why the tiaras were falling off [heads in the audience] practically. They were running backstage afterwards. You never saw such a thing. But it was emotion because it had touched all the raw nerves."

———

My first real conversation with Bill Cunningham occurred just after I had left my producing job at what was then a "start-up" network called Fox Television. I followed its creator, Barry Diller, to West Chester, Pennsylvania to work at QVC, America's number one TV shopping network.

Just as one remembers where they were when certain world events unfolded, like when Ronald Reagan was shot, or when Princess Diana was killed in a car accident, my personal remembrance is the moment I got a phone call while sitting at my desk at QVC from Bill Cunningham in January of 1994. I distinctly remember thinking, "Bill Cunningham? Who the hell is that?" Of course, I knew who *the* Bill Cunningham was, but why on earth would he be calling me at QVC? I also remember that Joan Rivers was live on our network at that moment, selling her costumed Bee Pin for $39.99. "Yes, it's Bill Cunningham…from *The New York Times*." Define irony, I thought. The legendary *New York Times* fashion historian and street photographer, Bill Cunningham, was calling me, at QVC, no less. I thought it was a joke.

"I'm so sorry to bother you at work," he began. "But I heard you did a story about me on television. I don't own a TV nor would I ever watch the damn thing, so I didn't see it. But a friend of mine named Stephen Gan—do you know him? Anyway, he gave me your number. I hate to ask you, but I am

supposed to accept an award from the CFDA at Lincoln Center. Why they want to give me an award for photography, I don't know. I'm not even a photographer! I'm so embarrassed. Would you mind coming over to my studio at Carnegie Hall for just ten minutes to interview me? They want me to do a one-minute video." "Really?" was all I could say. "How did you find me?" "I have half a mind to tell *The Times* I won't do it, but they really want me to, so I suppose I don't want to upset them," he continued. "It won't take much time at all."

Two days later, alongside a video and audio crew of two, I was in Bill's tiny, cramped two-level studio at Carnegie Hall. Inside, you could barely walk; file cabinets and books were everywhere. I advised Bill that it was too dark and crowded to shoot an interview in and asked if he might know of any other operable spaces. His long-time friend, Suzette Cimino, happened to live a few floors below him. It is there that we sat—not for "just ten-minutes"—but three and a half hours; where, on camera, he told me his entire life story. It was then that I first heard about the Battle of Versailles in 1973 and was inspired to make my documentary.

Years later, in August of 2023, I was reading about the upcoming 50th anniversary of the Versailles Fashion Show in November. I began reminiscently scrolling through the hundreds of photos and contact sheets of the event from Bill's archive that I had scanned for my documentary. I realized that, not only had he photographed the show, but he had also documented almost every step of the journey—the plane ride from JFK to Paris with many of the models; the rehearsals for the show; the dinner party given by Halston in honor of Liza Minnelli; and countless moments from backstage and the gala that followed. I was immediately keen to see the photos that his French counterpart, Jean-luce Huré, had taken at Versailles. I had previously met him while working on Bill's documentary; they knew each other from the early 1970's. He sent me the scans and contact sheets of all his photographs from Versailles. For obvious reasons, I liked the notion that the book would have an American photographer and a French photographer. Contrary to the title of this book, there was no such "battle" between these lifelong friends and passionate pursuers of fashion history. Jean-luce was thirty-years old, and Bill was forty-four.

There has been much written about the famous showdown between the French and American designers, as well as two documentaries. Rather than attempting to write a timeline narrative when other more notable journalists and authors have already done so, I've chosen to let Bill and Jean-luce's words and photographs portray a wholly new and fresh perspective.

Dedication

I dedicate this book with love and respect to my dearest friend and collaborator, Carol Elizabeth Dietz. Carol worked alongside Bill for over twenty years. Like Bill, she saved and remembered everything.

In her own words, Carol recounted their time together as follows:

"As the only art director at The New York Times who agreed to work with Bill, I knew deep down that he was a magician, leading us to unveil his discoveries every Sunday; his rabbit out of a hat every week.

"I remember calling down the hallway to him, 'Bill, what is the topic this week?' And he would yell back, 'it's all about the polka dot!' (or scrappy sandal, or tank top).

"It was a magical time for me, too. Working together was fun, creative, and supportive. When we finished the page, around 3 pm on Fridays, I would carry the layout and cropped images to the photo production department—every single one of them looking down at their desk ignoring me. I would announce 'Street!', 'Party!'—and hoped that someone would take on the tedious job of toning thirty-six black and white images in thirty minutes. Deadlines!

"Above all, Bill respected the deadline; after finishing with me, he went to the Style 'word people' who needed to write the captions and correct the spelling for anyone who was on the page. He was a master at it all, except for spelling."

There was no question that Carol would be the art director of this book. I am grateful and honored she said yes, and even more so for her unmatched love and support.

- M.B.

Foreword

Liza Minnelli

Penning the foreword for a book on Bill Cunningham? It's like being handed a glittering marquee with my mesmerizing memories in lights! Bill, an iconic photographer, embodied New York wherever he was. He always found the sparkle in the soul and the truth in the eyes. I have a heart-to-heart connection of our times together, the most famous of which is the legendary Battle of Versailles—and thank God there are so many wonderful photographs which memorialize that adventure! Halston and Elsa Peretti were two of my closet chums—we were the three musketeers. Bill's photographs, and those of Jean-luce Húre, brought the stellar success of Versailles, in fashion and jewelry, to audiences all over the world, giving Halston greater international acclaim and, ultimately, bringing Elsa to her forever home: Tiffany & Co. Breathtaking.

This beautiful book pays homage to Bill's symphony of life. Each word and image are an overture of an artist who saw people, and the world, through his lens with love and clarity. His eye for the exquisite made every subject a star. Take your fingers and tap dance through the pages, as you experience the wizard who turned even sidewalks into stages. Curtain up, light the lights, Bill—you've got a new show: *The Battle of Versailles: The Fashion Showdown of 1973*, made possible by you and Jean-luce Húre, and it is an aesthetic sensation!

In the kaleidoscope of art, entertainment and fashion, there are events that not only define a career, but also herald a cultural shift. The 1973 Battle of Versailles is one such glittering waypoint—an event where fashion, music, and art collided in a spectacle of transatlantic glamour. It was a night that saw American designers step out from the shadow of their European counterparts; a night where color, energy, and democracy in design took to the stage and left an indelible mark on history. My heart swells with gratitude and great pride whenever I reflect on that magical experience. We were all so scared! We knew our approach was different—bold. History has proven that the electric spirit of Versailles epitomized and revolutionized art, fashion and beauty in glorious ways. Minimal-

Opposite: Liza Minnelli & Bill Cunningham at rehearsal.

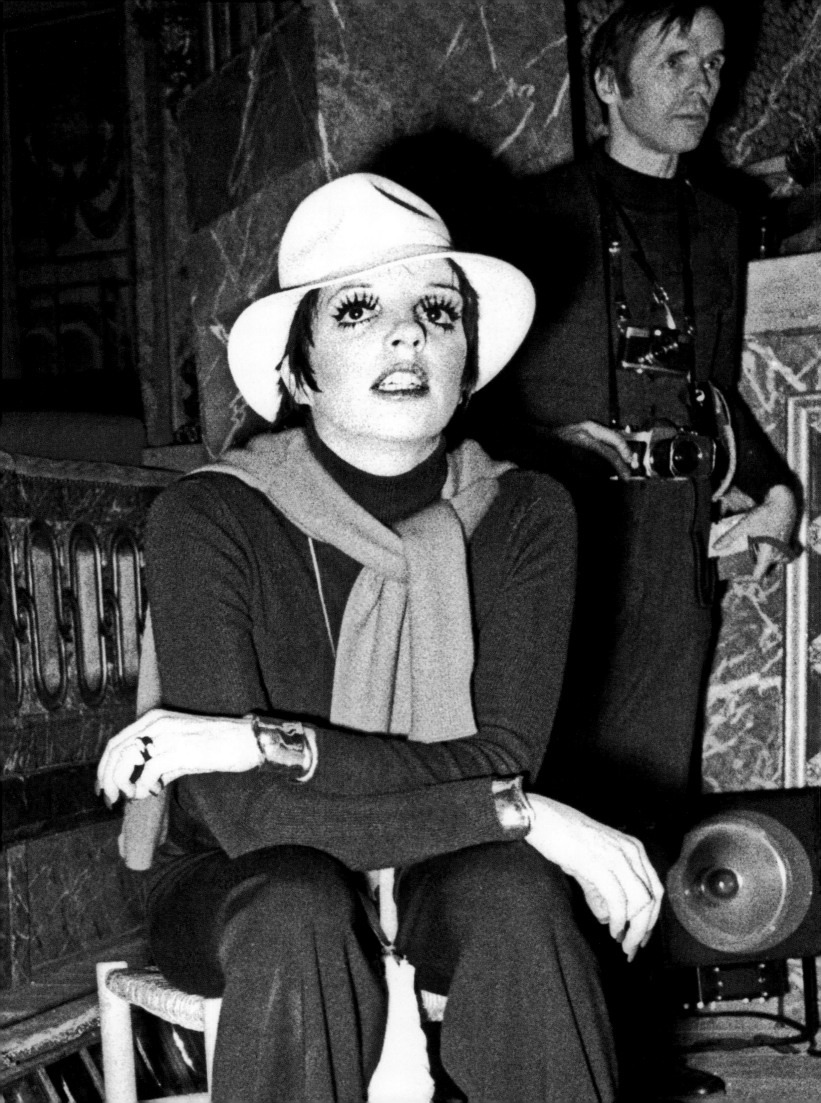

ism was suddenly über-chic: less, became powerfully more than ever before. Now, come with me, as we go behind the velvet ropes, the dressing rooms, and into the visual heart of that enchanting evening.

Bill's great showmanship continued beyond Versailles' hallowed and mirrored walls; his integrity was intense. He often said, "It's hard to play it straight and narrow in New York. I won't do the games"—and he didn't need to. His talent was enough to take him anywhere. During the marvelous carousel of life in the 1970s, Bill Cunningham was there, documenting the whirls and twirls with his images. He was so much more than a photographer; we were fellow artists and, like Halston and Elsa, I could trust him. I learned from my father: Surround yourself with the finest possible people, and then be smart enough to listen to them! And baby, in over 60 years in this business, I've known the best. Bill, as proven by this beautiful book, was certainly one of them.

I can speak more candidly about Bill than Jean-luce, because we became dear friends. Bill could charm you into wanting to have your picture taken, whether you felt like it or not! His photographs are poetry in motion, singing the symphony of the streets and the secret whisperings of the

soirées. Bill's eyes would twinkle with mischief and delight behind that ever-present canvas, finding beauty in what many would stroll by unnoticed. The fashion world had its bard, and we, its lucky muses, felt his admiration and love imbue every shot he took—at least the ones he showed us!

Bill Cunningham's photography, with its candor and vivacity, exerted a profound influence on pop culture, by chronicling the glittering face of fashion, as well as the vibrant, human intersection of people and daily living. The pictures in this book reflect the pulse of the zeitgeist; capturing trends before they burgeoned into movements. His democratic humanity gave equal weight to the flamboyance of uptown aristocrats as to the bold statements of downtown street style, blurring the lines between what high fashion was then, and indeed became. Halston and Elsa were centric to that… and how I loved being their mannequin in motion.

Bill worked predominantly with a 35mm camera, often eschewing the studio for the street, his true atelier. His insistence on natural light and candor gave his images an authenticity that resonated with the public. Finally, we were able to see people—famous or not—that felt real in work and life.

Collaborating with both icons and unknown, anonymous trailblazers on the sidewalks of New York, Cunningham was not just a witness, but also a creator of pop culture, etching eternally into the collective memory through his attentive and affectionate gaze.

Bill Cunningham's camera lens brushed paths with a celestial tapestry of society's luminaries, from Greta Garbo's elusive glimmer to Andy Warhol's iconic pop. His snapshots provide intimate gateways into the lives of my elegant friend Jacqueline Kennedy Onassis—whose effortless charm he adored capturing—and the flamboyant Anna Piaggi, who paraded avant-garde fashion. Echoes of aristocrats, voguish tastemakers, and downtown eccentrics alike, all shared the grand stage of Bill's world, each a thread in the vibrant tapestry of his life's work.

Every page of this stunning tome is a tribute to Bill Cunningham's legendary vision; a plethora of moments in time that continue to breathe life into the world decades after the shutter's first click. *The Battle of Versailles* is not just a book; it's an odyssey of New York glamour, guided by the maestro of the candid shot. To say it is a feast for the eyes would scratch the surface of this pictorial exploration; it's a love letter to all, captured by a man who was, in every sense,

a visual poet. From Jacqueline Kennedy Onassis and André Leon Tally, to the divine Greta Garbo (trying and failing to be anonymous on the sidewalks of New York City) and Pat Cleveland—arguably America's first African American supermodel to achieve prominence in her field—allow yourself to be whisked away on a journey whose destinations include sartorial splendor, faces you love, and people you've never met

One of my favorite expressions is something I borrowed from Bill. My "Hey kids," which is a greeting for friends and family, is a personal riff on Bill saying, "Hey you kids." Bill created moments, and like an archaeologist of culture, revised the familiar to make it fresh. The ubiquitous photo of Marilyn Monroe, with her skirt blowing from a subway grate in Some Like It Hot, was recreated with a sweet, young girl in front of Henri Bendel's. Bill's wry sense of humor is expressed by a matron who clearly disapproves, clutching her sunglasses tightly like a string of pearls. It's fantastic!

Get ready to be captivated by *The Battle of Versailles*. This book—this collection of art—is truly the "pièce de résistance" of photographic memoirs. I know you'll love it. I do.

Love, Liza

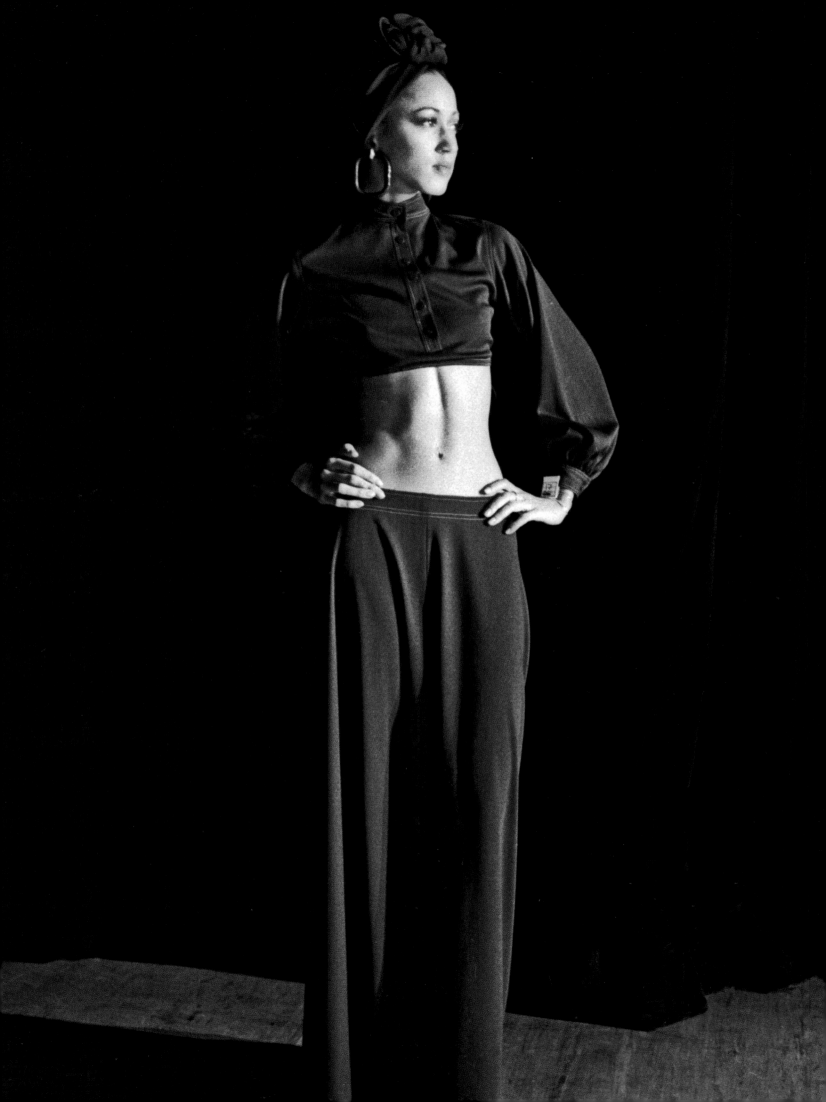

Introduction

Pat Cleveland

In Versailles in 1973, the Americans captured fashion leadership from the city of Paris, where fashion itself was born a hundred years ago. Of course Bill Cunningham was there! He was part of our gang. We were like a tribe going over to Paris. He represented art in our group—along with Antonio Lopez and the Carnegie Hall gang: Donna Jordan, Pierre Houlès. And Andy Warhol!

Bill Cunningham was like Fellini with a still camera. He's not trendy. He allows you to understand the history of fashion from his point of view. He was very poetic and quiet in a way, and the things he created are more like fairy tales. I really believe he was living in some kind of fantasy world. And he would honor the people who were misfits. I was a misfit and he photographed me.

The French are better in their fashion history, but they get annoyed very easily, and that was very intrusive, but, of course, the Americans love the French. They have such deep knowledge about their fashion that I think they feel like they're on another level. They're the teachers and the masters of couture. They grew up with it. They knew Dior, they knew the House of Patou, all the beautiful houses, Madame Grès, the ones who started it all, before the contemporary designers.

By the time 1973 came around, the French were kind of used to the American invasion of small artistic groups coming over to explode, to make a crack in their reality. By the time we got to Versailles the egg had cracked open. And then came these magnificent Black creatures like they had never seen before! Like when you put two kinds of flowers together and you make a completely new bloom.

The battle was like a competition every time. It was very sexy in a way, because it was like everybody was going after the same beautiful lover. The beautiful lover of recognition. And everyone wanted that status. Everybody wanted to be the most beautiful. Like a peacock when it opens its feathers. Bill Cunningham was a big part of my life in so many ways. He was so joyful and so open. He always had something to say about ev-

erything. He would tell you the truth and make you understand who everyone was in the history of fashion. We need this book, something you can hold onto, because of that. I tried to live up to what was given to me. I only had that one thing to give at that time, and it was all I could do in that moment. Who knows what's going to come next? But in that moment, I was truly in my element, and I felt very divine. And I was with so many people that I have real affection for, and I hope I meant something to them. I'm really so happy and honored to be a part of this wonderful and historical book because I don't want to fade away.

ON BILL'S VERSAILLES DIARY:
The "catastrophe" Bill writes about in his Versailles diary was that the rules of high society were tumbling down. Before, you couldn't go to a couture show unless you were invited, as a lady of society. You didn't have ready-to-wear. But Bill had been following it, going to the couture shows in the fifties with those women from Chez Ninon, the ones who Chanel allowed to make the pink suit Jackie Kennedy wore in Dallas. It was real Dior and real Balenciaga in the fifties. So Versailles was like a tsunami for him. The tower was falling, and he was watching it as it was tumbling down right before his eyes.

THE DUCHESS OF WINDSOR
I was hanging out with the Duchess of Windsor. She was so cute and little and so historic. And I thought, this is something! She's from the 1920s—she's like one of those women who was a flapper or something. I was just so happy to sit with her. I thought at any second now she's going to put one of those flapper dresses on. And her hair! They always put so much hairspray in. It looked very French. All those society ladies—their hair was so sprayed up, like lacquered up, nothing moved. It was like Marie Antoinette, but more like modern French. Instead of a wig, a place for the tiara so it wouldn't fall off. They glued it to their hair with hair spray.

RUDOLF NUREYEV:
I stepped on Nureyev's toes before he went out on stage for Swan Lake. I was on my way to the bathroom, and he came by and I stepped on his toe. I said to one of the girls, "Oh my God, I can't believe what I just did." But he just danced out there in his white tights. The men in tights! Over the years, whenever I encountered him, he'd always joke and say, "You're not going to step on my toe, are you?"

VICTORY & TIARAS
I didn't feel intimidated at all. I just felt embraced. And the tiaras weren't something that we had ever had. The girls didn't have tiaras. Normal people don't have tiaras! Does that mean everyone's better than we are? Well, you know, money talks. It was money put into the most beautiful things. Candelabras and the beautiful atmosphere and the gorgeousness of it all was overwhelming. The girls were so happy.

Everything was like a fairy tale. The cherubs were dancing on the ceiling! It was akin to an even playing field. That's a feat, isn't it? To accomplish such a thing when you had such diversity in that room. It wasn't just Black versus white. The socioeconomic diversity: ridiculously, insanely rich, and not so much. But that's where you see the humanity of the arts. You see what's important. The things that you cannot buy in an environment that is so sumptuous and beautiful and over-exaggerated. America is a fruit bowl. You can expect that every color, every level of society, is going to be represented. A sort of tower fell for the French in 1973. Accepting people just as human beings, from different levels, from different backgrounds, coming into your country. They had sympathy, too. They had feelings about Americans. "Those poor Americans, they don't know fashion like we know fashion." They were like, "Okay, let's let them come over and play." But we came over and we won the chess game. It was checkmate.

GIVENCHY
It was overwhelming. Walking down the Hall of Mirrors with Givenchy. He gave me his arm. It was like heaven to walk with this tall, beautiful human being, so elegant. We were laughing and taking it all in, looking at the chandeliers, just enjoying the moment. That was such a big moment for me, to be escorted to dinner by him.

THE GALA
I don't remember eating anything. The only one who was really interested in the food was Norma Jean Darden, because she's a cook. I wasn't interested in food. I was too busy looking at the men in tights. Who had time for food? There were a lot of servants—young men dressed in white tights and white powdered wigs and white gloves, with satin vest jackets, all in the style of the 1700s. I think I was just all over the place. I was more like table-hopping and zipping under chandeliers, looking out for who was there. Everybody was moving around like they were on a playground. The kids were wild in there. They couldn't wait to see each other, talk to each other, mingle. It was just like one big, beaded pearl necklace—everybody getting on the string together and just being gorgeous.

MARISA BERENSON:
She was going out with one of the Rothschilds. Everybody was excited because she was going out with one of the richest men in the world. I had been over to their house, I think, earlier or something. We were having cake in the afternoon. I was waiting for him to come in. It was so fancy. I thought, "Oh my God, this is her life now." Schiaparelli's granddaughter must live like Marie Antoinette. It was her natural environment, really. I just thought of her as the most beautiful, pretty girl.

LIZA MINNELLI:
The part she played was that she came to the rehearsals with us in New York; she was

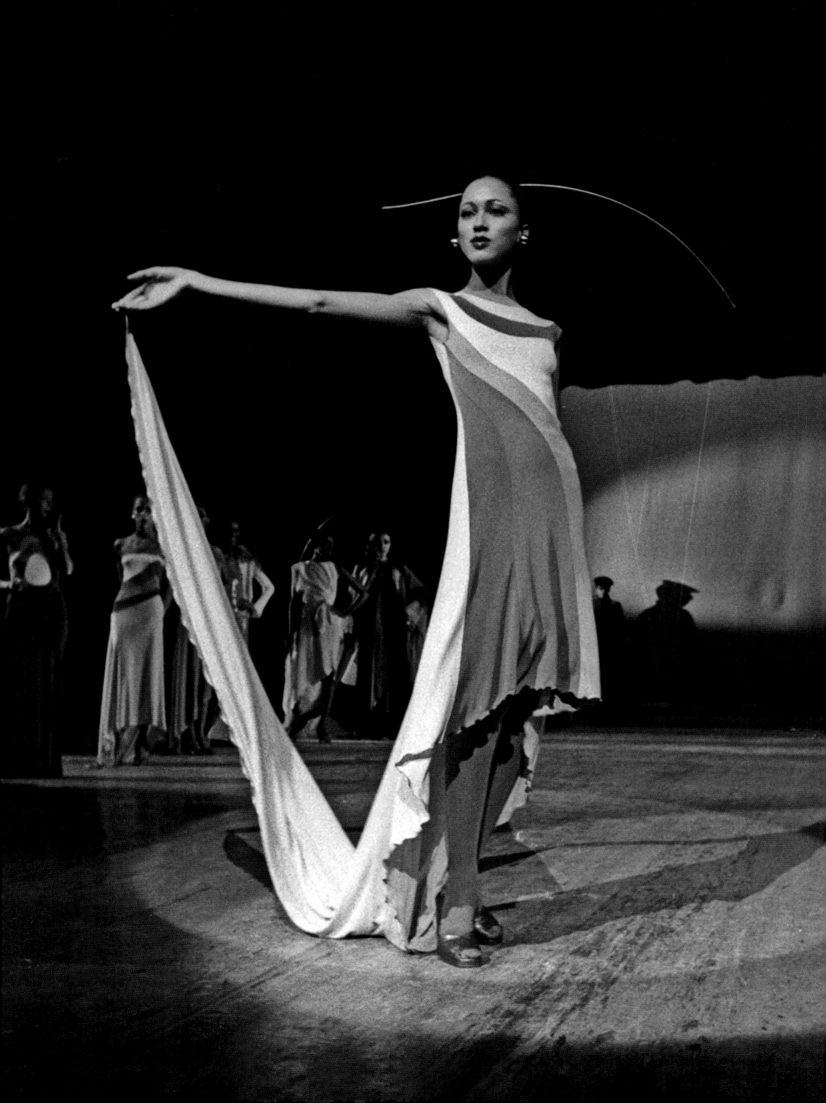

present, and she made it known that she was going to be present. She was happy to be with all the models and the girls, the back-up dancers. She was very much at home. She felt very safe with all of us. It was her family, in a way, because Halston was like her big brother. And she'd just won the Oscar for Cabaret. She was a big star and Halston brought her along because Hollywood is America's royalty. But she had to be herself and still be that star because everyone was depending on her to bring the shininess. And it was so funny because before she went on stage, I was standing behind her and a few other girls. She said, "I can't go out. I can't go out." I said, "Look, there's a rainbow on the stage. Just step over the rainbow." And she went out.

JOSEPHINE BAKER:
She was back there for the dress rehearsal. That's why the girls all look so good next to her—because we didn't have our street clothes on. But the funny thing is that in the moment that we were with her, some of the naughty girls were behind her, fussing with the feathers from her dress. I was standing there, and she was holding my arm and talking to me. I looked around, and one of the girls was actually plucking feathers from the back of her dress, like a souvenir. After Josephine went on the stage she said, "Here's a feather for you."

BEING ON THE COVER OF THE BOOK:
Are you kidding? The photograph that Jean-luce took of me in Stephen Burrows is totally judging a book by its cover. It's fierce and powerful and just says "bonjour – we're not going anywhere!" Yes, I do love covers.

I will never forget Versailles. You find out what your passion is and then you're just flown to Europe to express yourself and you're lucky enough to capture some sort of nectar from it all. Then the hummingbird flies off again. And then it's done.

PAT CLEVELAND
February 2024

Opposite: Upstage, Stephen Burrows watches his muse Pat Cleveland rehearse his segment's finale.

Arrivals

"Bonjour, Paris! Sunday morning,
November 24, 1973
The 'gorgeous mosaic' of thirty-six American models
arrived from JFK/NYC and went straight
to the Palace de Versailles.
They had zero awareness about the victory
that was to come."

- Bill Cunningham

Opposite: Model Tanya Dennis.

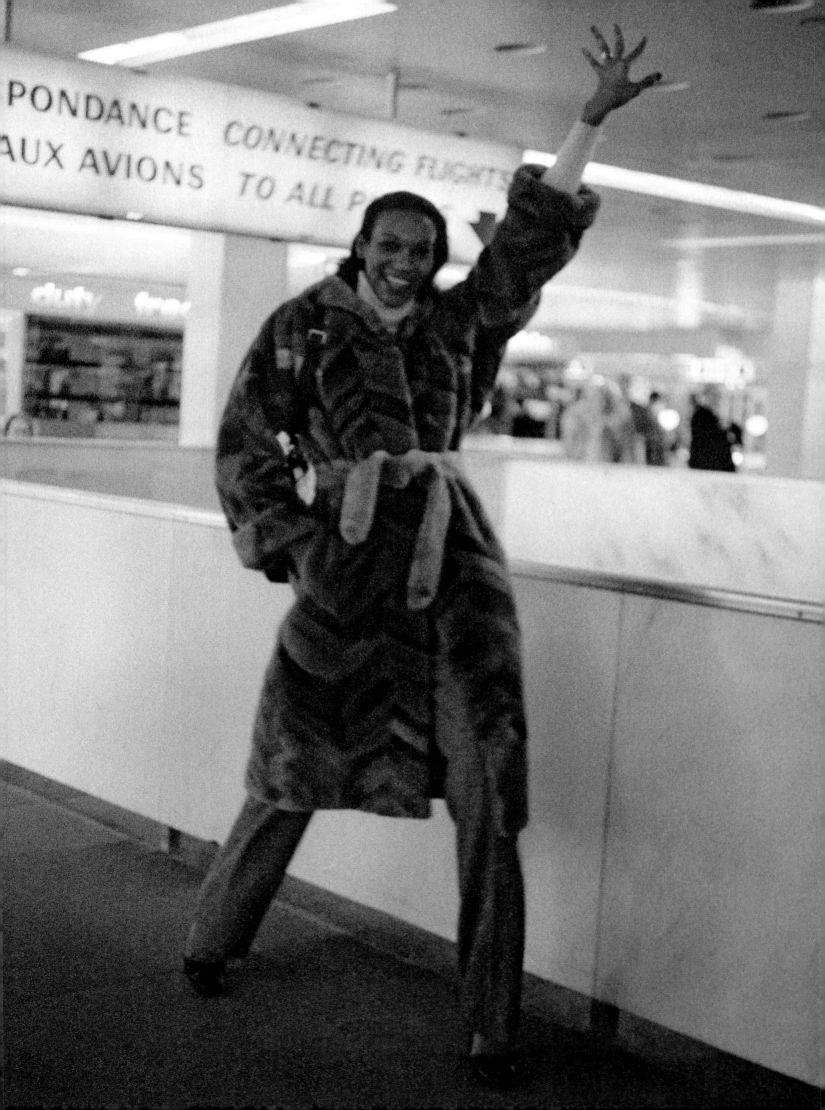

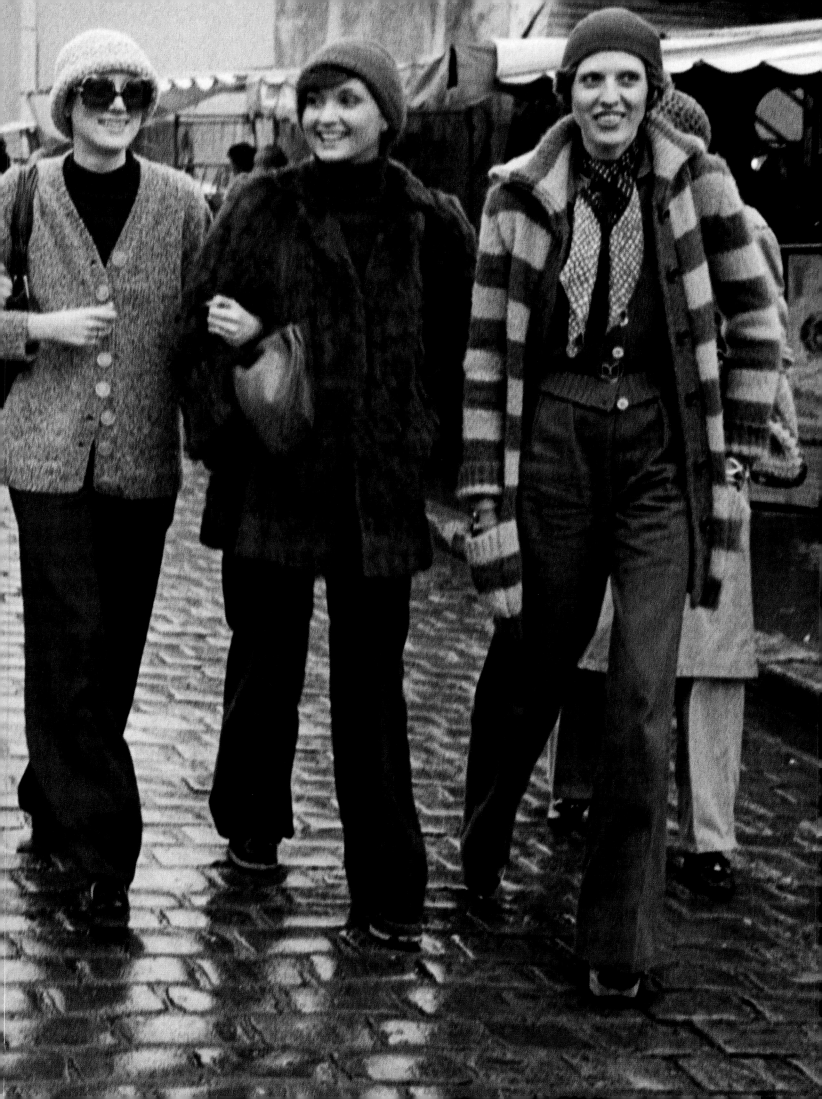

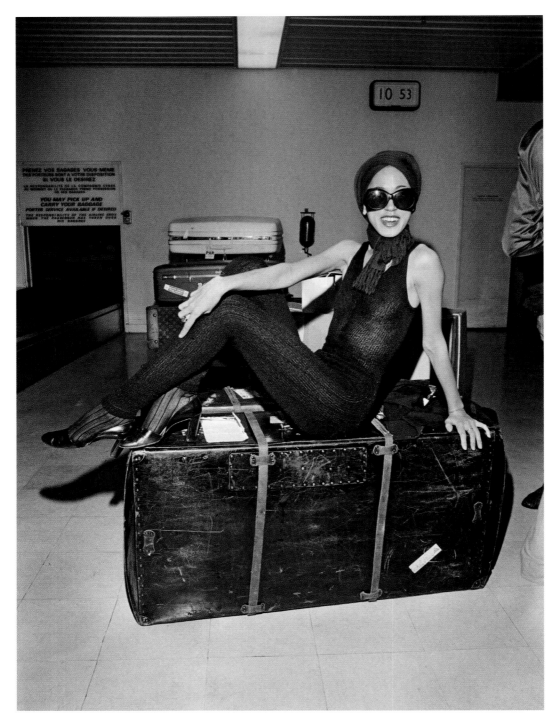

Previous Pages: American models including Marion York, Jennifer Hauser, and Virginia Hubbard are escorted through an open air market in Paris.
Above: Pat Cleveland at Orly Airport, Paris.
Opposite: Dennis Christopher, then an assistant to Halston, follows model Billie Blair through Orly Airport, Paris.

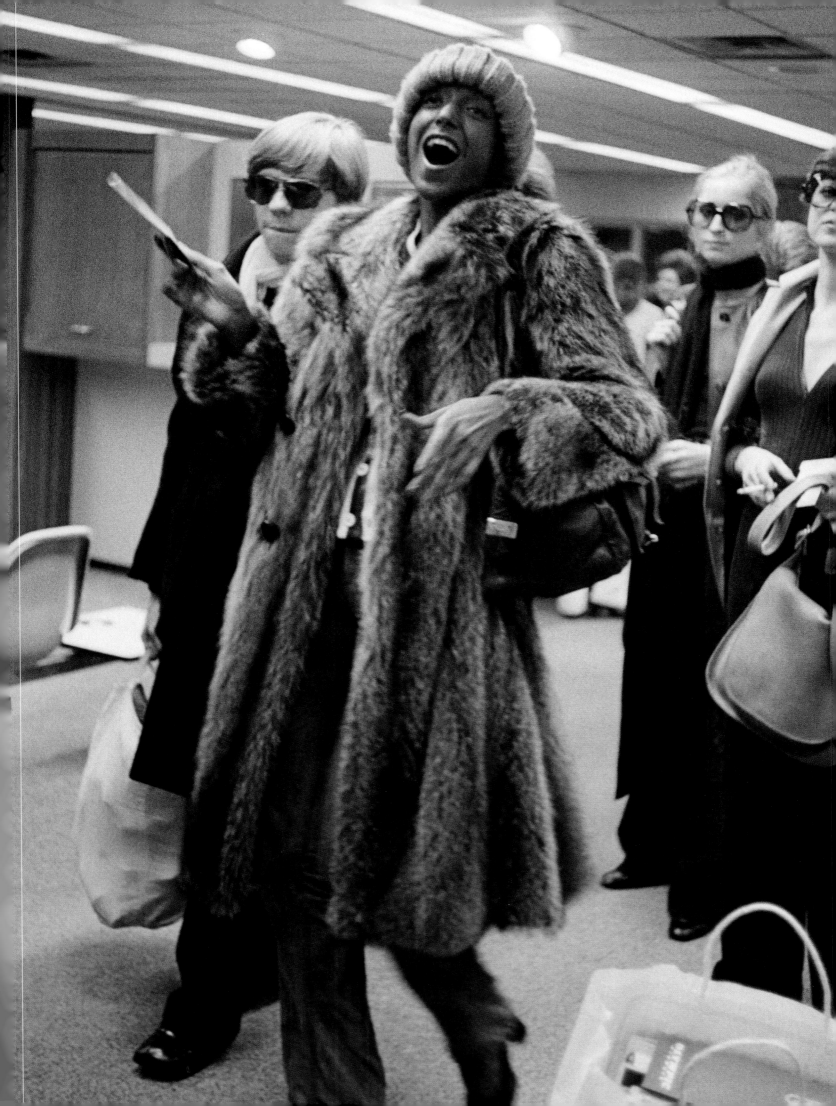

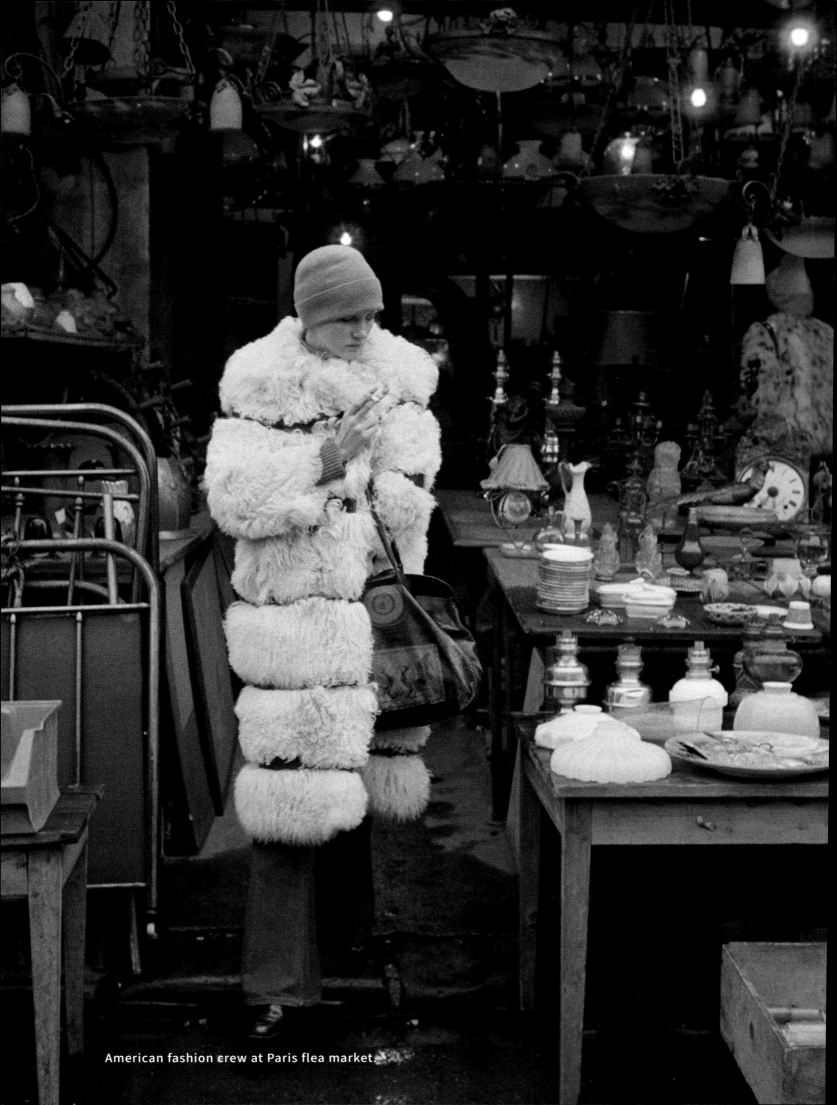

American fashion crew at Paris flea market.

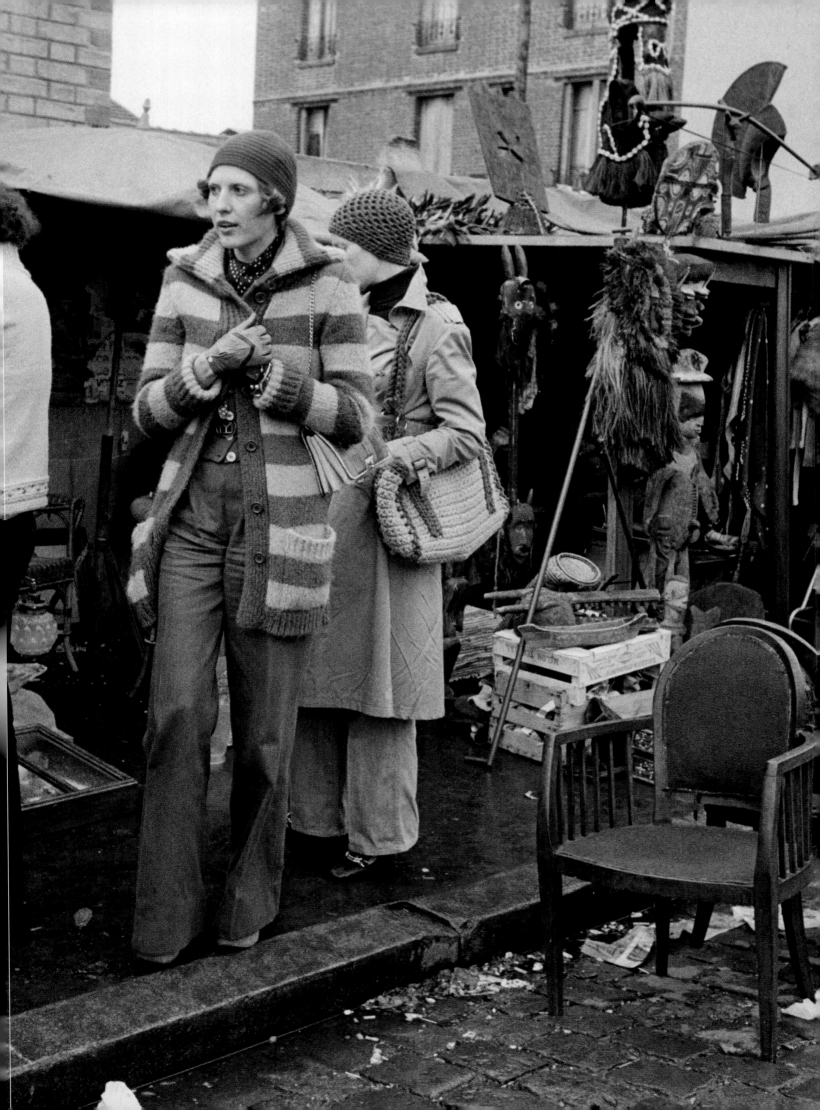

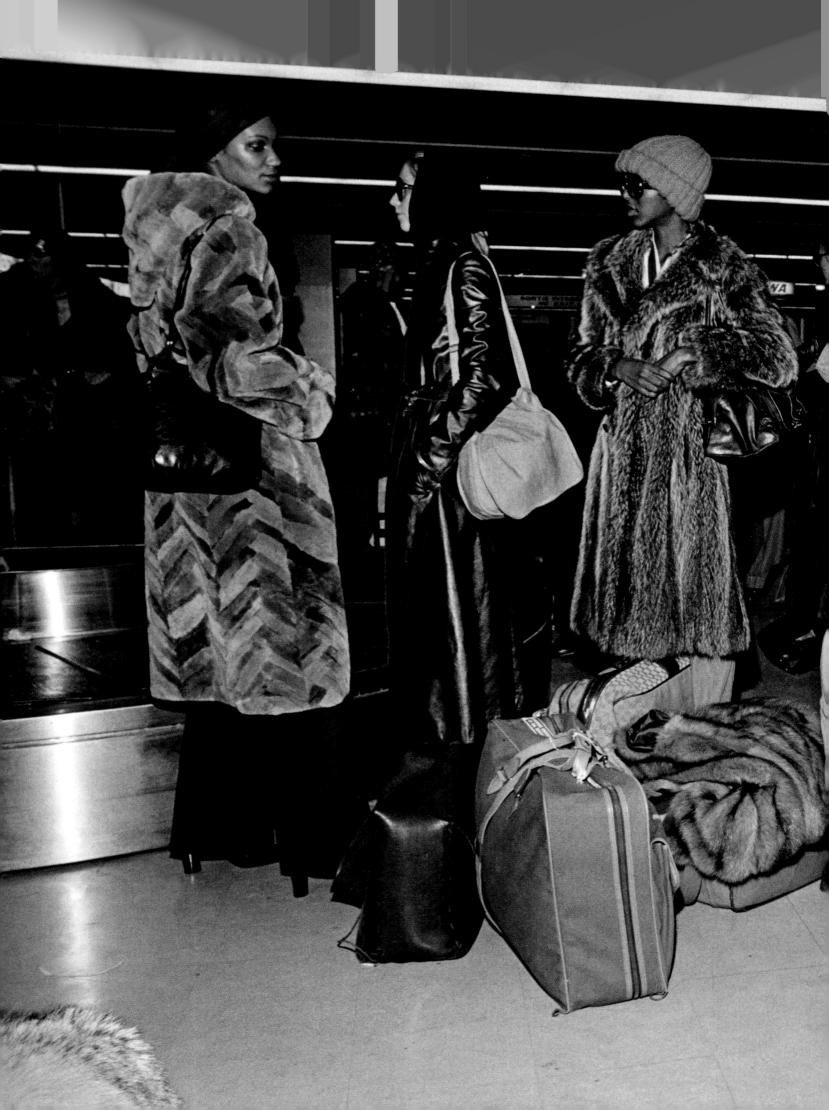

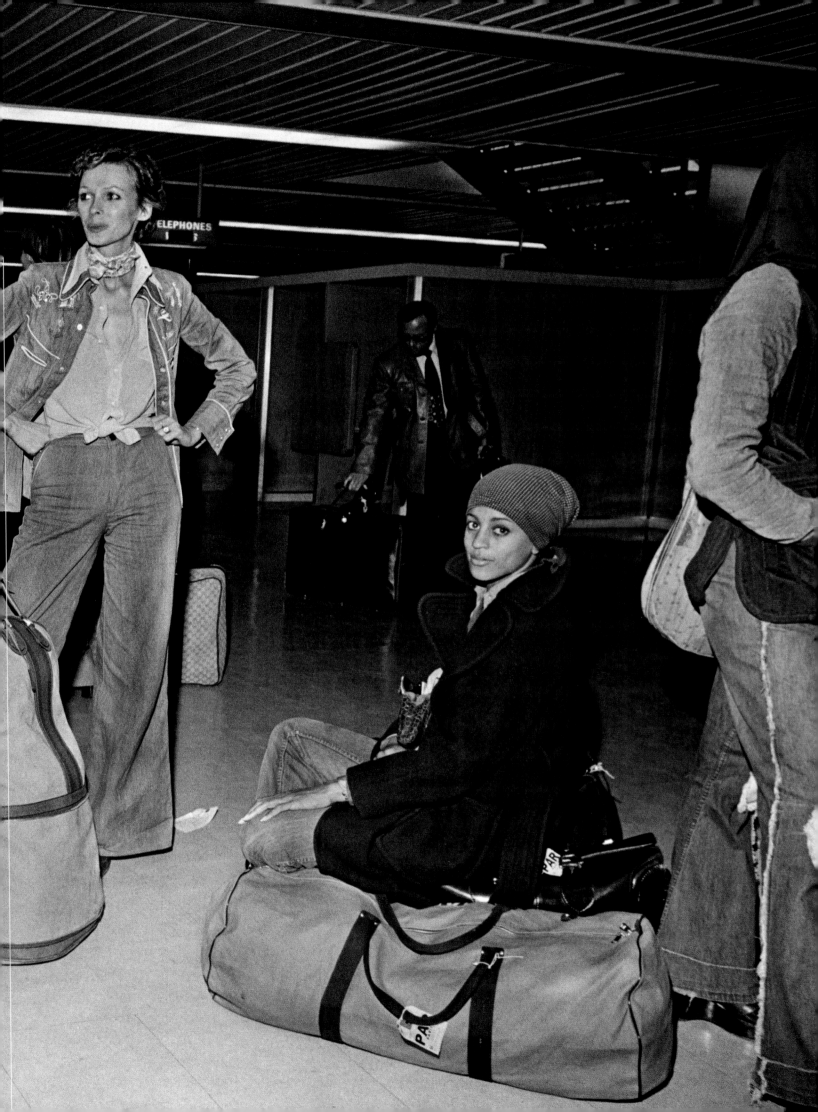

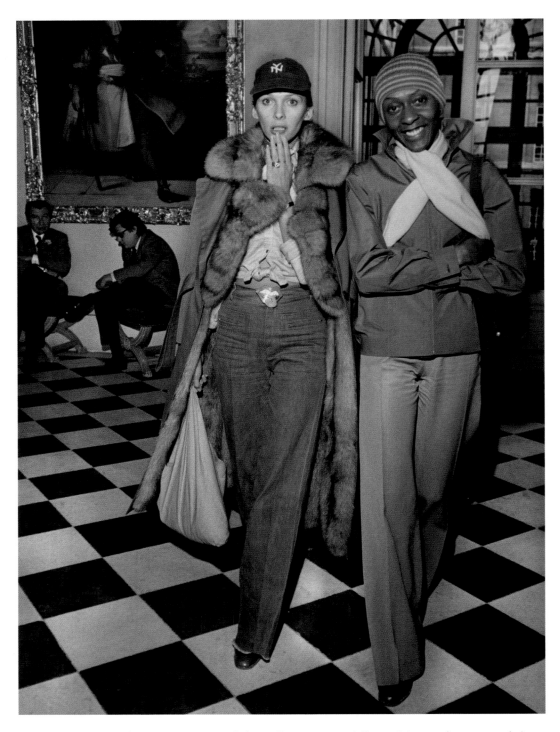

Previous Pages: The American models strike a pose while waiting at baggage claim:
Tanya Dennis, Shirley Farro, Billie Blair, Basha, and Alva Chinn.
Above: Basha and Bethann Hardison.
Opposite: Norma Jean Darden, Jean-luce Huré, and Jennifer Brice.

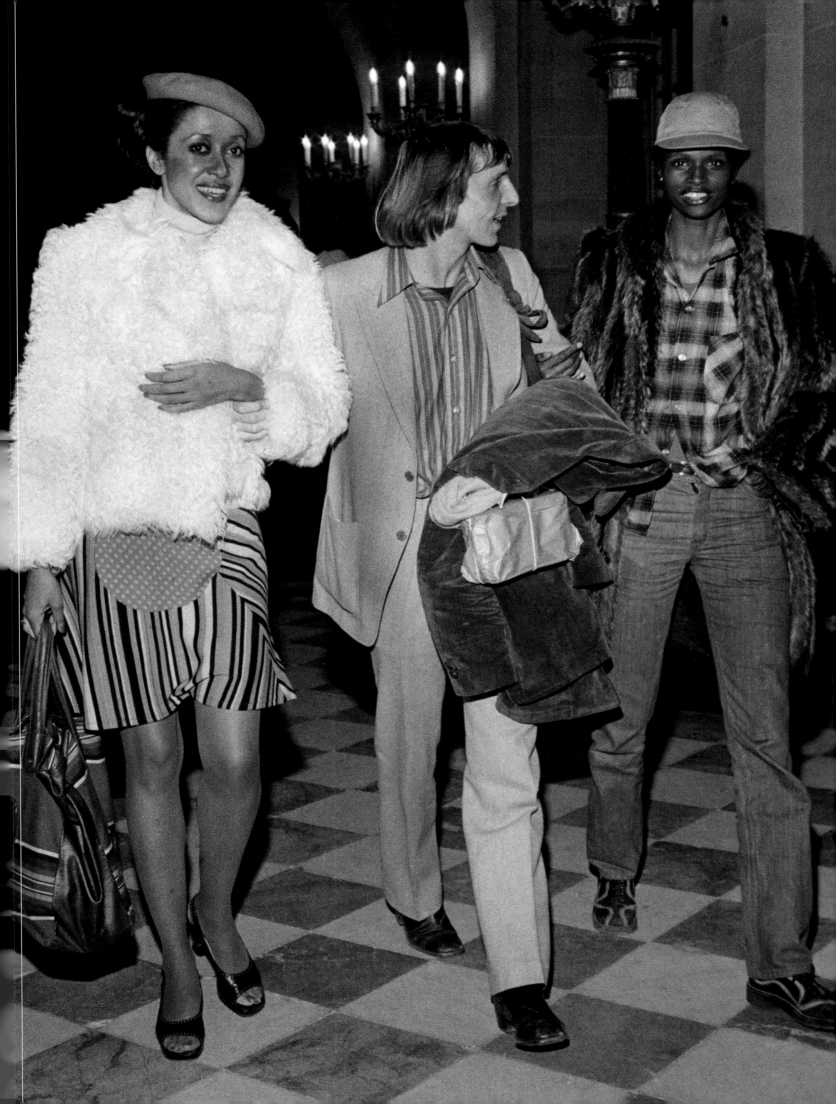

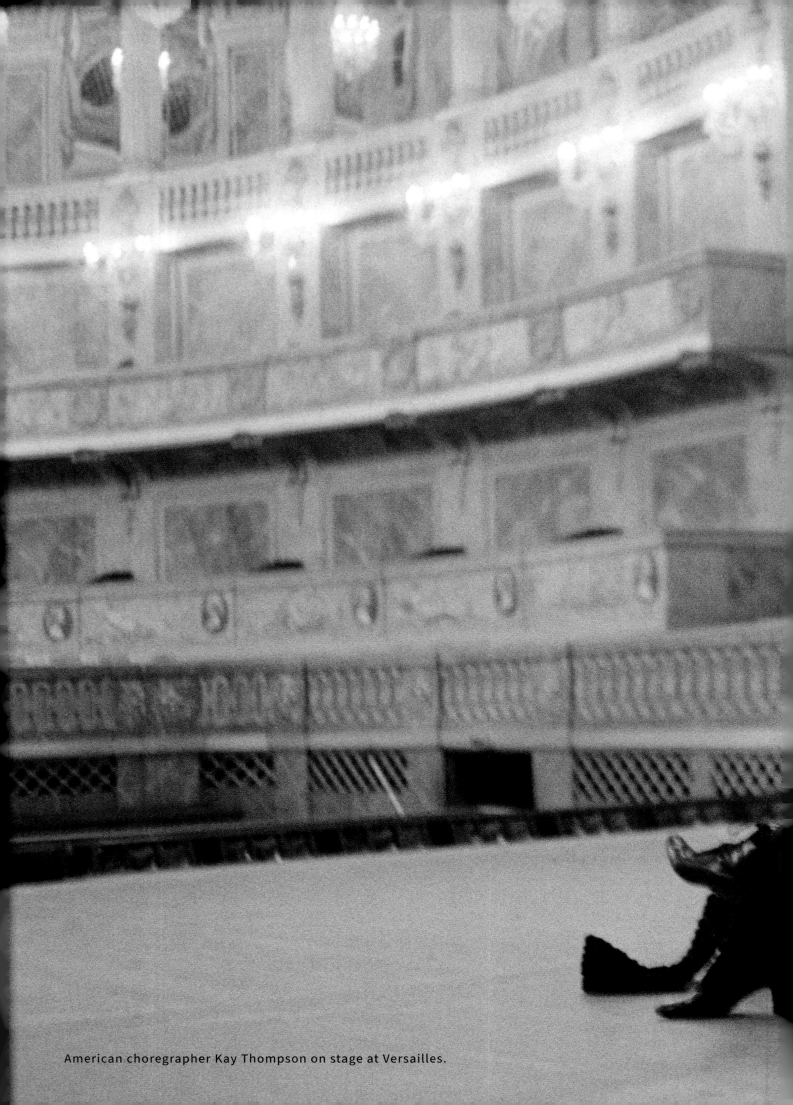

American choregrapher Kay Thompson on stage at Versailles.

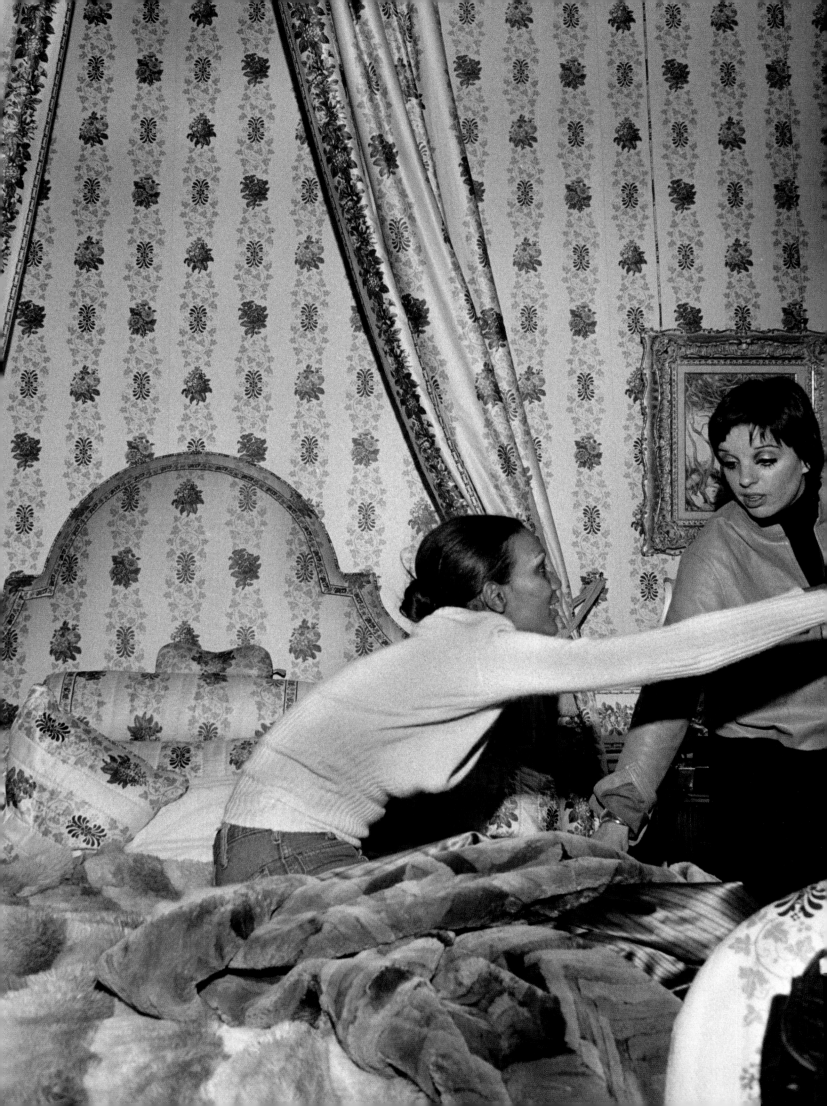

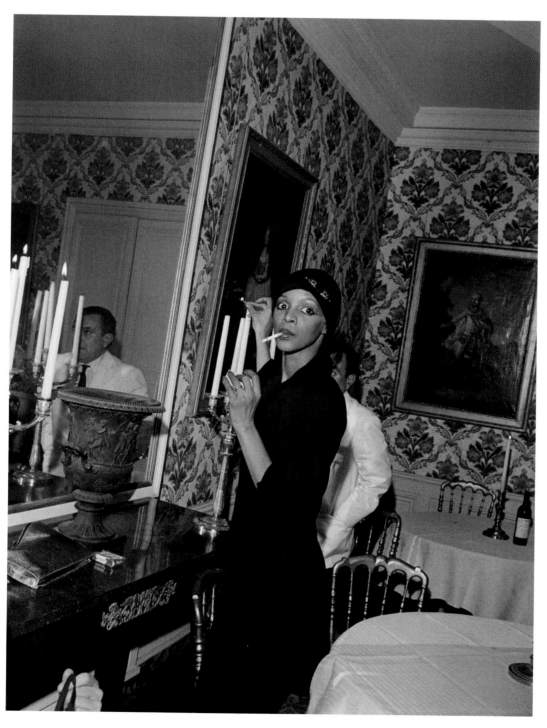

Opposite: Model Tanya Dennis and Liza Minnelli having fun before rehersals.
Above: Ramona Saunders before rehearsals.

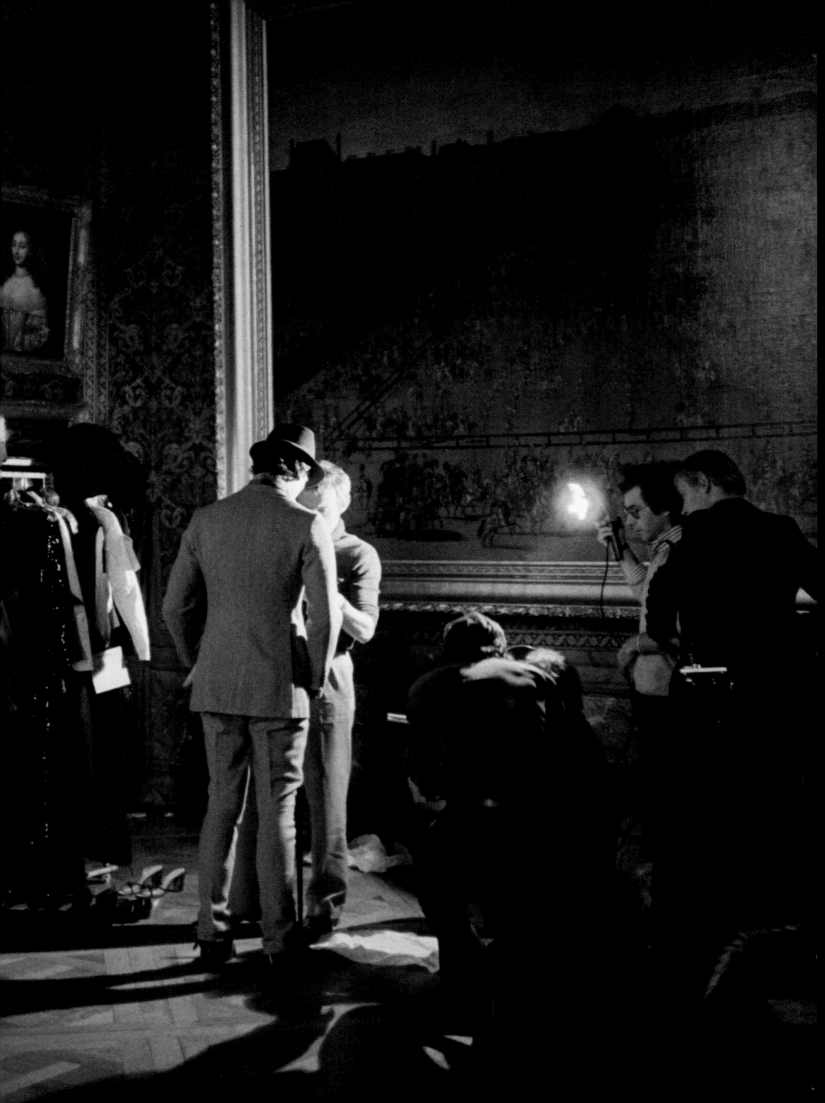

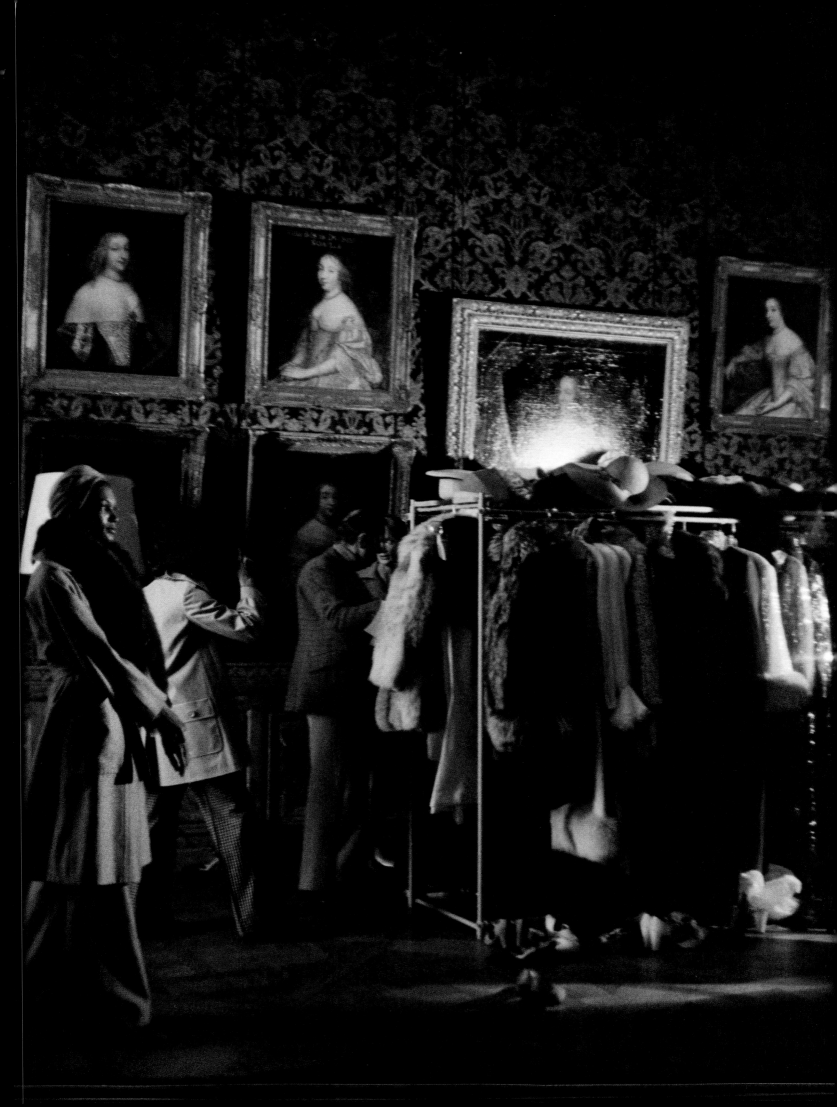

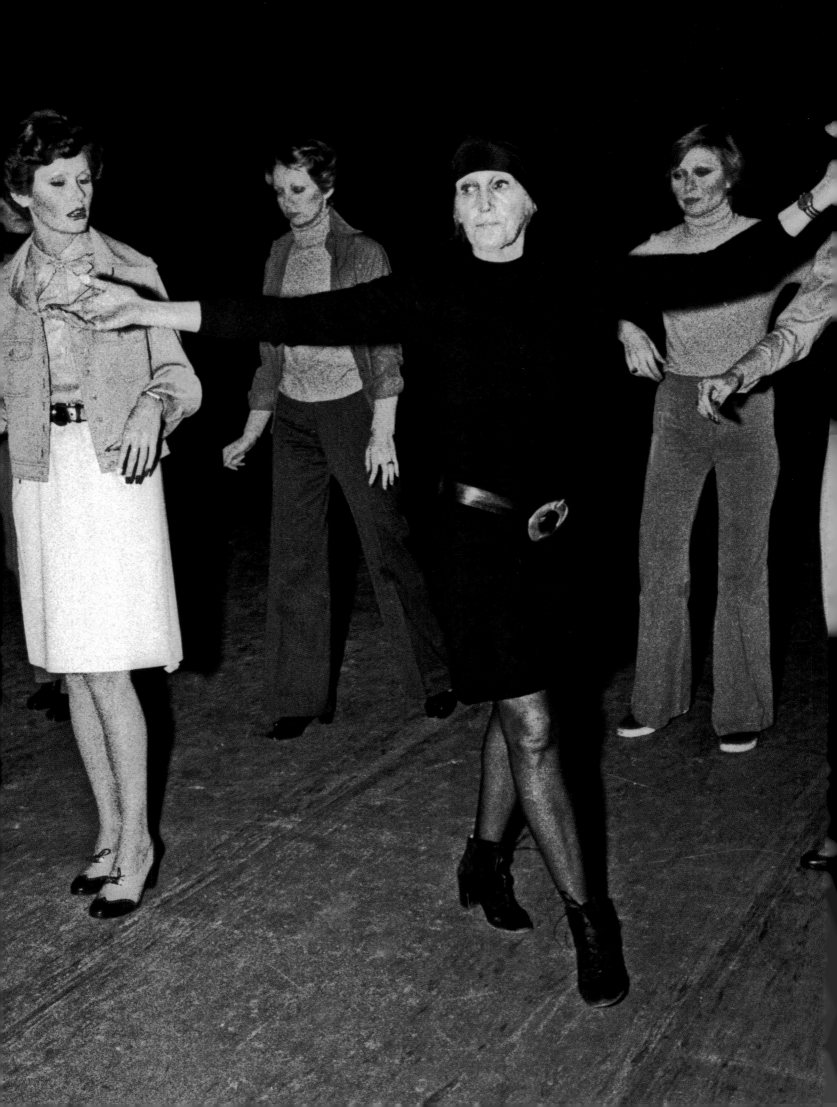

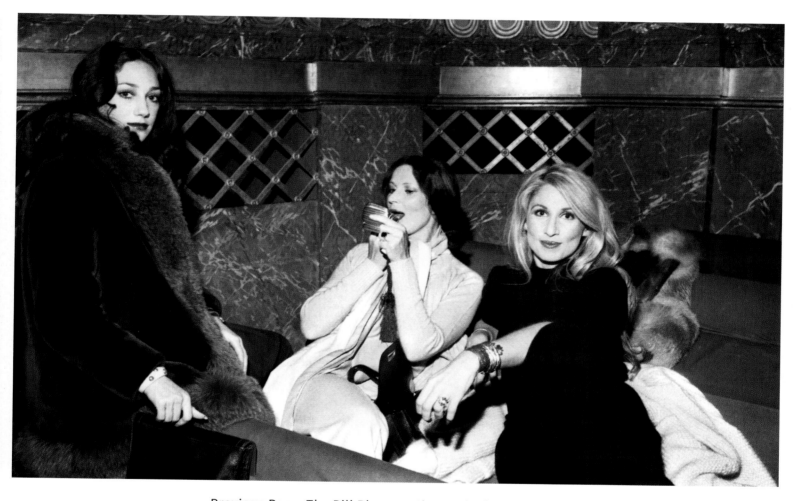

Previous Page: The Bill Blass contingent had to contend with many hardships at Versailles,
including getting dressed and rehearsing in the dark.
Opposite: Choreographer Kay Thompson gets the models ready for the big night,
despite butting heads with Halston.
Above: Halston invited Marisa Berenson, Betsy Theodoracopulos,
and Jane Holzer to model exclusively for his segment.

Maxim's

"Two nights before the big showdown at Versailles, designer Halston threw a VIP dinner for Liza Minnelli at the famed Maxim's Restaurant in Paris. Yet there were no visible signs of backstage rehearsal dramas they had just left at Versailles, including designers fighting on both sides of the stage, American models and fashion crews freezing cold and sans toilet paper."

\- Bill Cunningham

Opposite: Marisa Berenson.

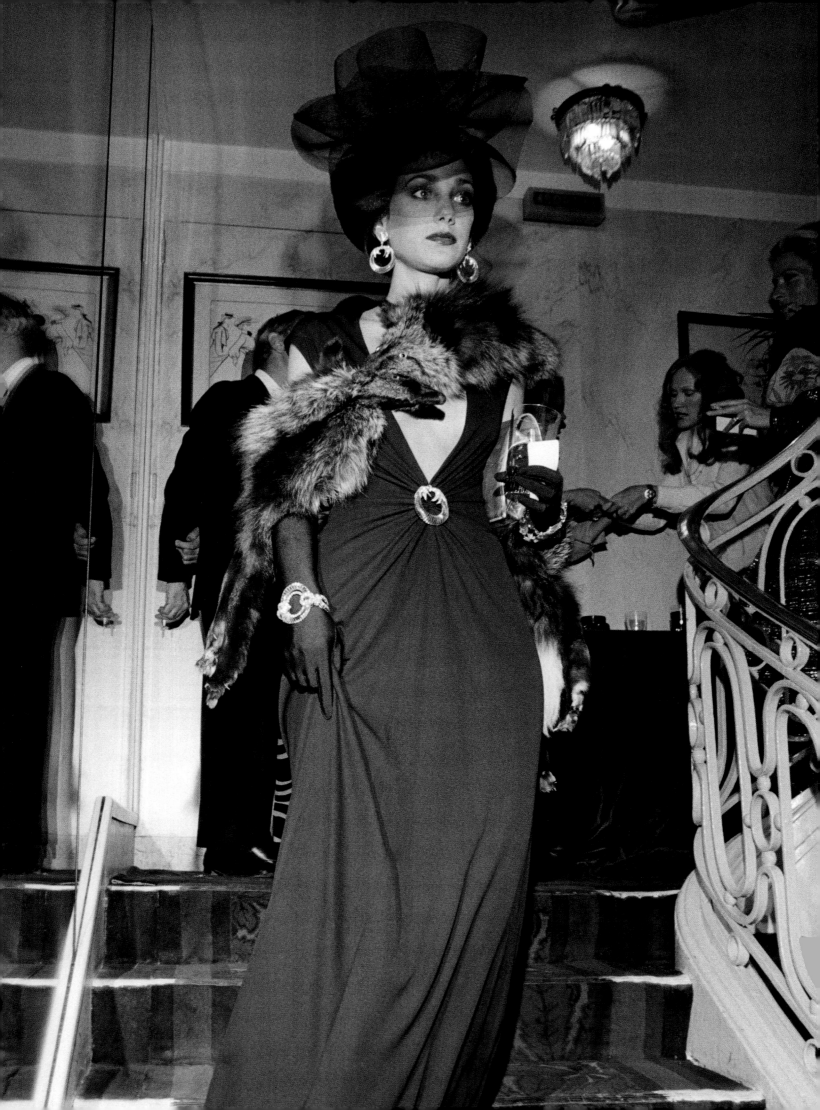

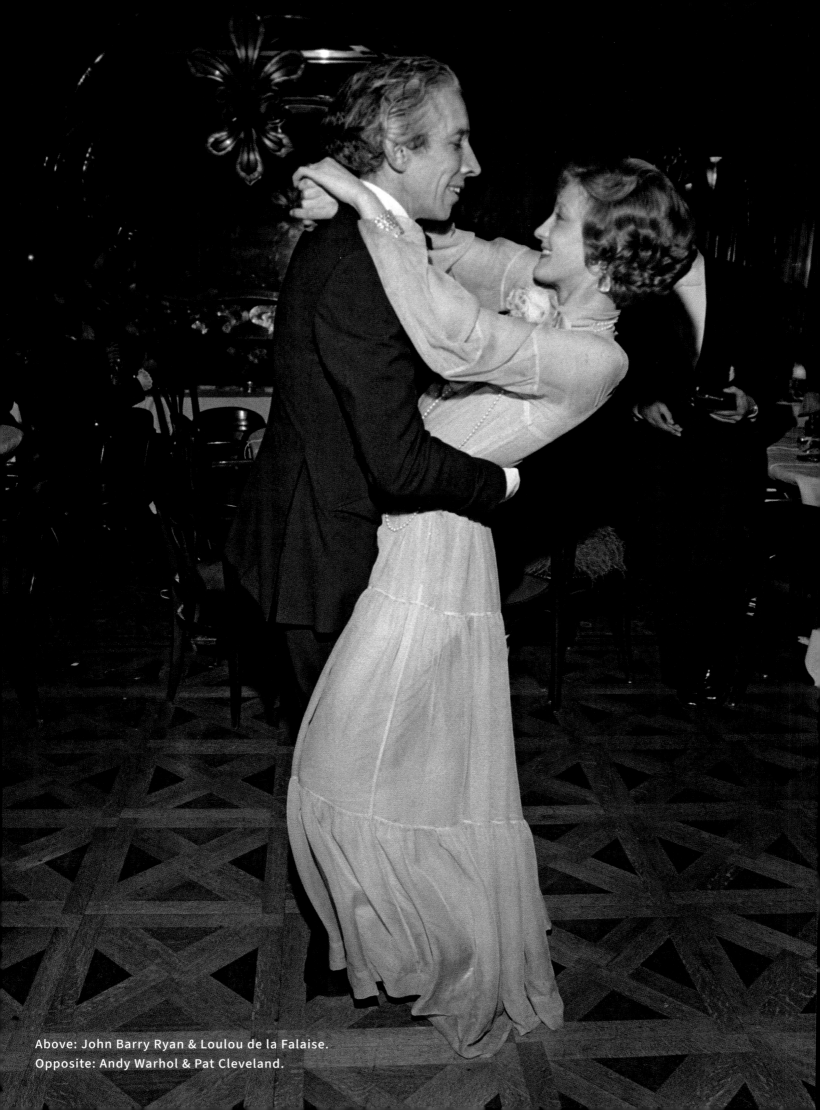

Above: John Barry Ryan & Loulou de la Falaise.
Opposite: Andy Warhol & Pat Cleveland.

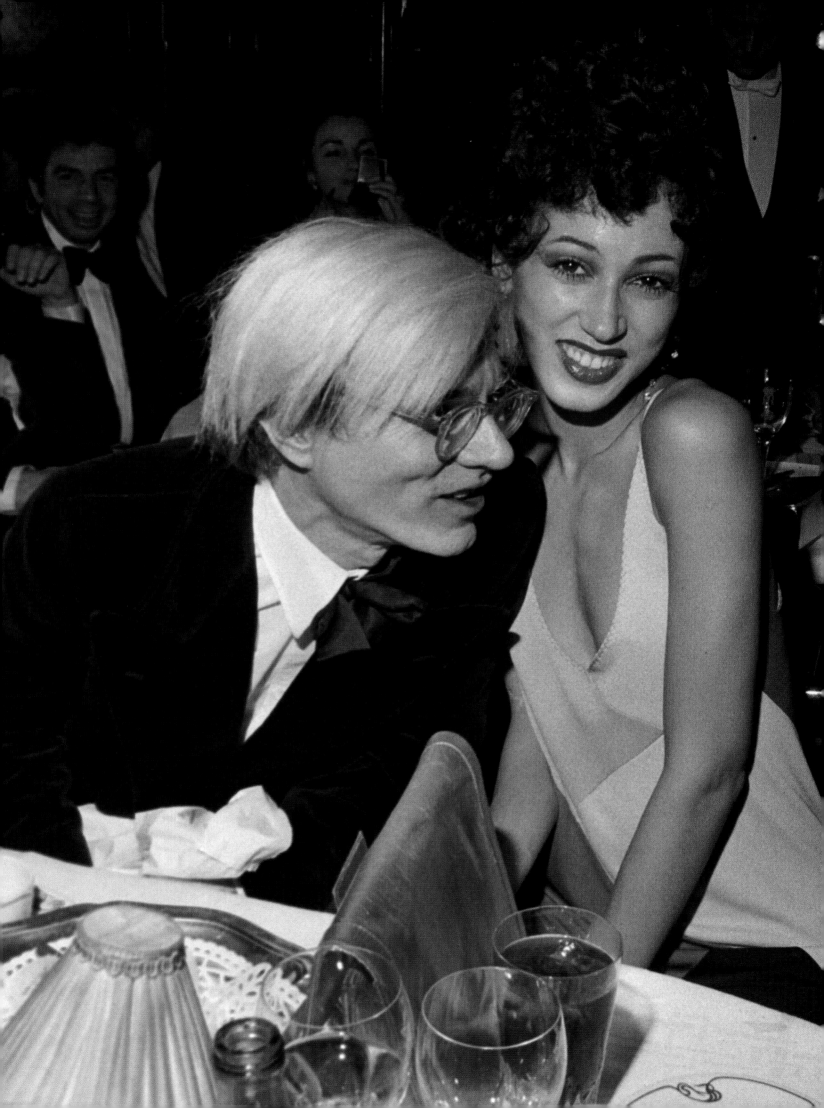

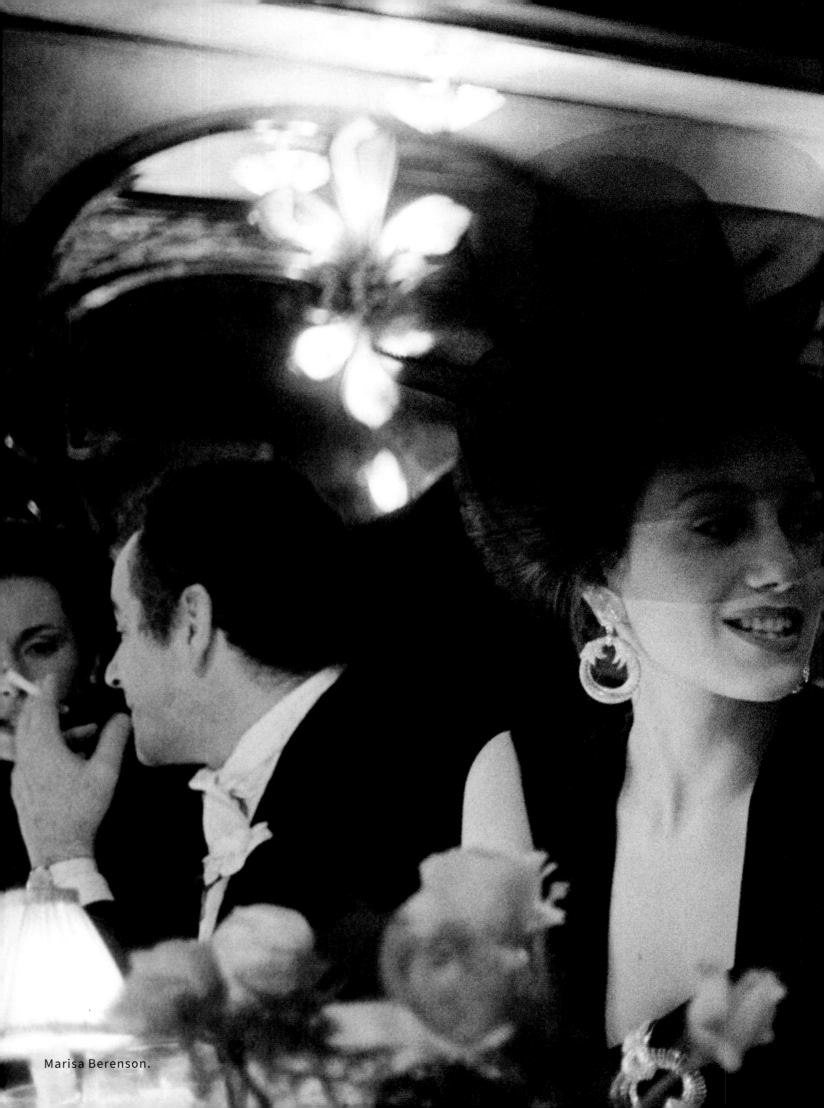

Marisa Berenson.

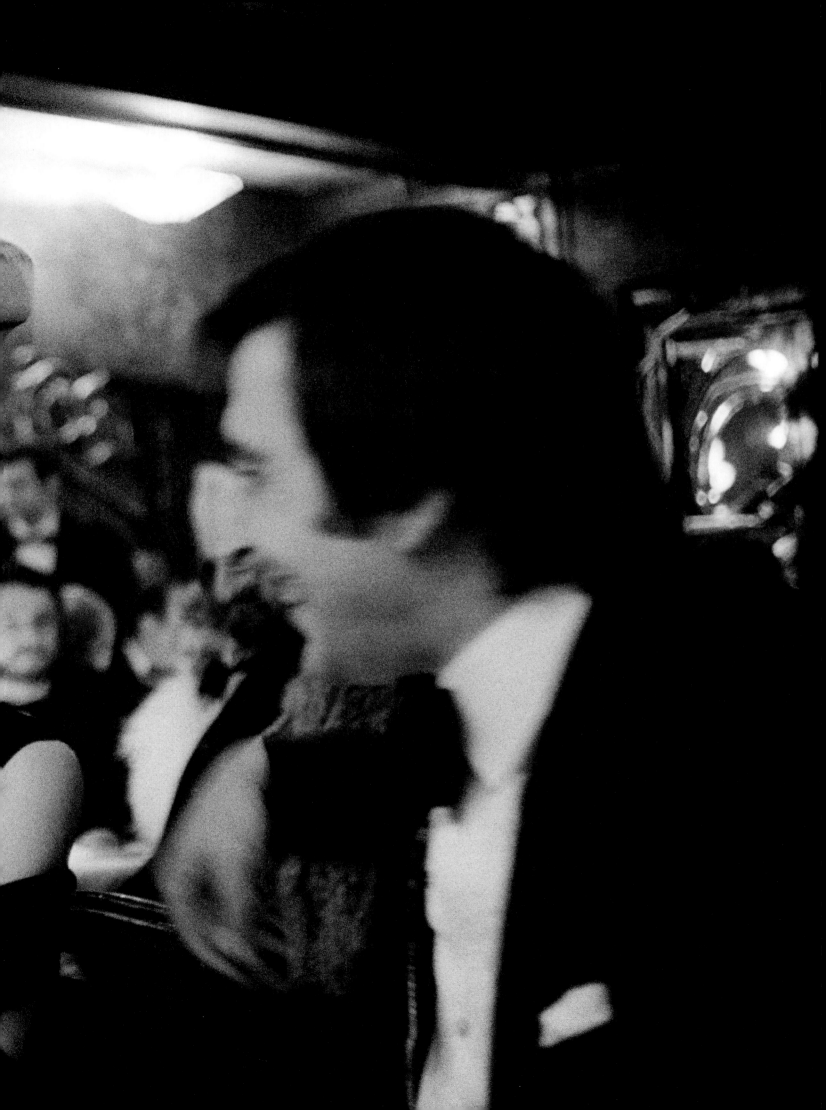

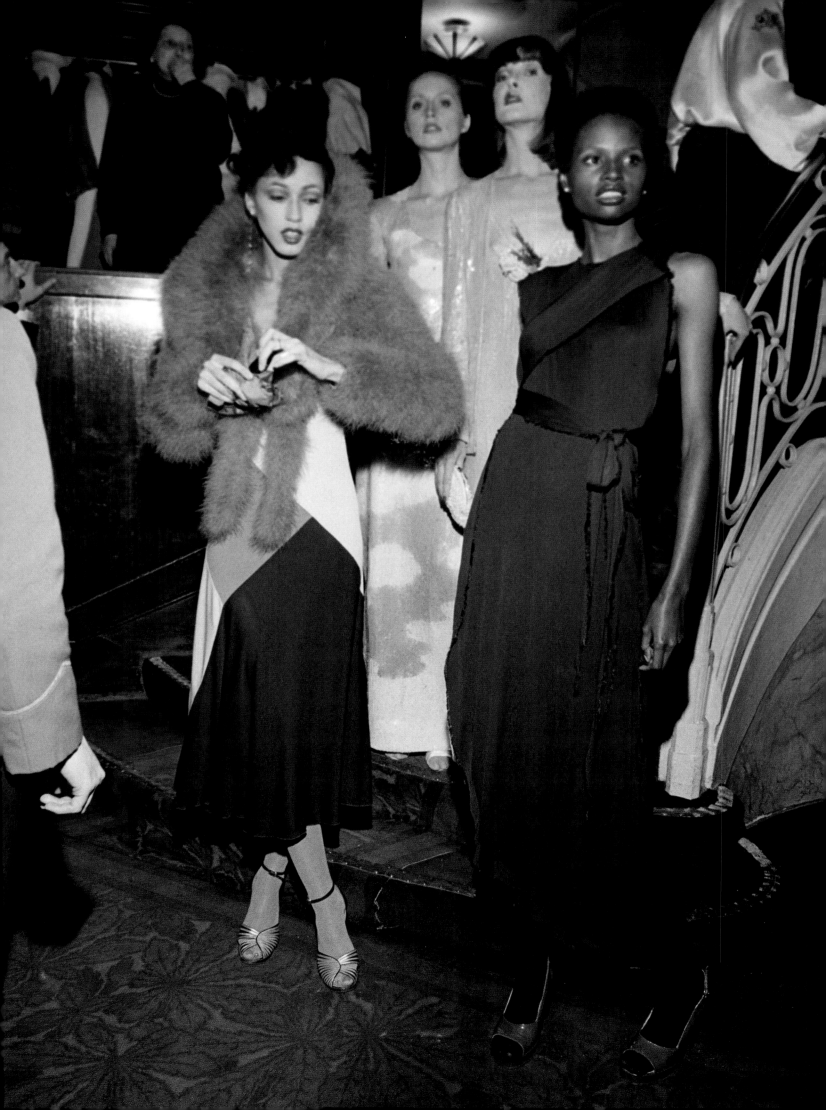

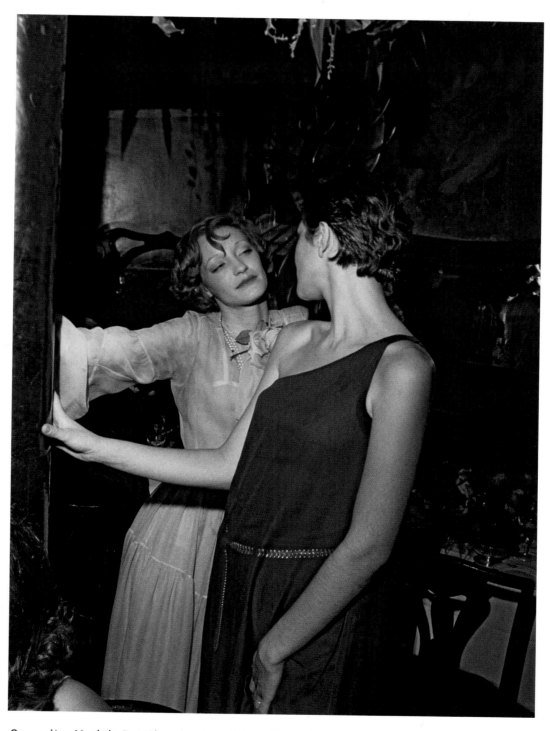

Opposite: Models Pat Cleveland and Jennifer Brice arrive wearing Stephen Burrows,
while Chris Royer and Nancy North opt for designs by Halston.
Above: Loulou de Falaise takes a break from the dance floor to catch-up
with Halston's assistant Carola Polakov.

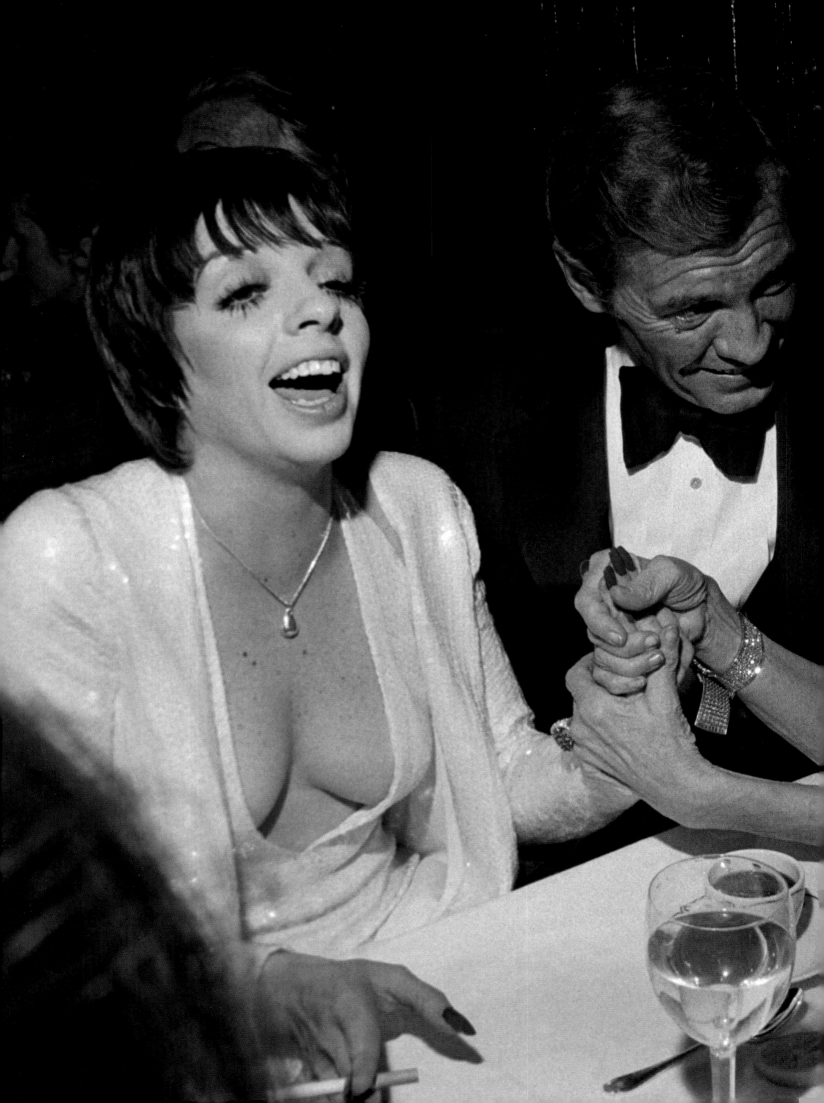

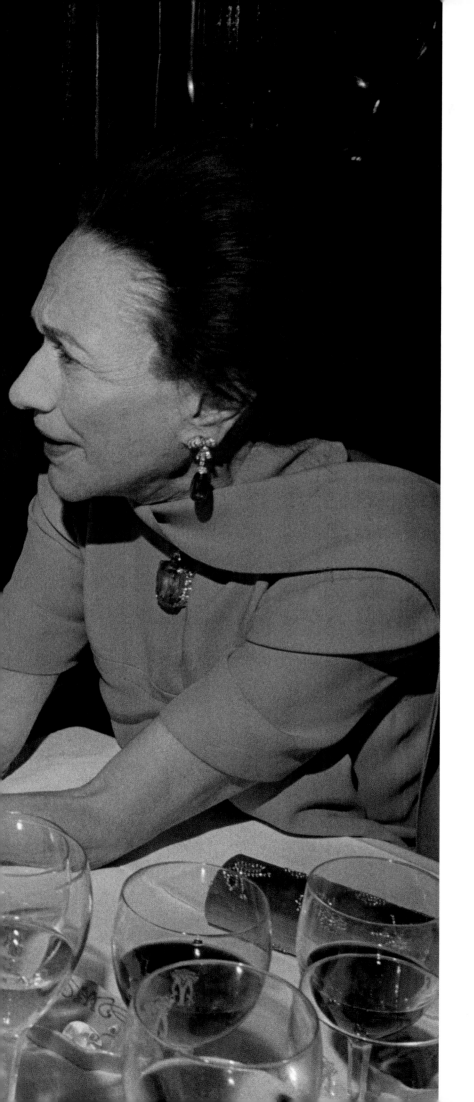

Norton Simon CEO David J. Mahoney picked-up the $13,000 tab for the A-List dinner including guest of honor Liza Minnelli (left) and Wallis Simpson, Duchess of Windsor (right).

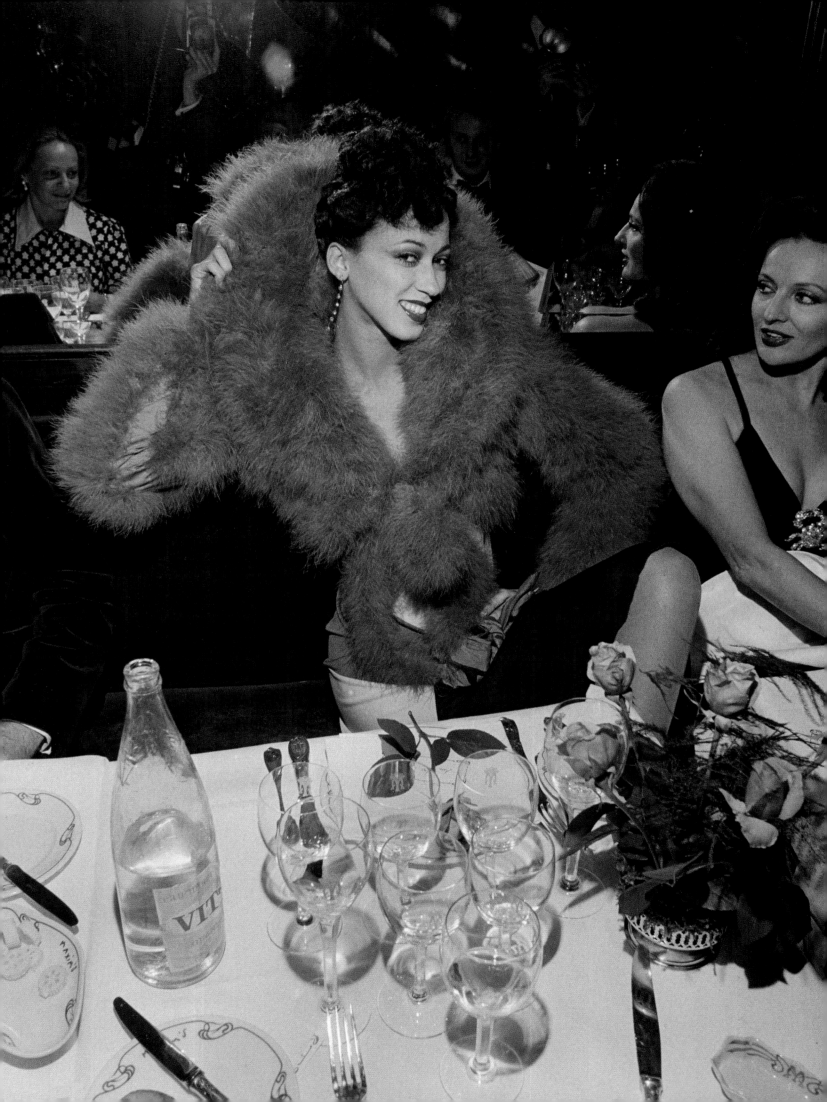

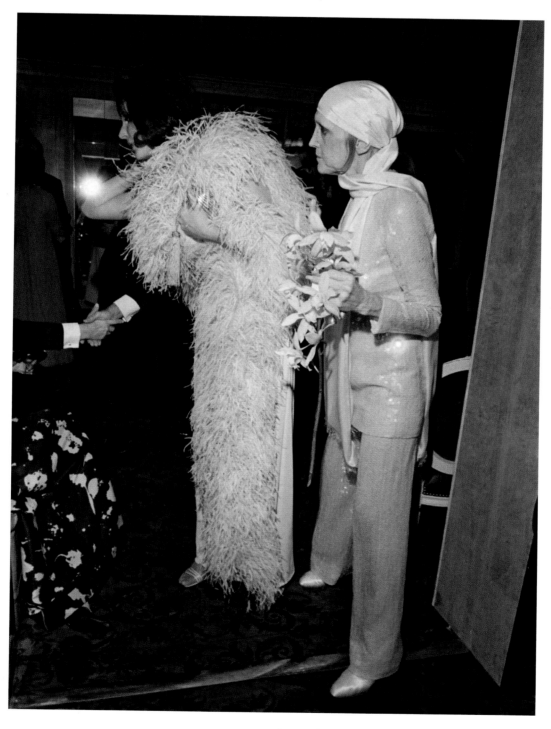

Opposite: Pat Cleveland & Cappy Badrott.
Above: Kay Thompson arrives at Maxim's with Betsy Theodoracopulos.
Following Page: Nancy North & Pat Cleveland singing "Isn't it Romantic."

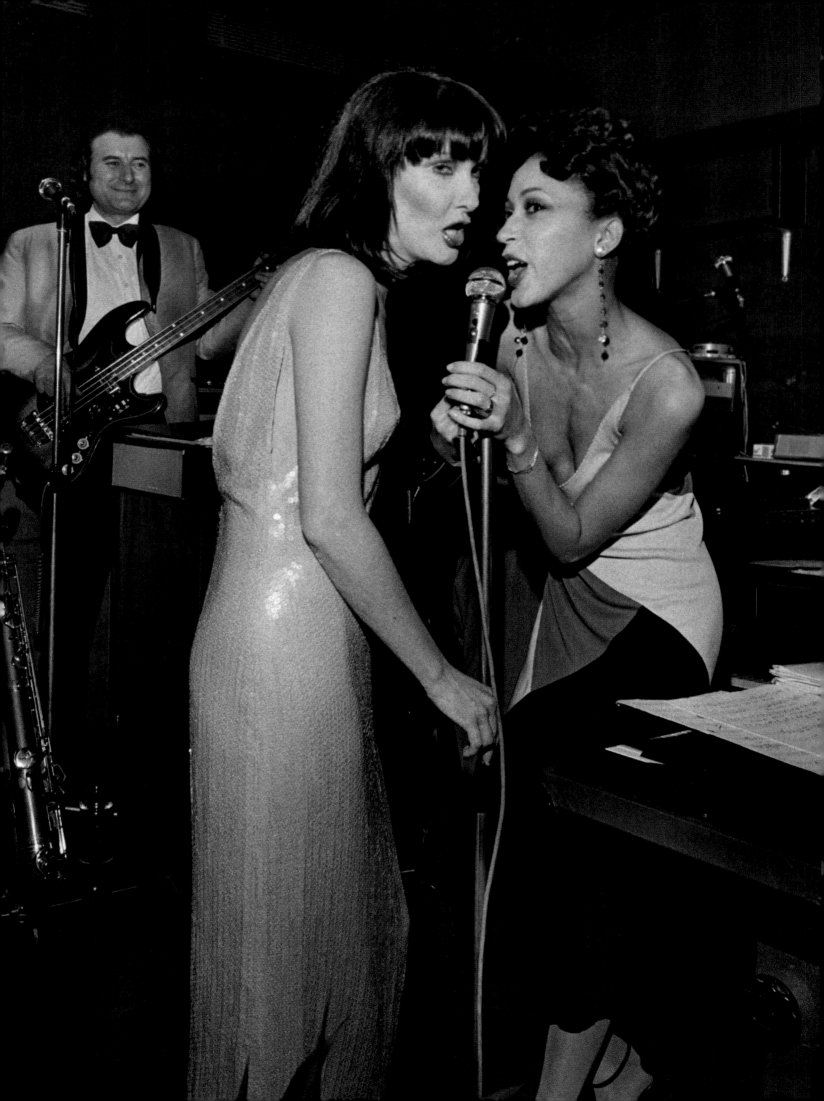

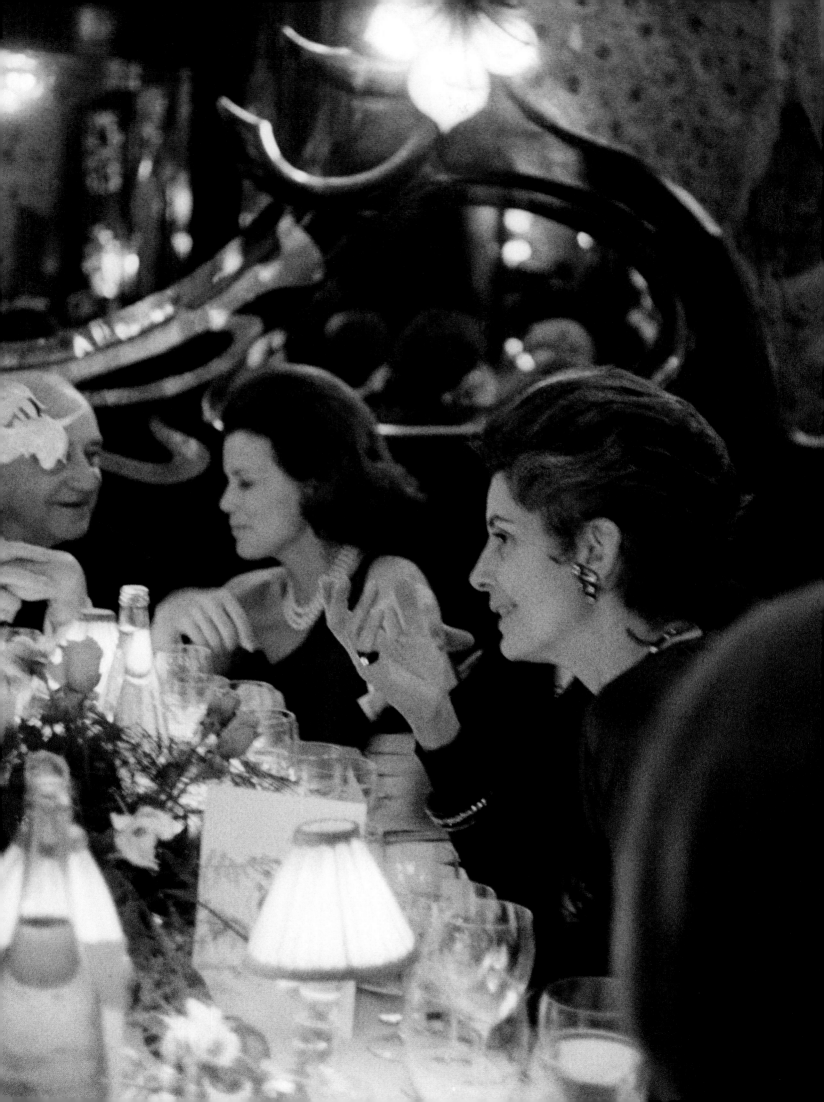

Opposite: Hubert de Givenchy, Halston, Fred Hughes, Paloma Picasso, and Oscar de la Renta.

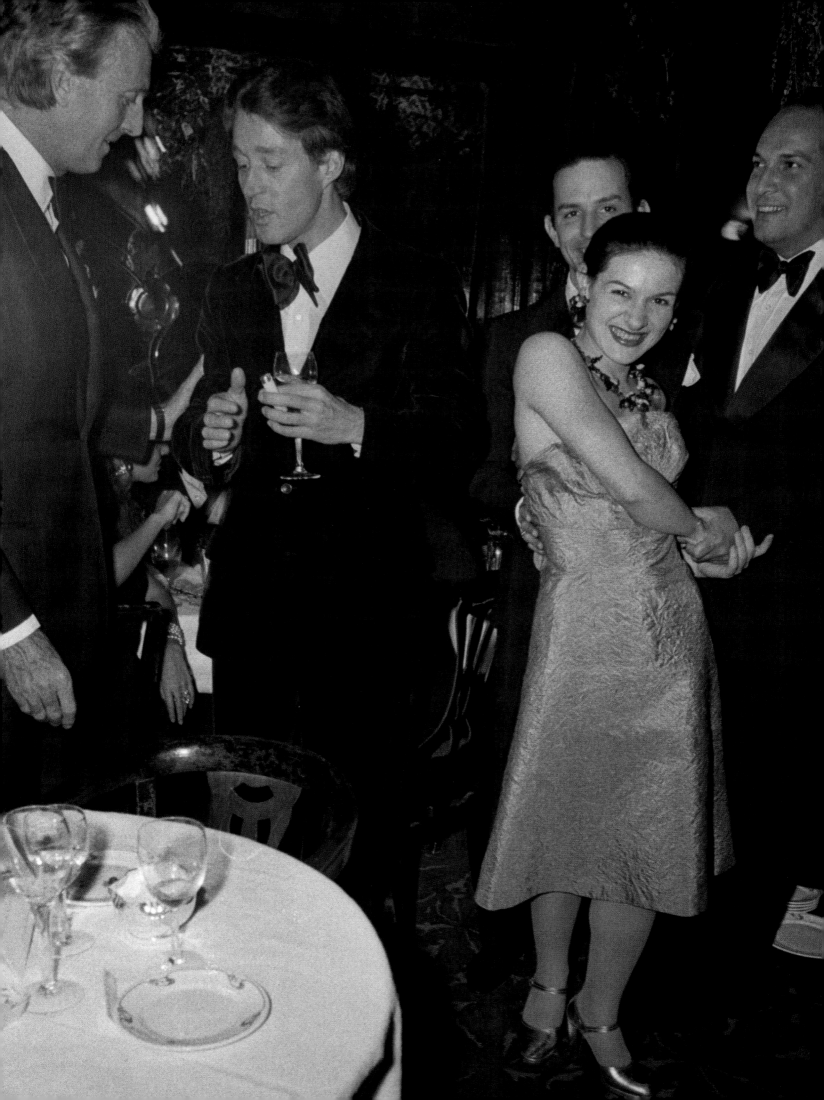

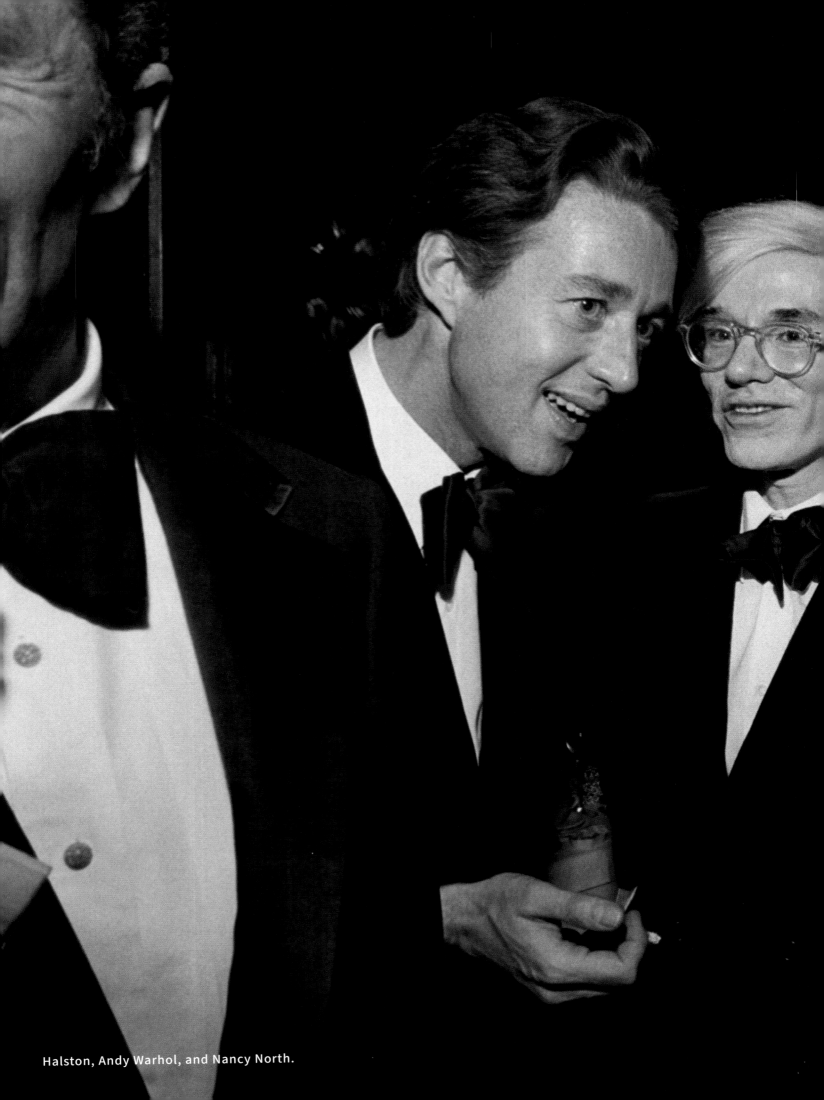

Halston, Andy Warhol, and Nancy North.

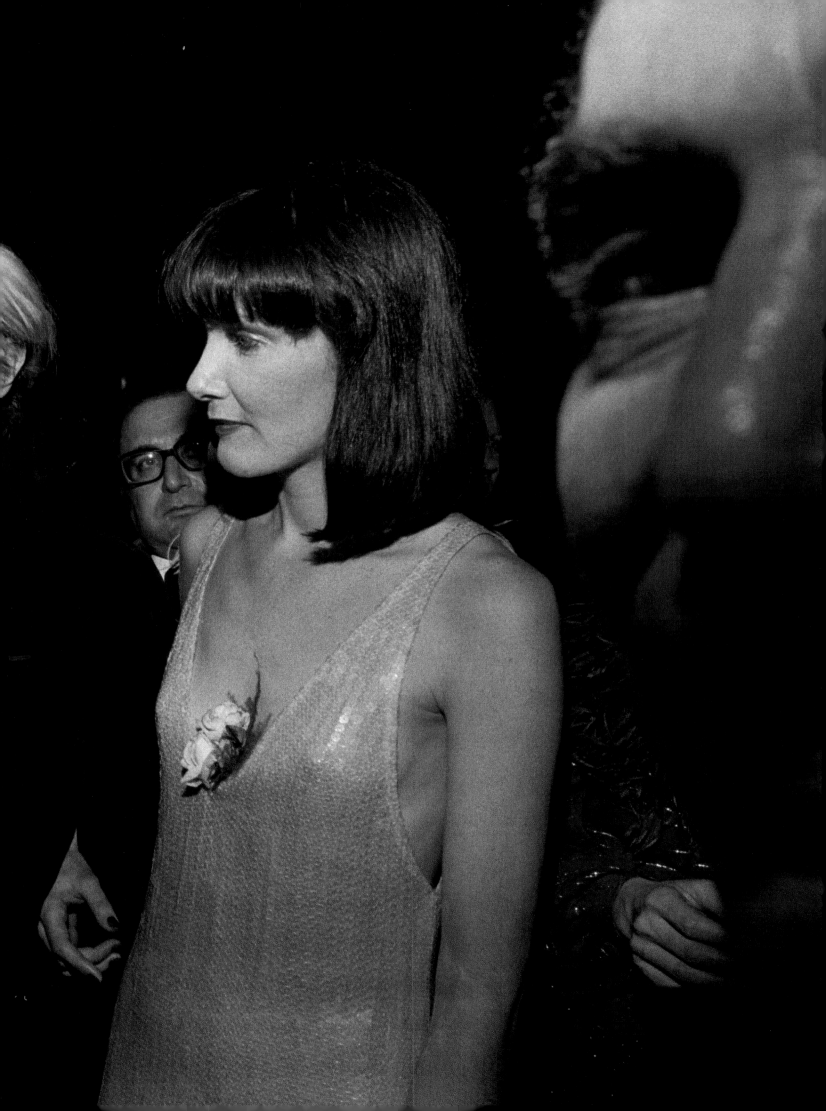

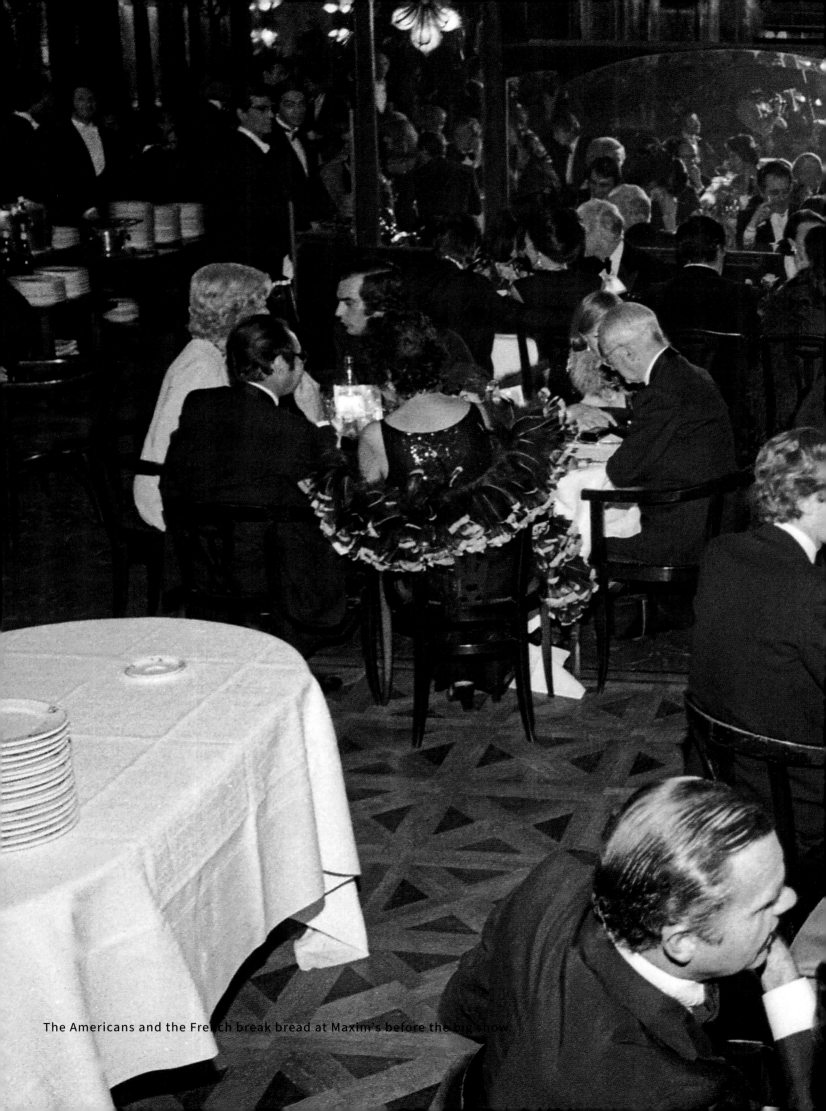

The Americans and the French break bread at Maxim's before the big show.

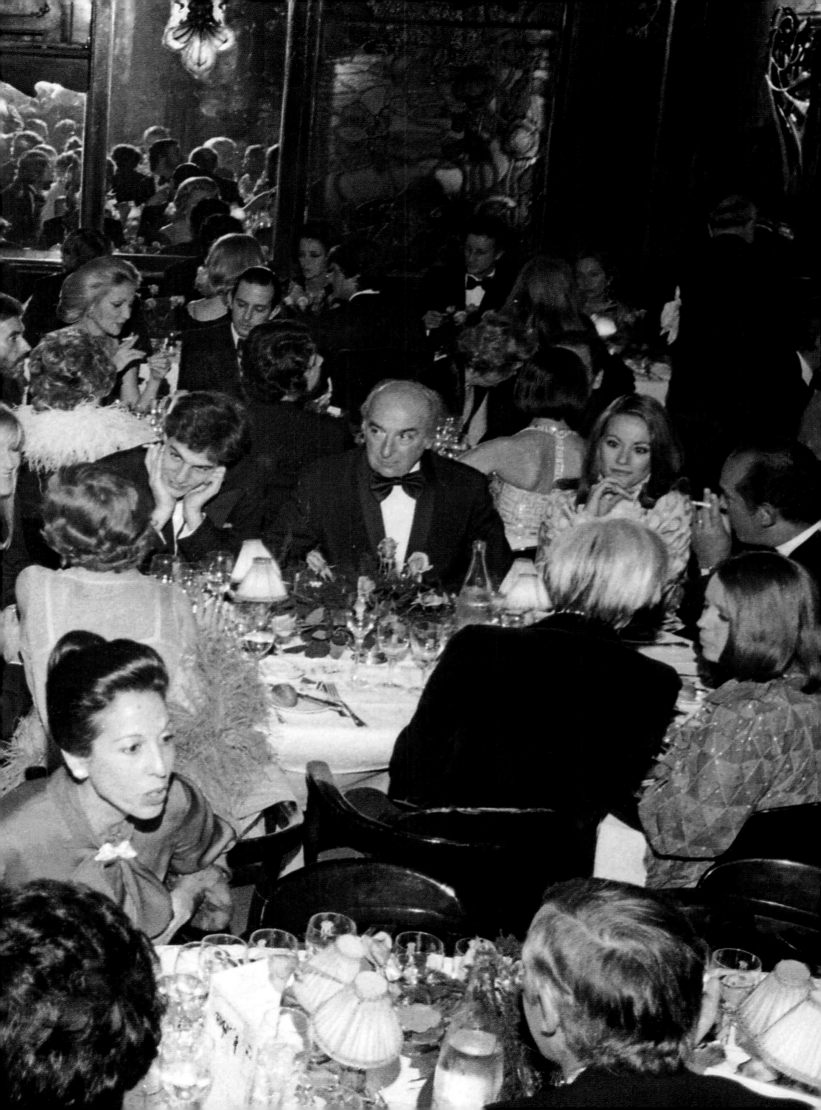

The French

"Hadn't I felt more excitement when photographing the haute couture collections in the salons of Paris back in July, without fruit stands, giant pumpkins and rockets?"

- Jean-luce Huré

"The visual collapse of the French couture design and their expensive, hideously cheap, over-production reminded one of the Macy's Thanksgiving Day Parade."

- Bill Cunningham

Opposite: American expat Josephine Baker opens the French act.

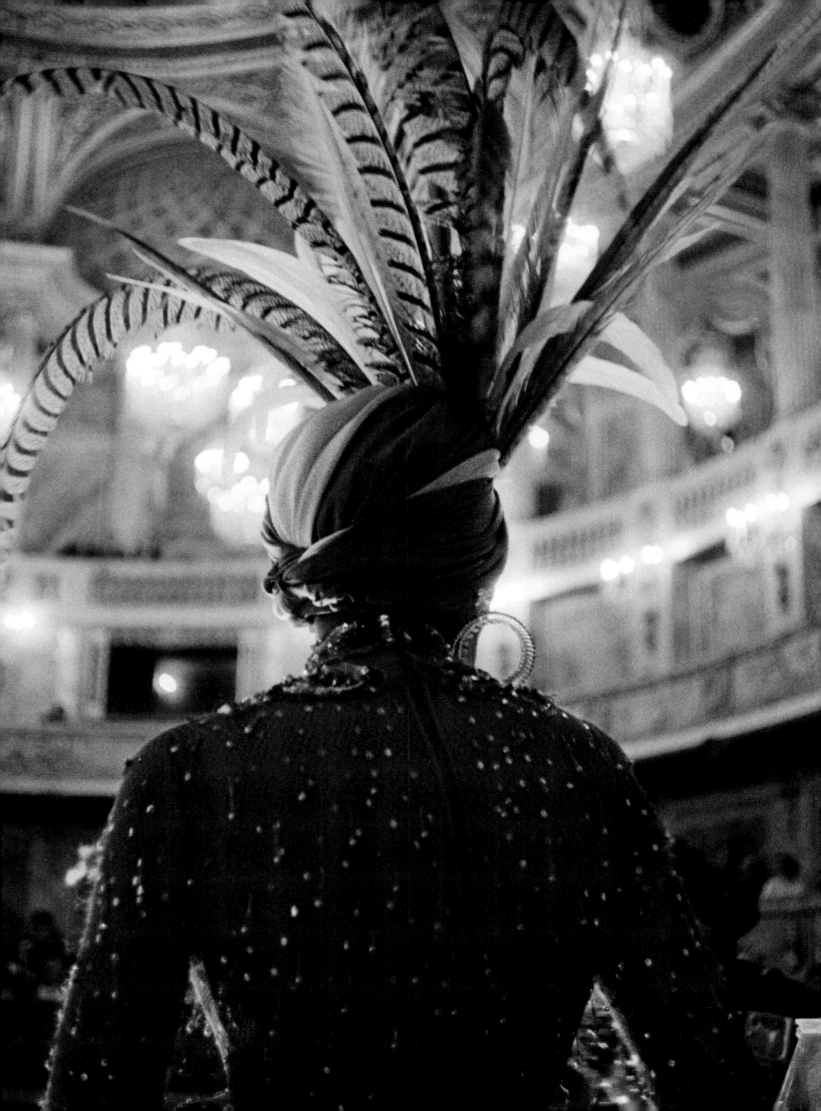

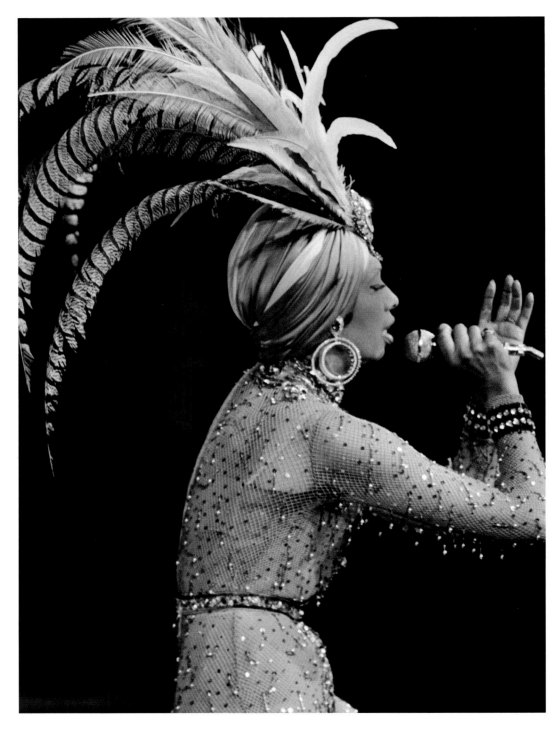

Above: Josephine Baker.
Opposite: Josephine Baker in a rhinestone Yves Saint Laurent bodysuit and eighty
pound fur coat.

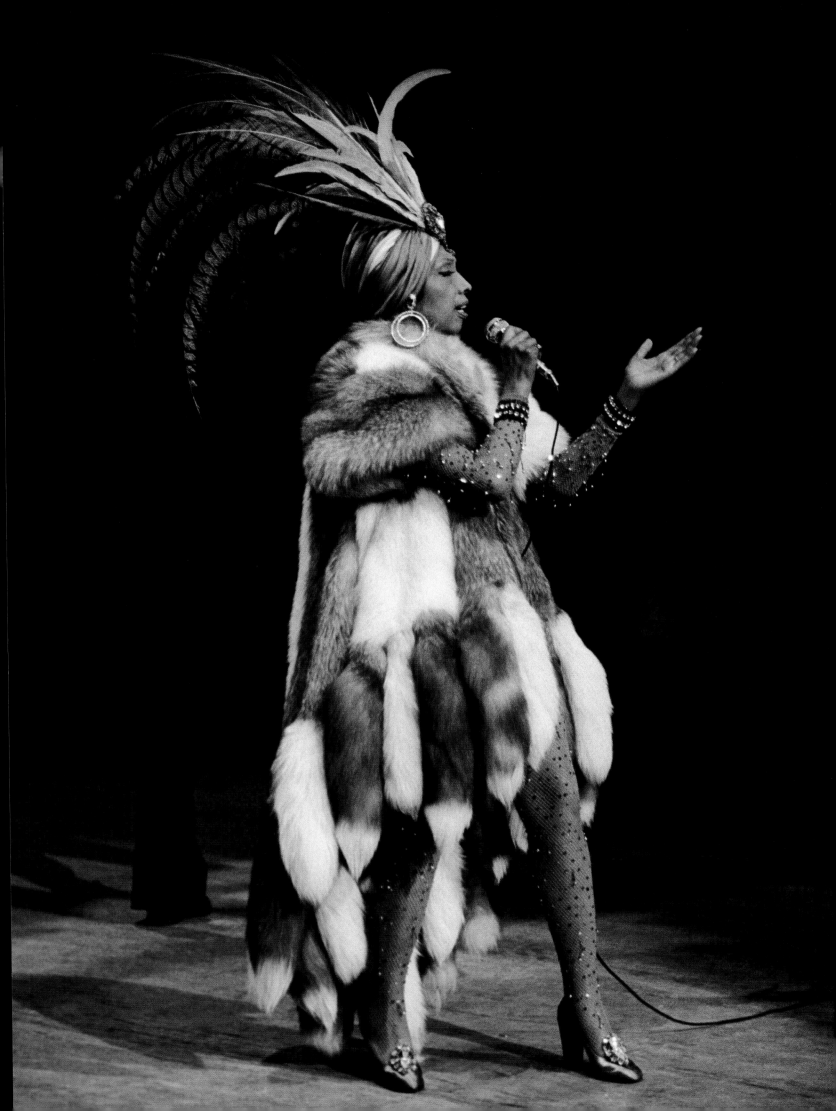

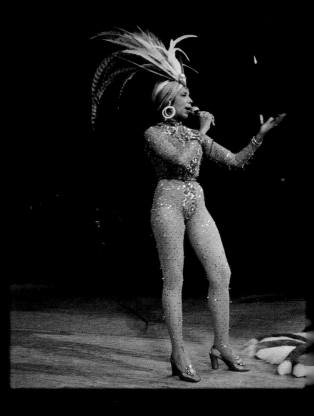

→ 26 → 26A → 27

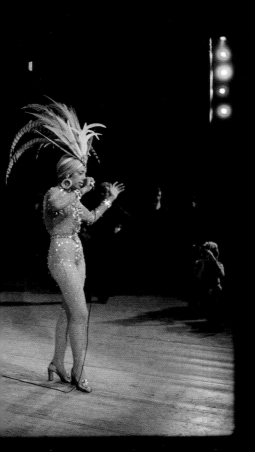
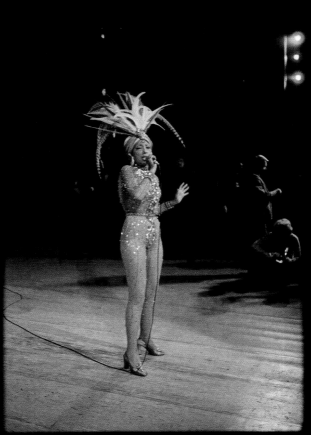
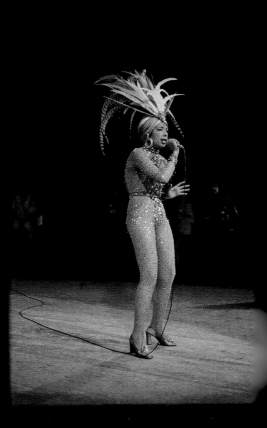

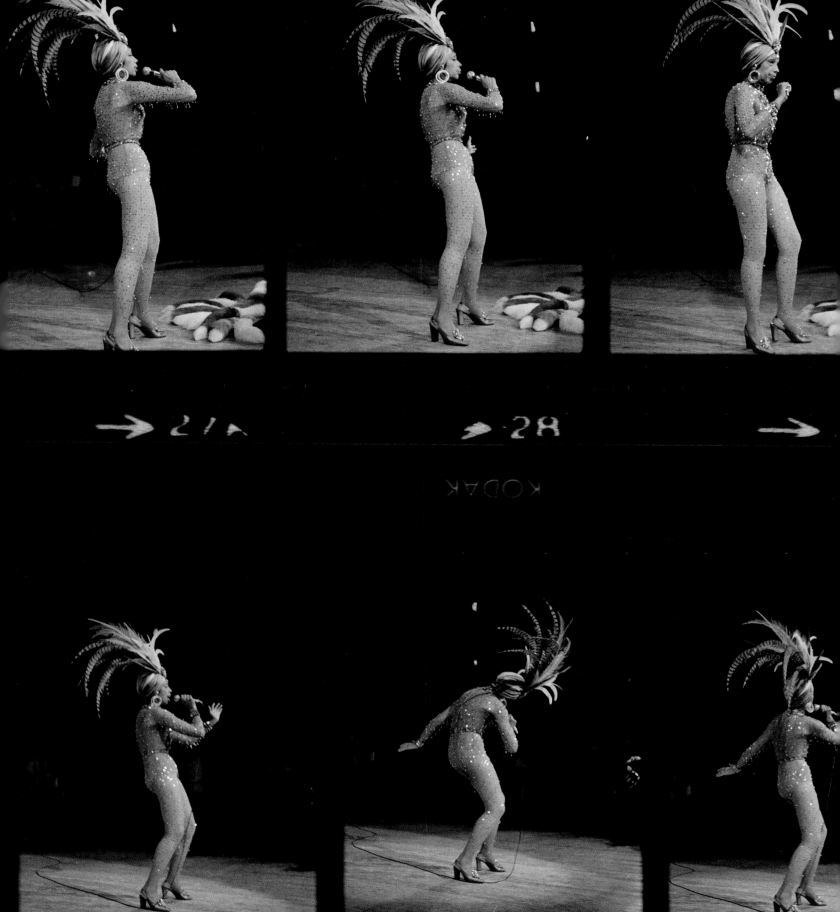

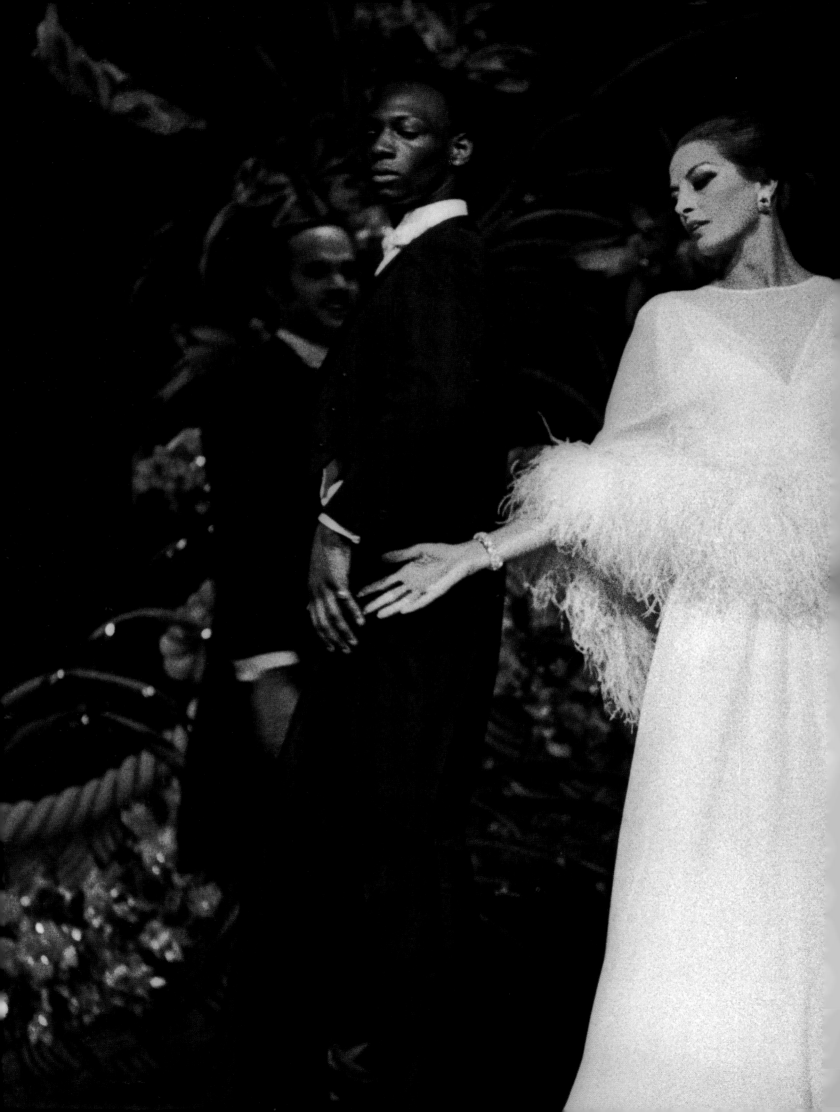

Model Capucine headlined Givenchy's segment.

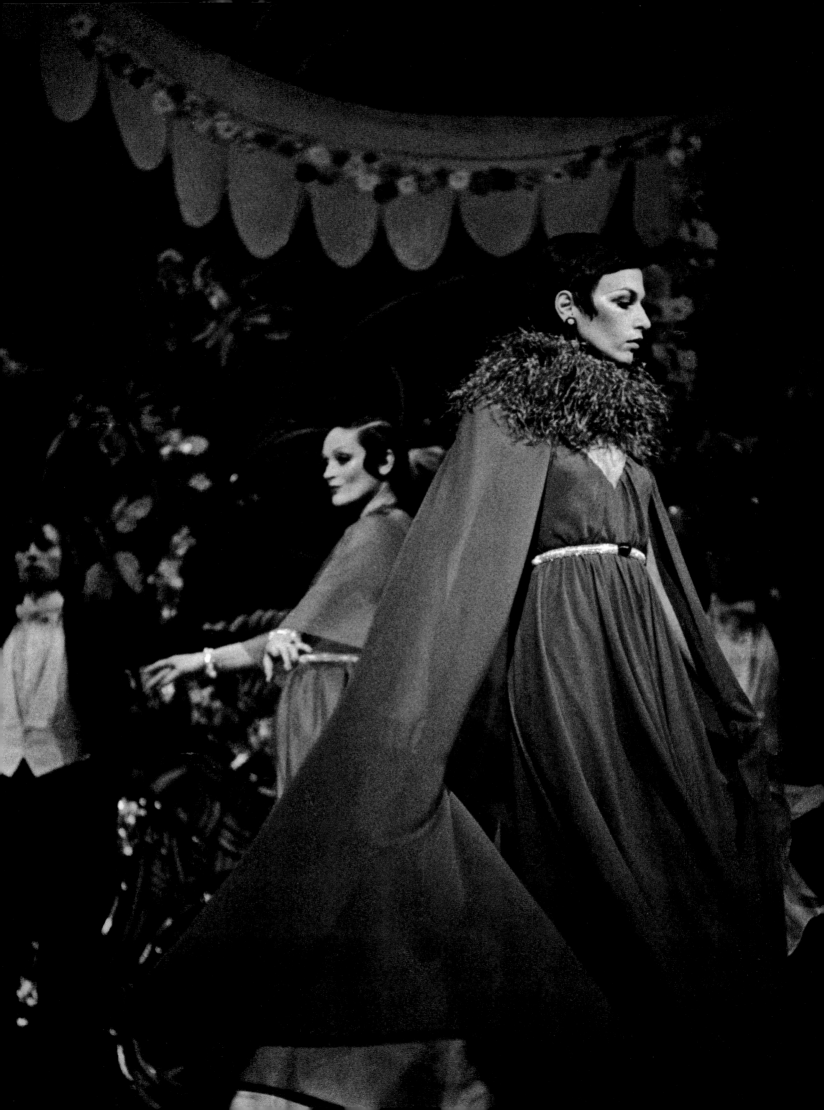

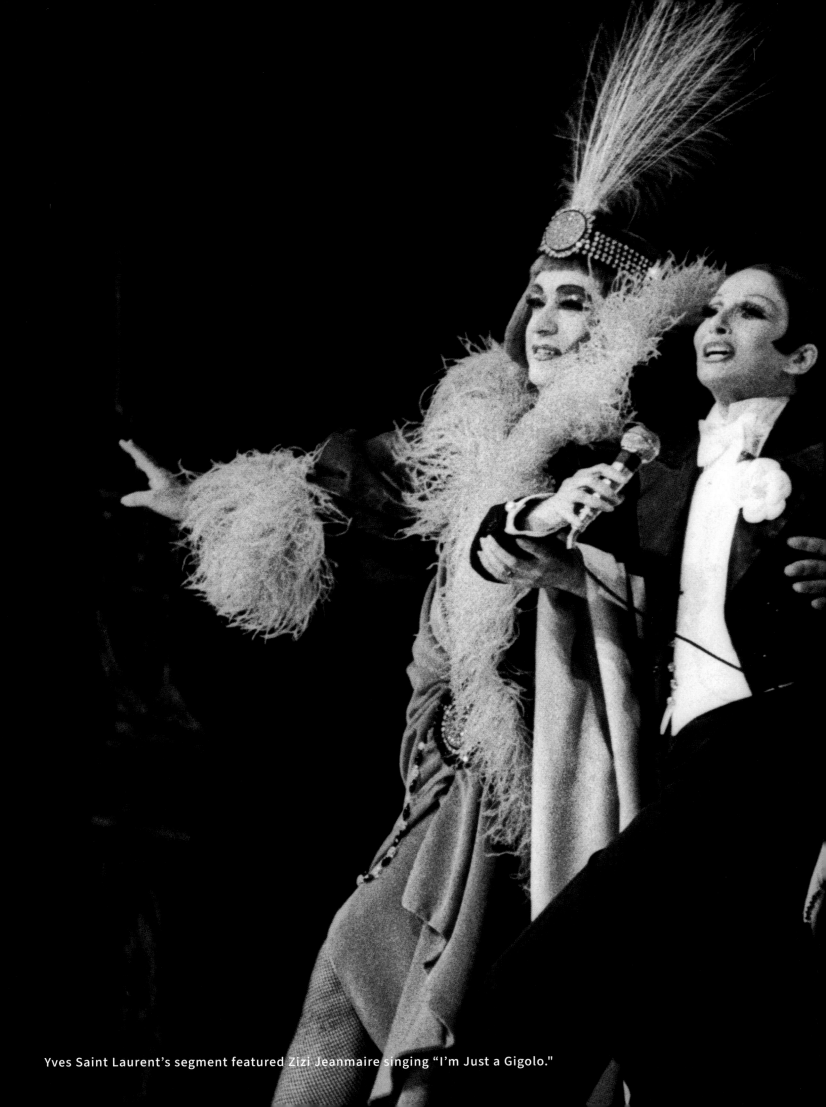

Yves Saint Laurent's segment featured Zizi Jeanmaire singing "I'm Just a Gigolo."

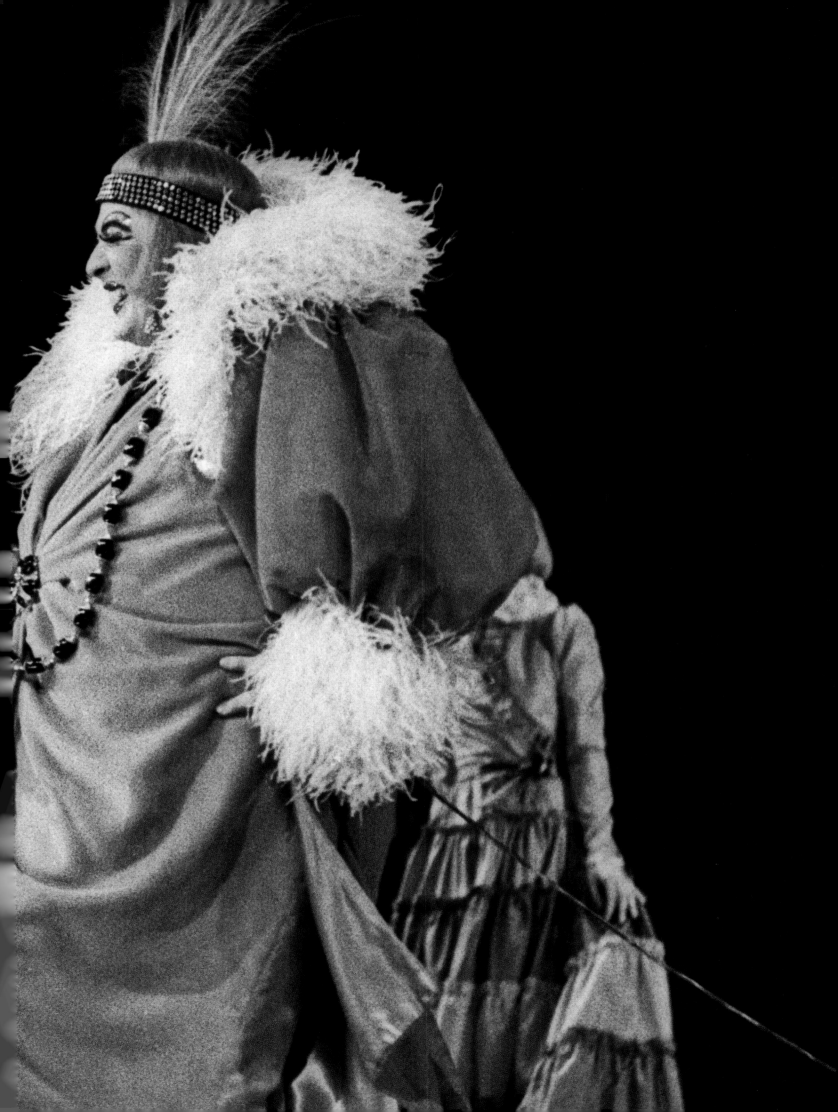

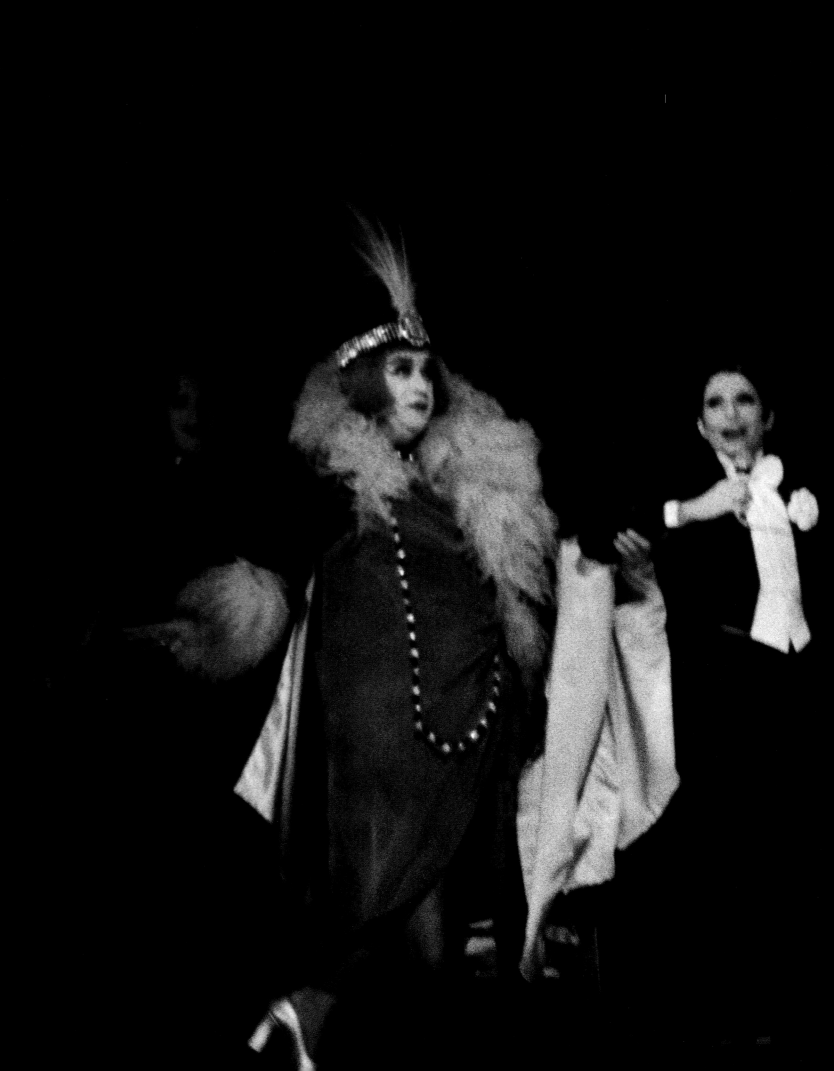

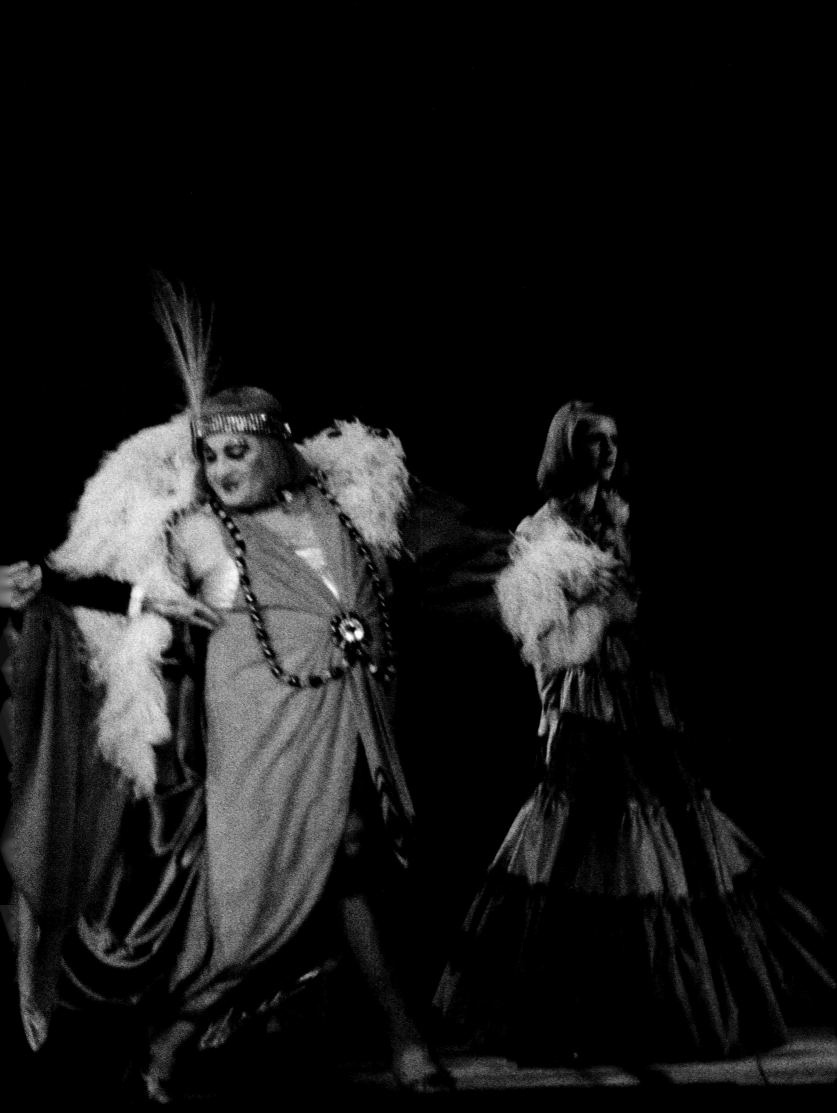

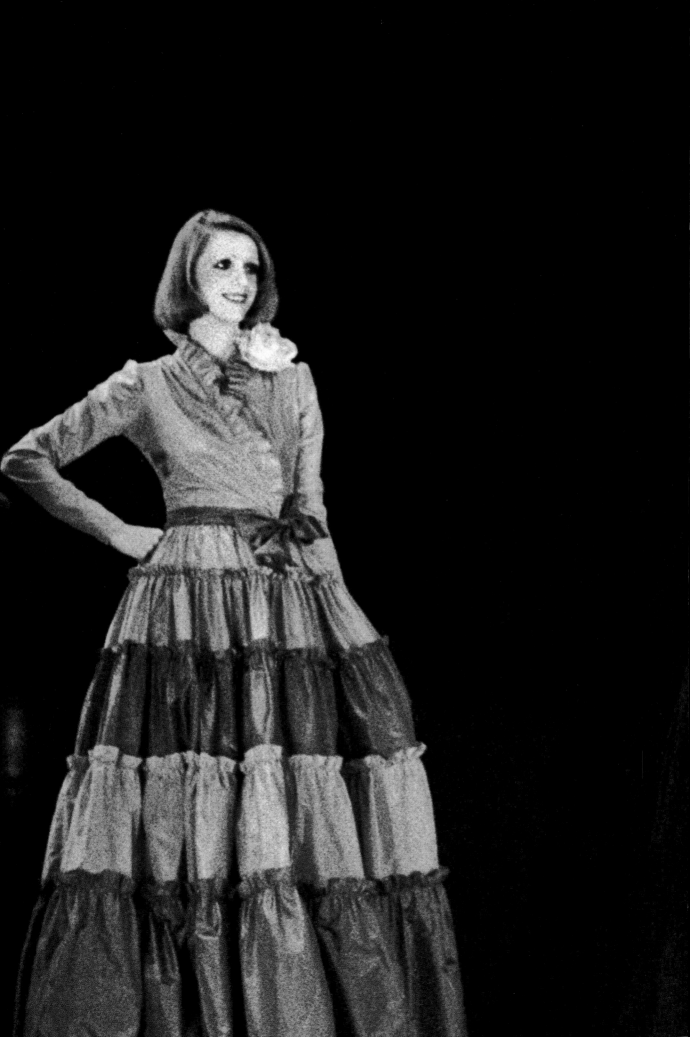

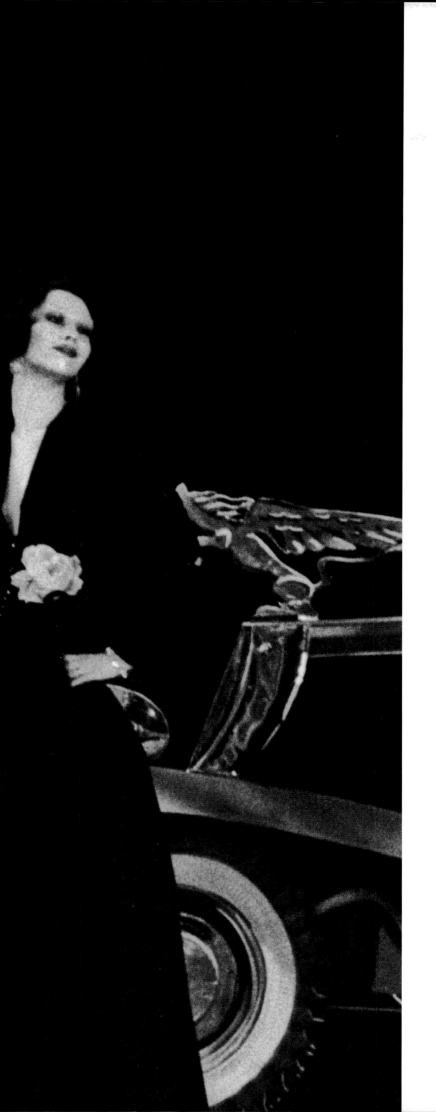

Opposite: Yves Saint Laurent. 77

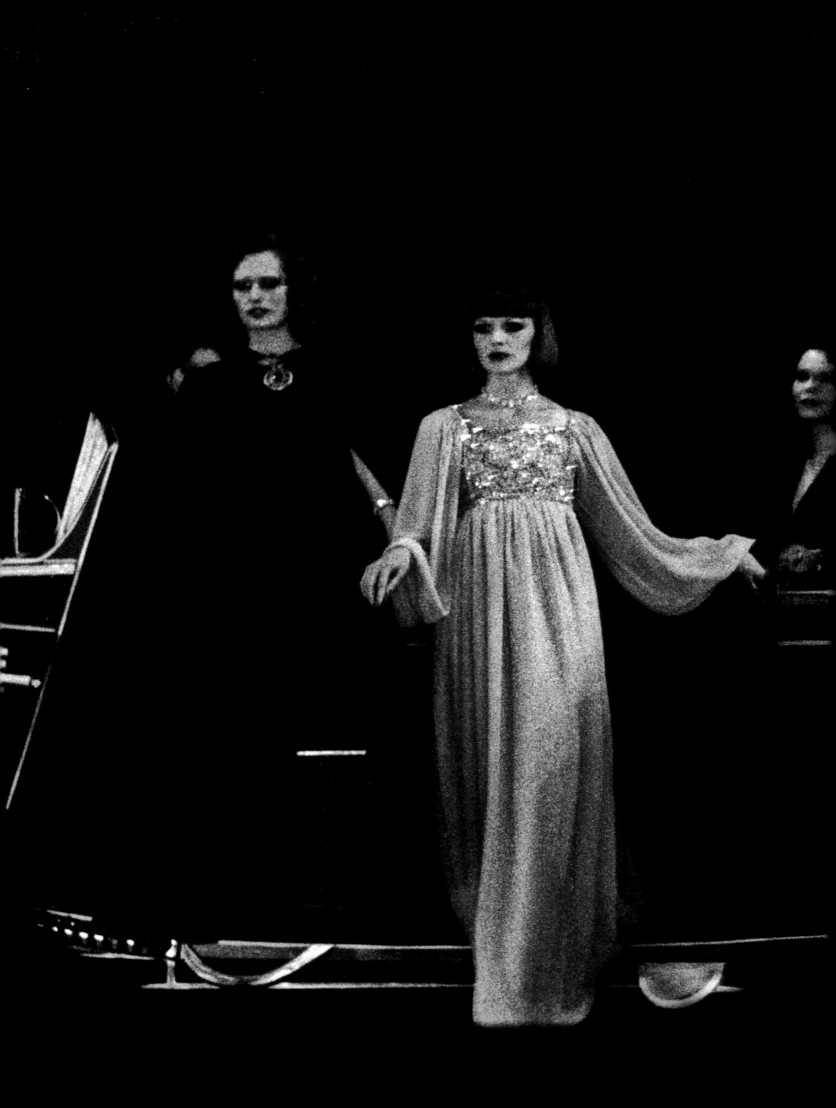

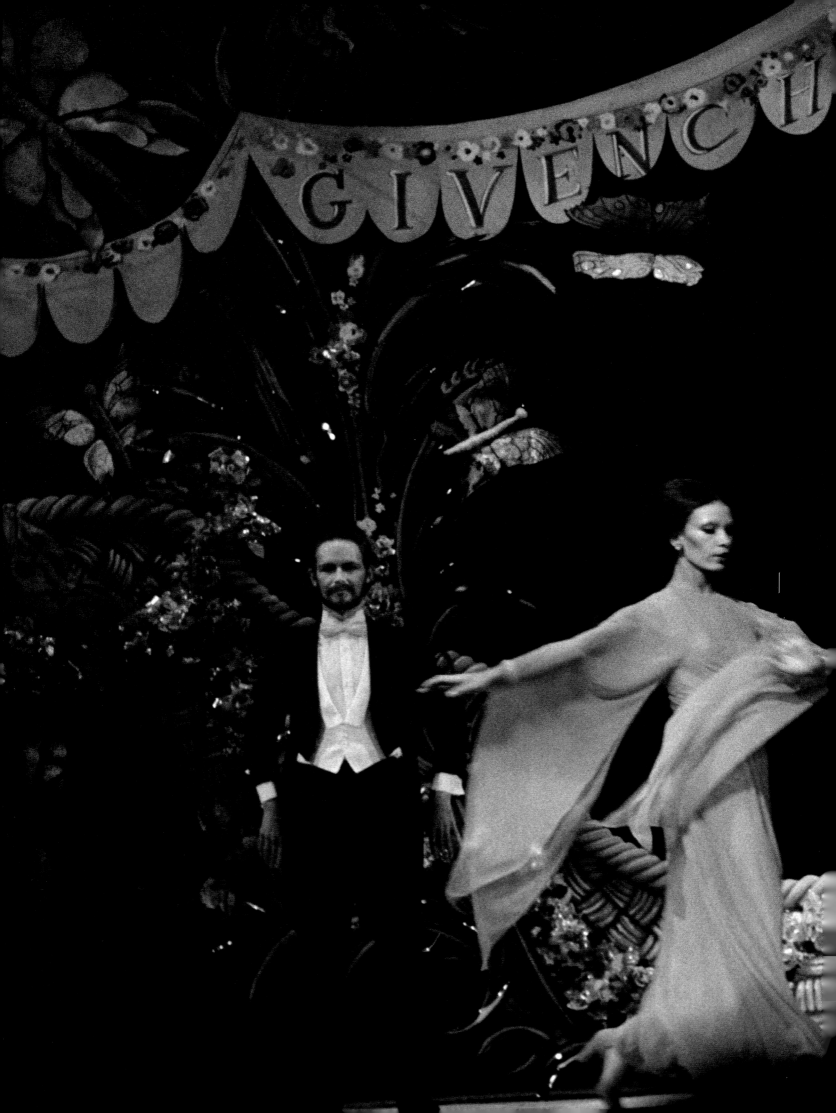

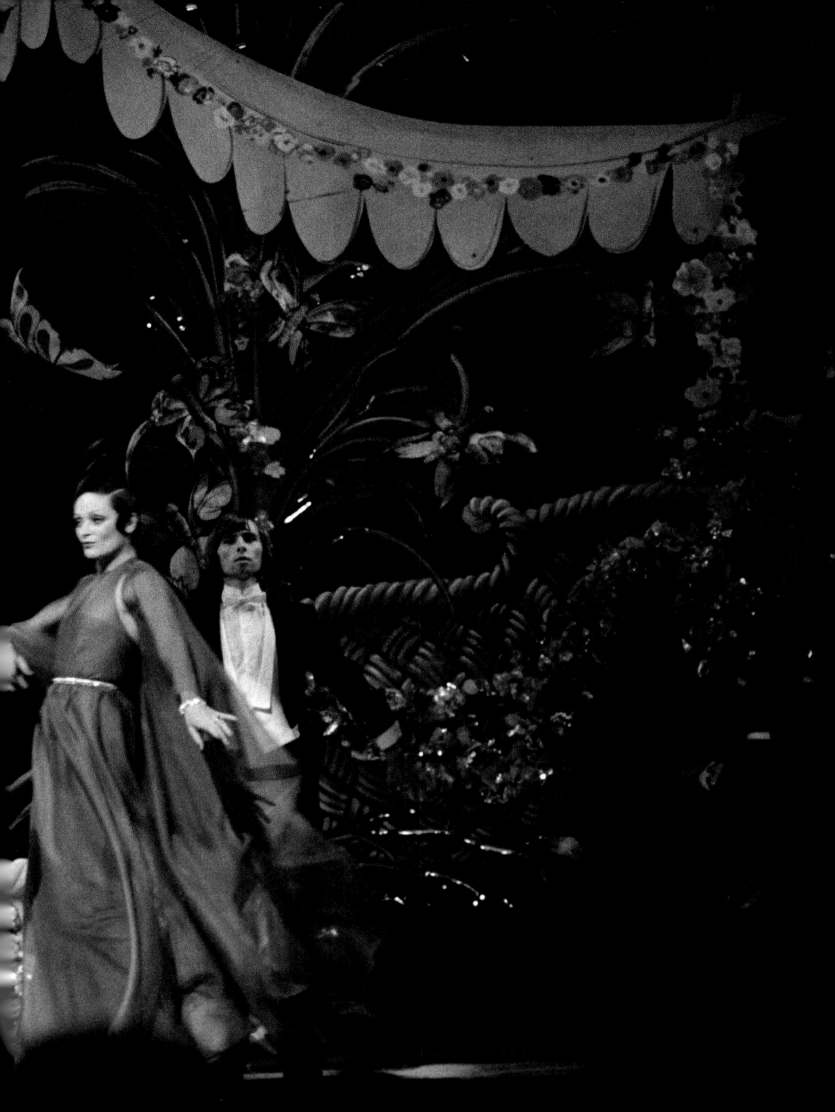

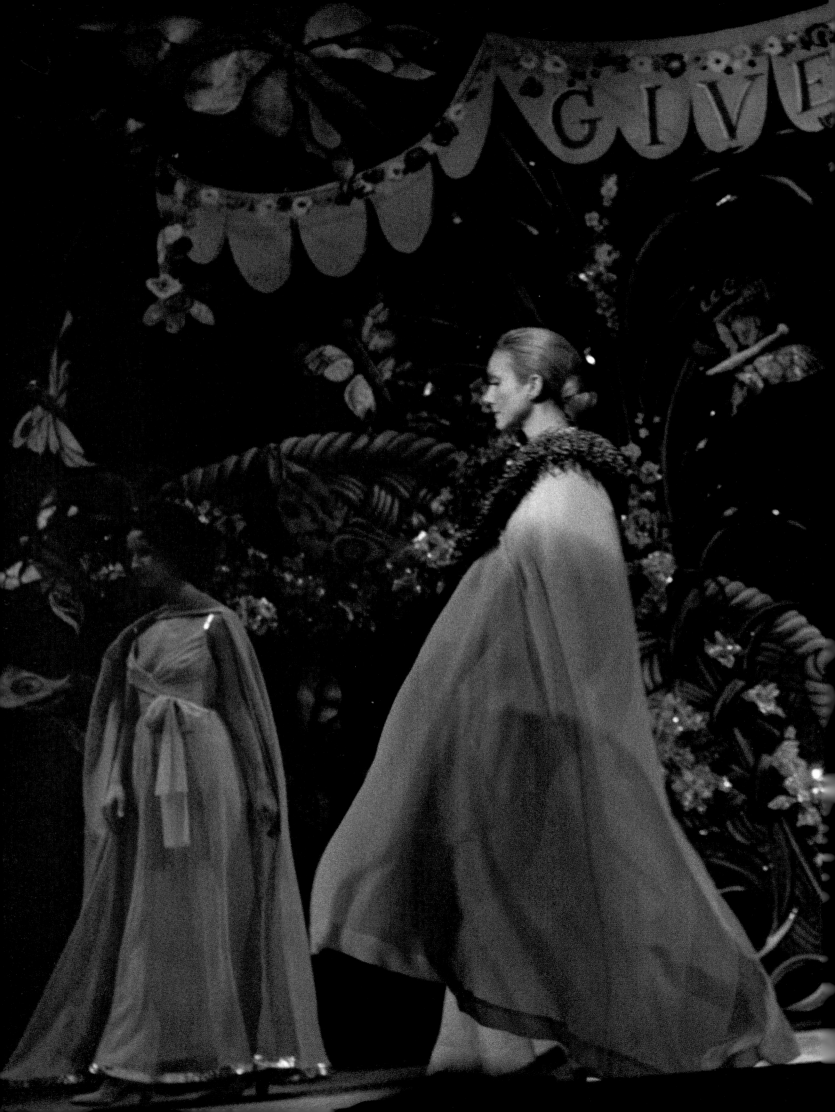

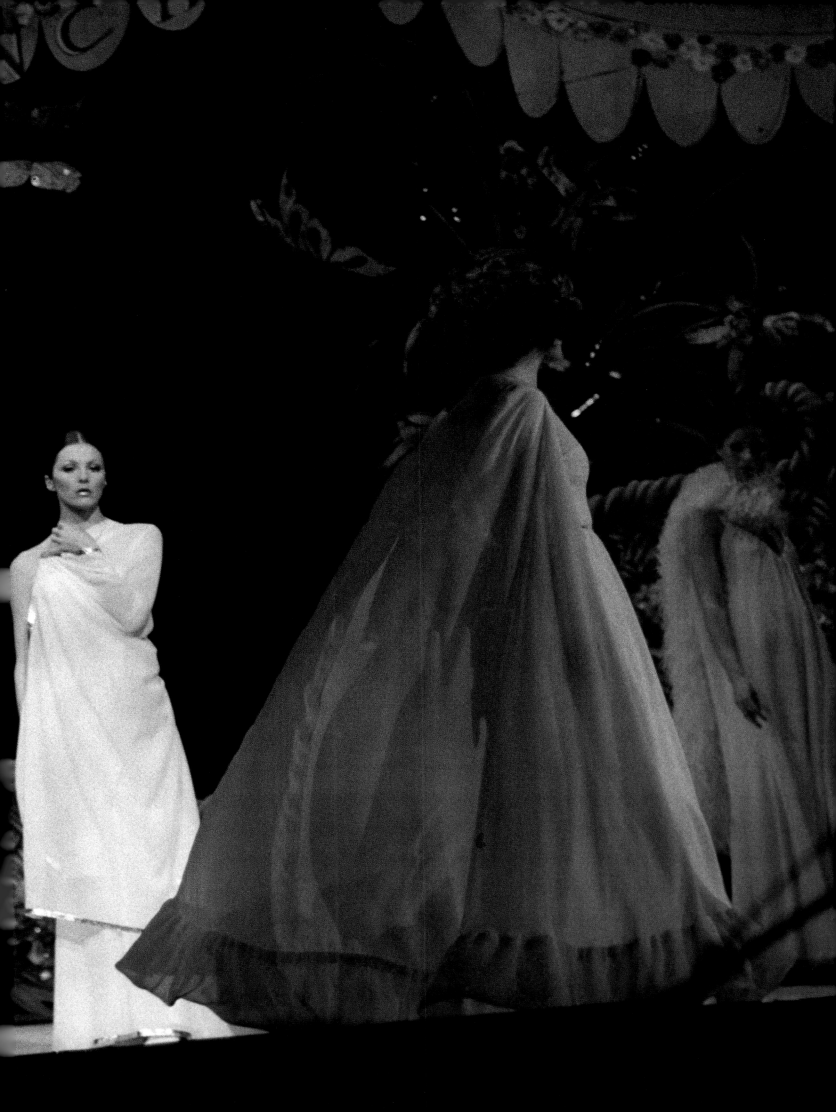

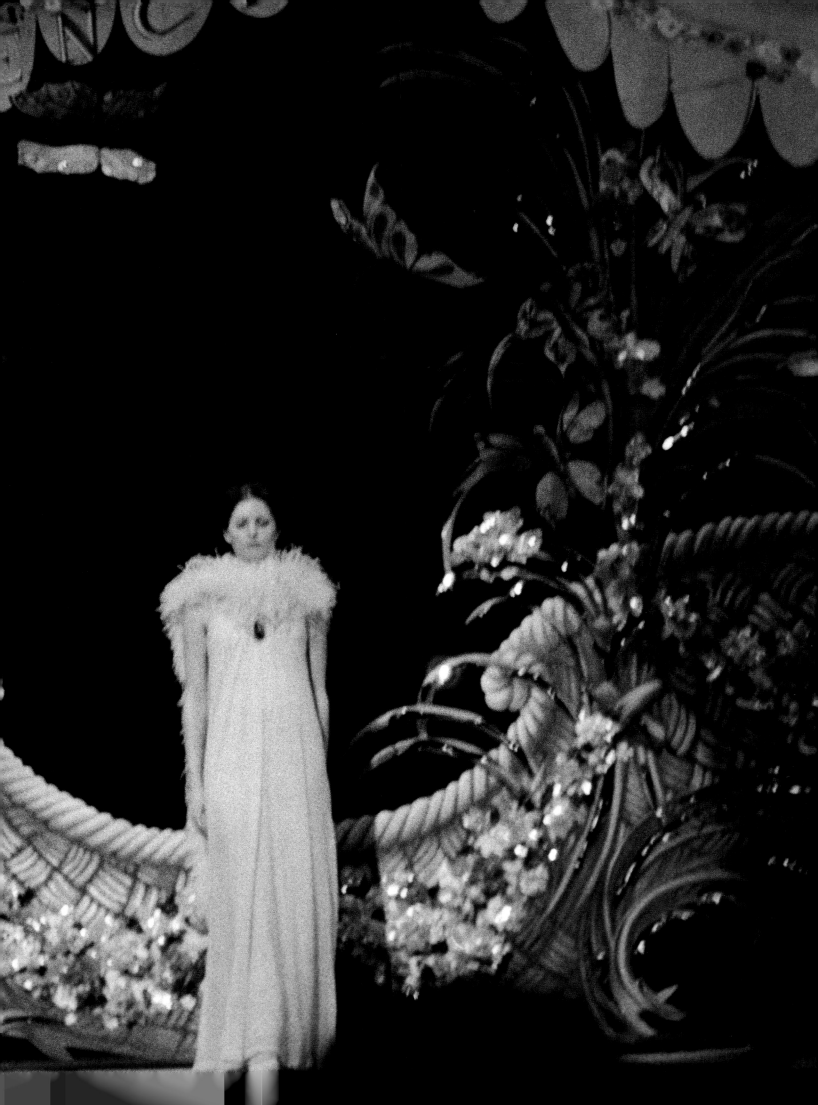

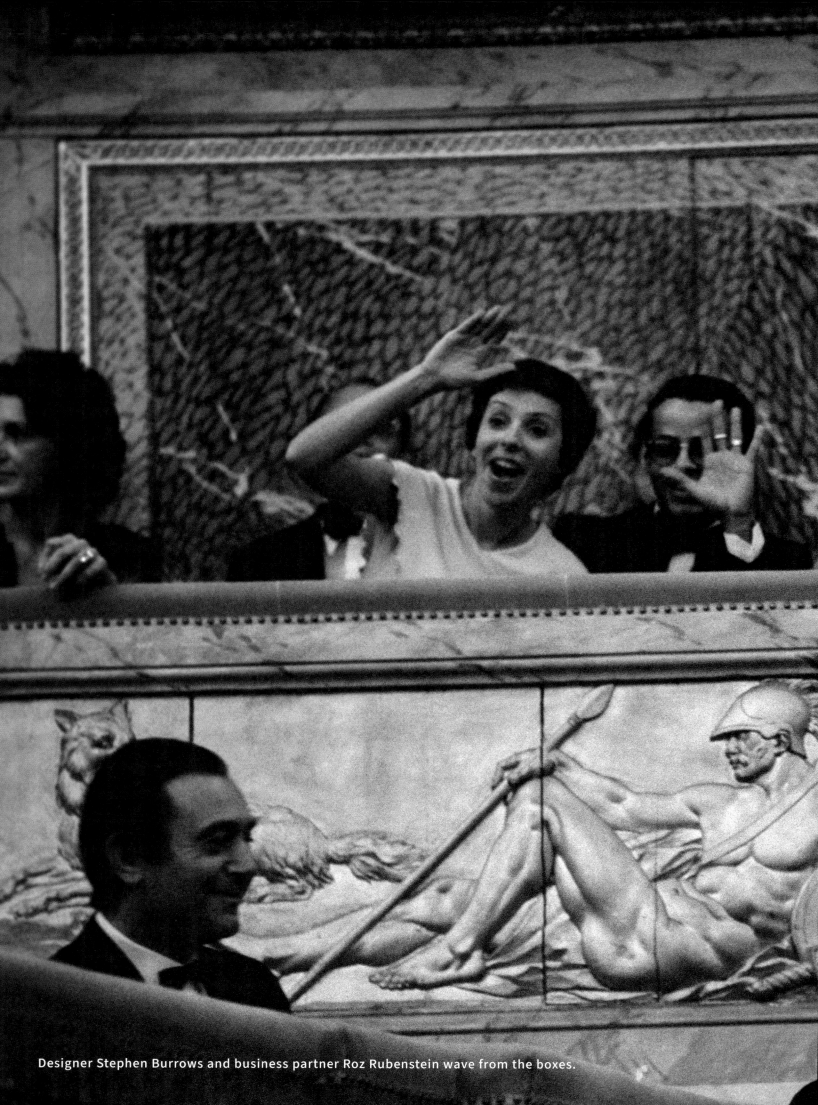

Designer Stephen Burrows and business partner Roz Rubenstein wave from the boxes.

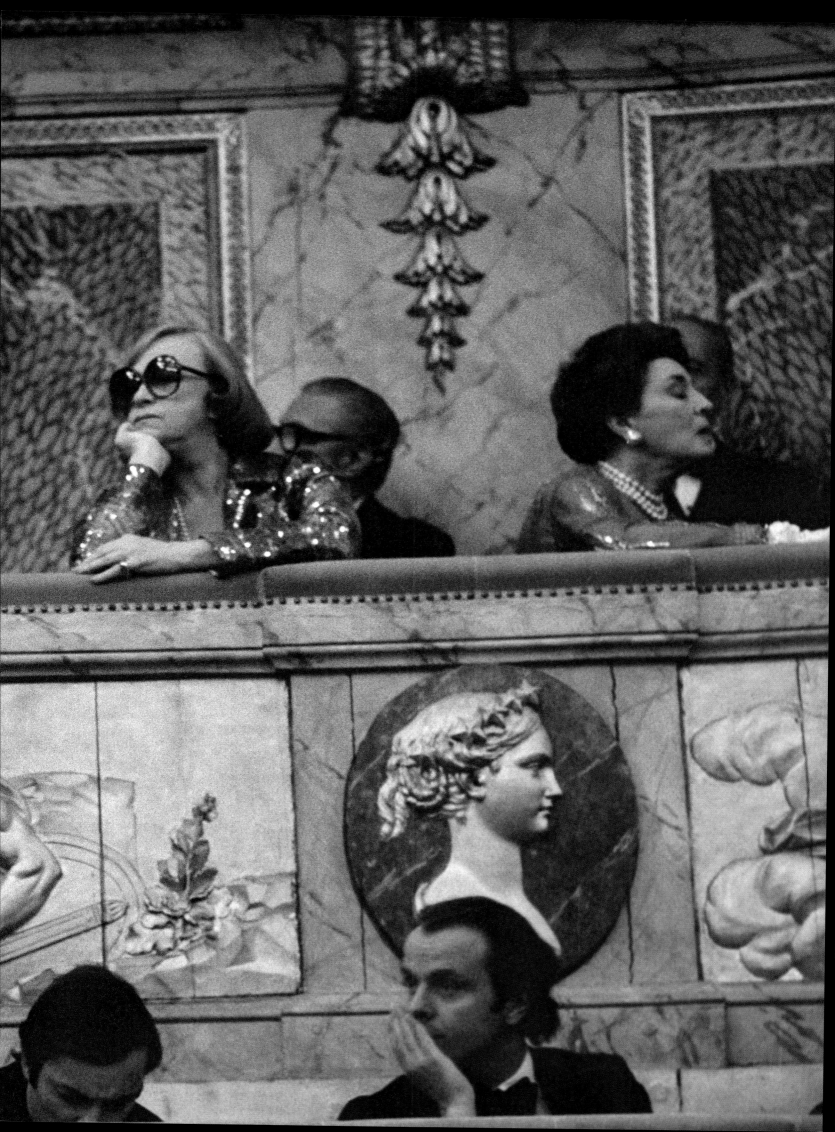

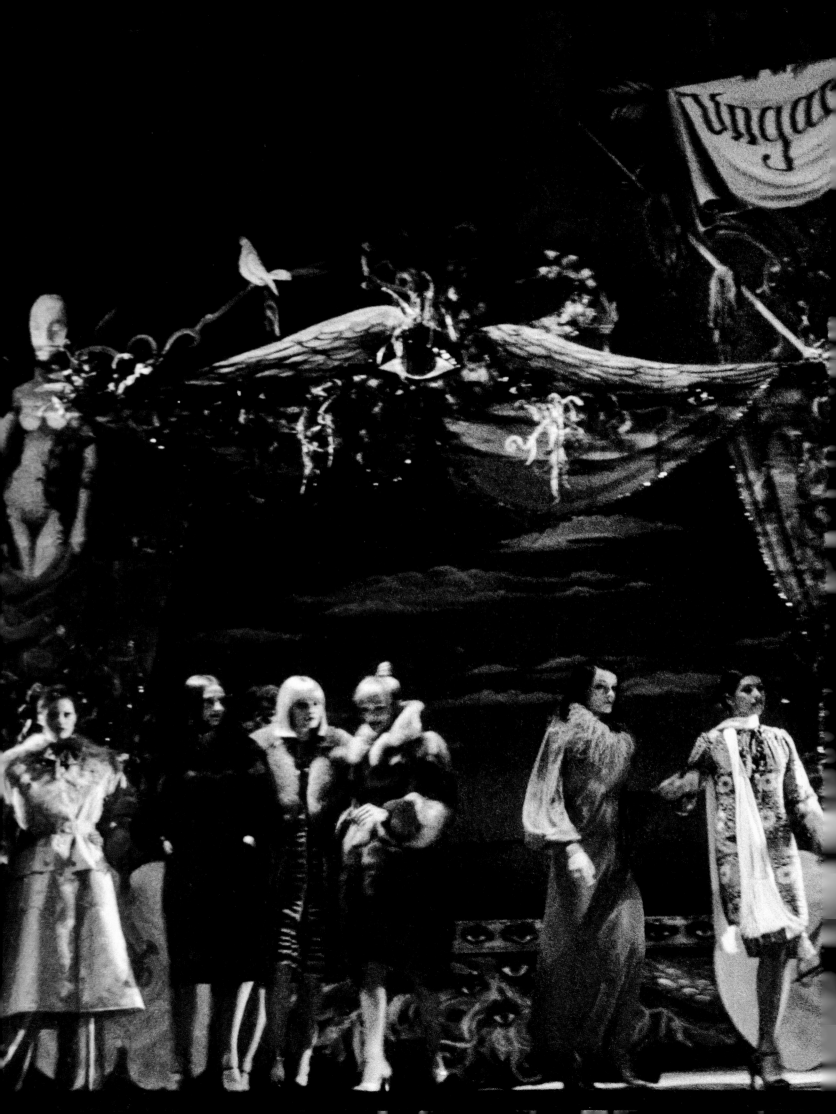

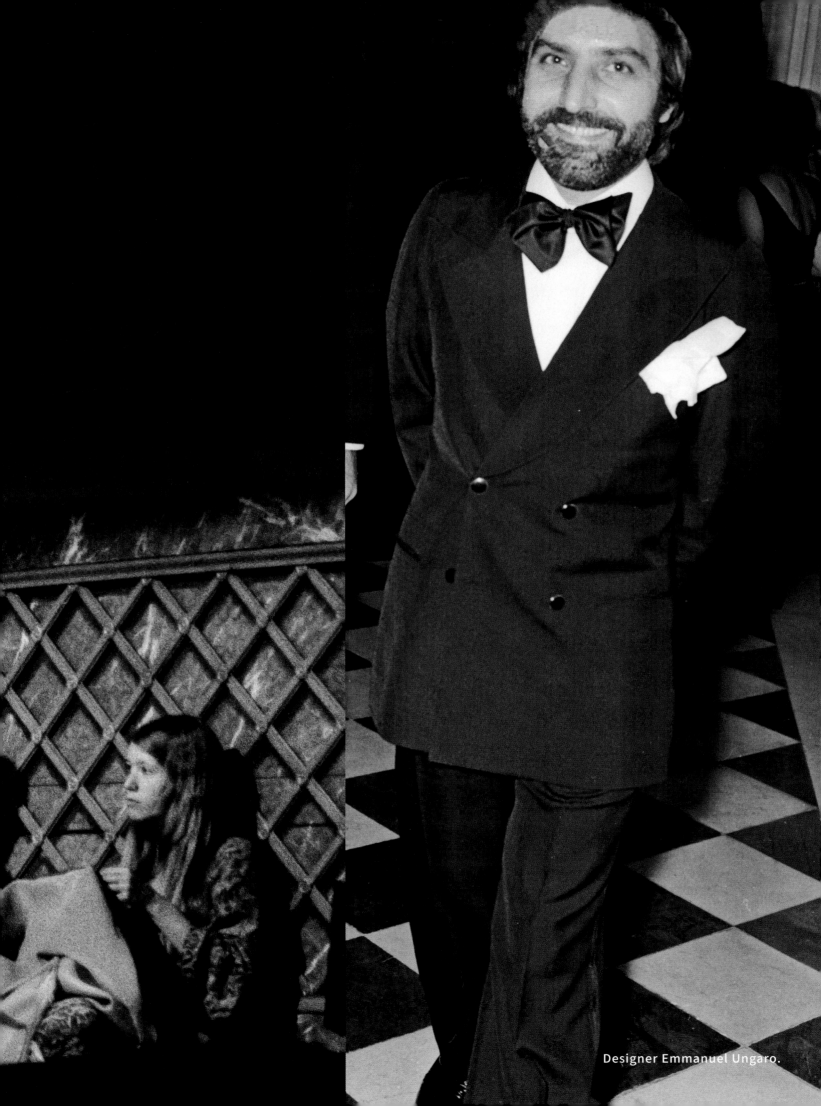

Designer Emmanuel Ungaro.

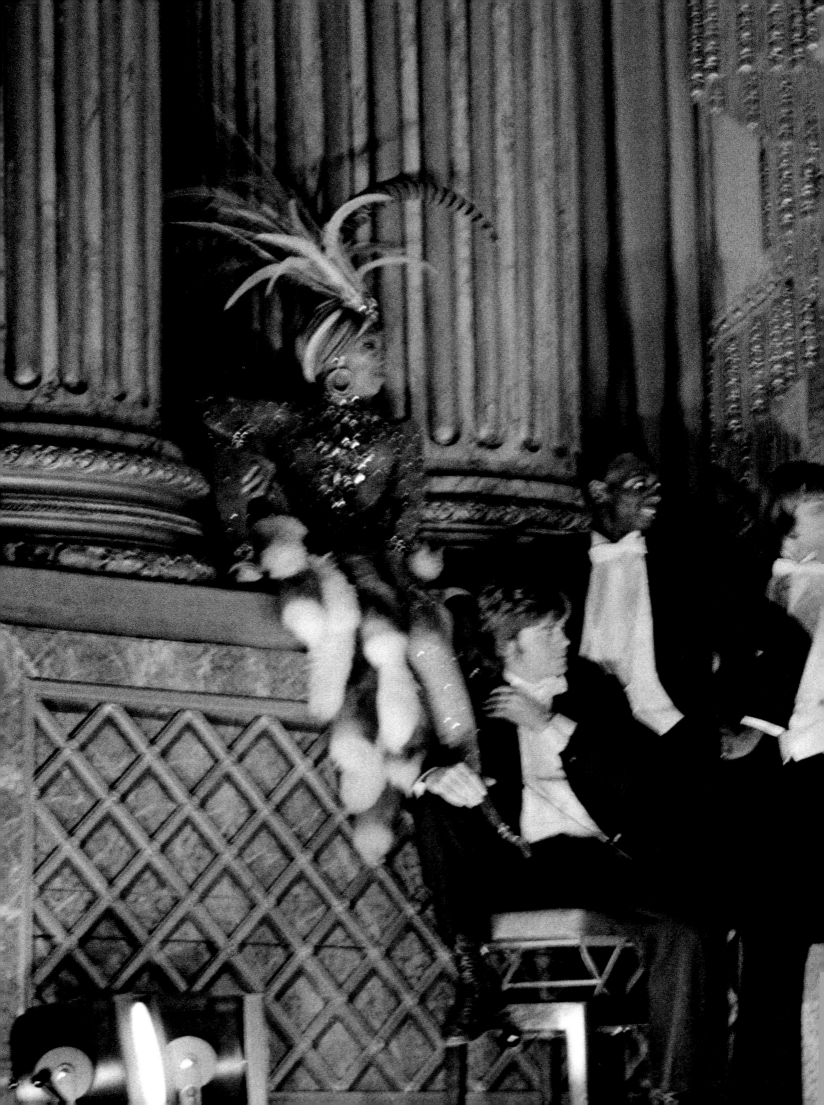

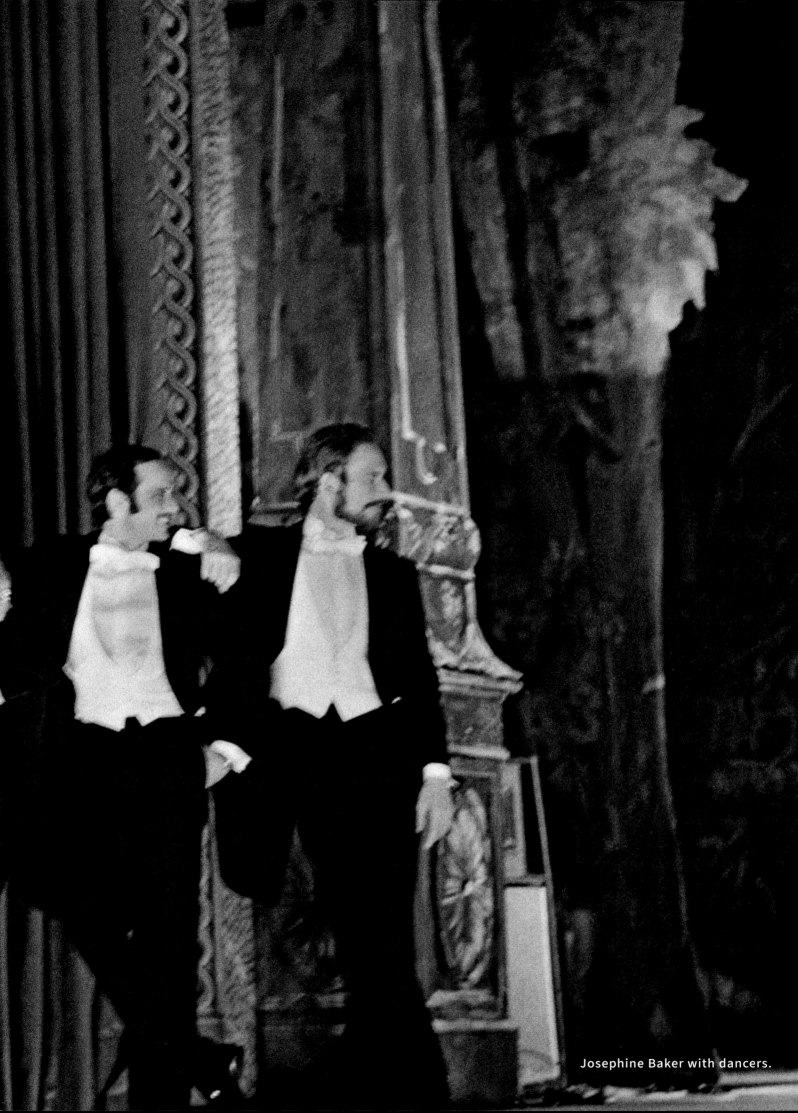

Josephine Baker with dancers.

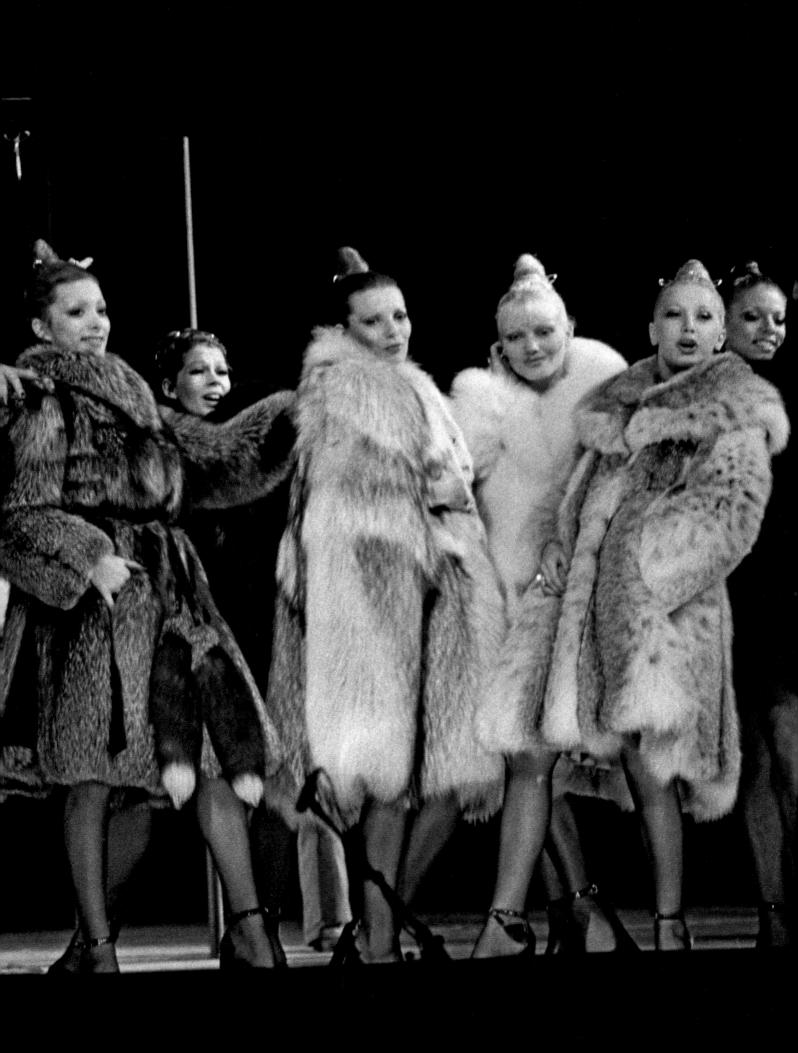

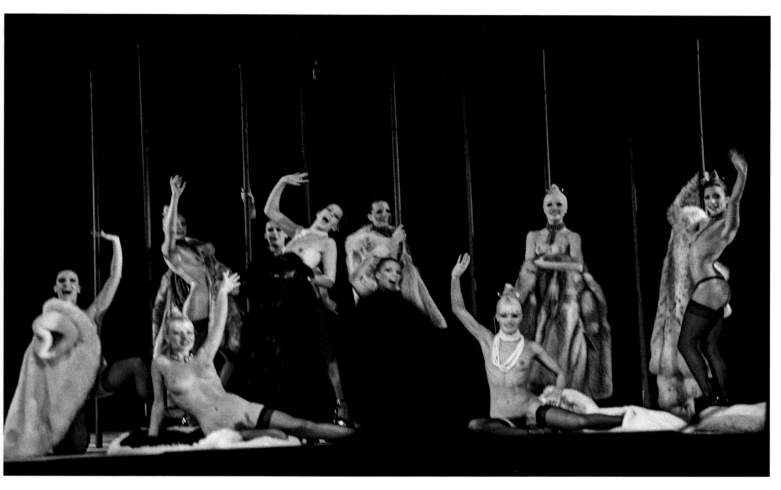

Above and opposite: Crazy Horse Saloon dancers in furs by Christian Dior, Revillon, Ungaro, and Yves Saint Laurent.

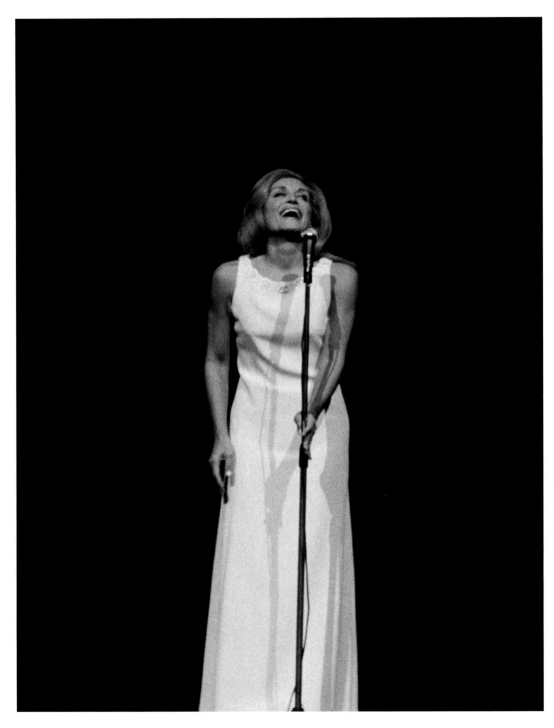

Above: Singer Dalida.
Opposite: Pierre Cardin.

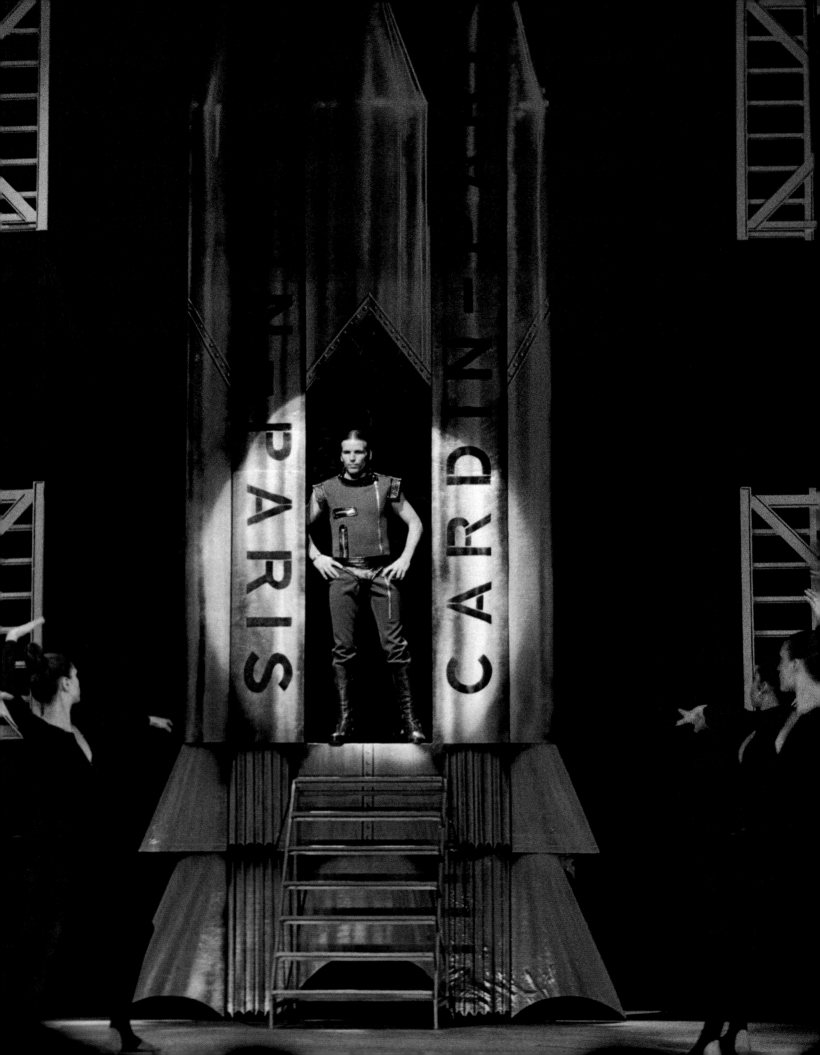

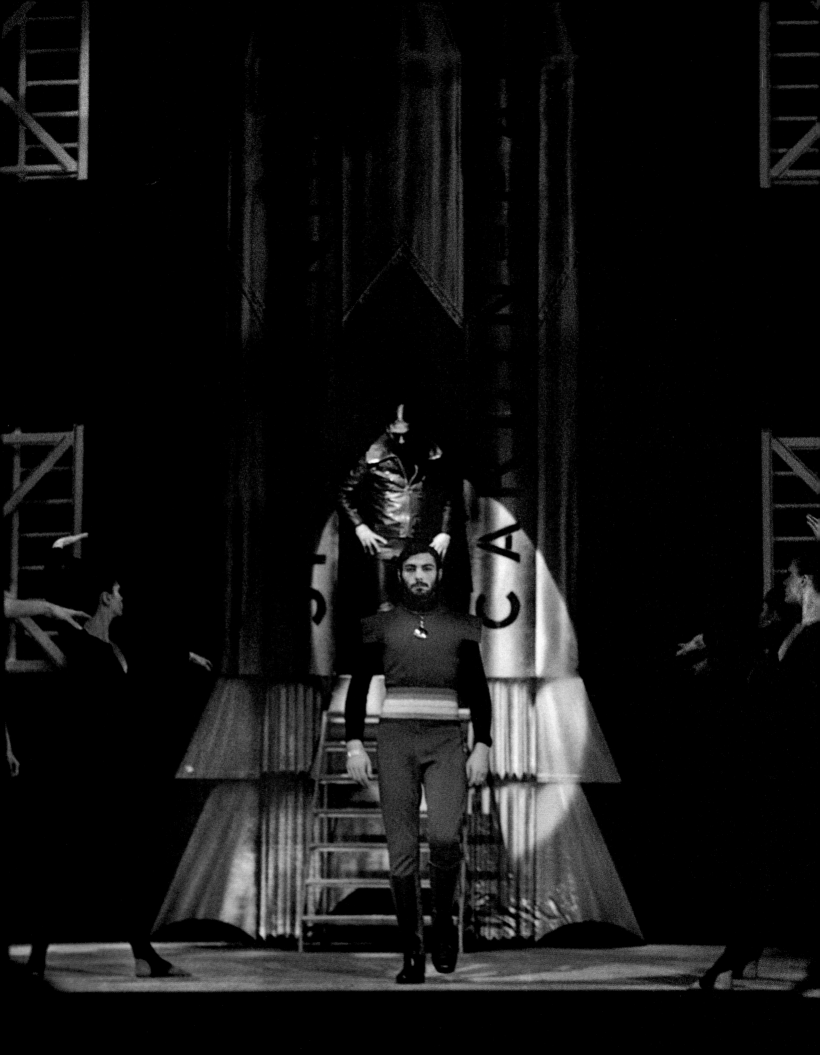

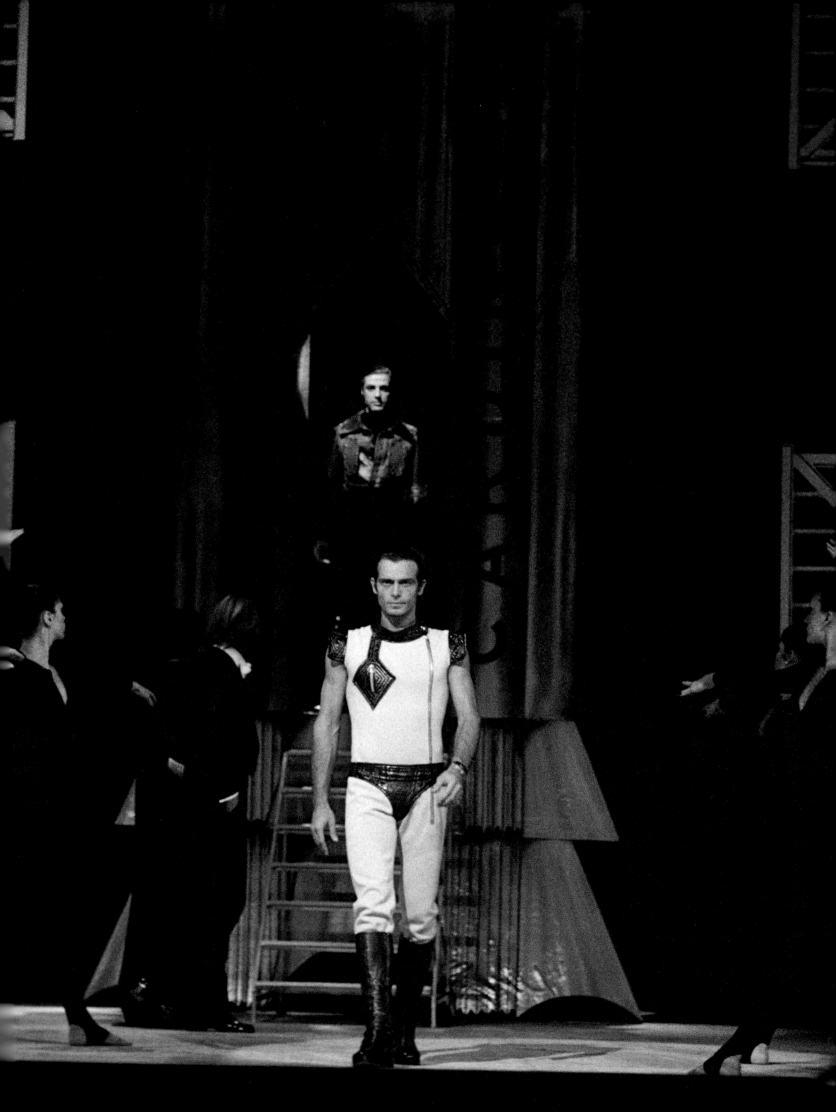

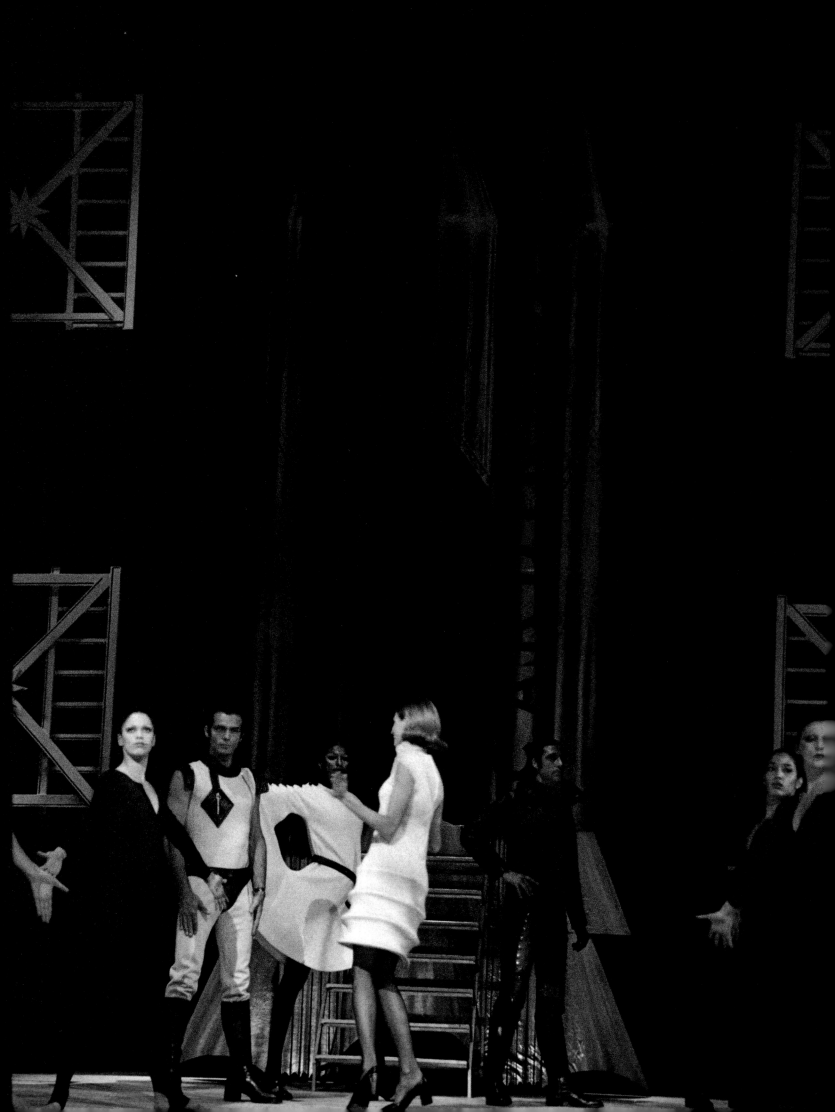

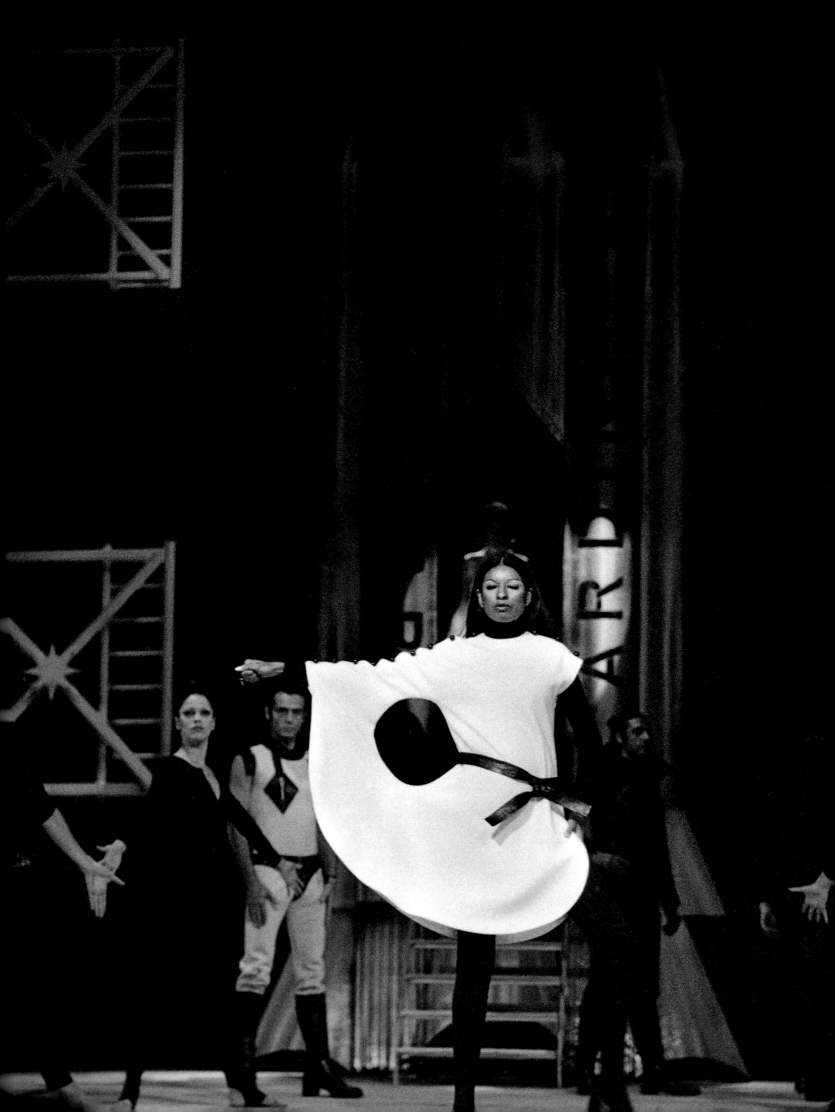

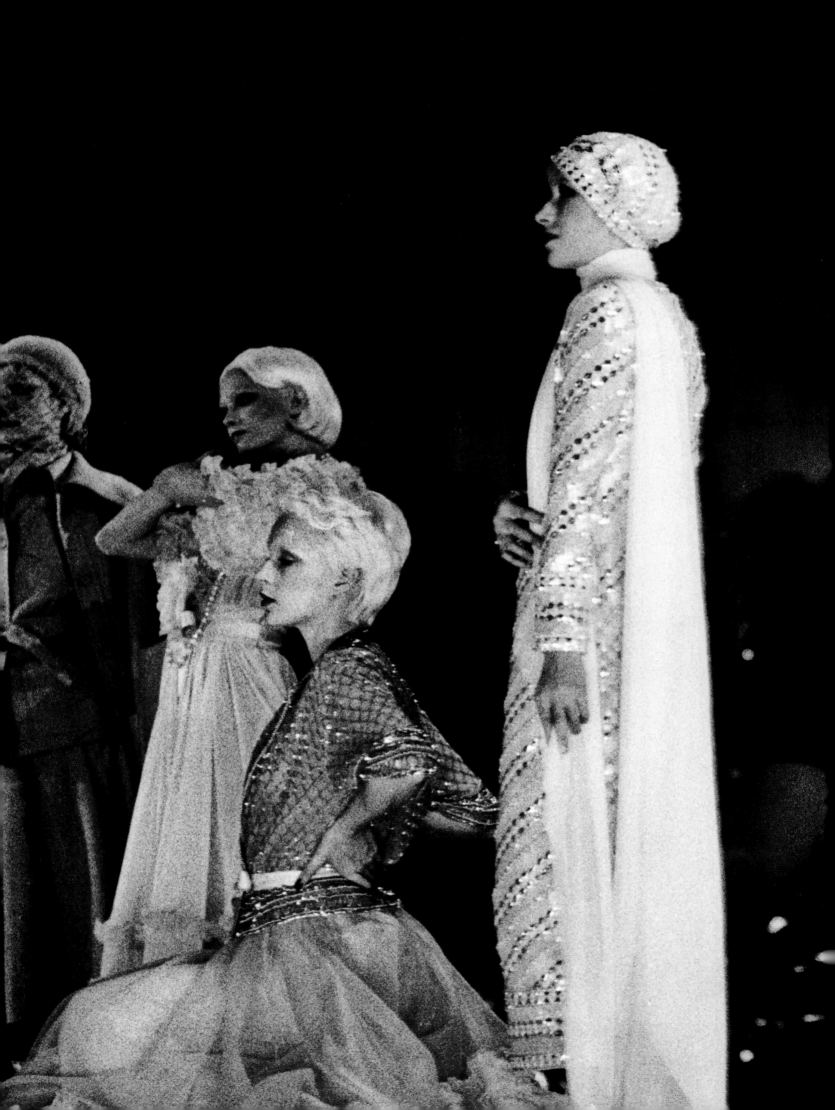

Opposite: Christian Dior's presentation included
Cinderella's pumpkin carriage.

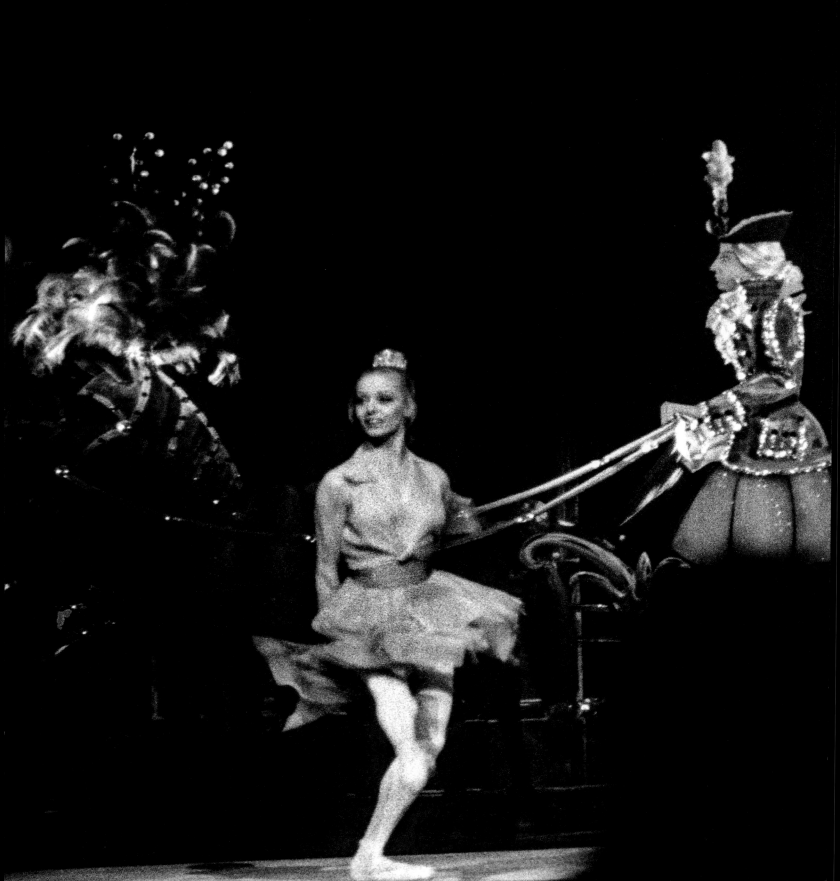

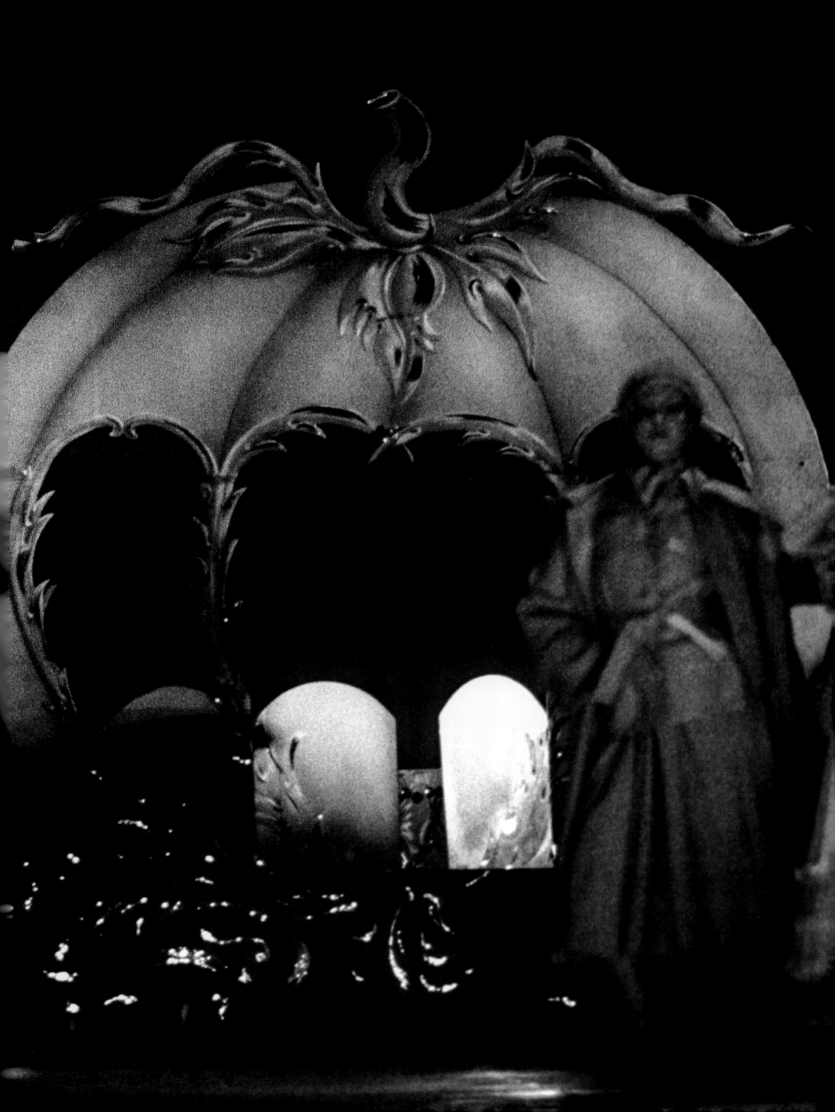

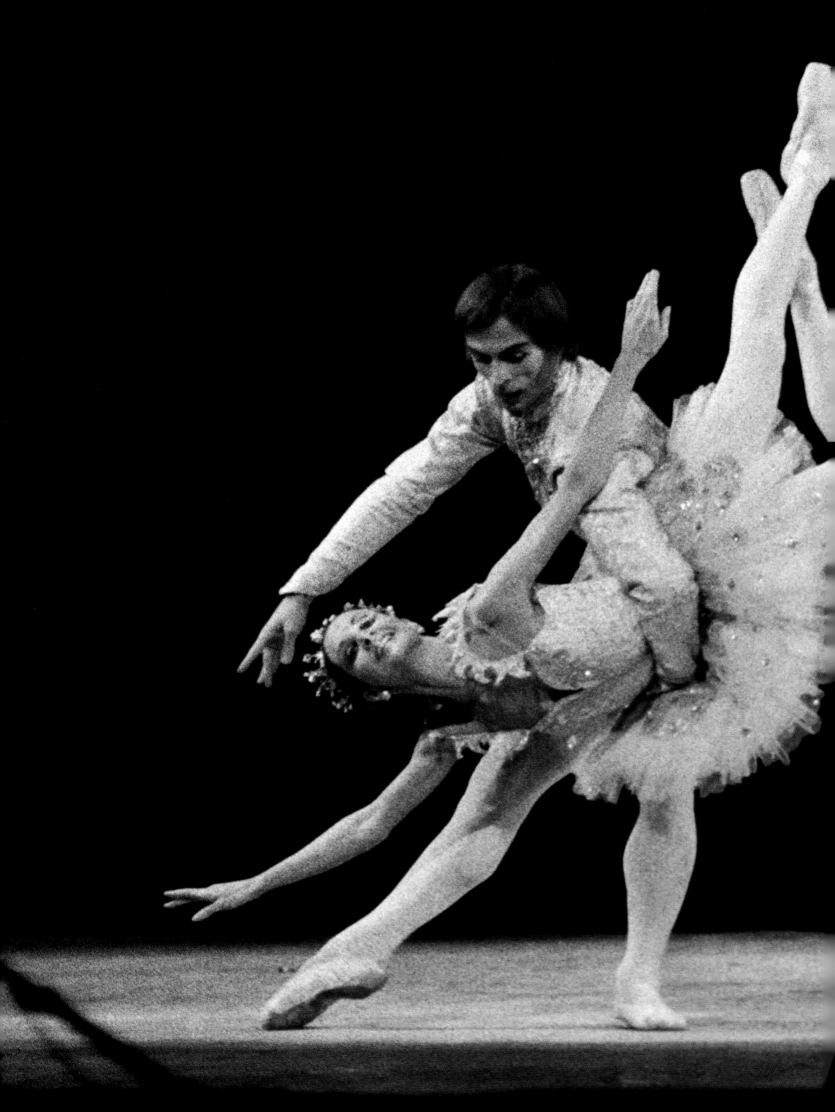

Opposite: Rudolf Nureyev dances a scene from "Sleeping Beauty" with Merle Park.

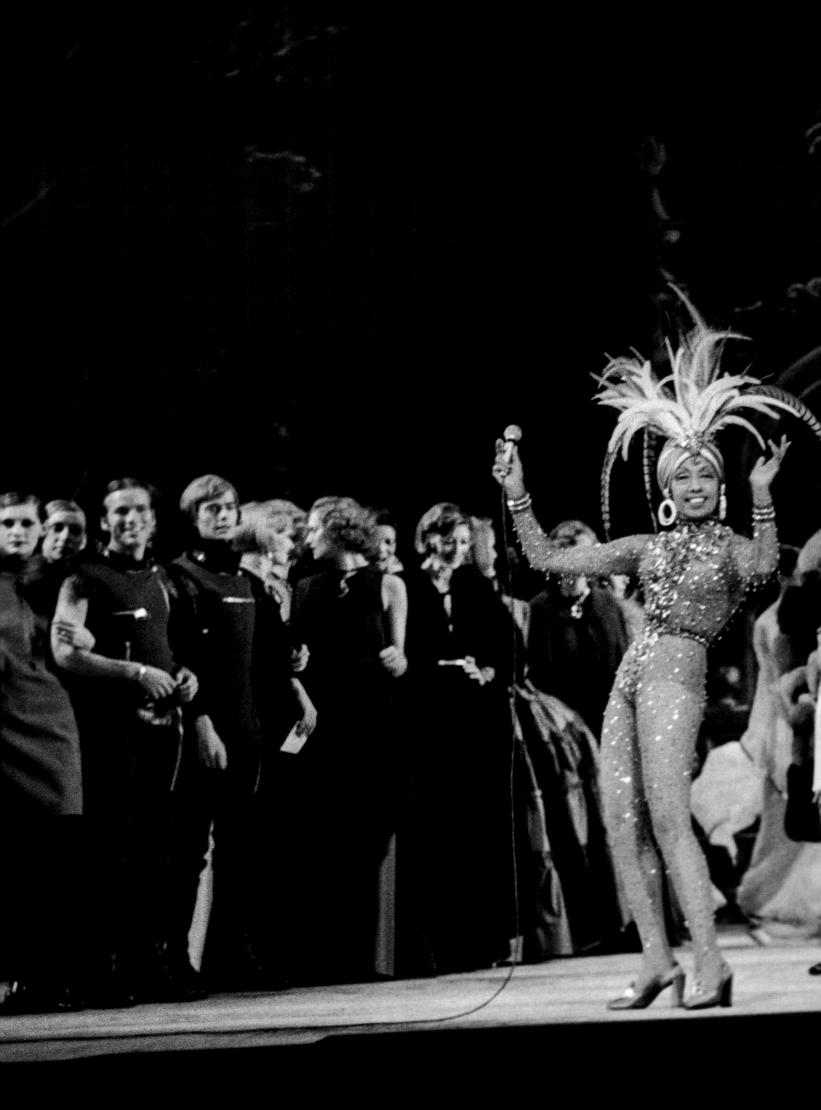

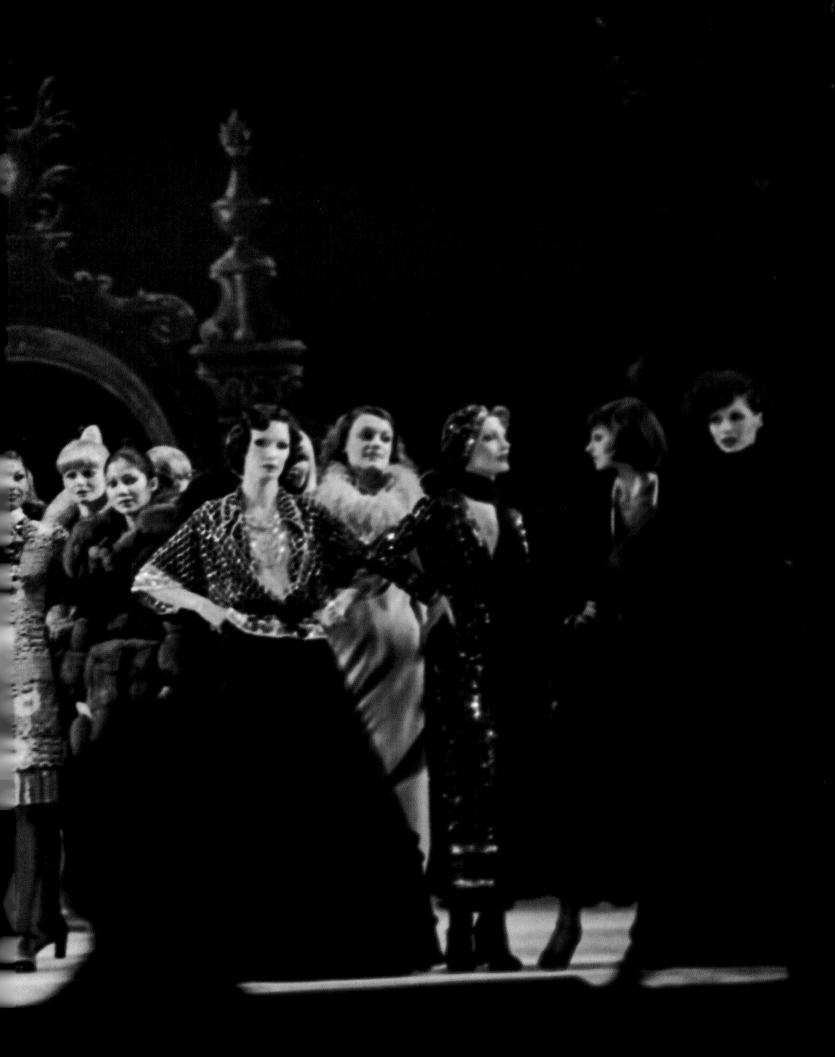

The finale led by Josephine Baker ended the ninety-minute French show.

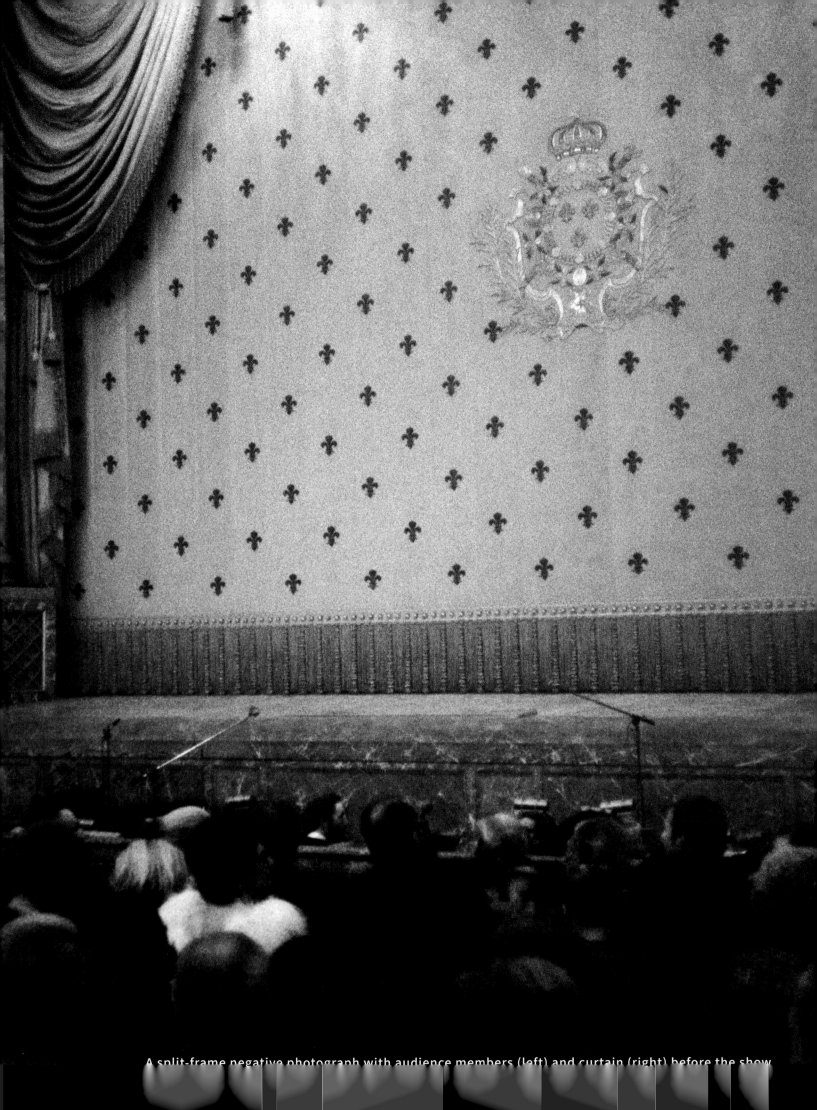

A split-frame negative photograph with audience members (left) and curtain (right) before the show

The Americans

*"The Americans' show followed
the French, after intermission.
The moment Liza Minnelli entered the empty set-less
stage singing "Bonjour Paris," followed
by over thirty models, including fifteen that were Black,
was unlike anything the French had ever seen.
The most sophisticated of audiences roared
and applauded their approval.
The fancy programs were actually flown into the air."*

- Bill Cunningham

Opposite: Fresh-off her Oscar win for *Cabaret*, Liza Minnelli performs
at Versailles as a favor to long-time collaborator Halston.

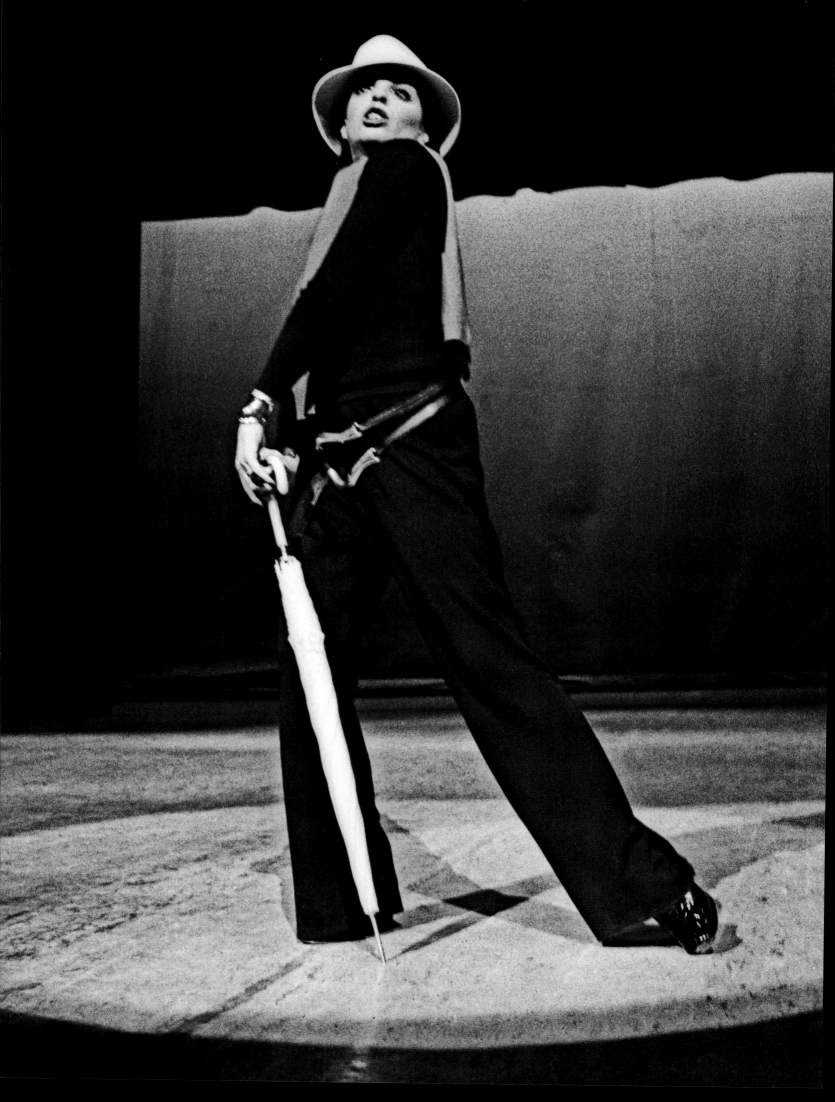

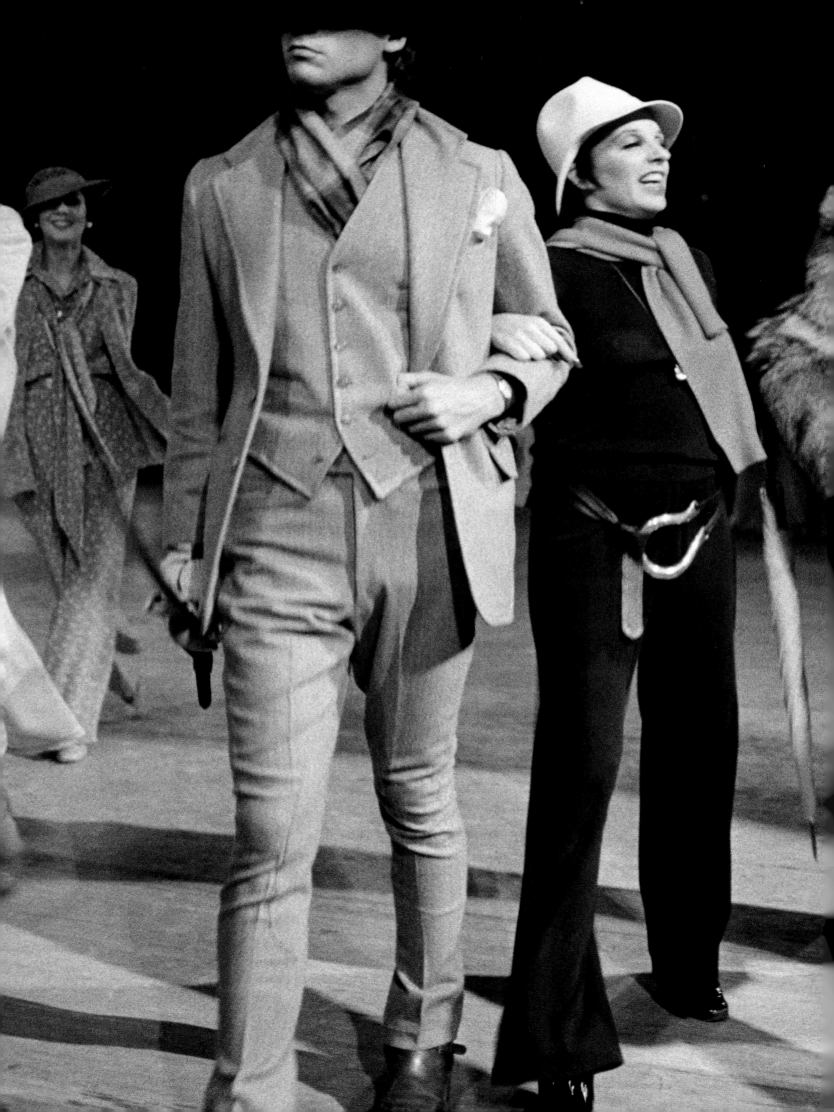

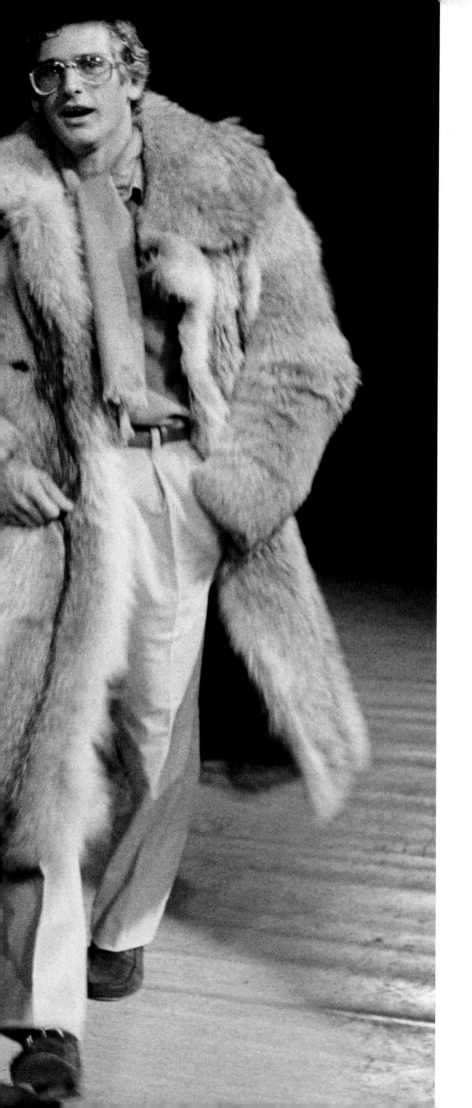

Liza Minnelli leads a troupe of American models
in a performance of "Bonjour Paris."

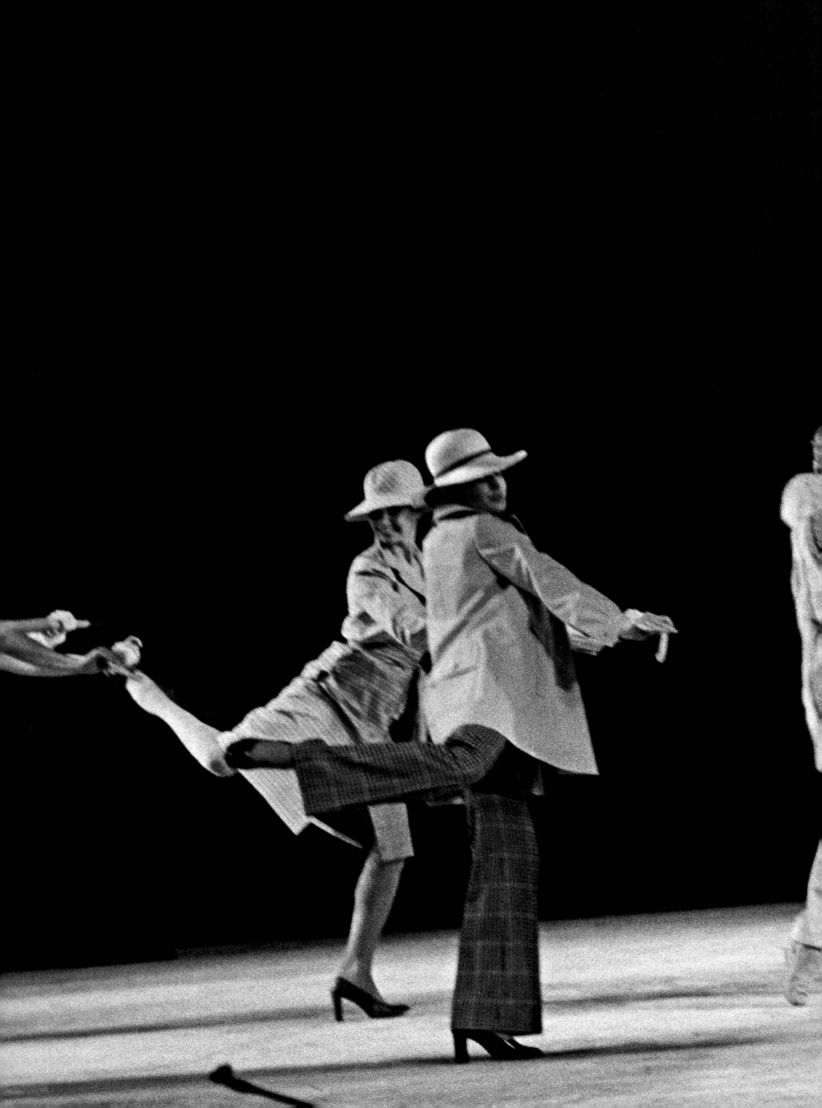

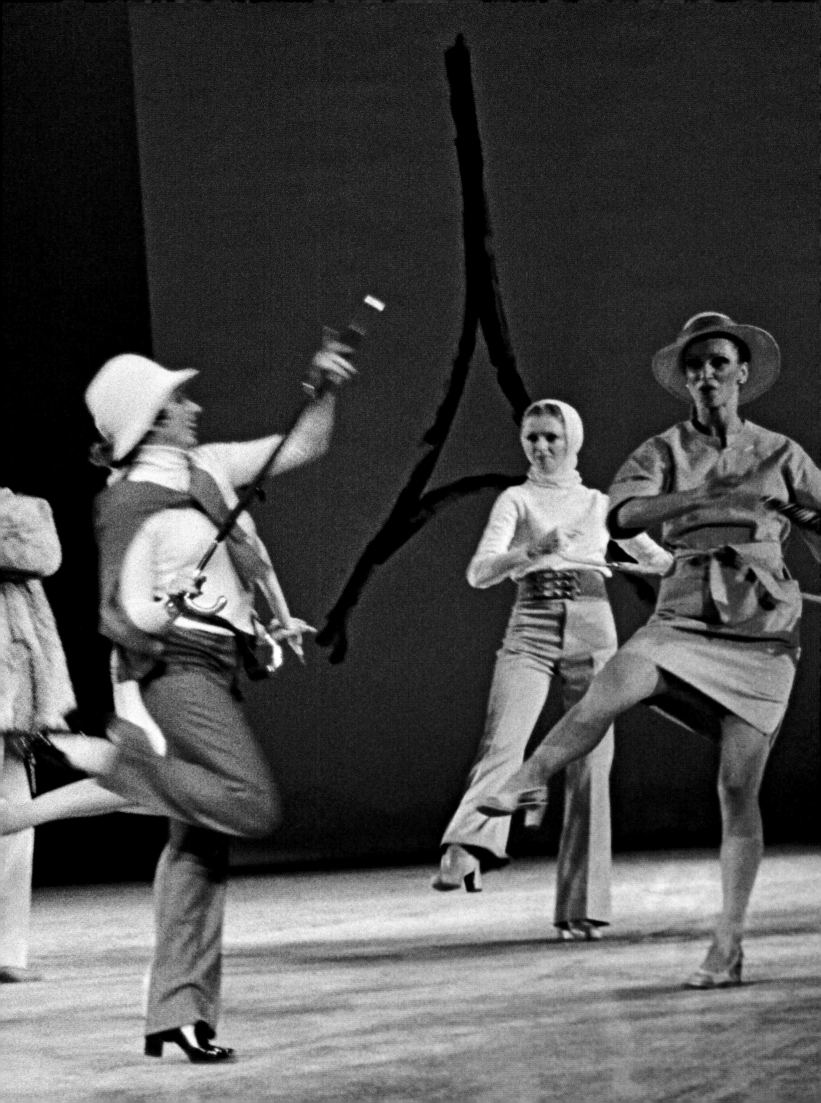

"Five designers all trying to be last.
And thirty-five models all trying to be first.
Oscar de la Renta who had been fighting
with Anne Klein was now helping
to dress her models.
Halston, who had walked out of the show,
was now helping to dress the models of designers
whom he thought competitors a few hours before."

\- Bill Cunningham

Opposite: Bethann Hardison.

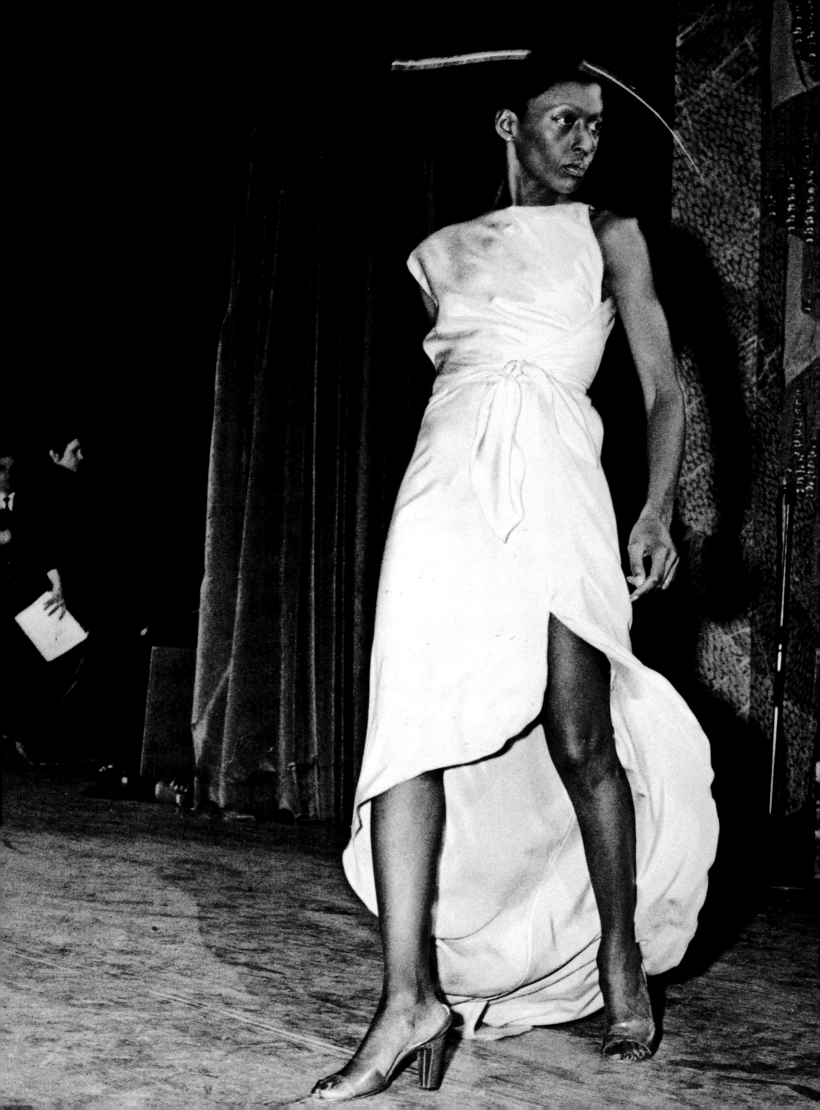

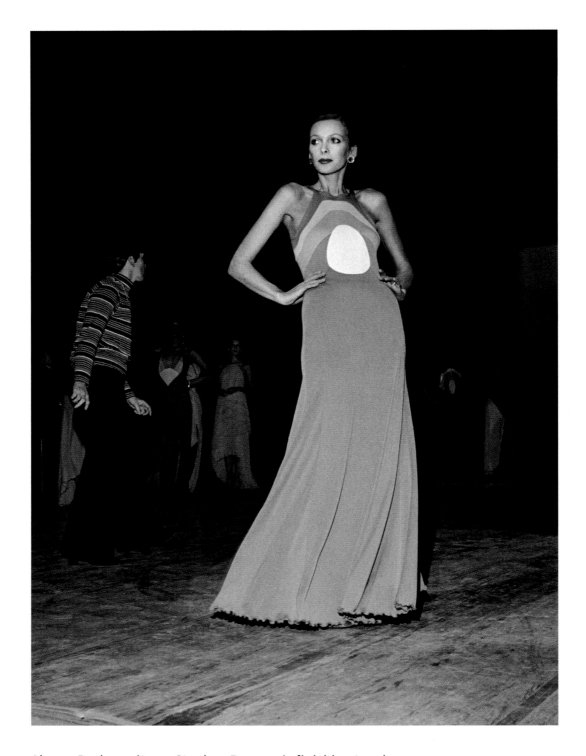

Above: Basha waits on Stephen Burrows's finishing touch.
Opposite: Ramona Saunders, Alva Chinn, and Bethann Hardison in Stephen Burrows.

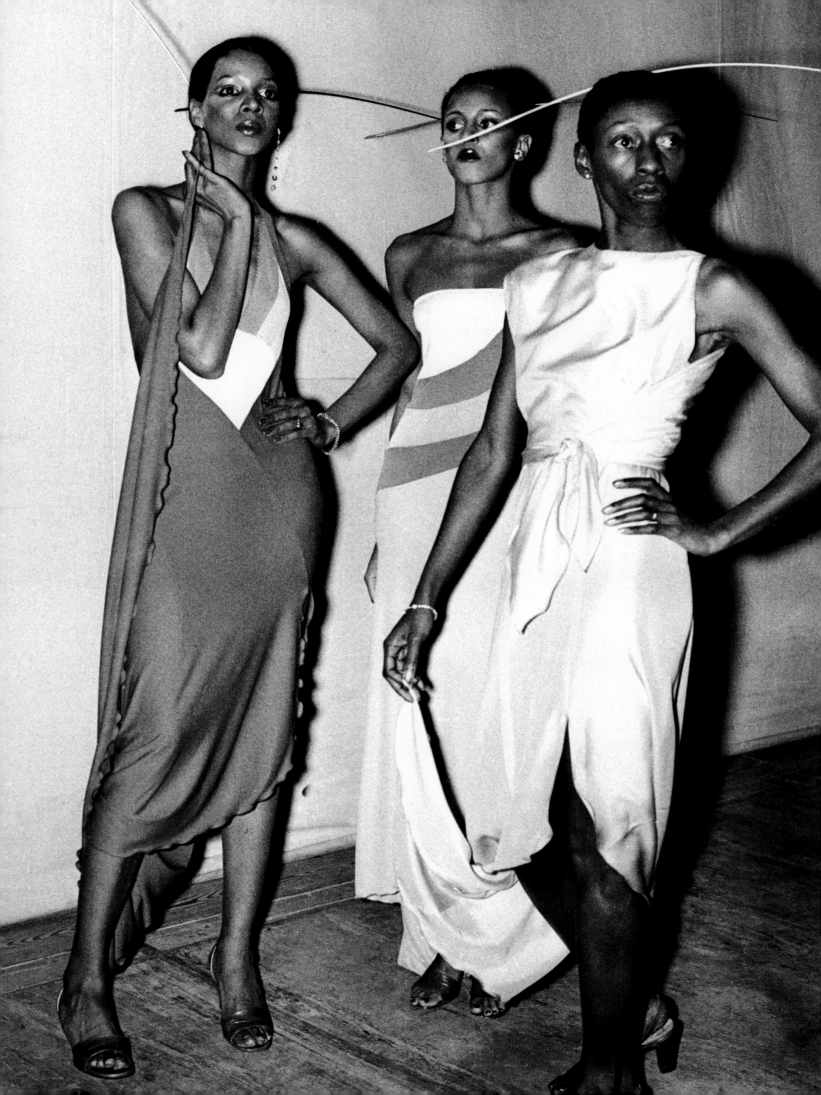

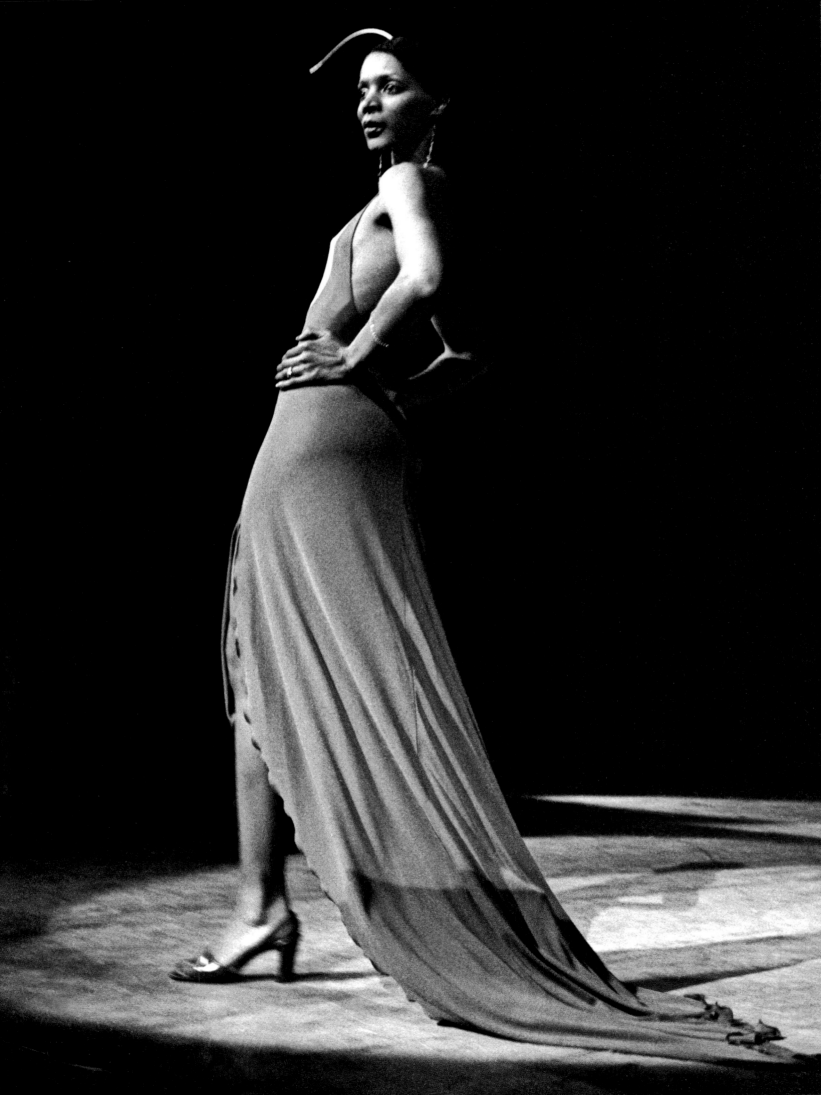

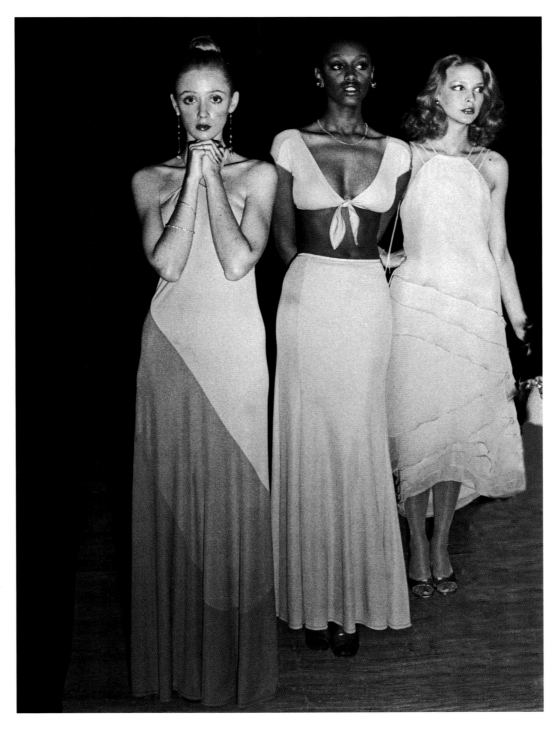

Opposite: Ramona Saunders.
Above: Heidi Goldman, Amina Warsuma, and Karen Bjornson Macdonald
in Stephen Burrows.

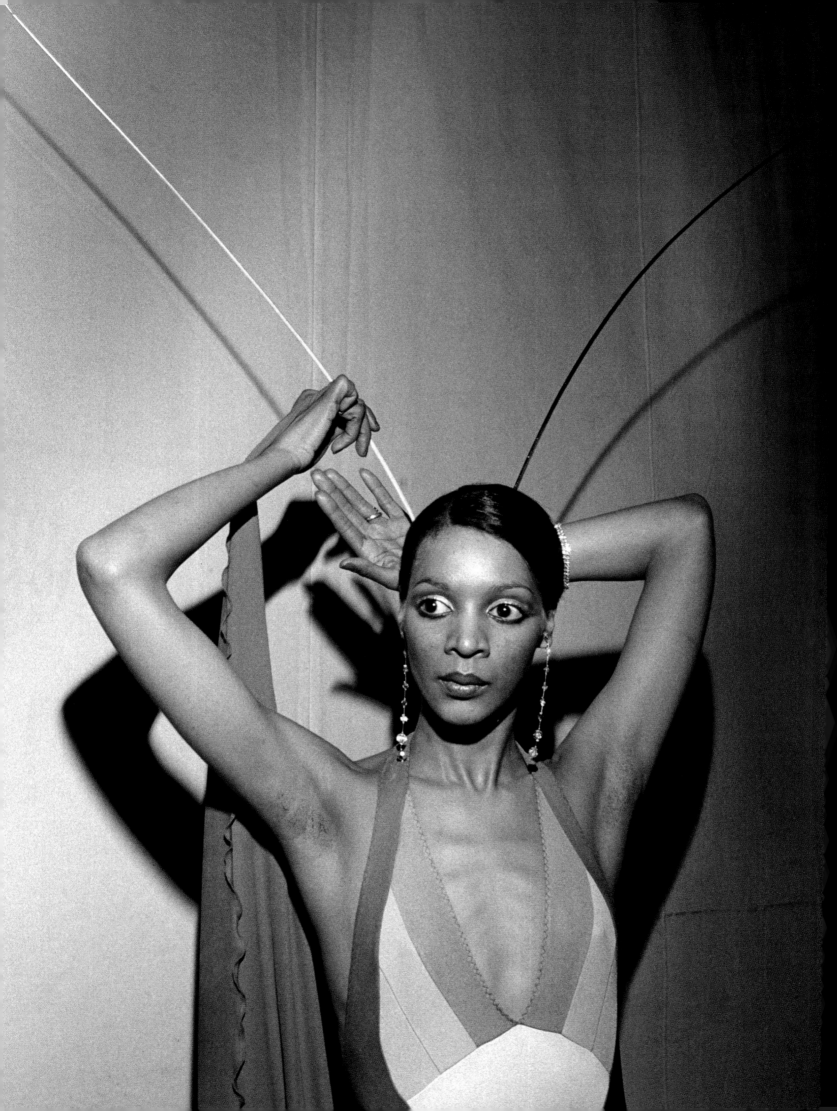

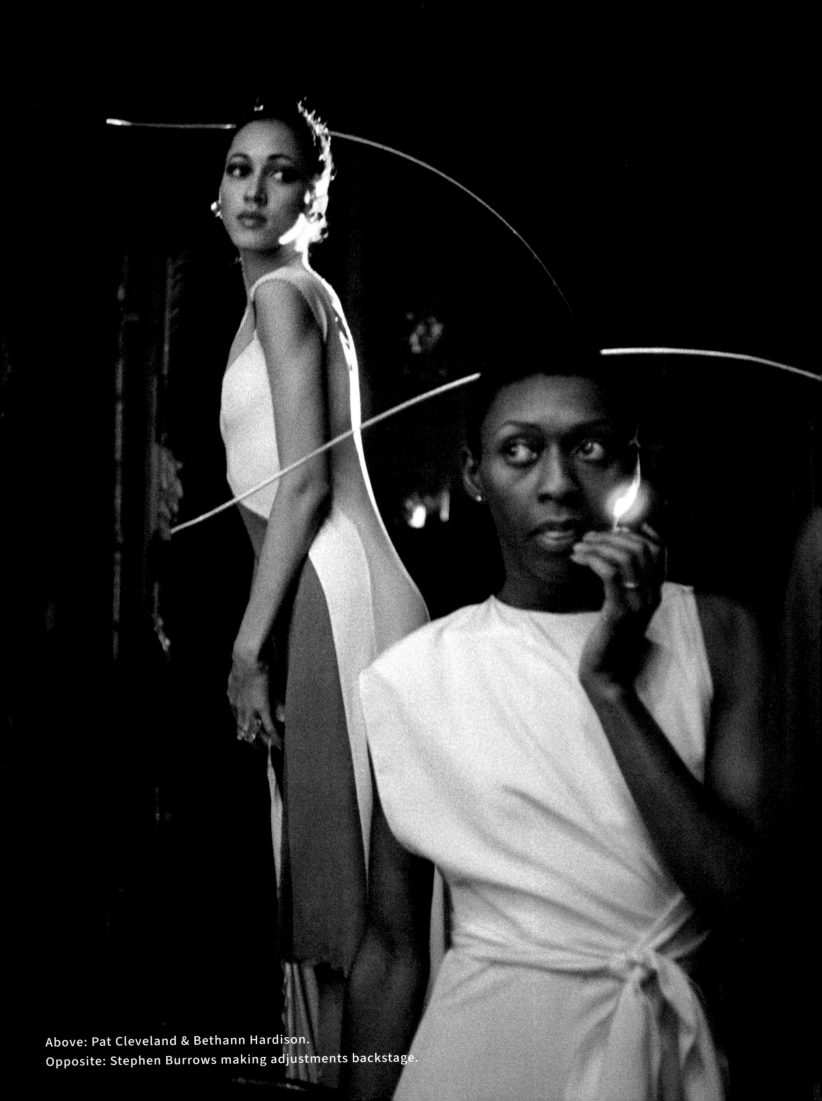

Above: Pat Cleveland & Bethann Hardison.
Opposite: Stephen Burrows making adjustments backstage.

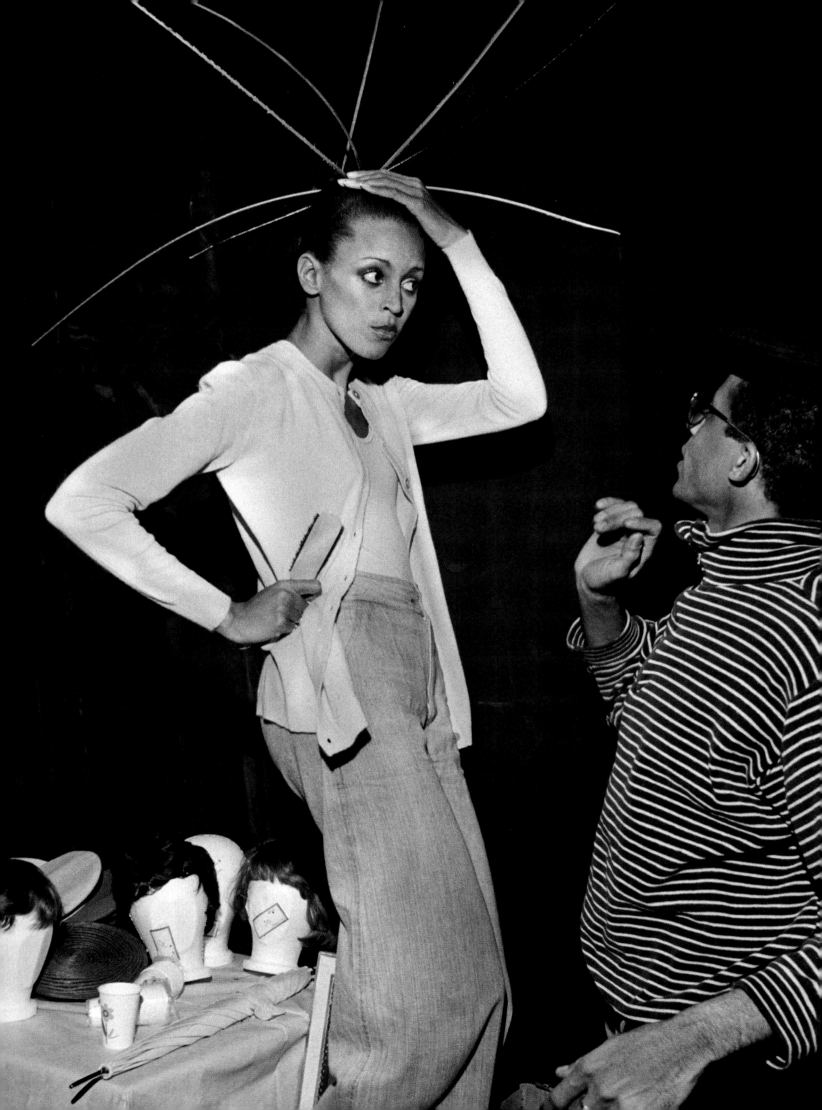

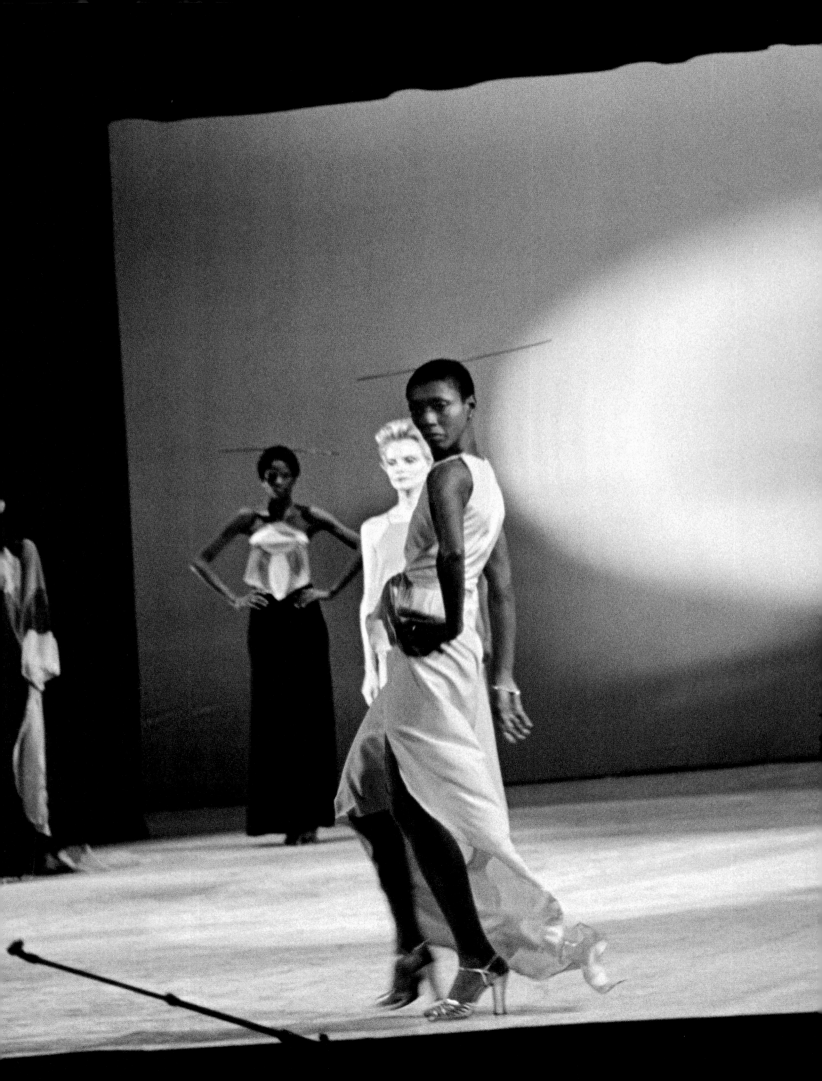

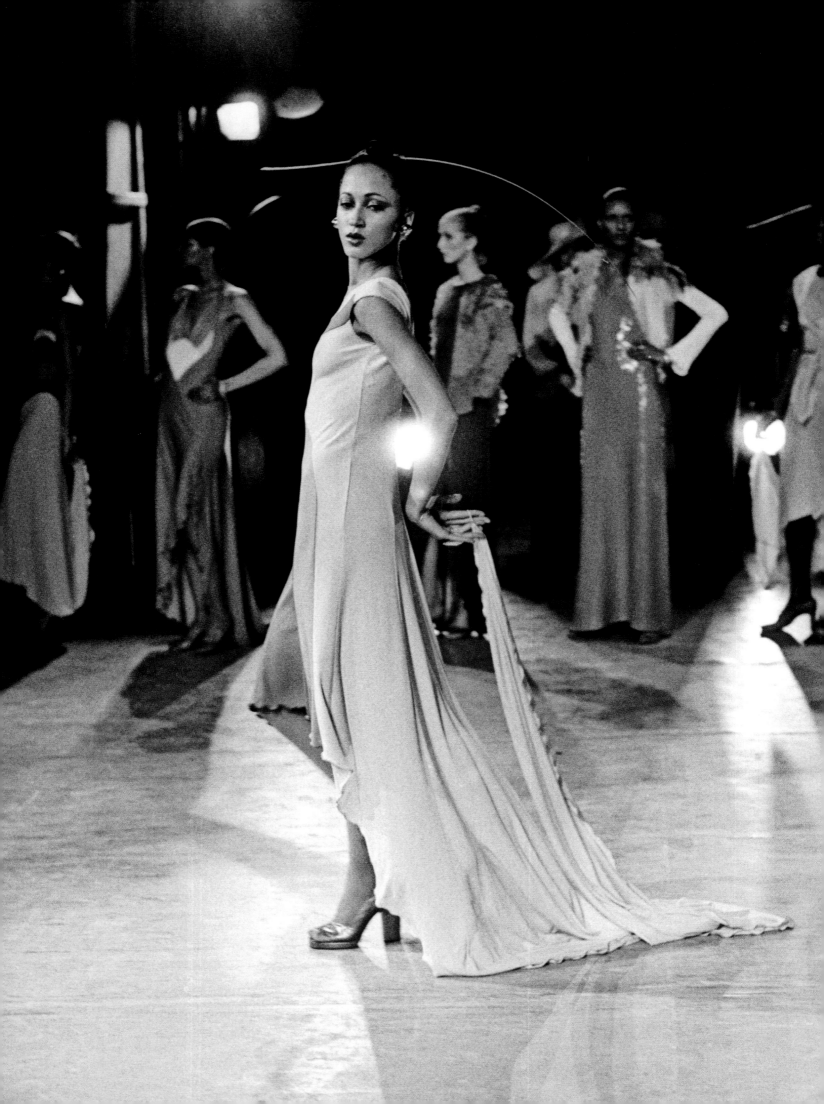

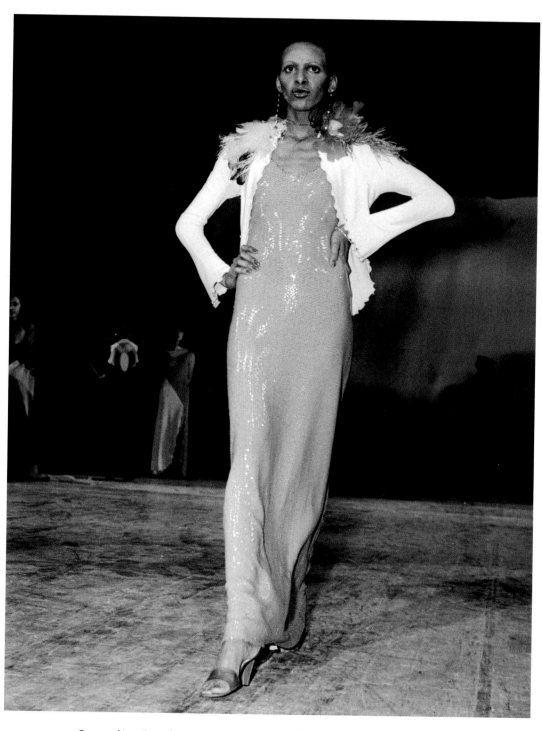

Opposite: Stephen Burrows's muse Pat Cleveland models his finale look,
with the longest train on all his creations that night.
Above: Barbara Jackson in Stephen Burrows.

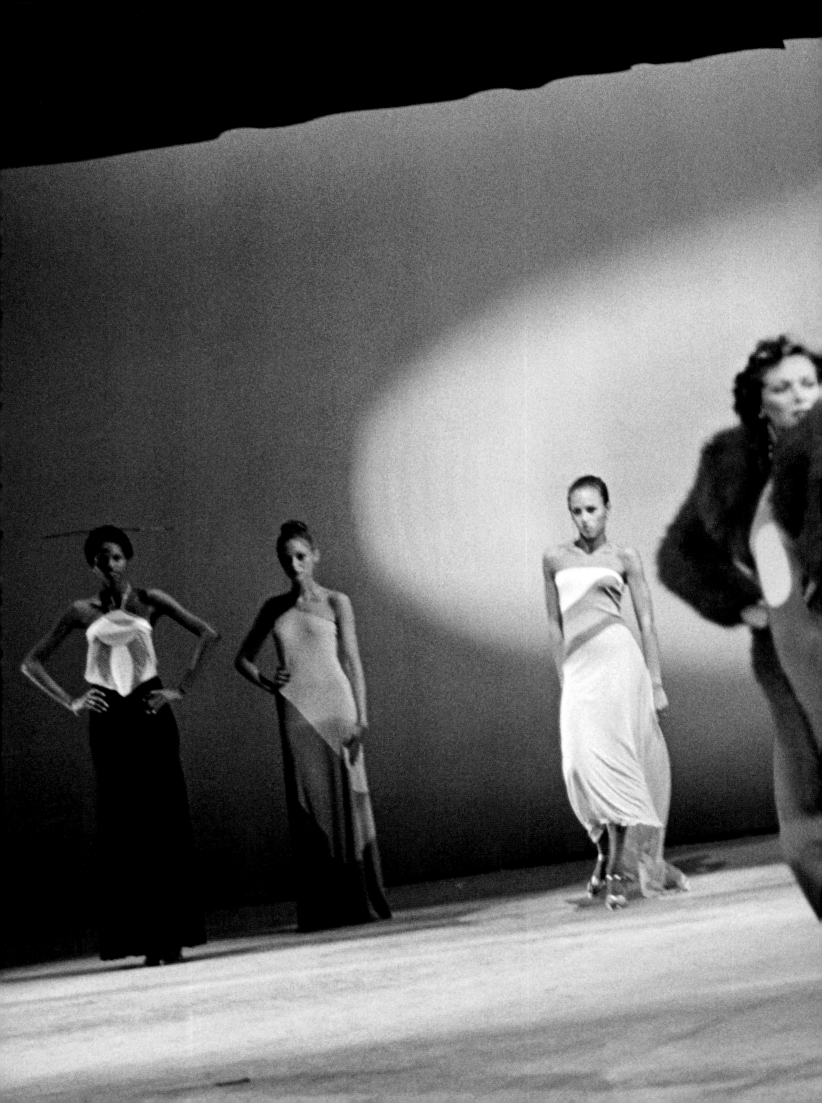

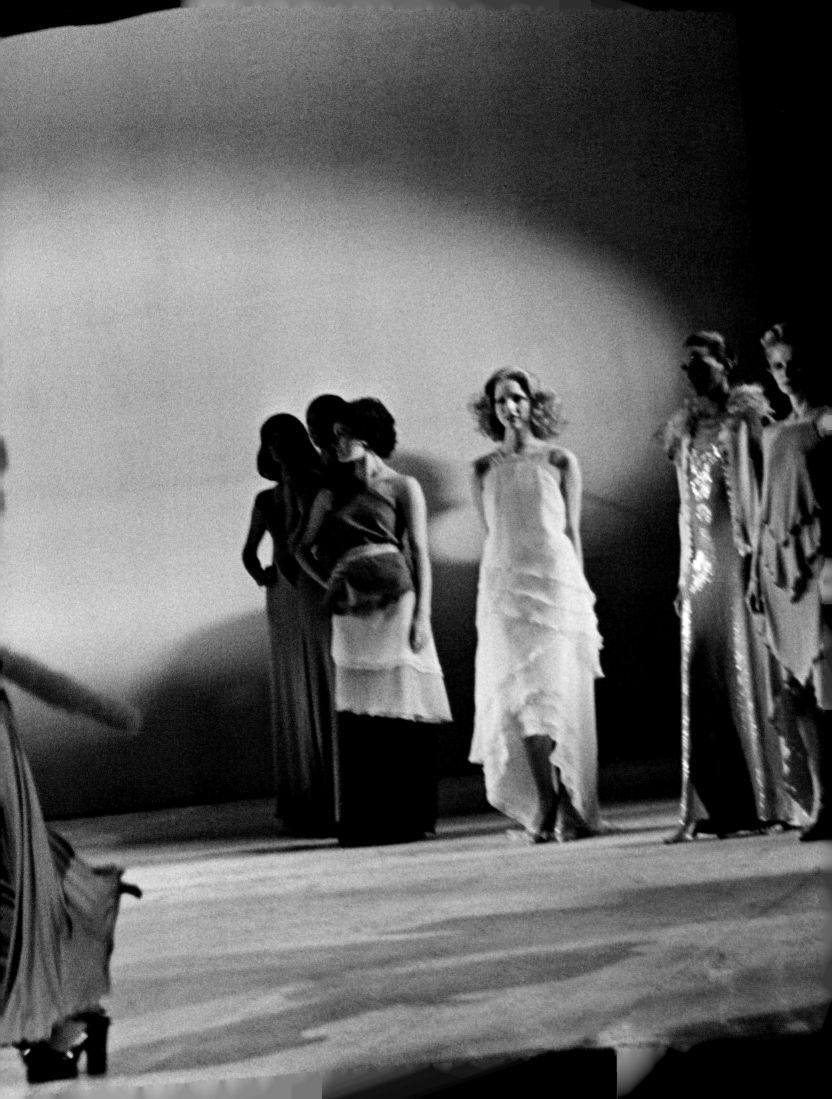

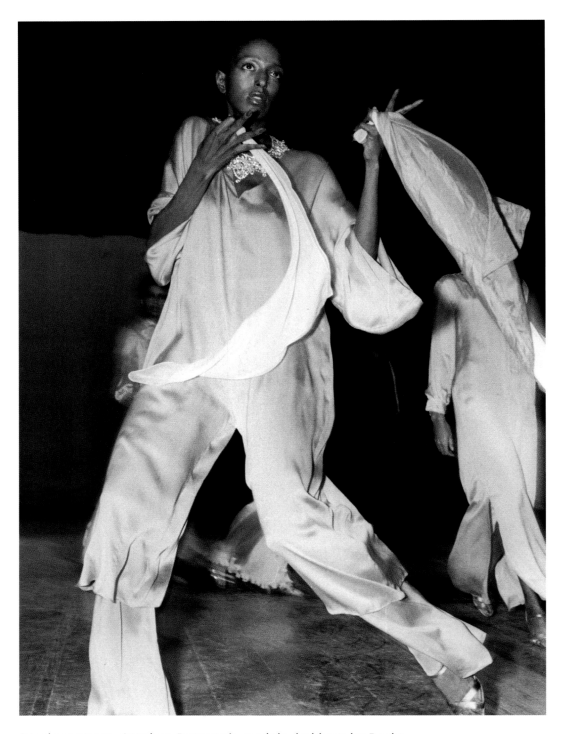

Previous Pages: Stephen Burrows's models, led here by Basha.
Above: Billie Blair in Oscar de la Renta.
Opposite: Jennifer Brice in Stephen Burrows.

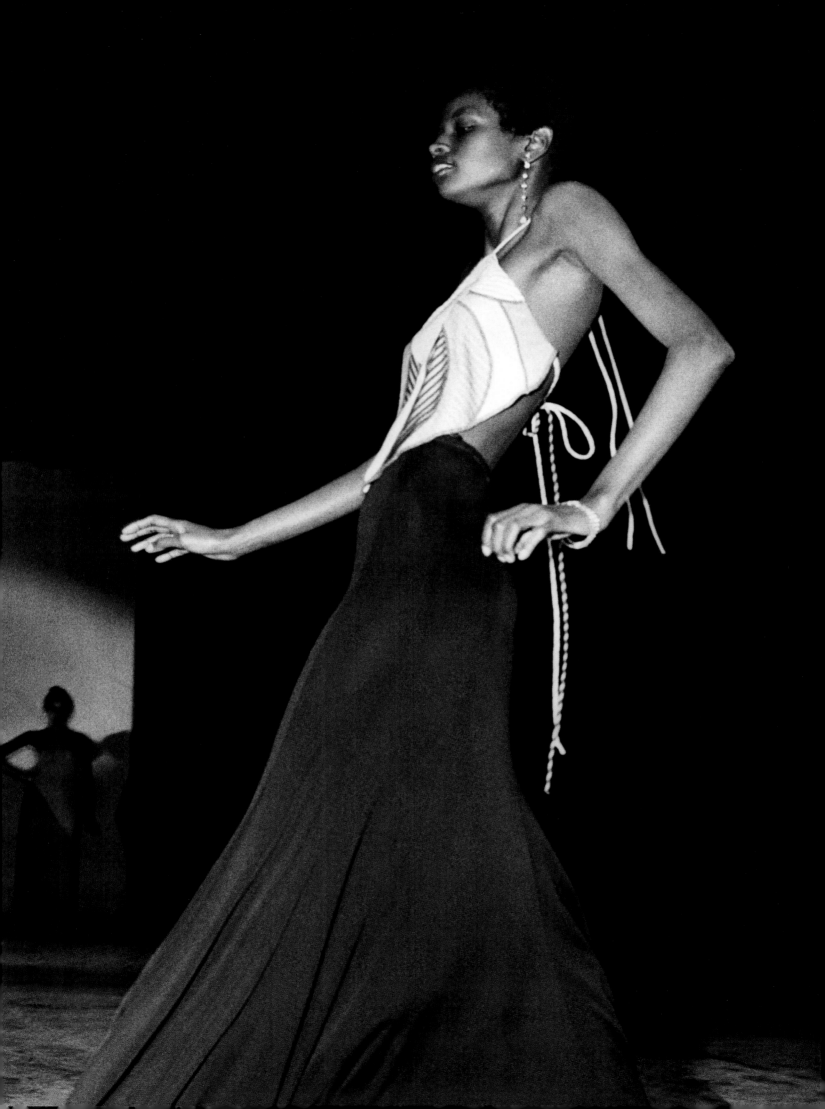

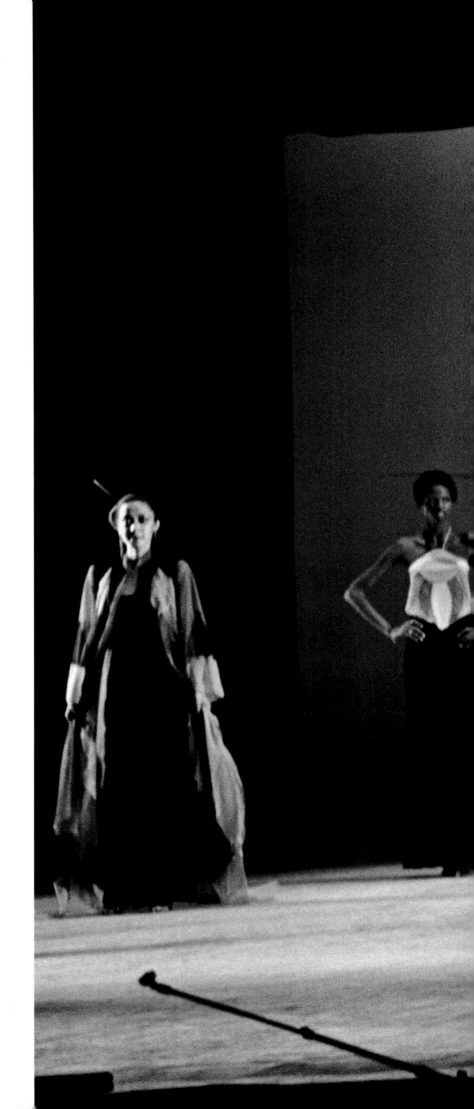

Opposite: Stephen Burrows enlisted his friend
and photographer Charles Tracy
to choreograph his segment, that ended
with the models "Vogue-ing" upstage.

136

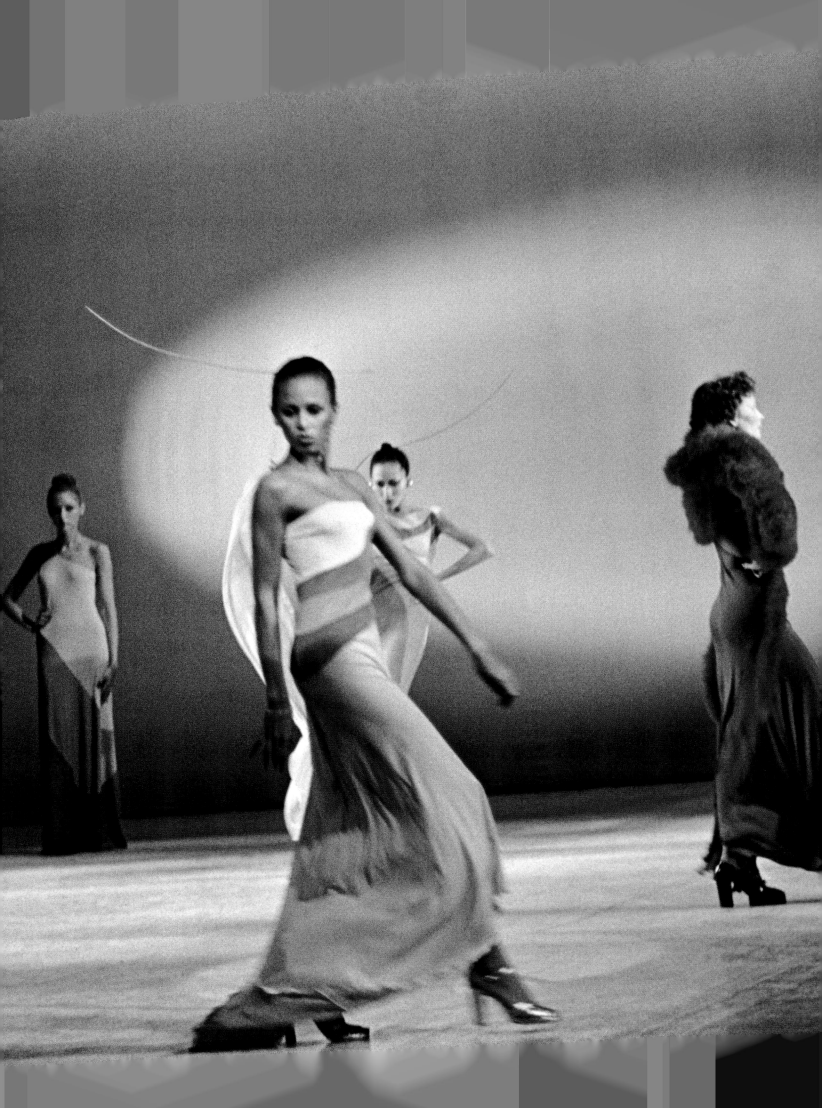

" 'I was so pleased, and proud,'
said guest of honor and American born,
Princess Grace of Monaco,
in a beige and red outfit by Mme. Grès."

- Bill Cunningham

Opposite: Marion York and a male model in Bill Blass's *The Great Gatsby* inspired collection.

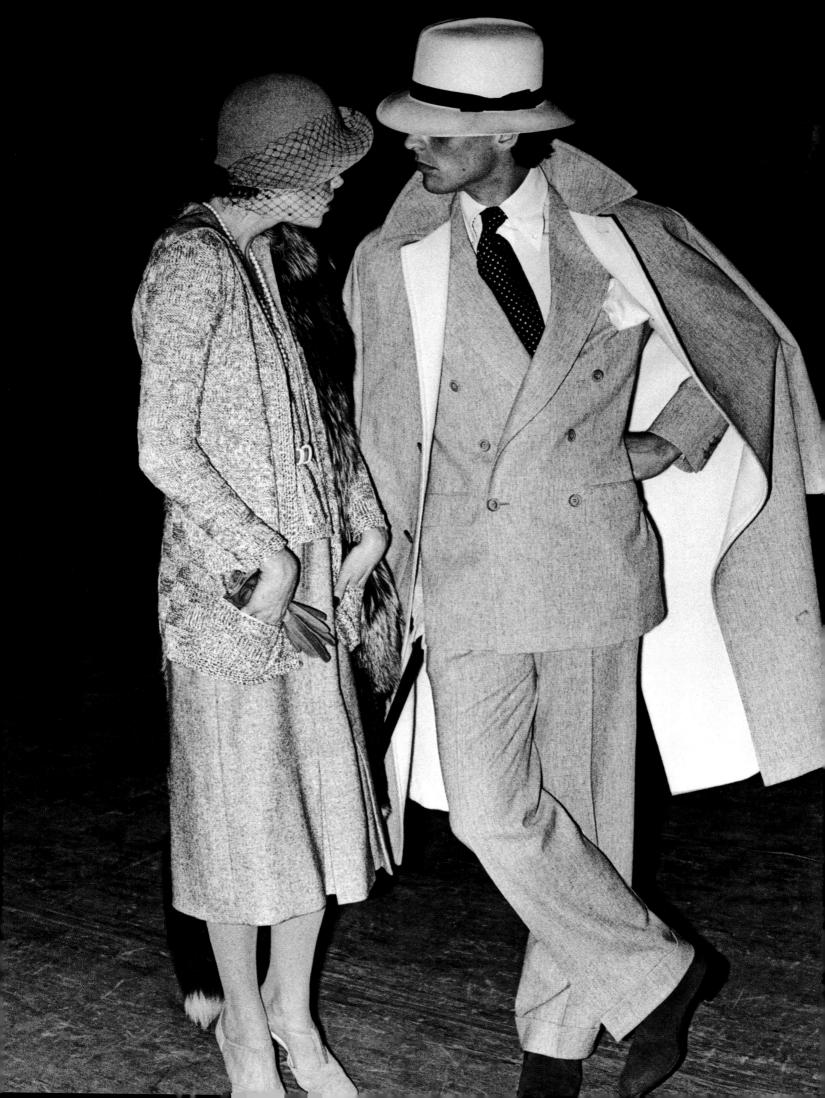

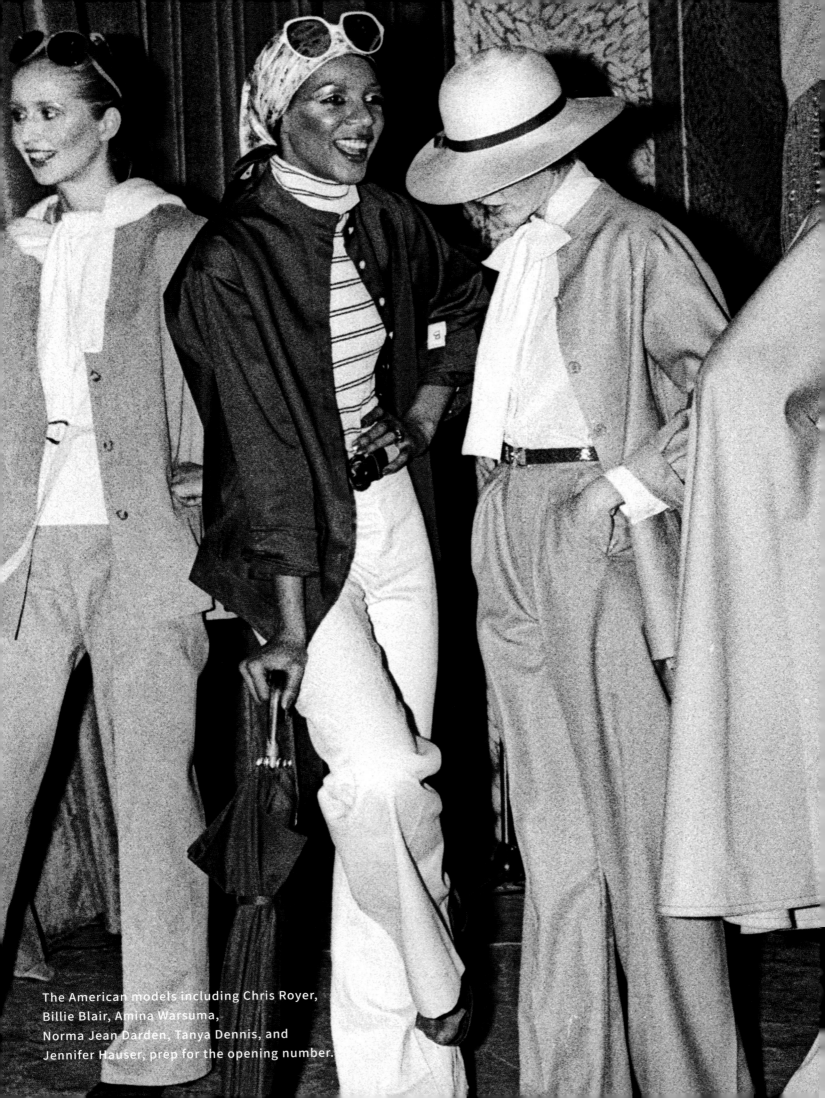

The American models including Chris Royer, Billie Blair, Amina Warsuma, Norma Jean Darden, Tanya Dennis, and Jennifer Hauser, prep for the opening number.

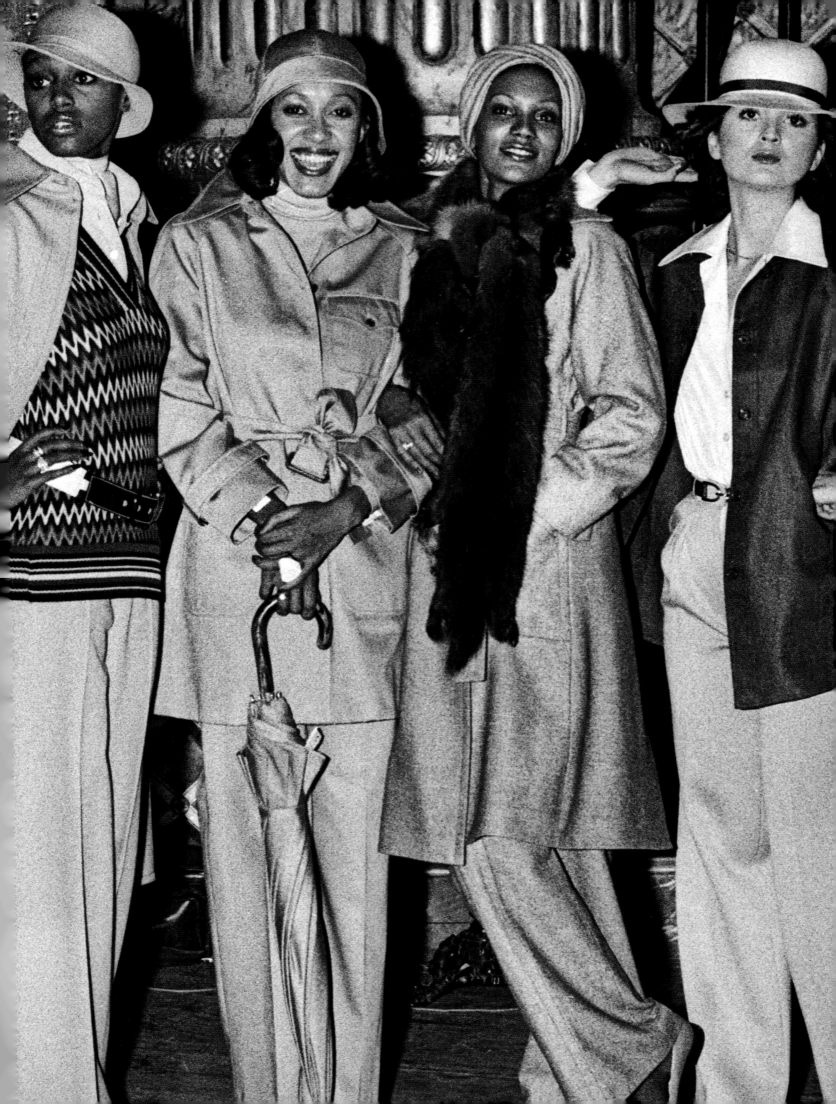

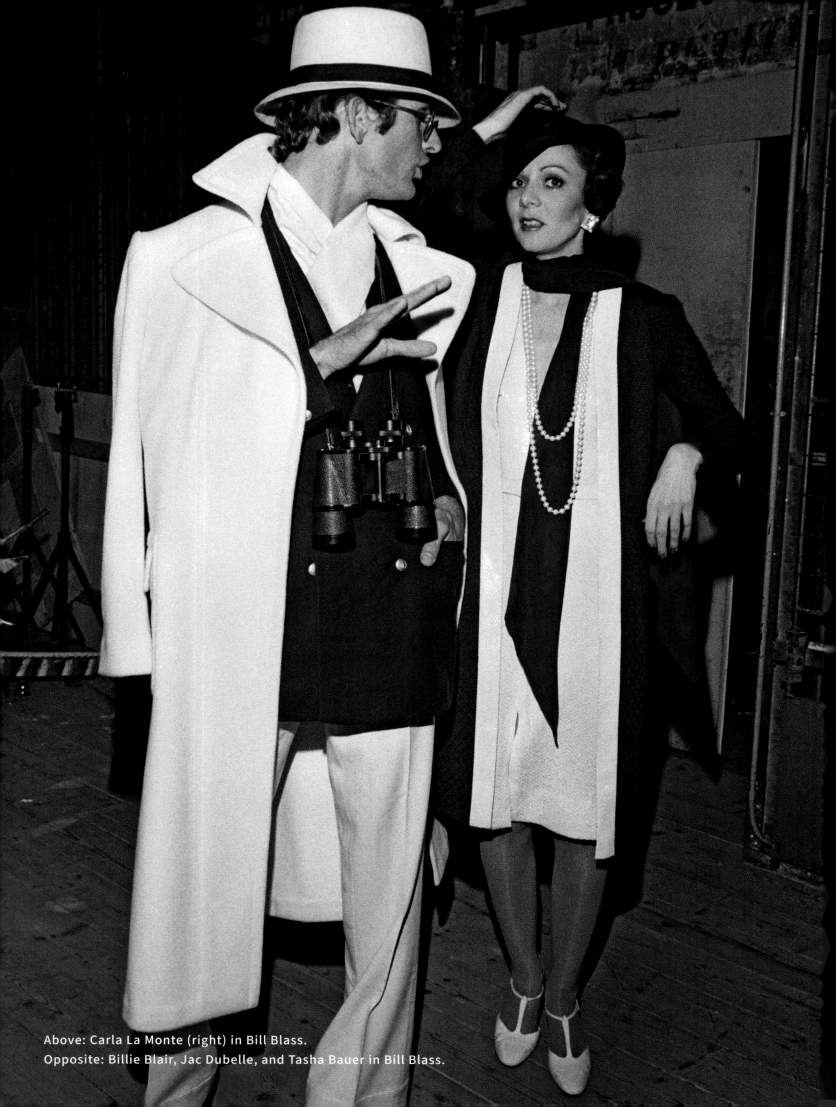

Above: Carla La Monte (right) in Bill Blass.
Opposite: Billie Blair, Jac Dubelle, and Tasha Bauer in Bill Blass.

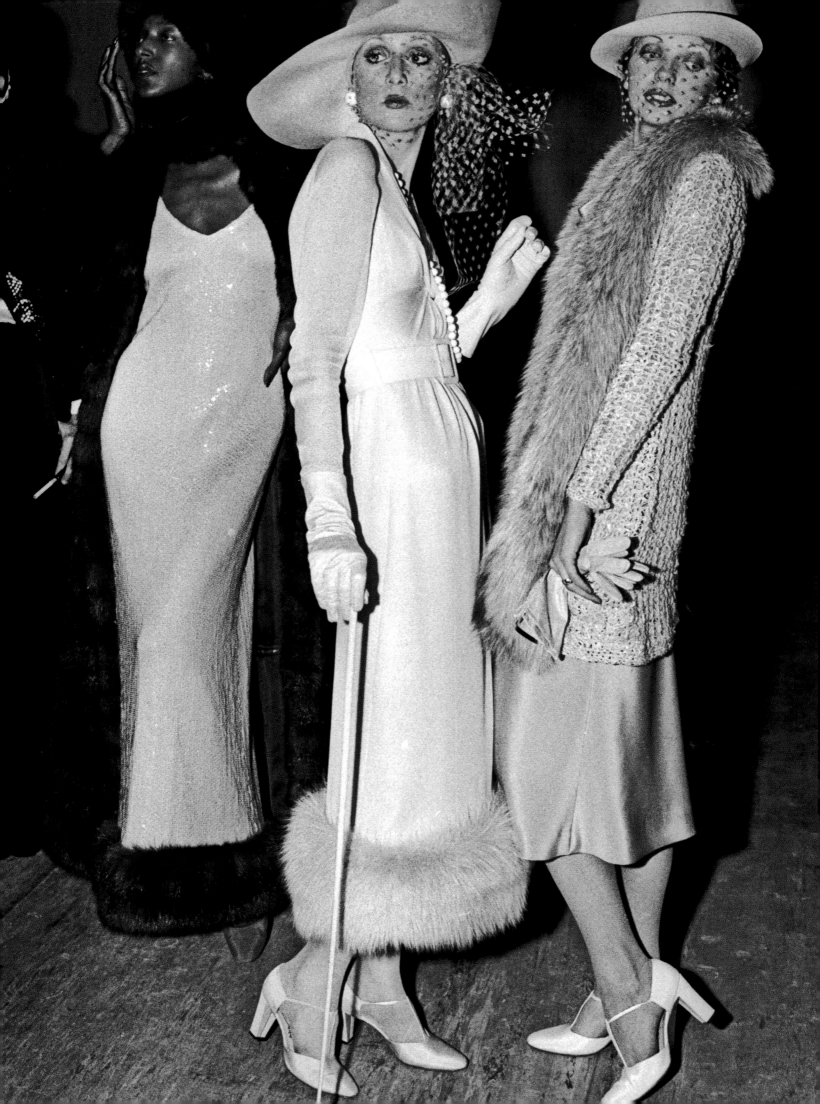

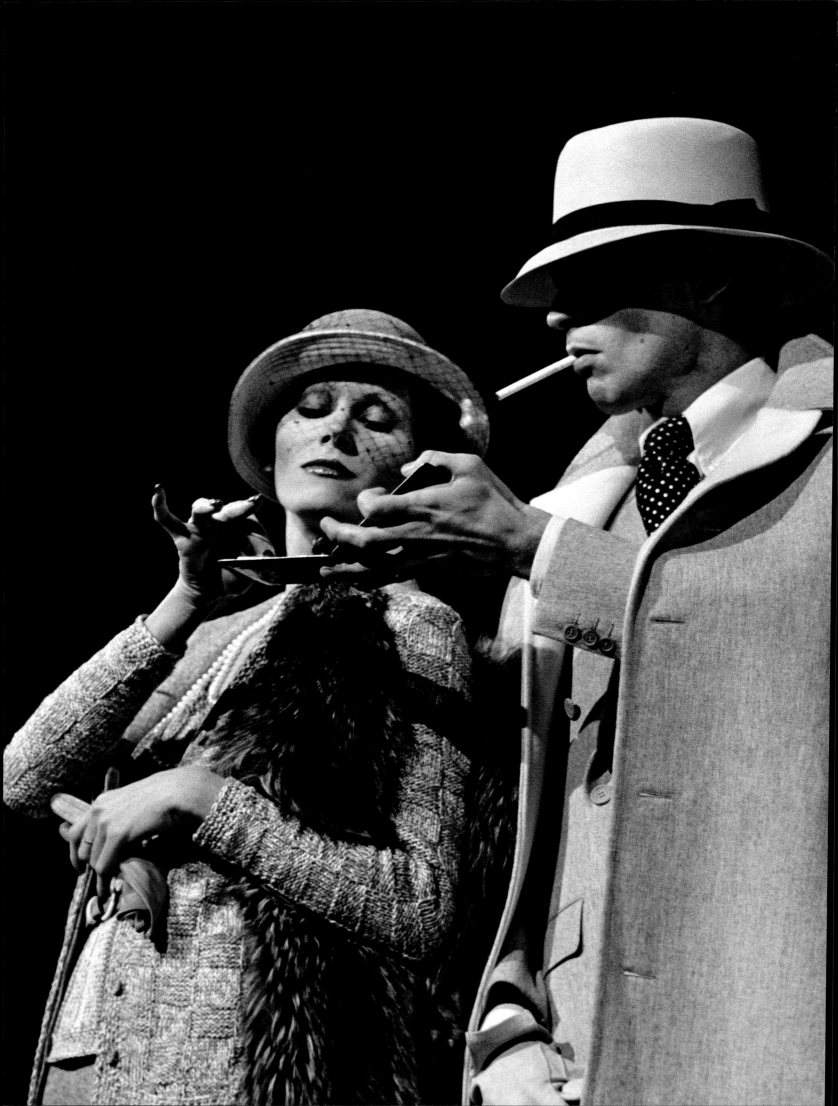

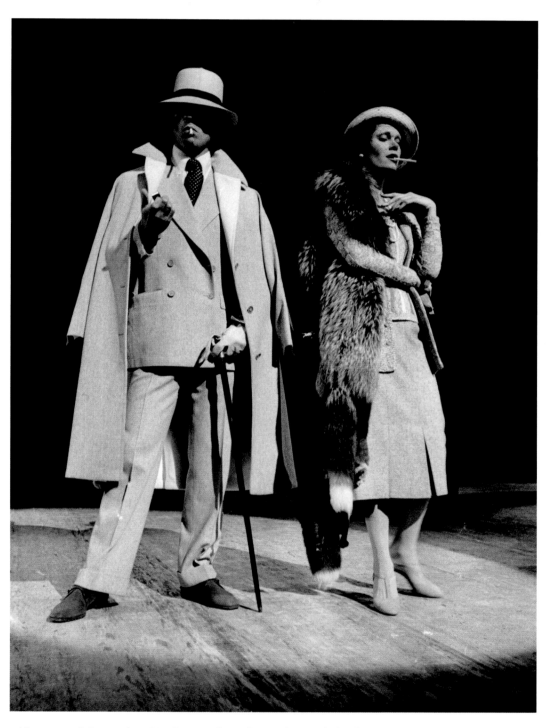

Above and Opposite: Marion York and a male model take center stage for Bill Blass.

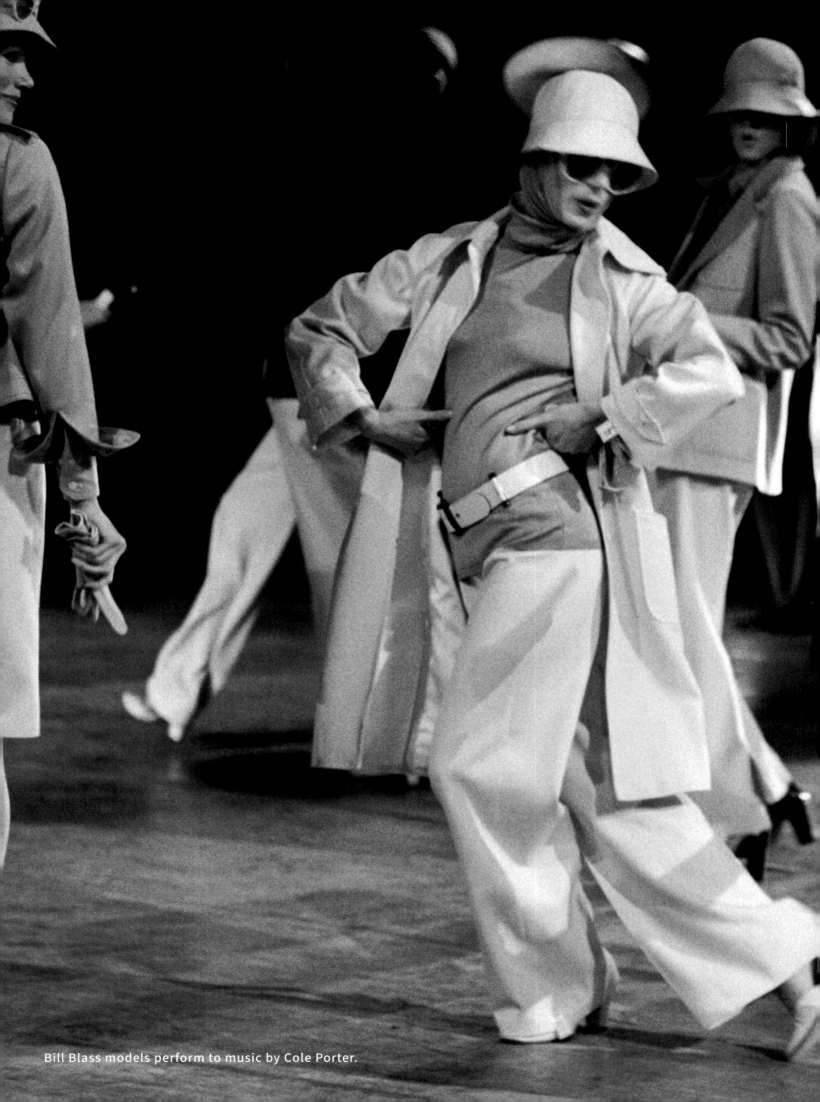

Bill Blass models perform to music by Cole Porter.

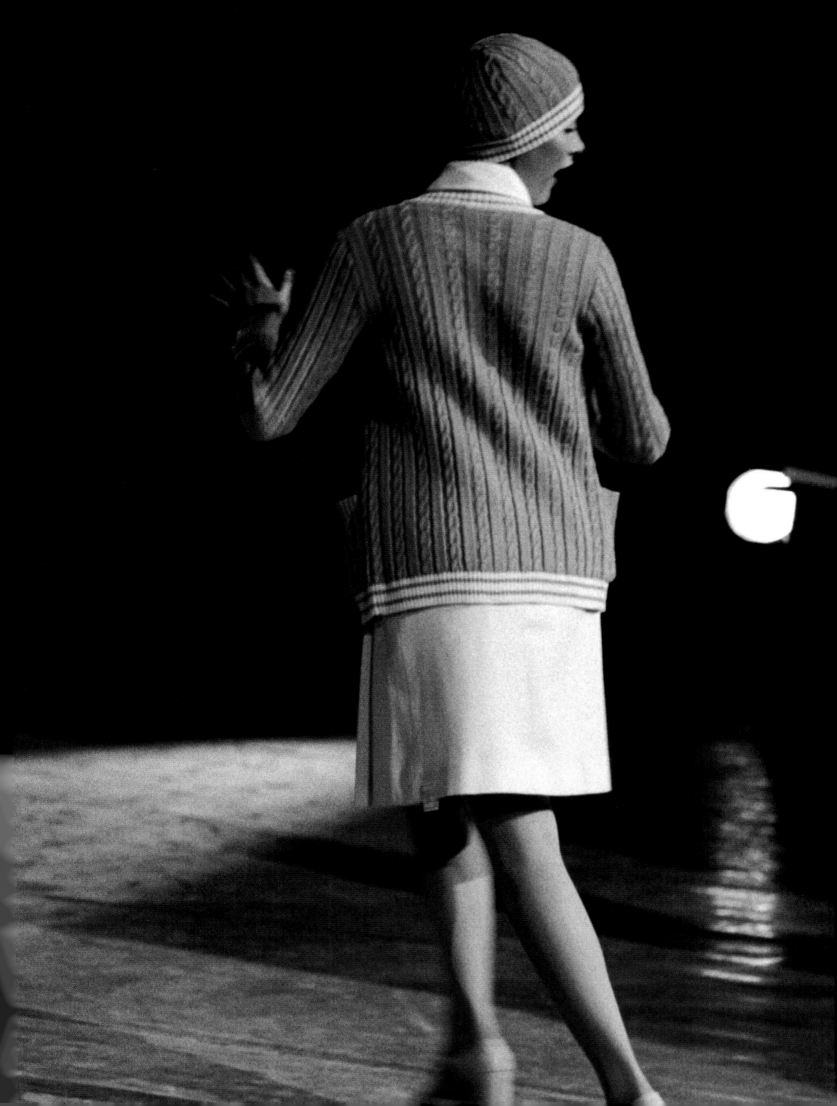

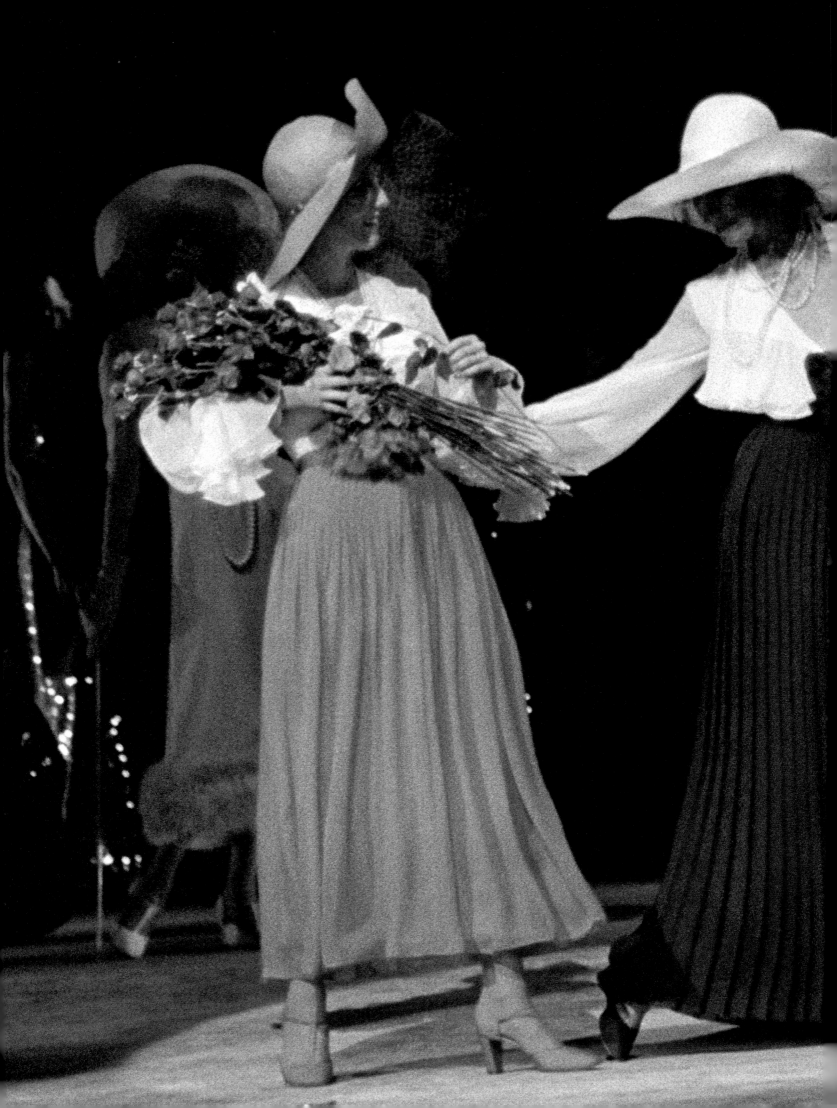

"They were like,
'Okay, let's let them come over and play.'
But we came
over and we won the chess game.
It was checkmate."

- Pat Cleveland

Opposite: Pat Cleveland spinning in Halston.

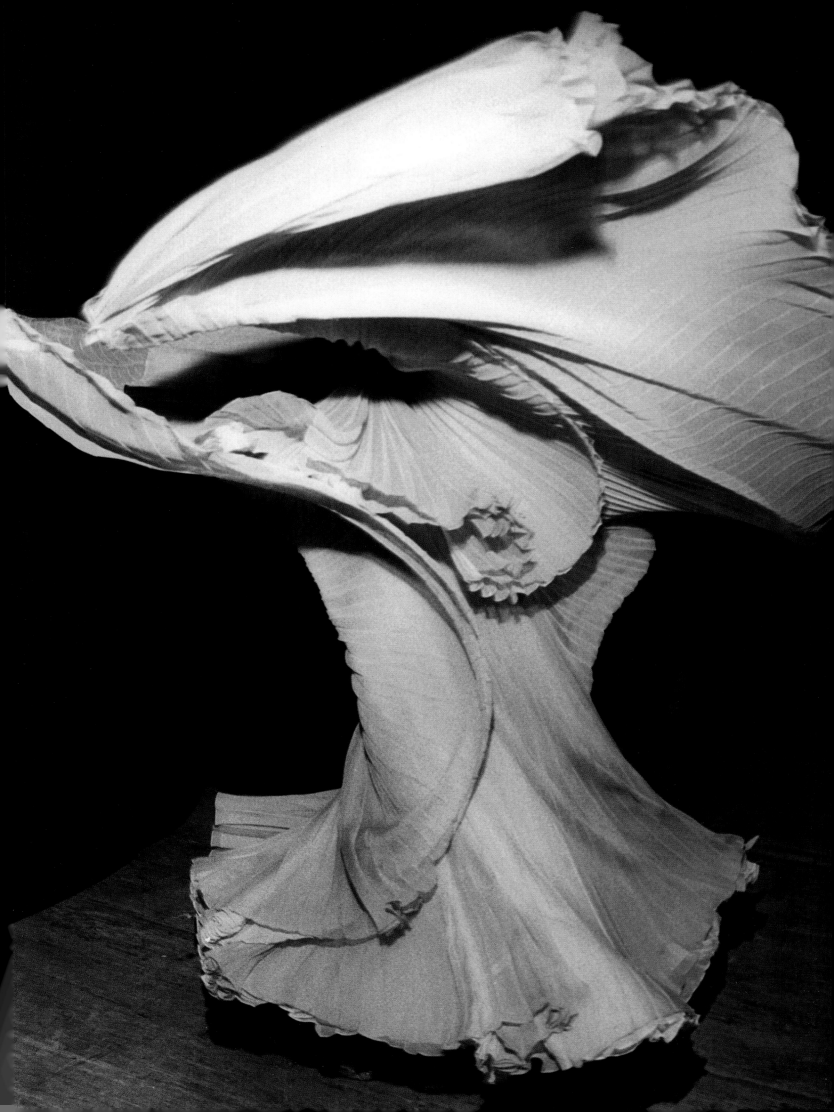

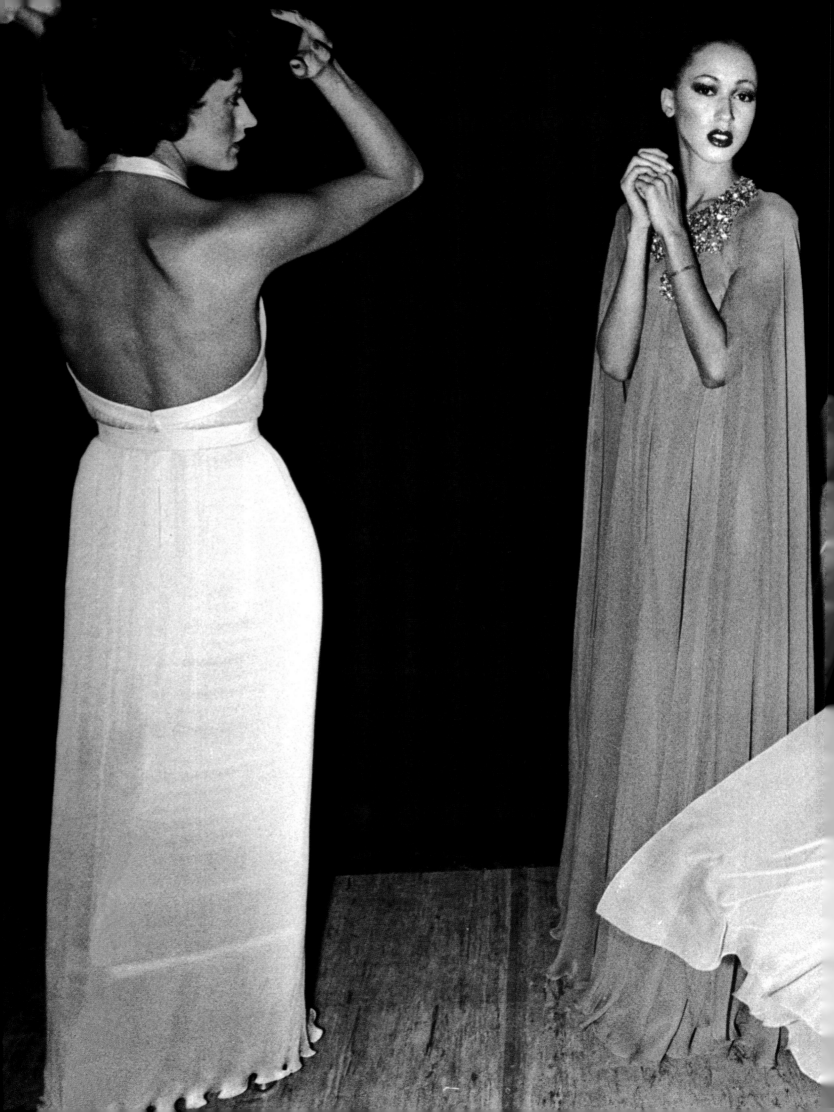

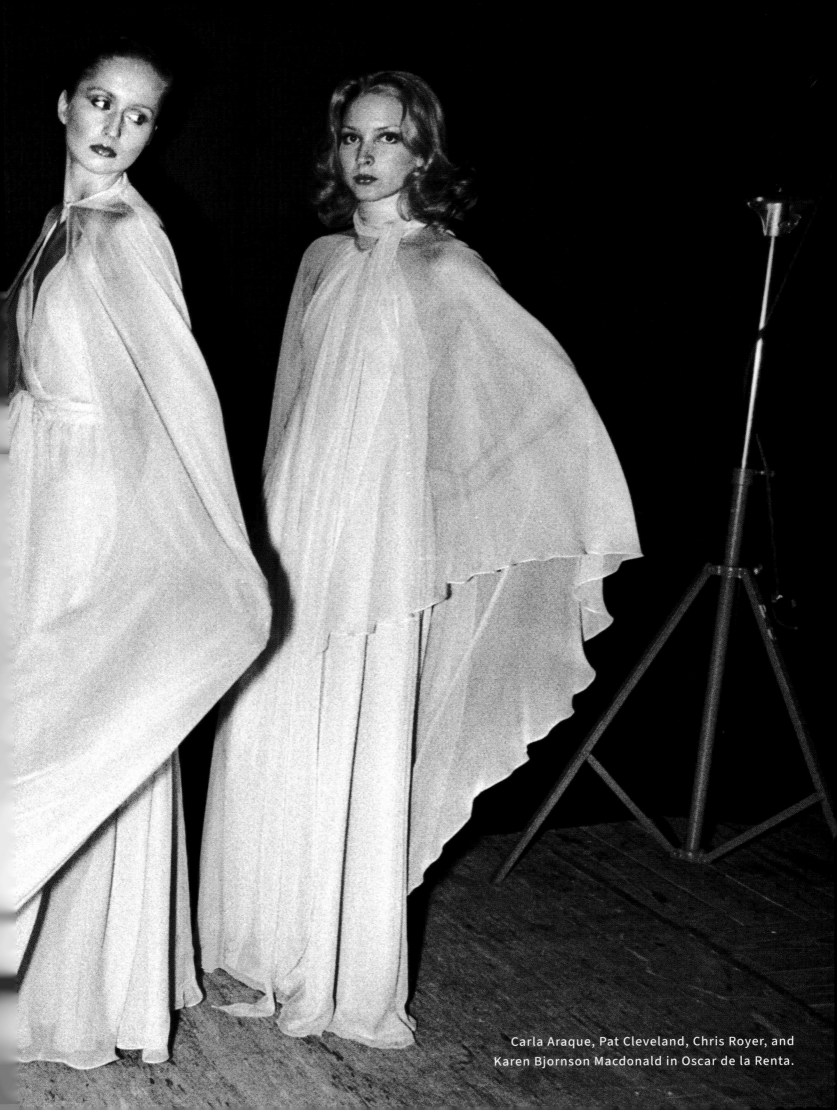

Carla Araque, Pat Cleveland, Chris Royer, and
Karen Bjornson Macdonald in Oscar de la Renta.

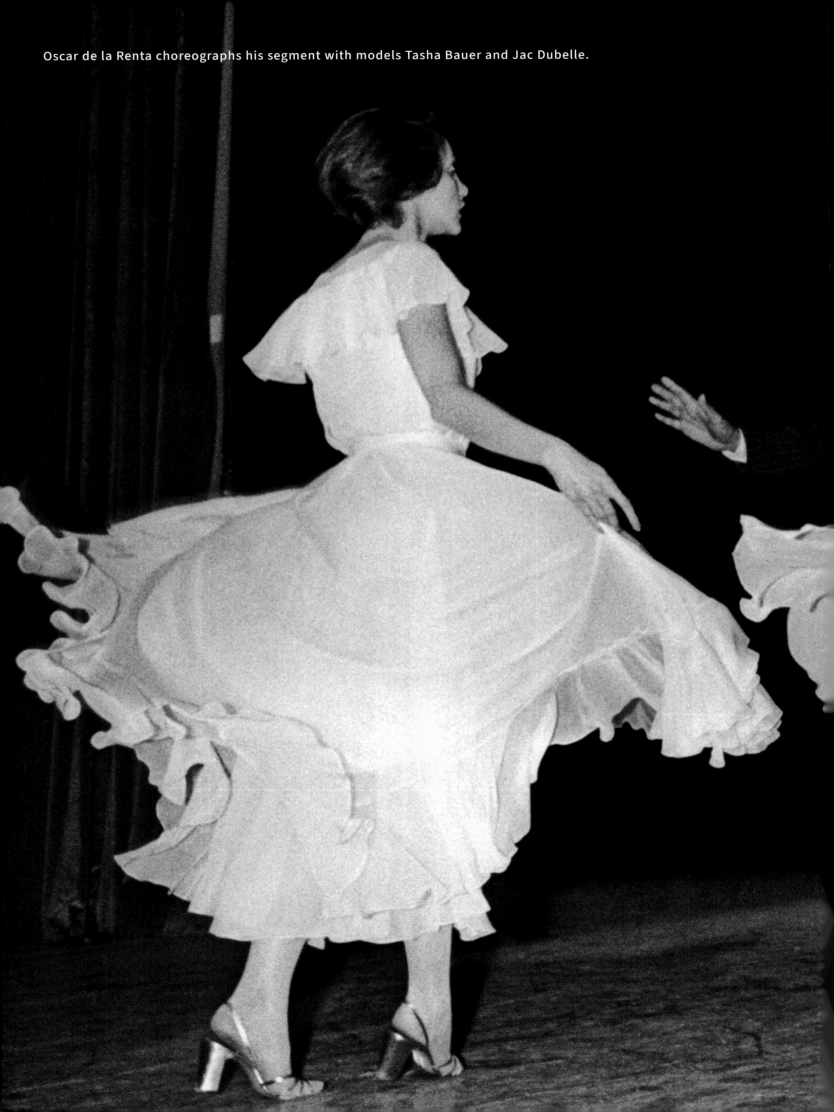

Oscar de la Renta choreographs his segment with models Tasha Bauer and Jac Dubelle.

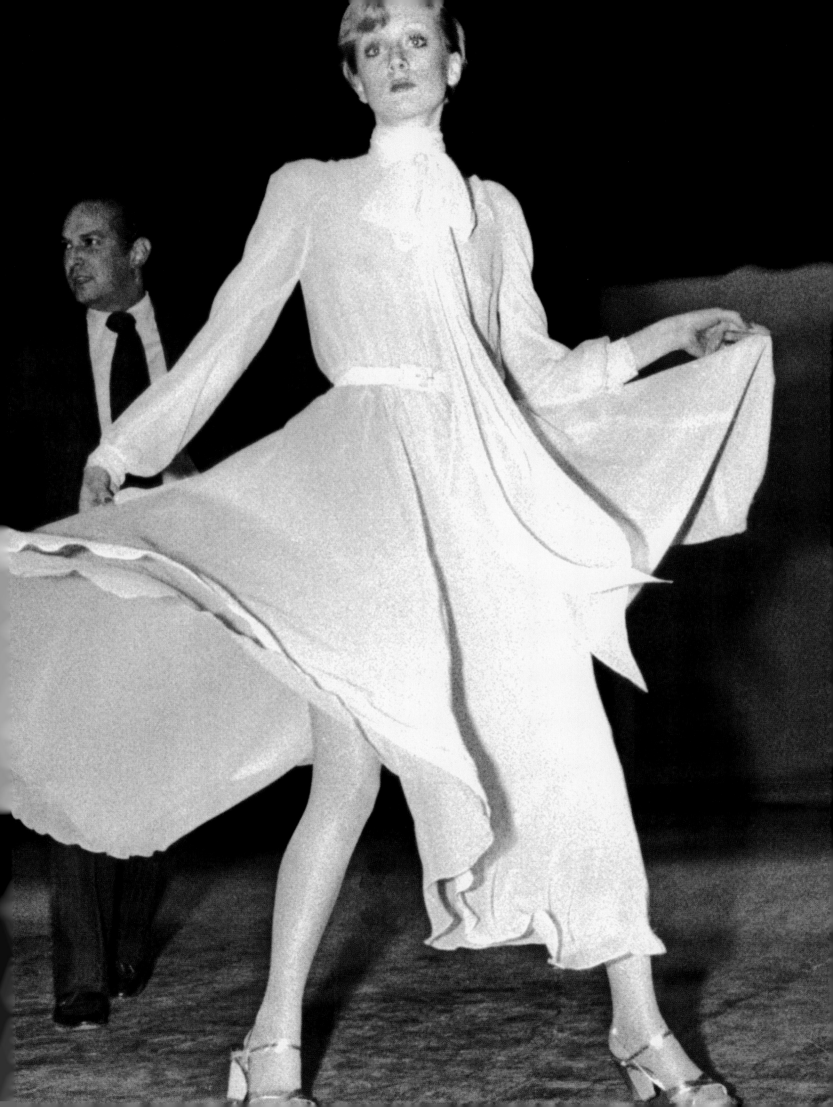

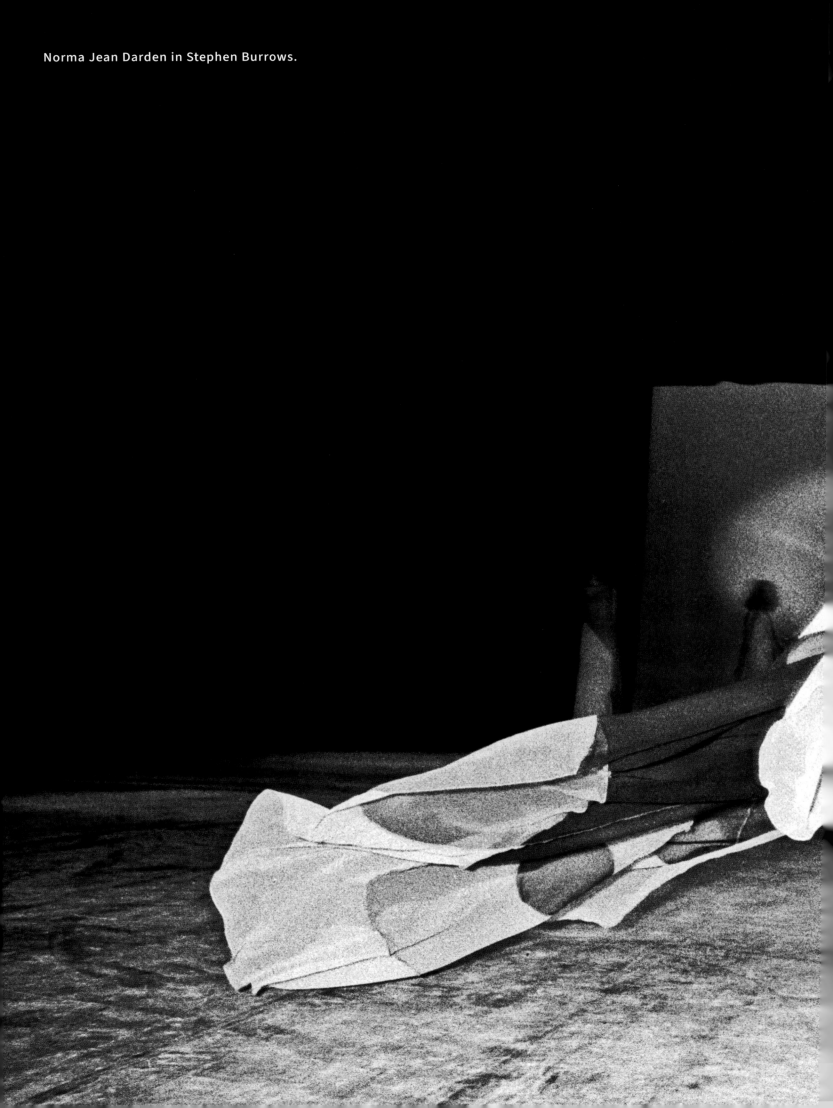

Norma Jean Darden in Stephen Burrows.

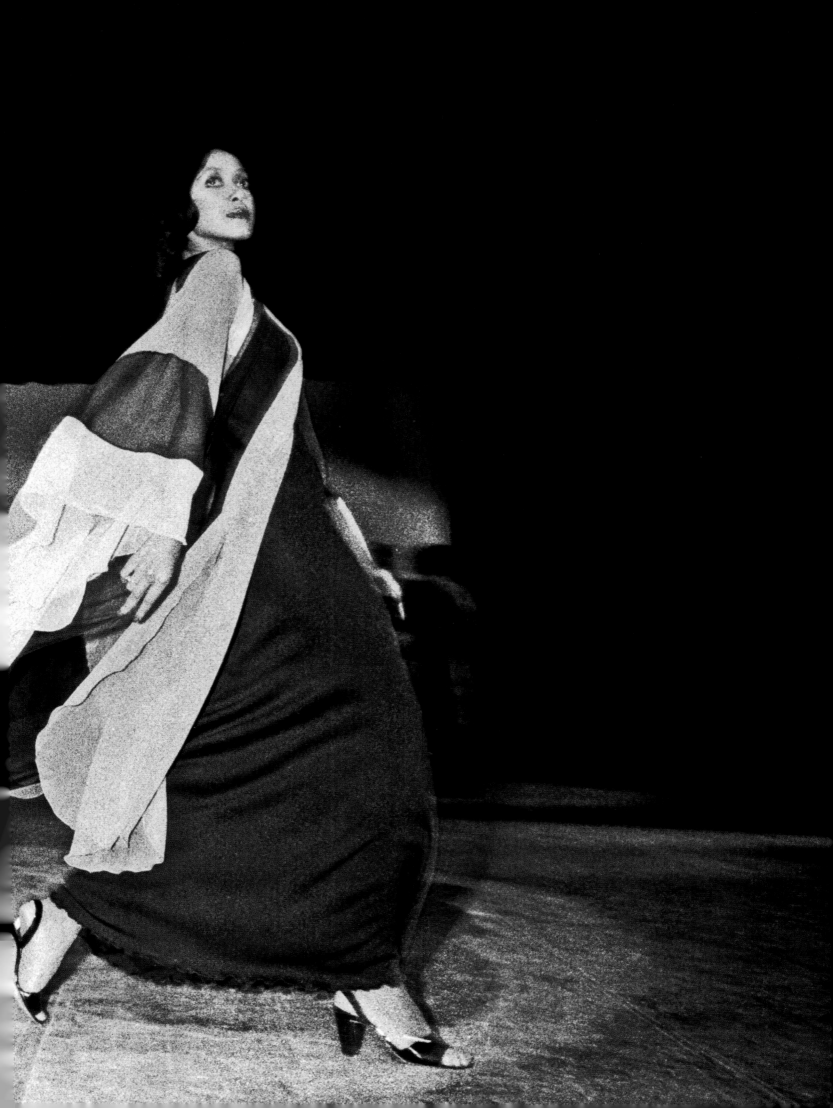

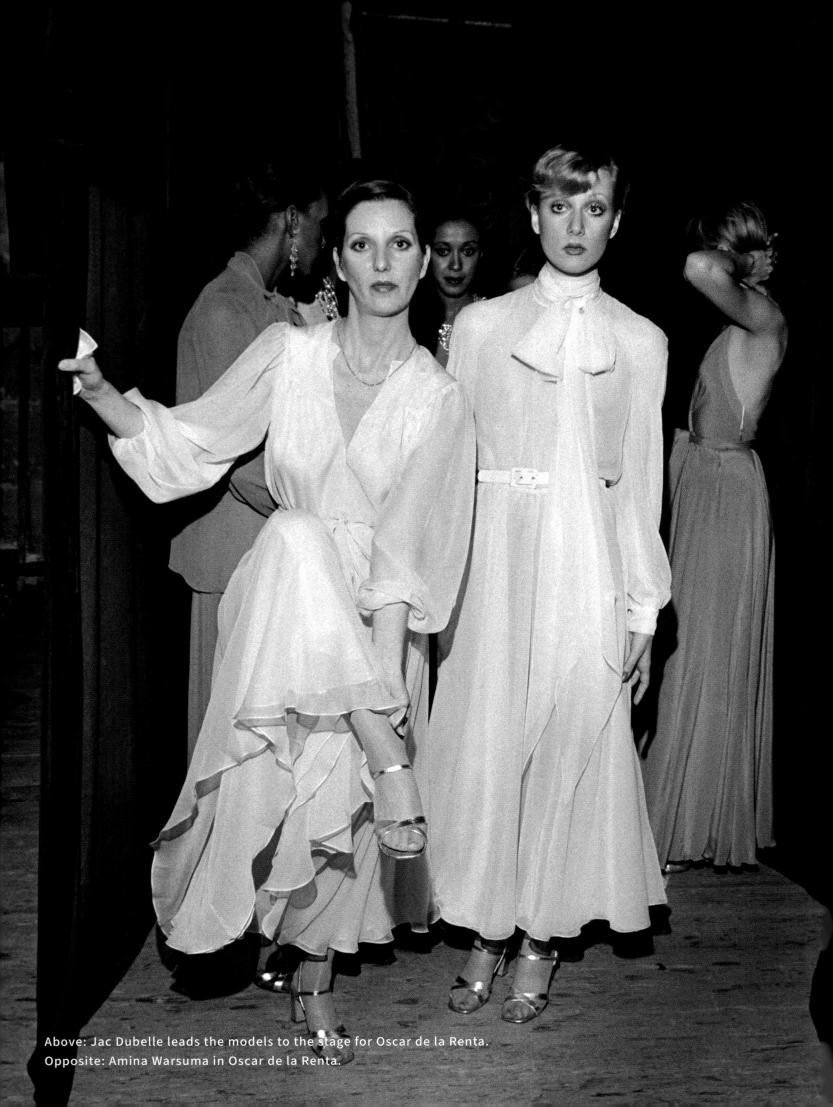

Above: Jac Dubelle leads the models to the stage for Oscar de la Renta.
Opposite: Amina Warsuma in Oscar de la Renta.

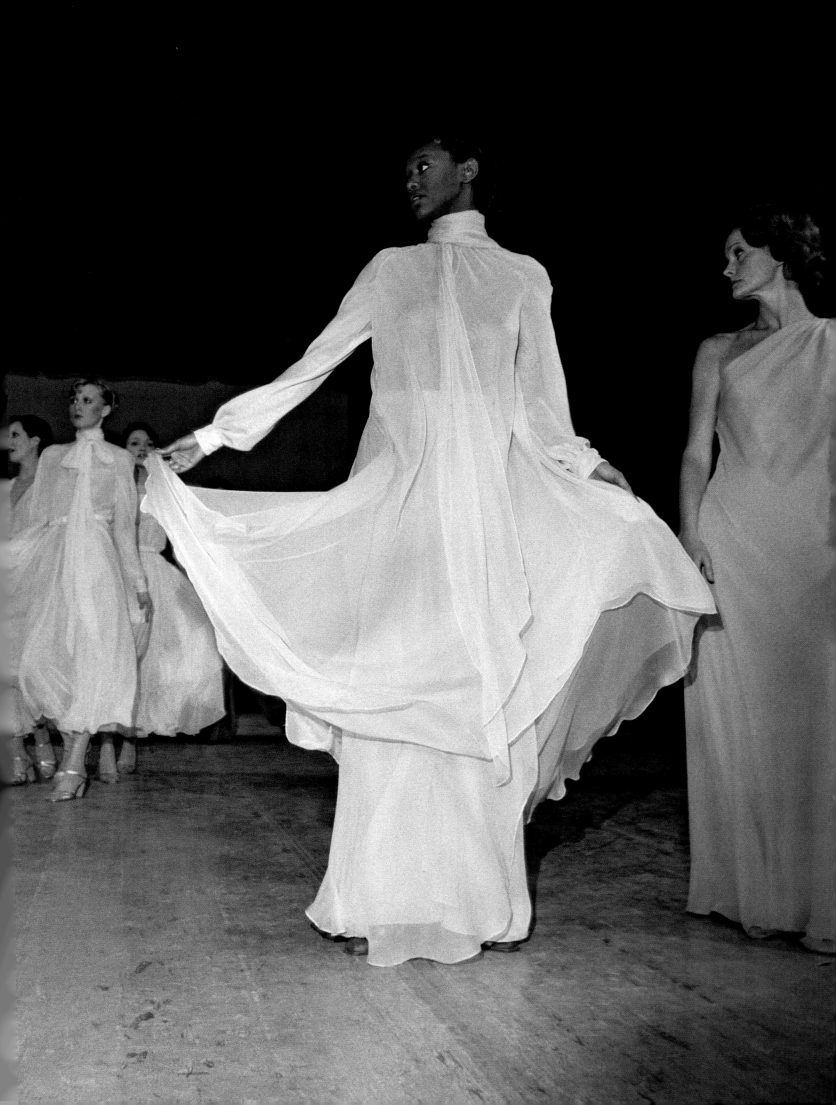

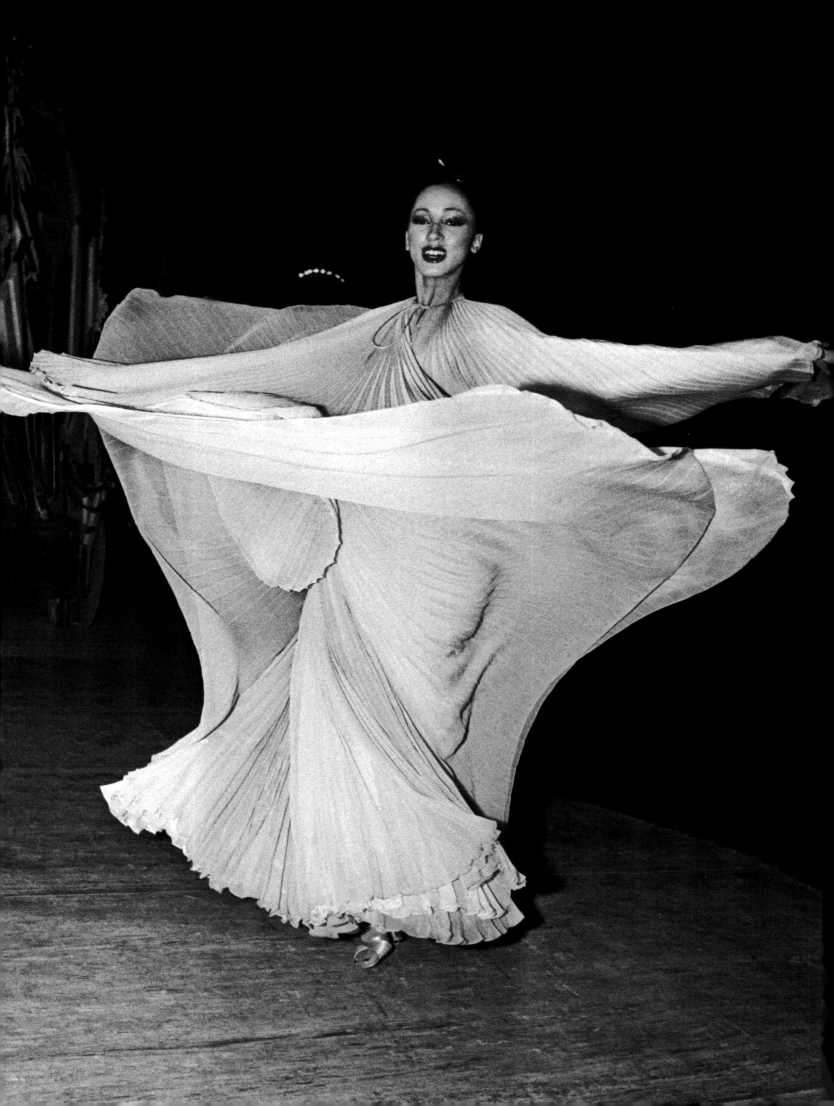

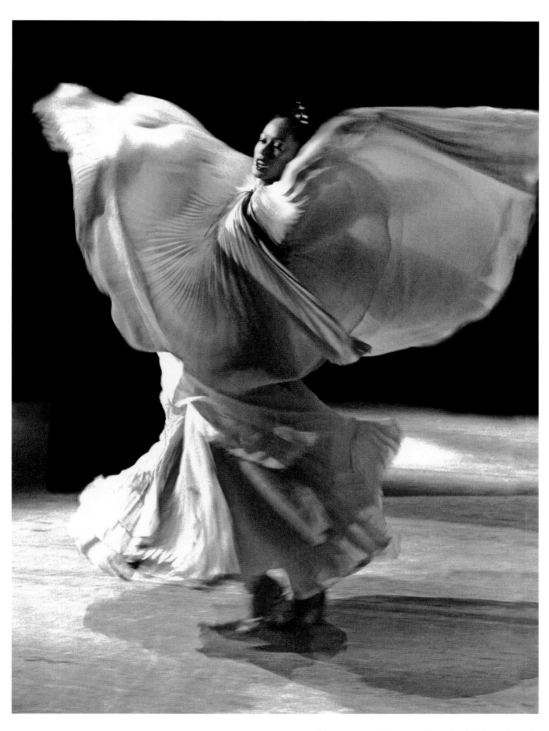

Above and Opposite: Pat Cleveland.

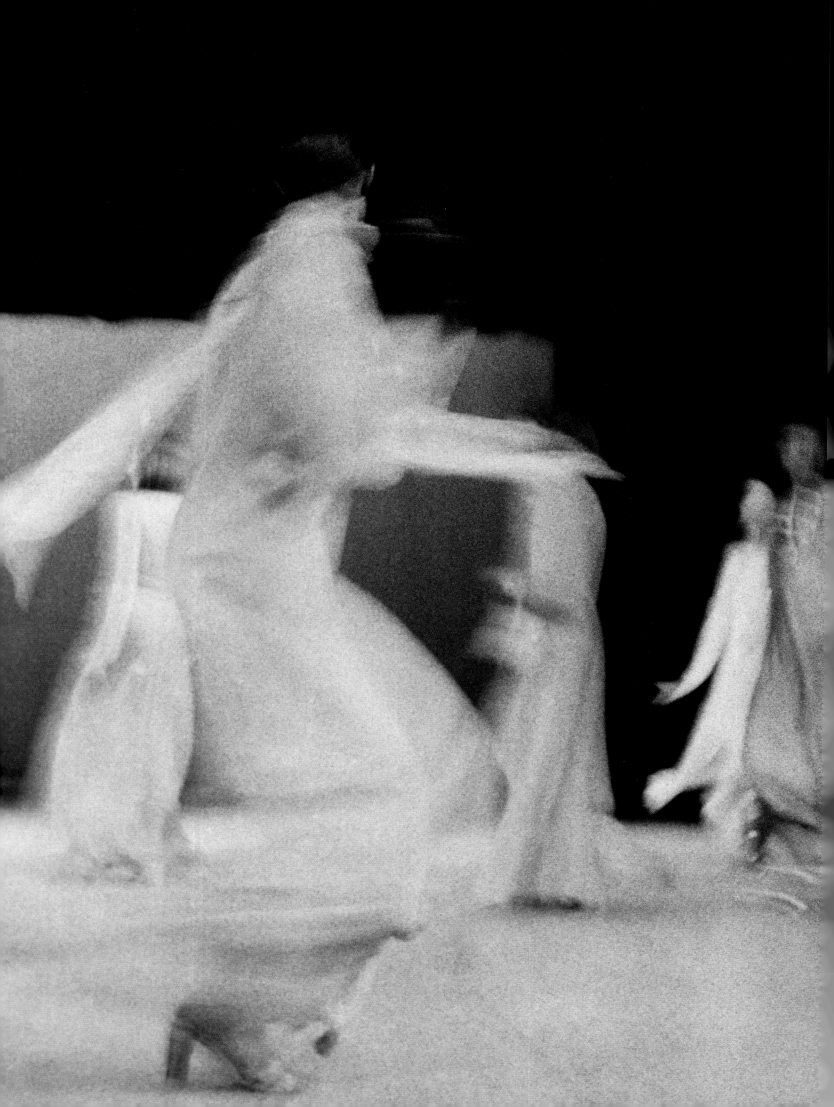

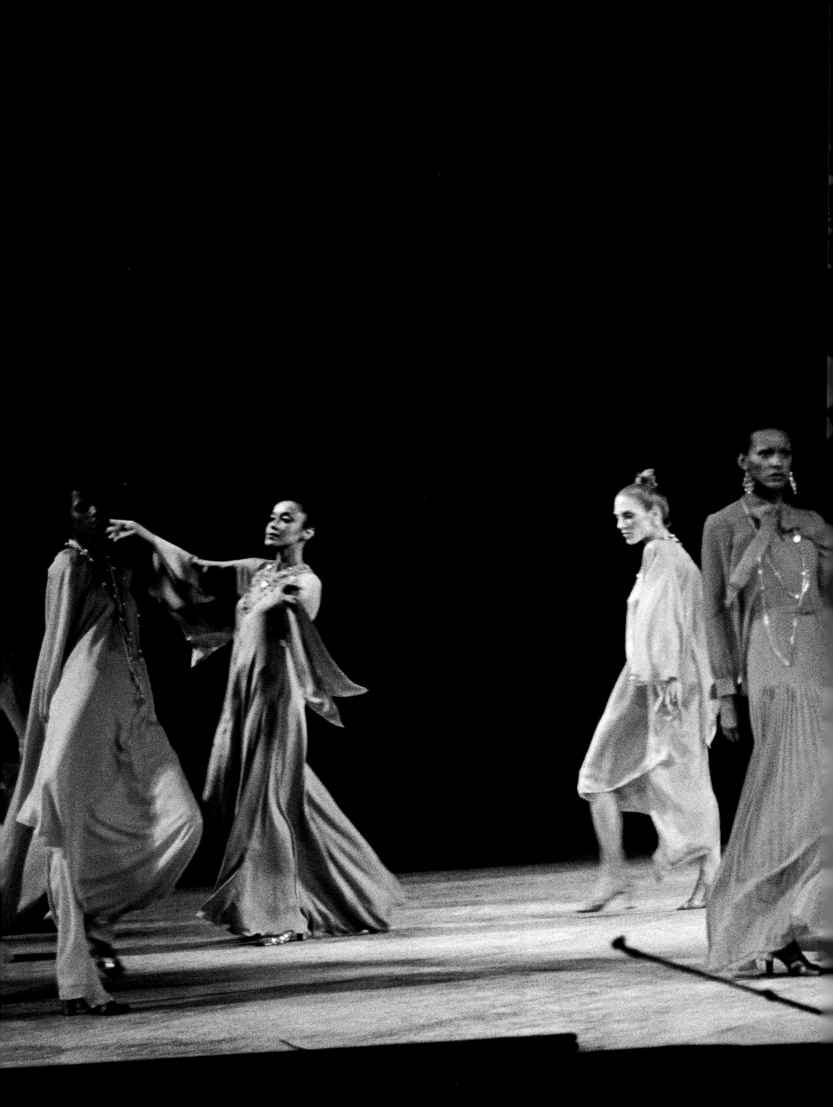

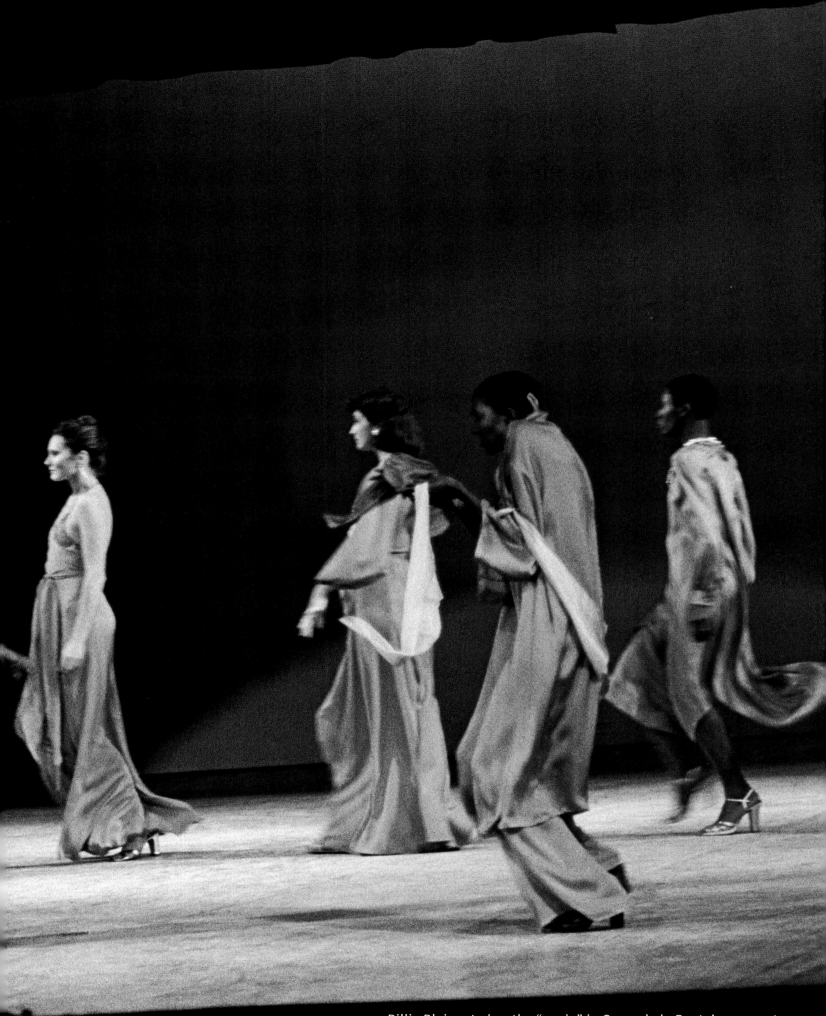

Billie Blair acted as the "genie" in Oscar de la Renta's segment, hypnotizing the other models to follow her lead.

"The French show lasted almost two hours.
Yet in just thirty minutes the Americans
simply overwhelmed the audience and themselves.
Models rushed off the stage crying
'They Love us - They love us.'
As Anne Klein would later say,
'I knew we won the Olympics'"

- Bill Cunningham

Opposite: Jennifer Brice in Anne Klein.

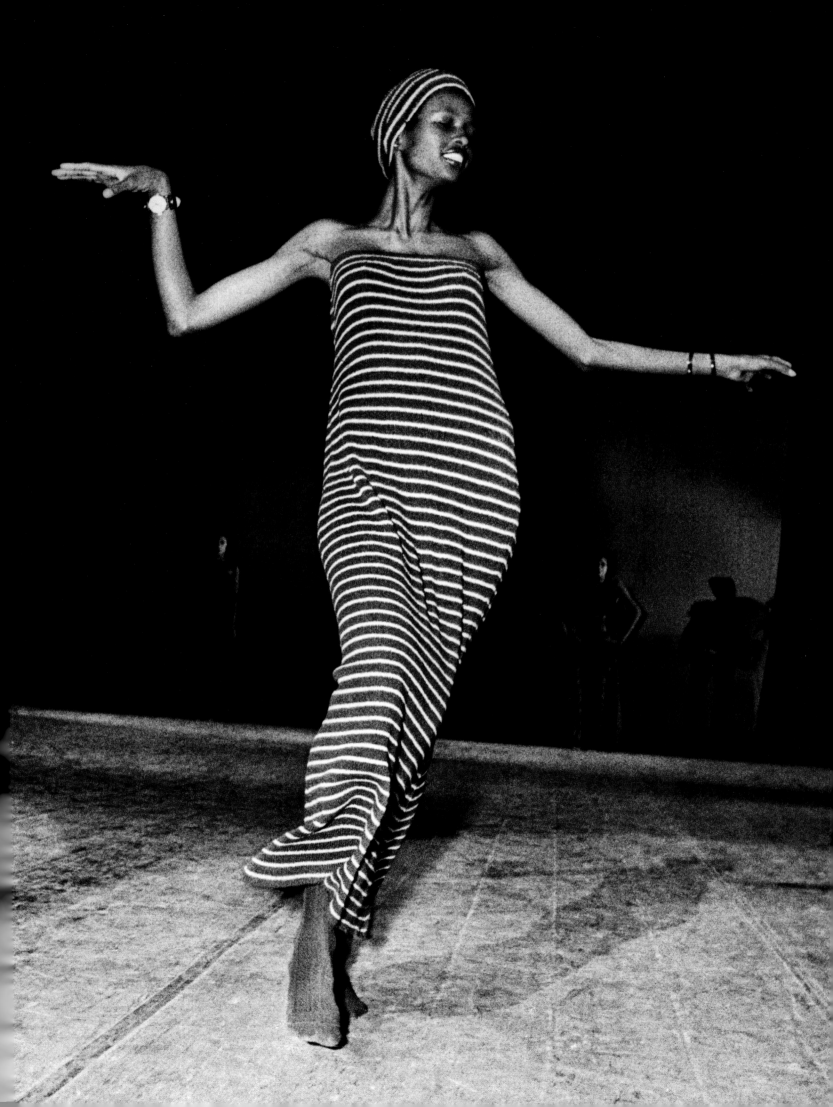

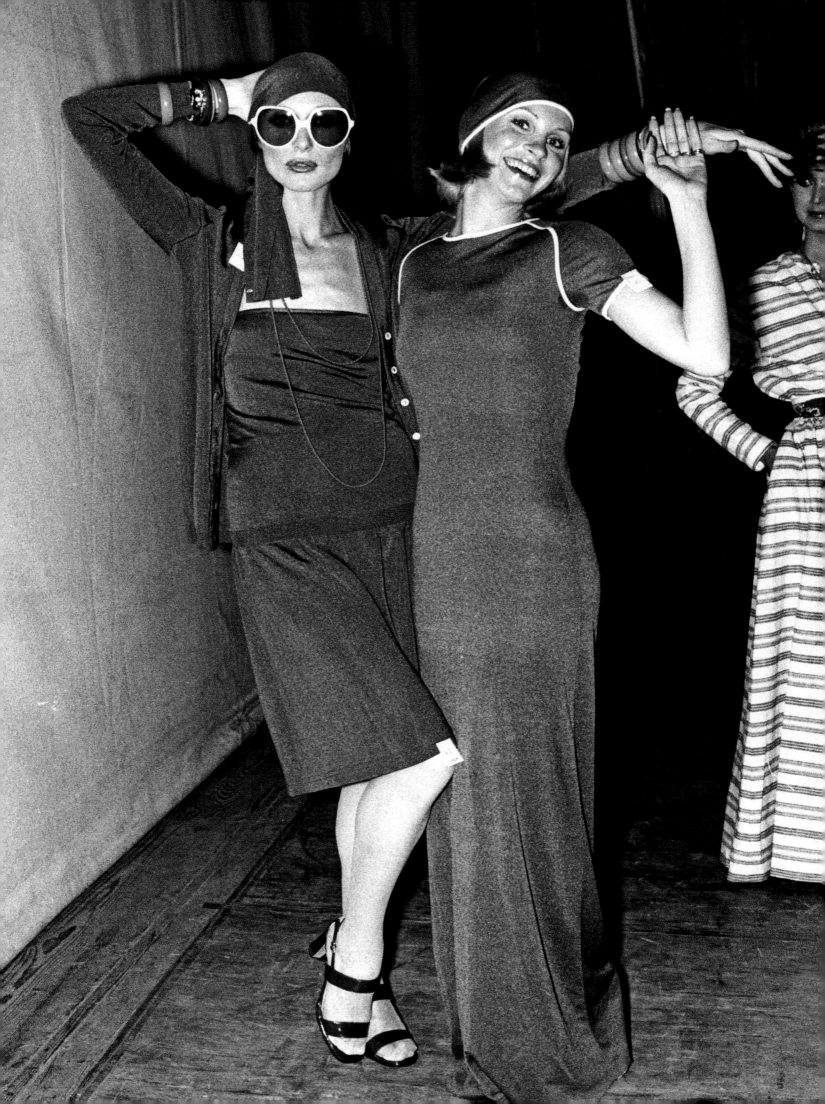

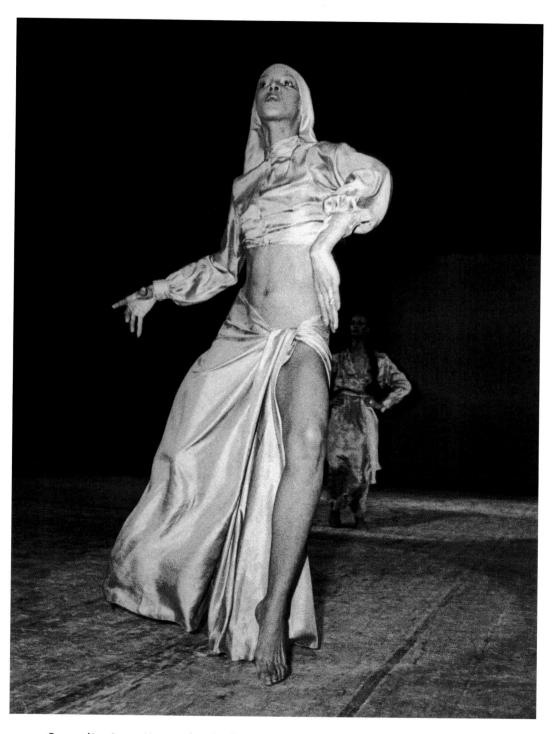

Opposite: Lynn Yaeger leads the models to the stage for Anne Klein's segment.
Above: Ramona Saunders in Anne Klein.

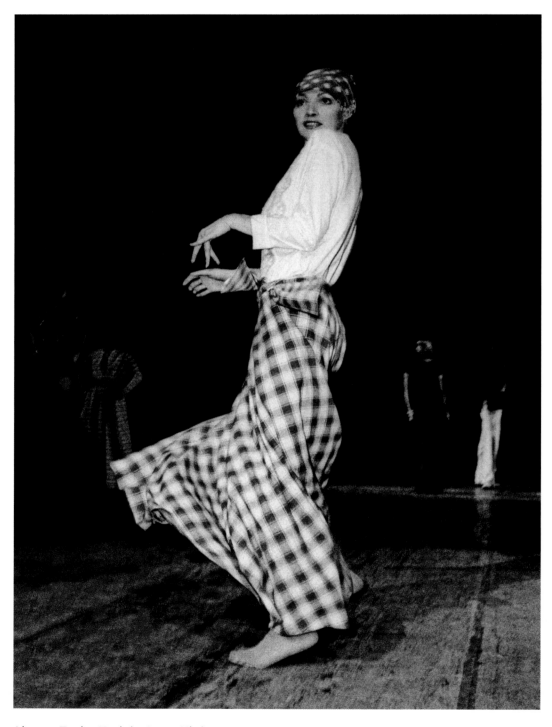

Above: Tasha York in Anne Klein.
Opposite: Pat Cleveland holds court with Alva Chinn,
Barbara Jackson, Charlene Dash, and Jennifer Brice.

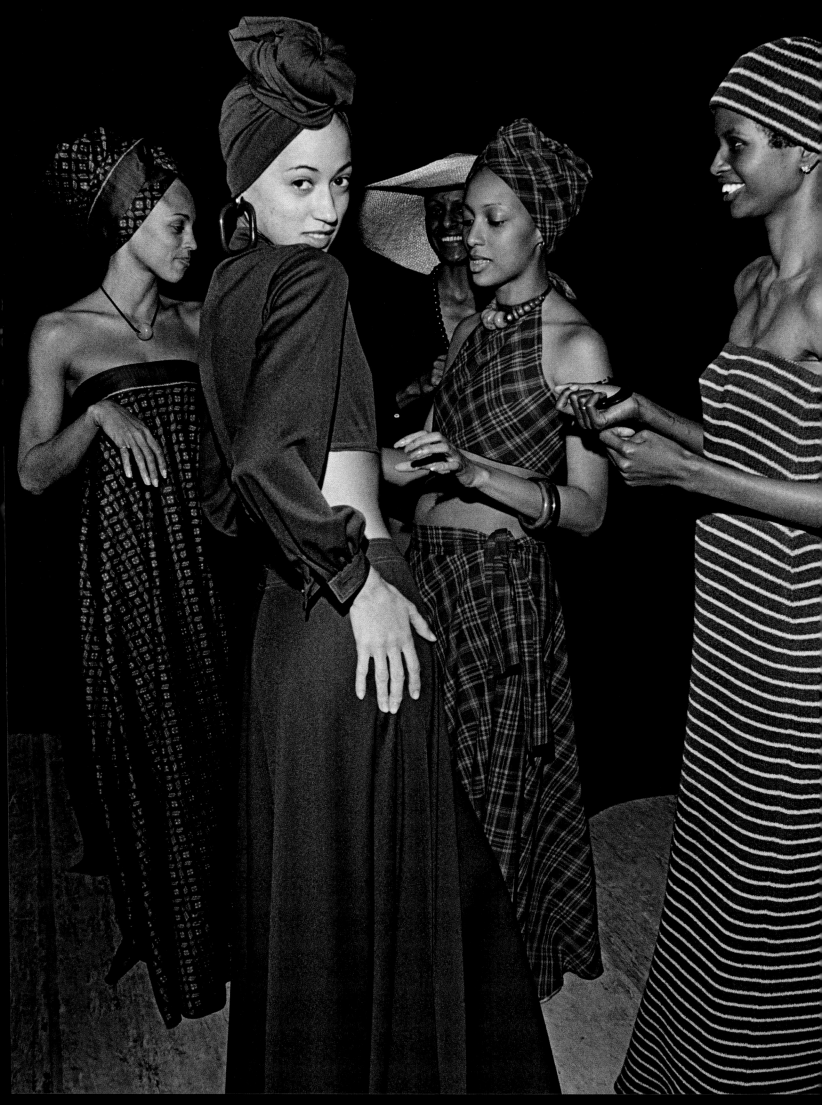

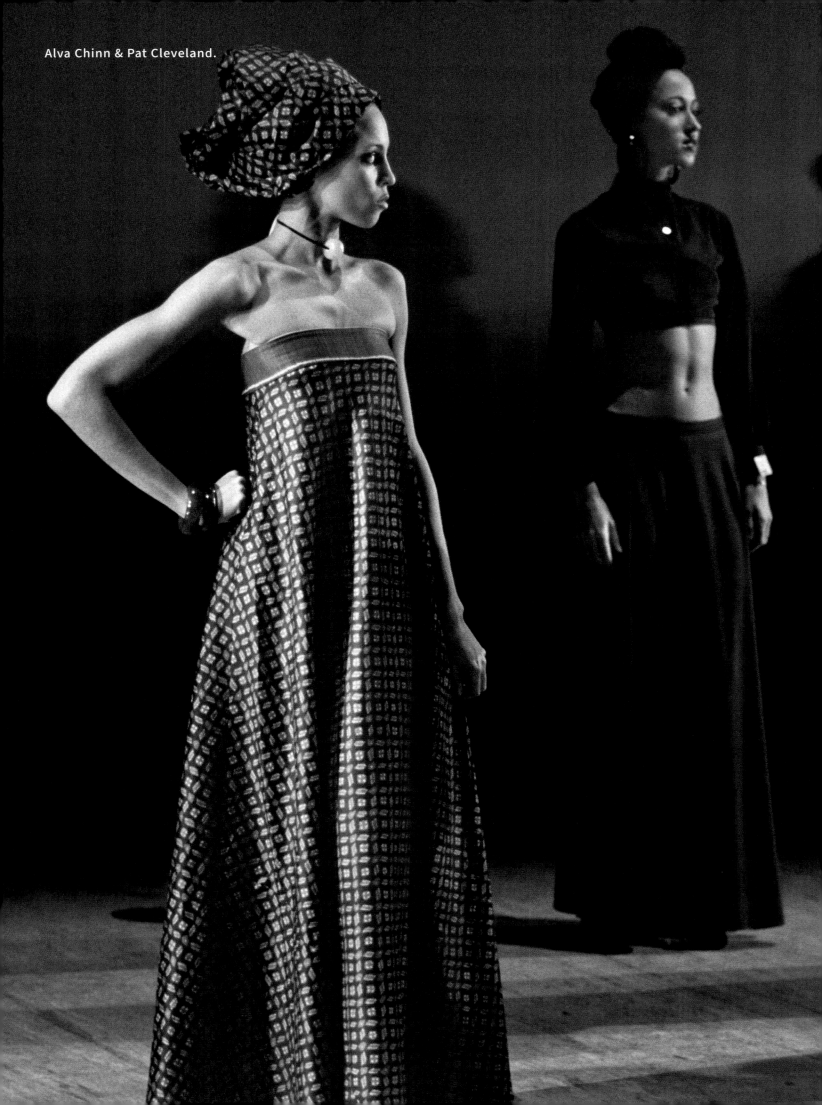

Alva Chinn & Pat Cleveland.

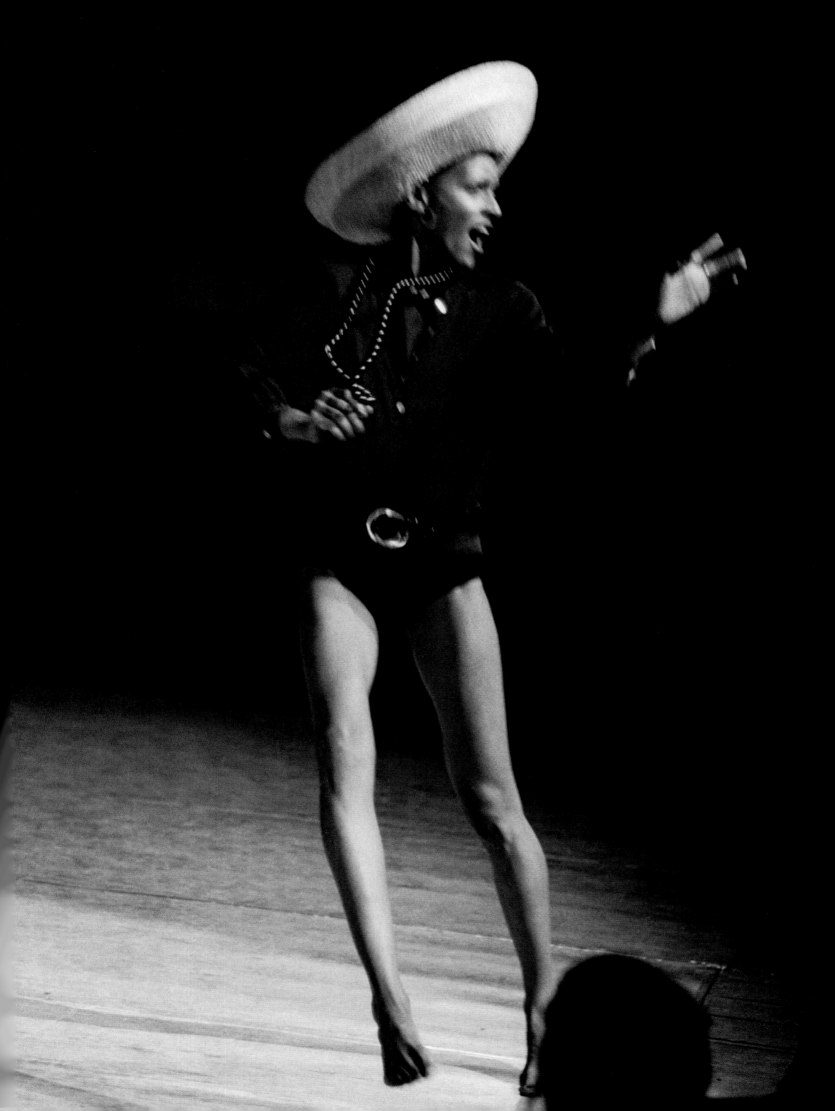

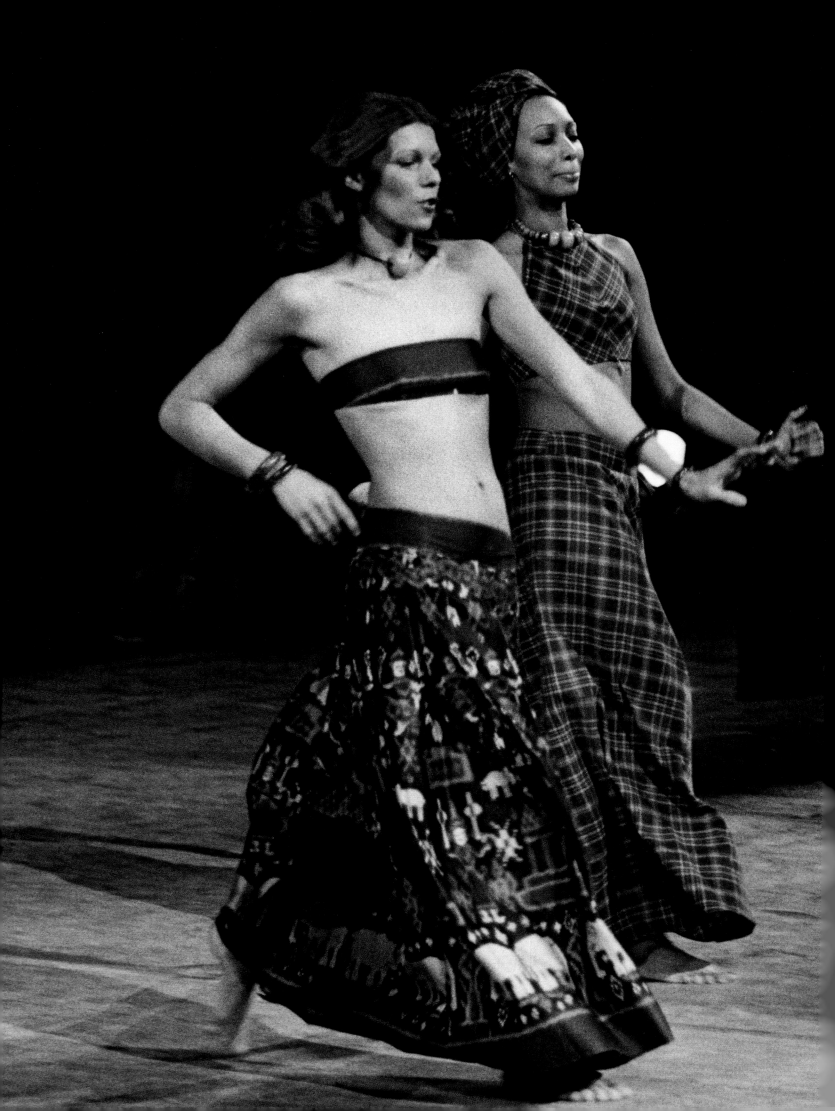

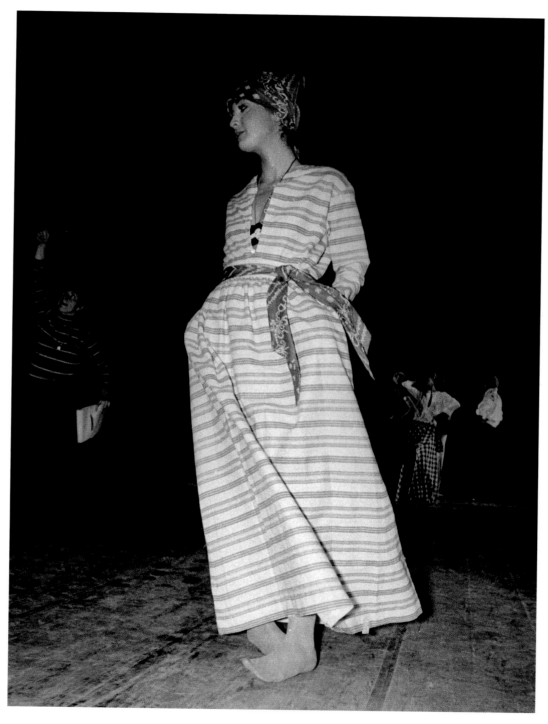

Previous Page: Barbara Jackson leads Anne Klein's models downstage.
Above: Jennifer Hauser in Anne Klein.
Opposite: Charlene Dash and the other Anne Klein models dance to
contemporary music, in stark contrast to the French presentation.

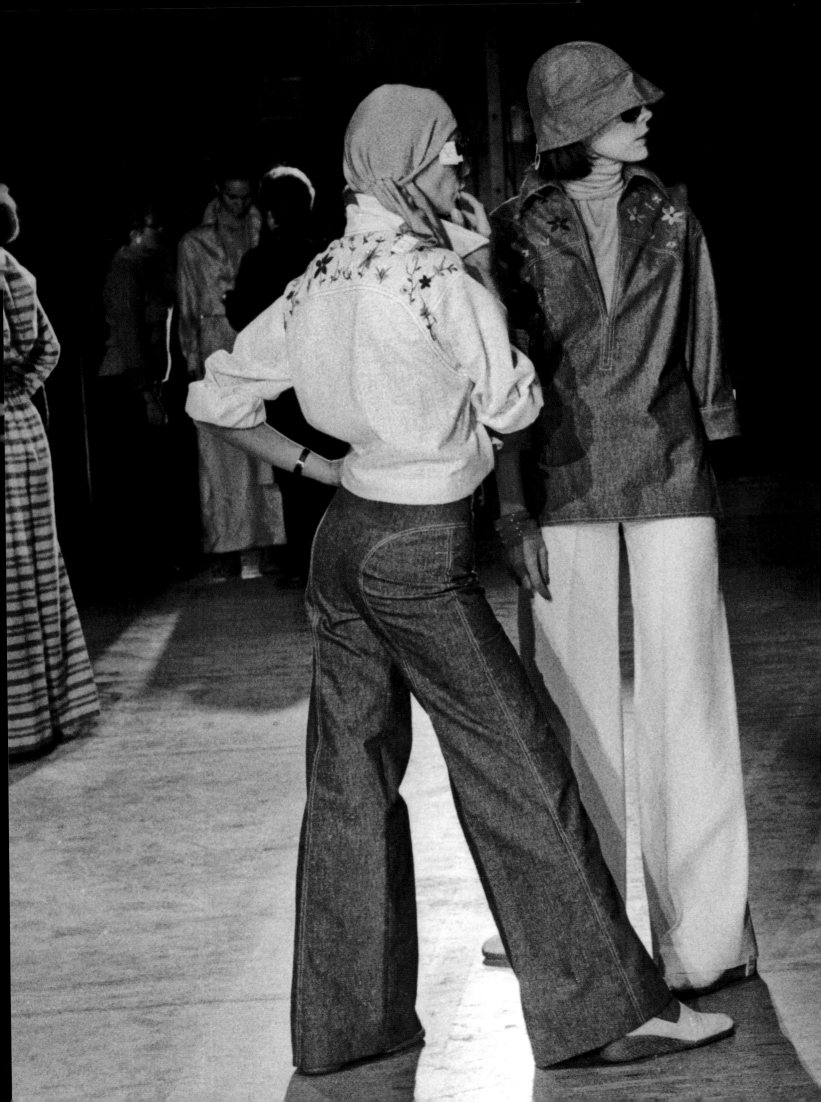

Opposite: Basha (left) at rehersals with the other Anne Klein models.

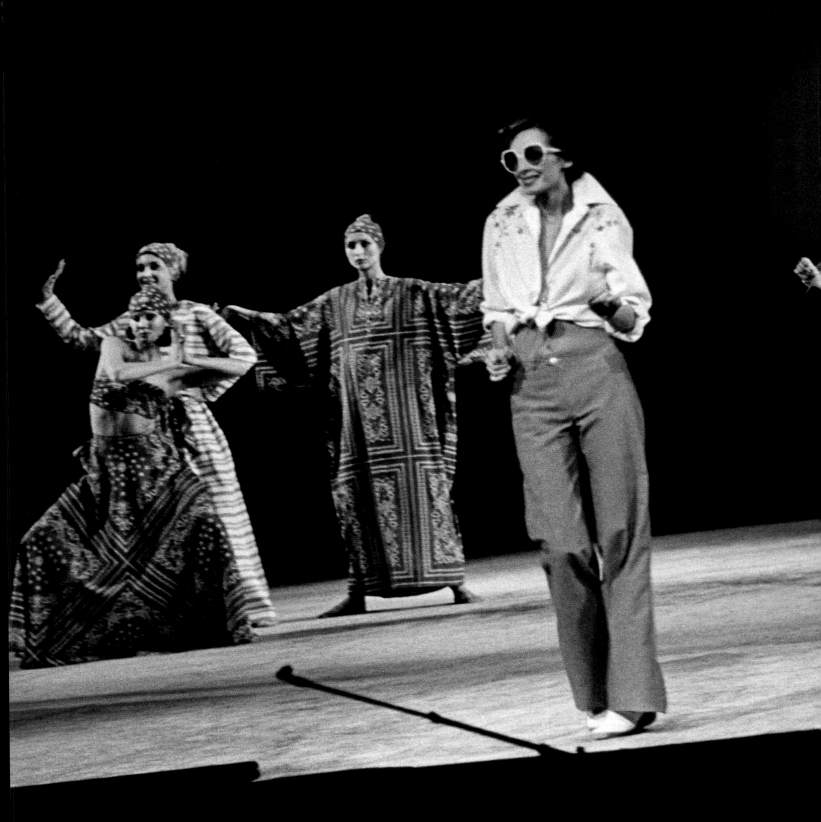

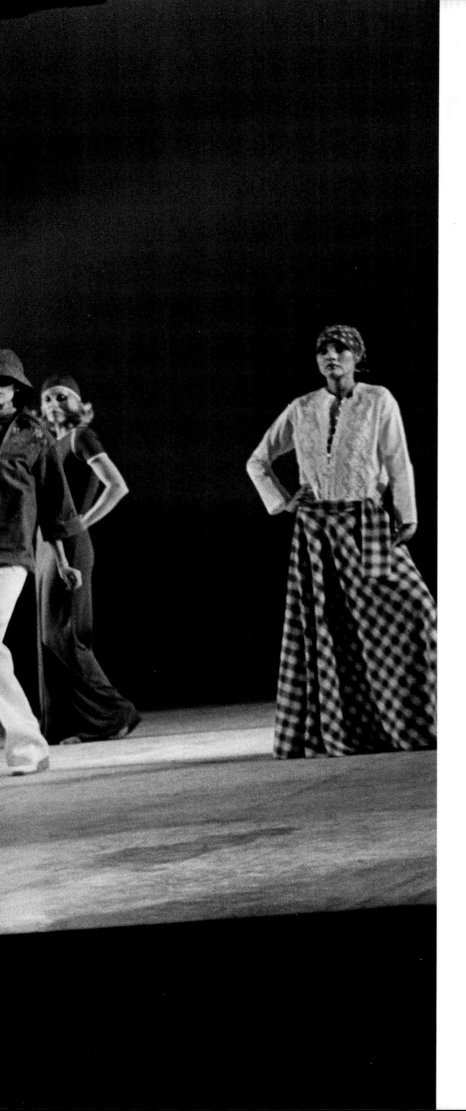

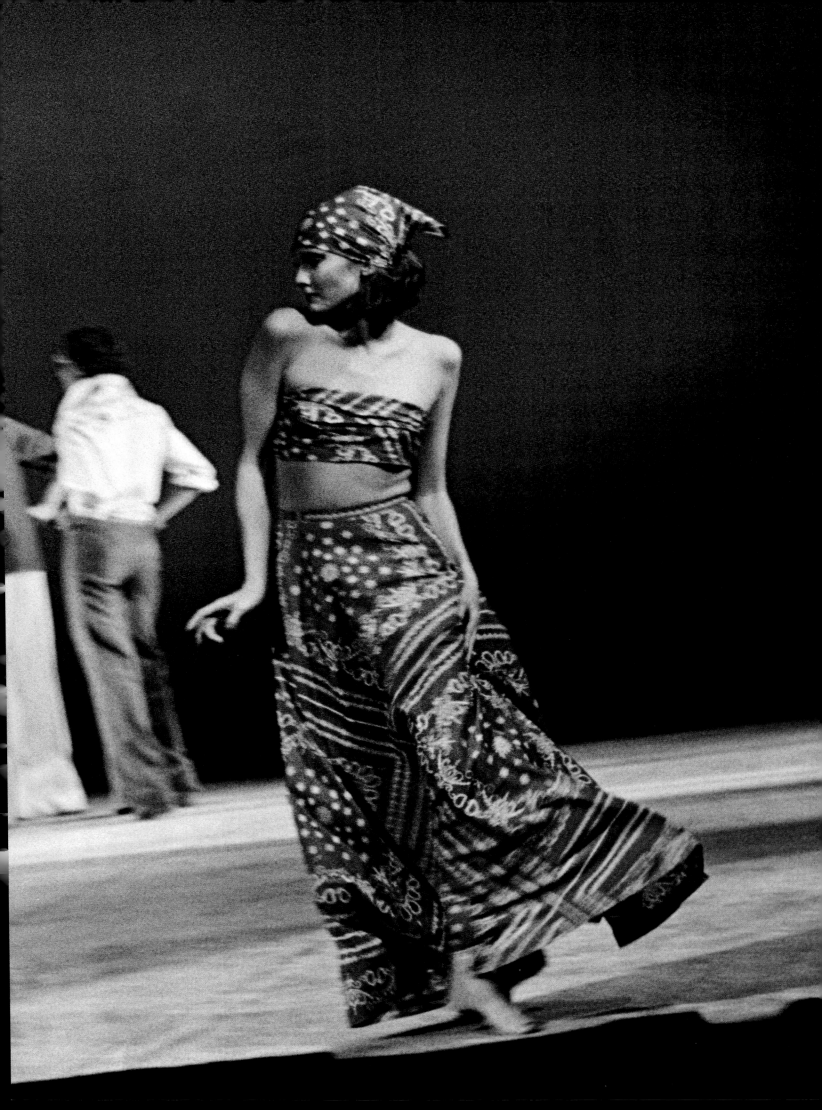

Opposite: Shirley Farro leads the Halston models.

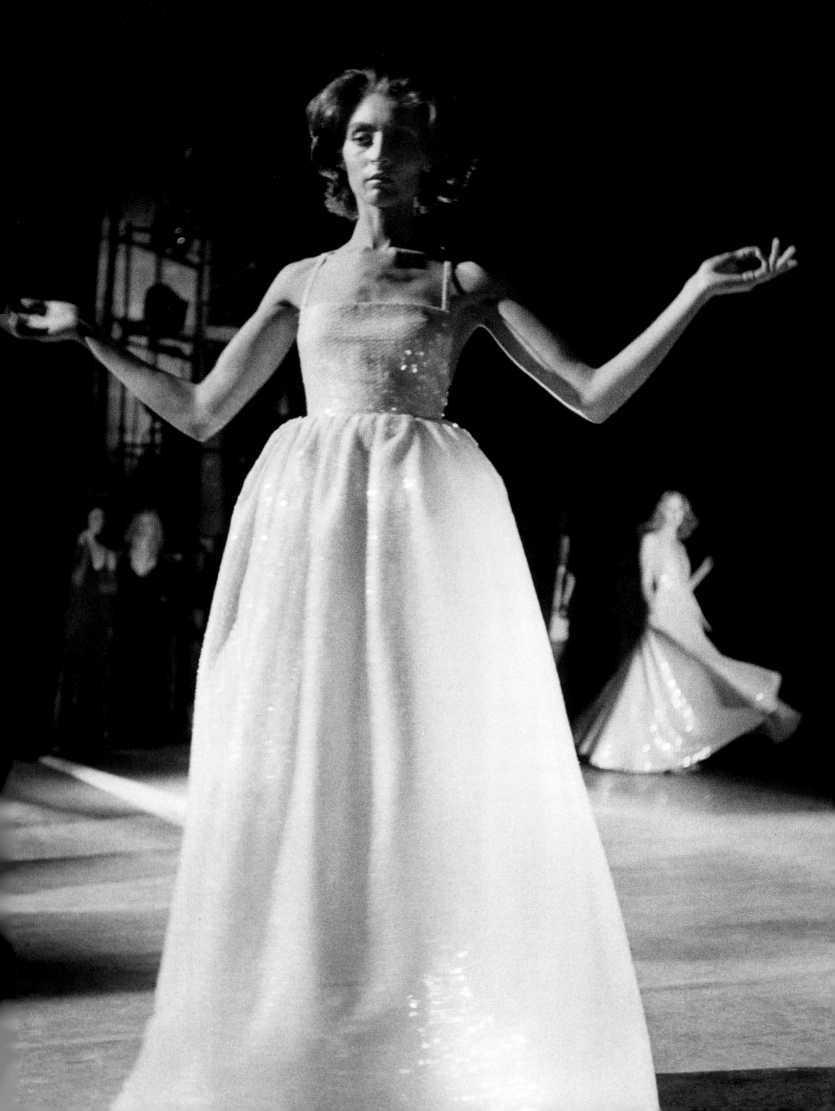

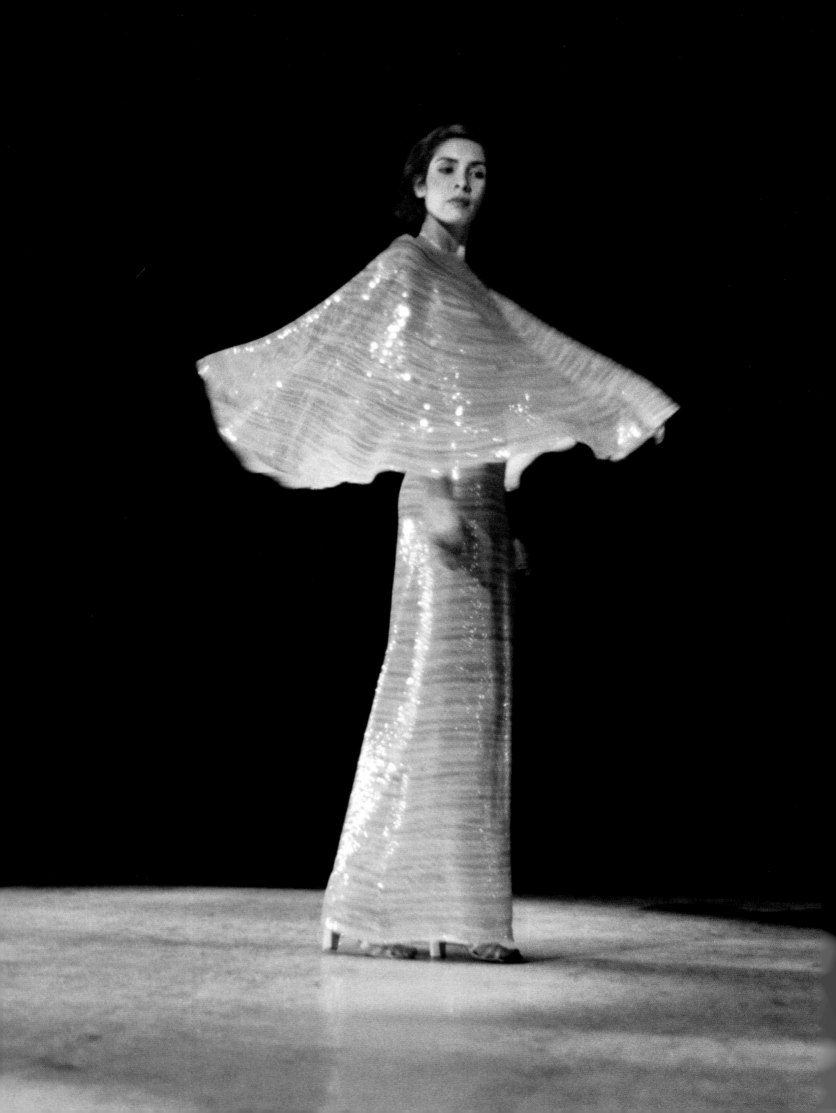

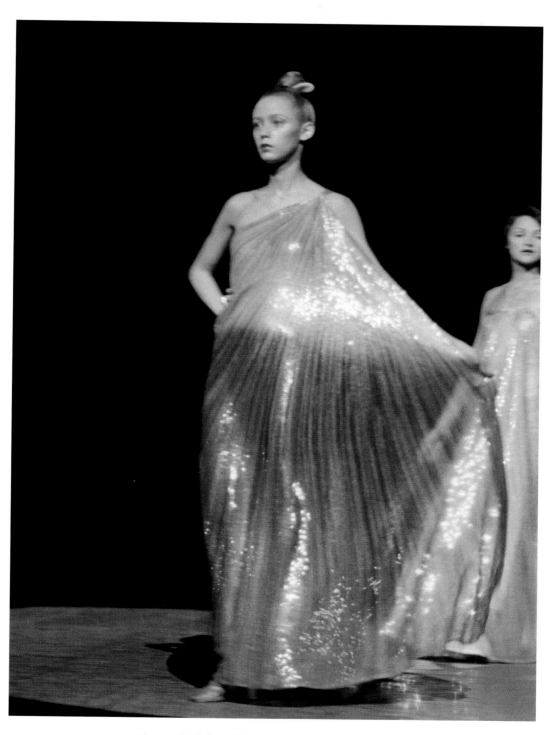

Above: Heidi Goldman shines in the finale of Halston's segment.

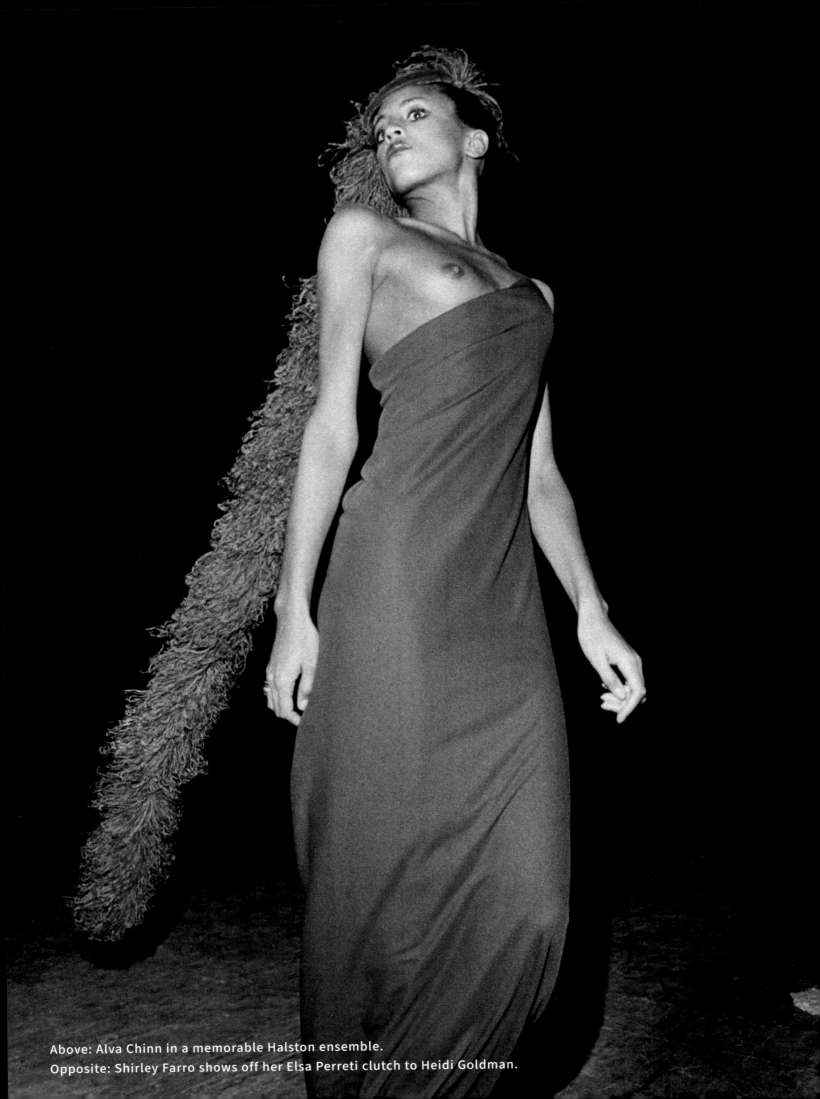

Above: Alva Chinn in a memorable Halston ensemble.
Opposite: Shirley Farro shows off her Elsa Perreti clutch to Heidi Goldman.

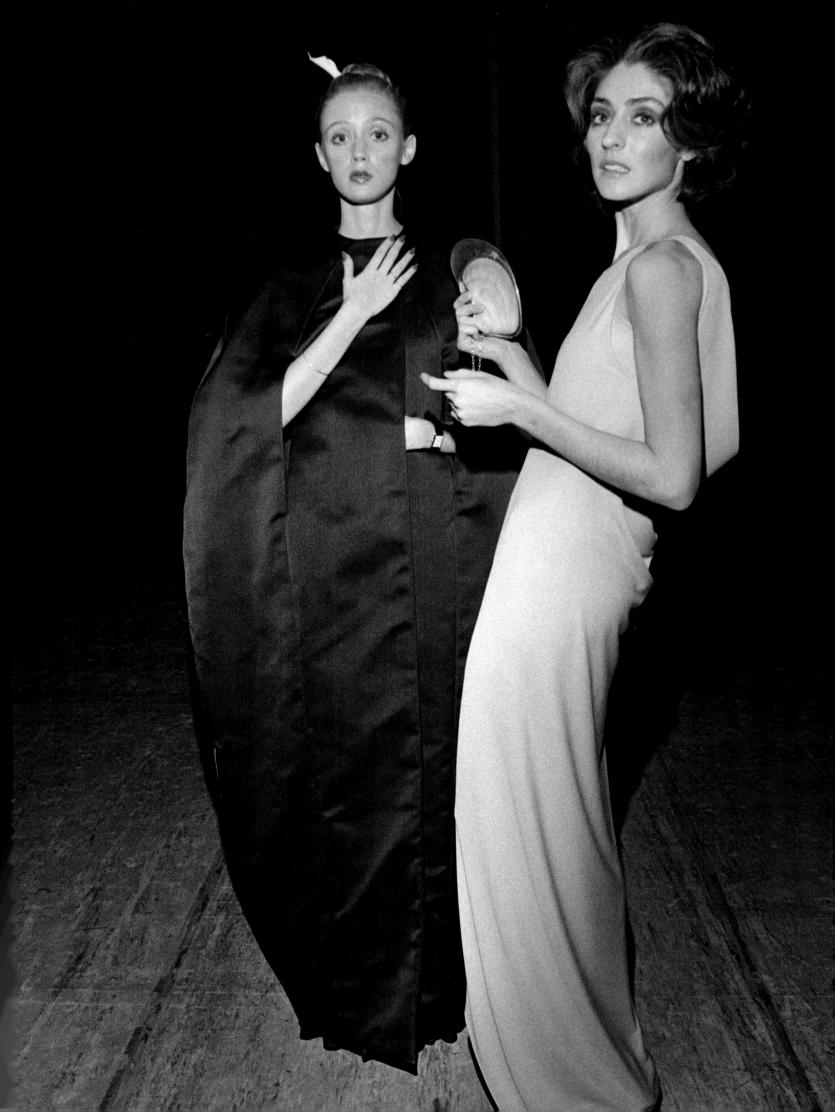

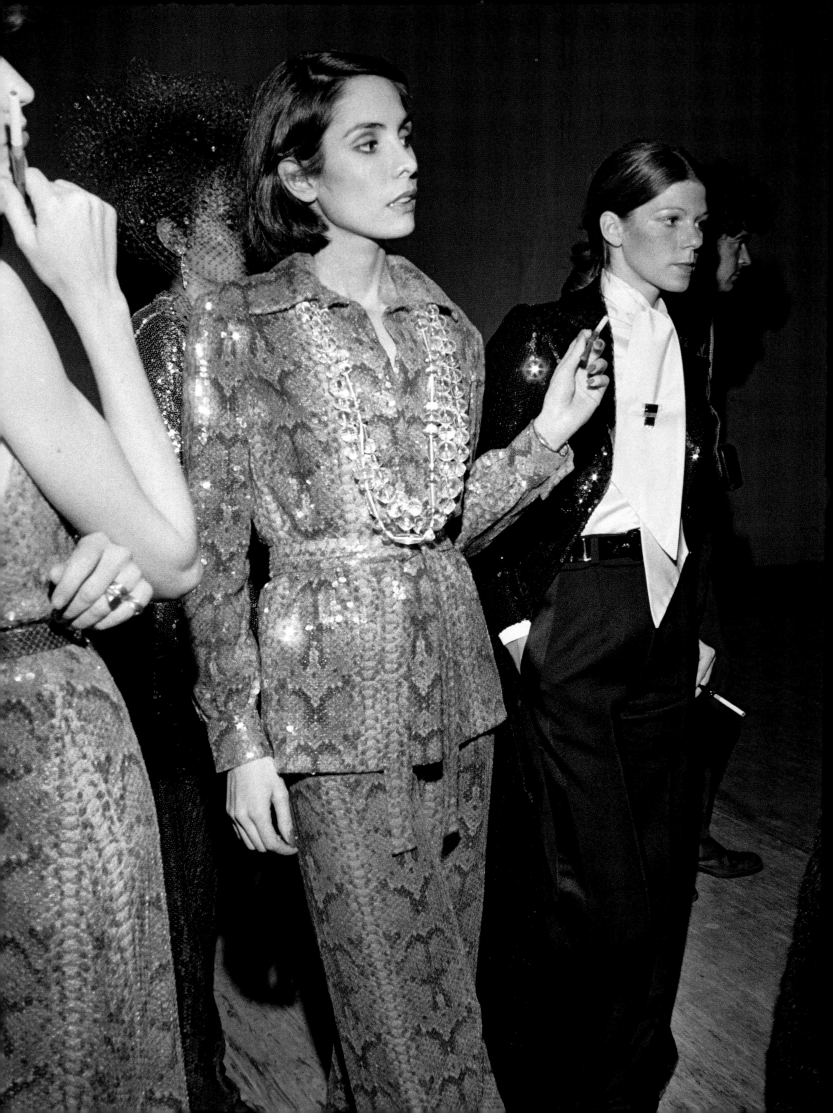

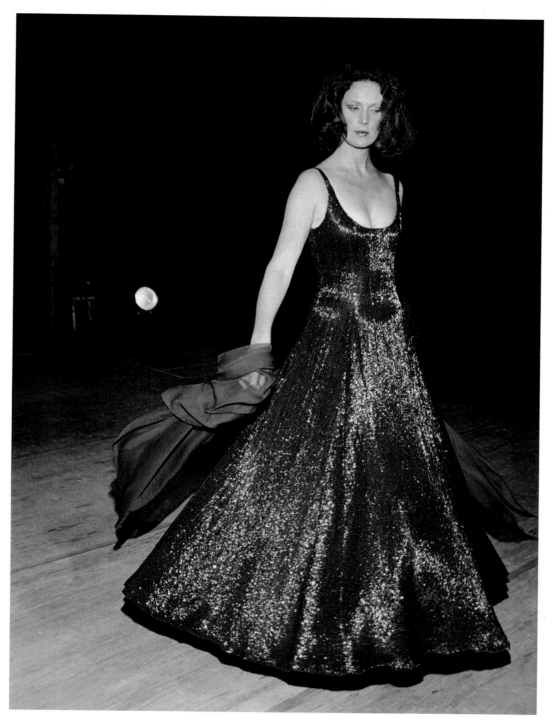

Above: Betsy Theodoracopulos in Halston.
Opposite: Models and dancers for the American presentation finale.

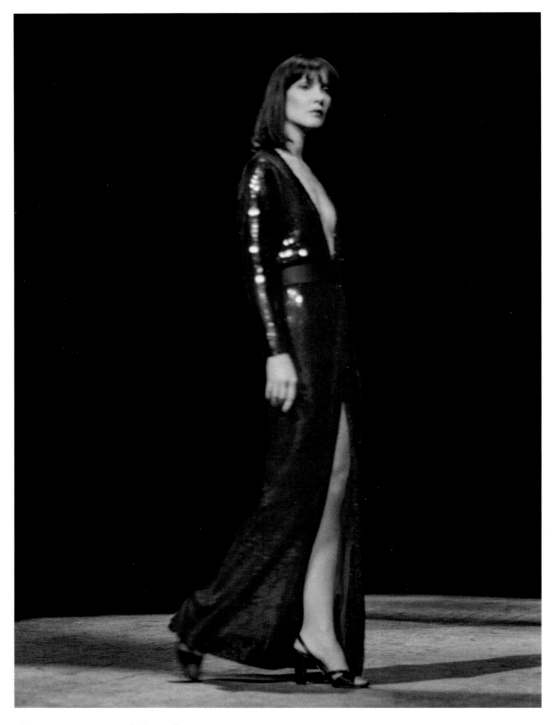

Above: Nancy North in Halston.
Opposite: Tasha Bauer in Halston.

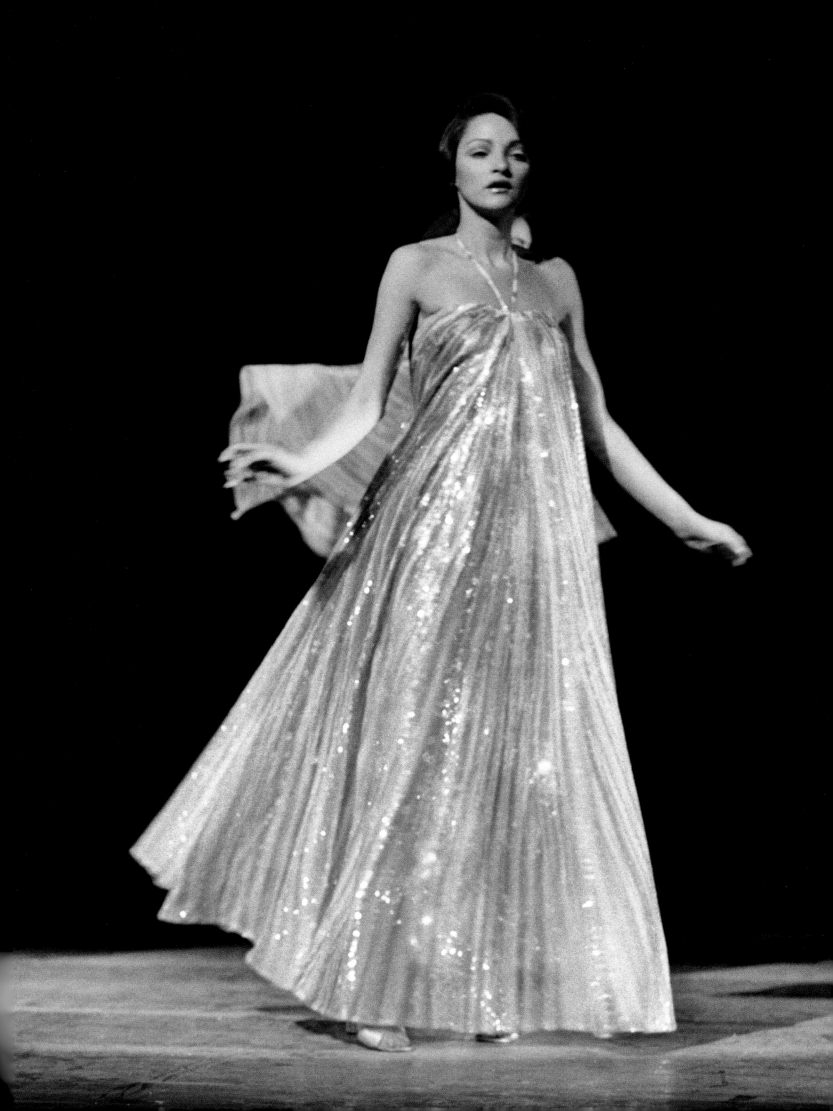

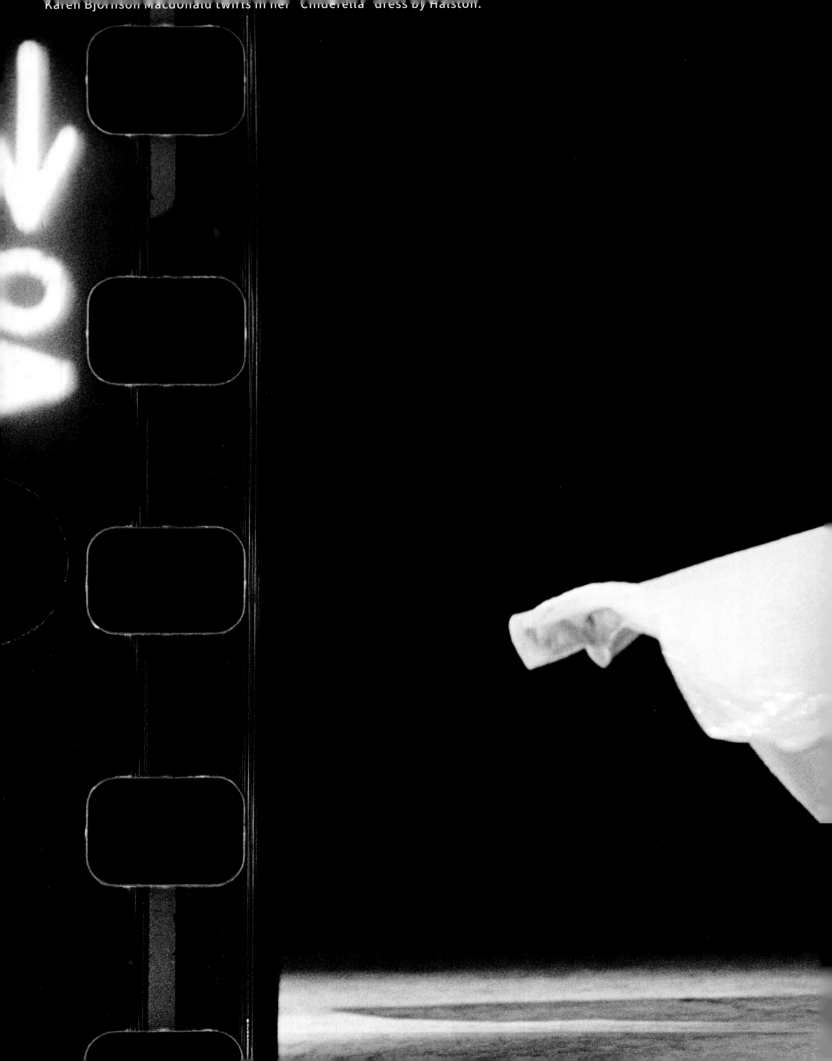

Karen Bjornson Macdonald twirls in her "Cinderella" dress by Halston.

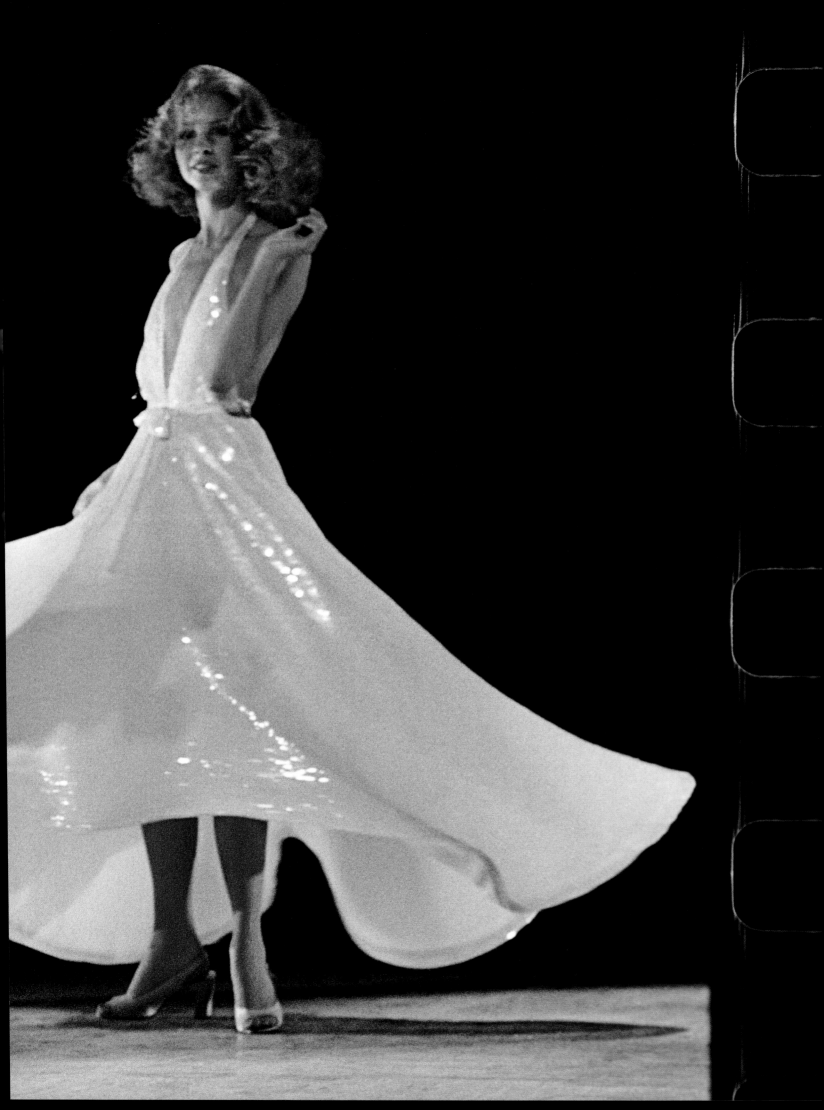

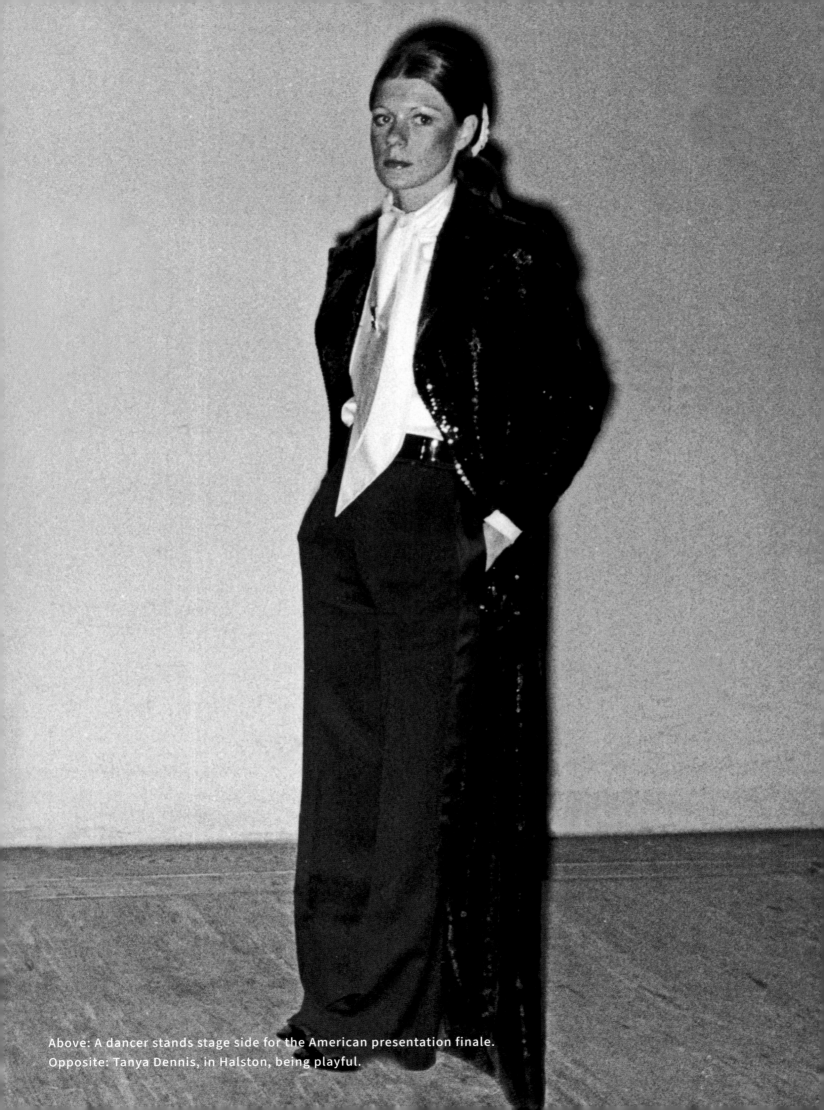

Above: A dancer stands stage side for the American presentation finale.
Opposite: Tanya Dennis, in Halston, being playful.

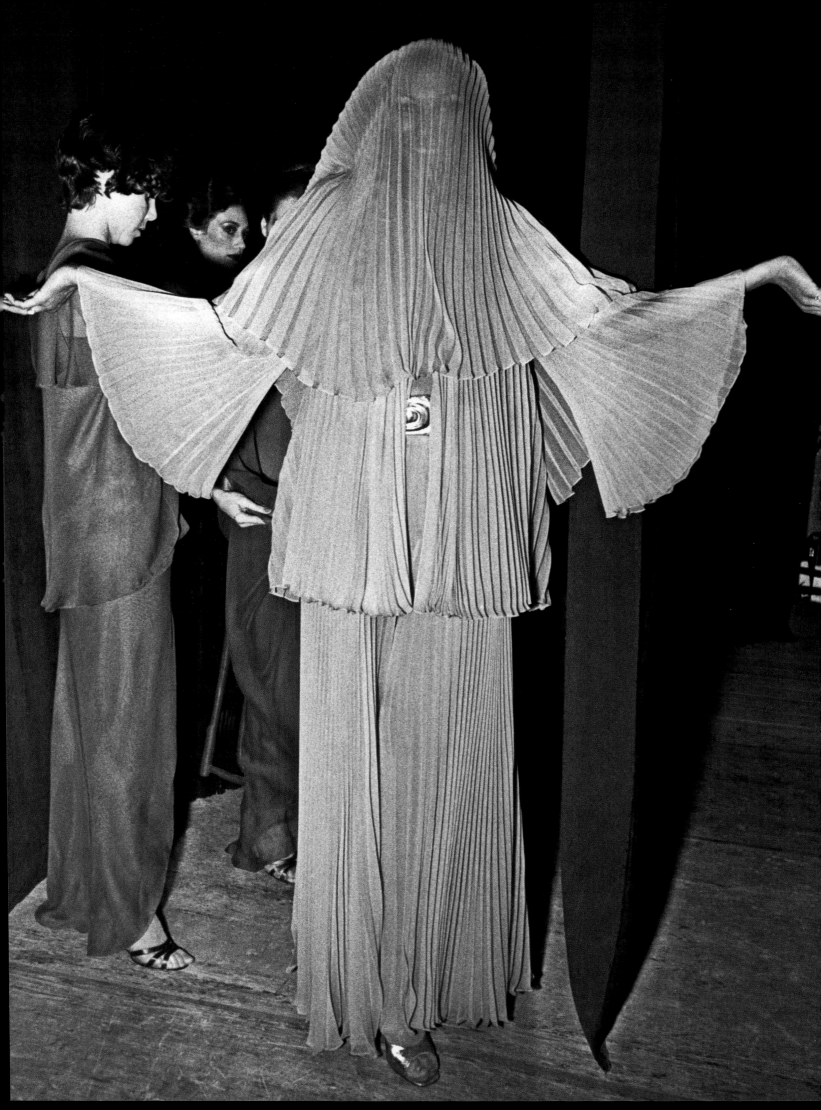

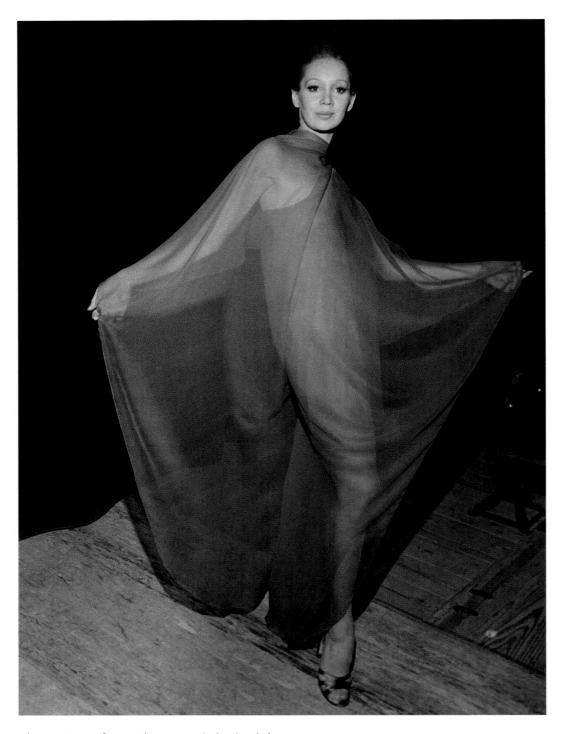

Above: One of Kay Thompson's invited dancers.
Opposite: Virginia Hubbard (left) strikes a memorable pose in the American finale.

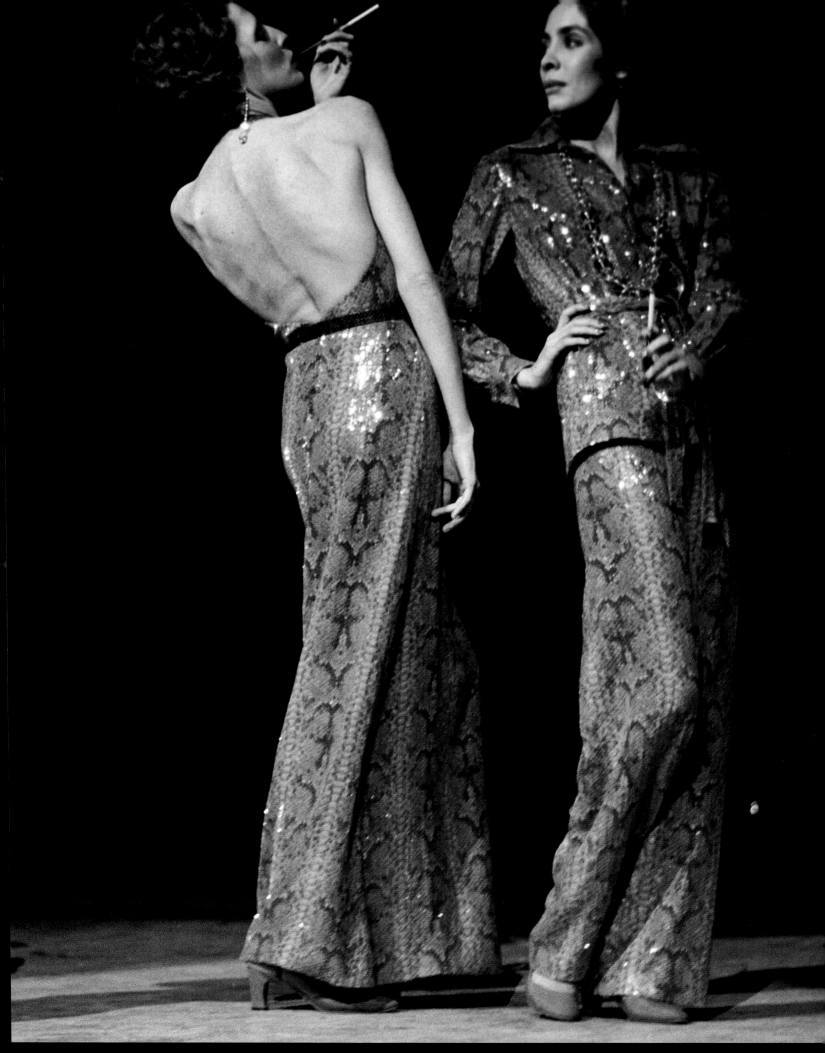

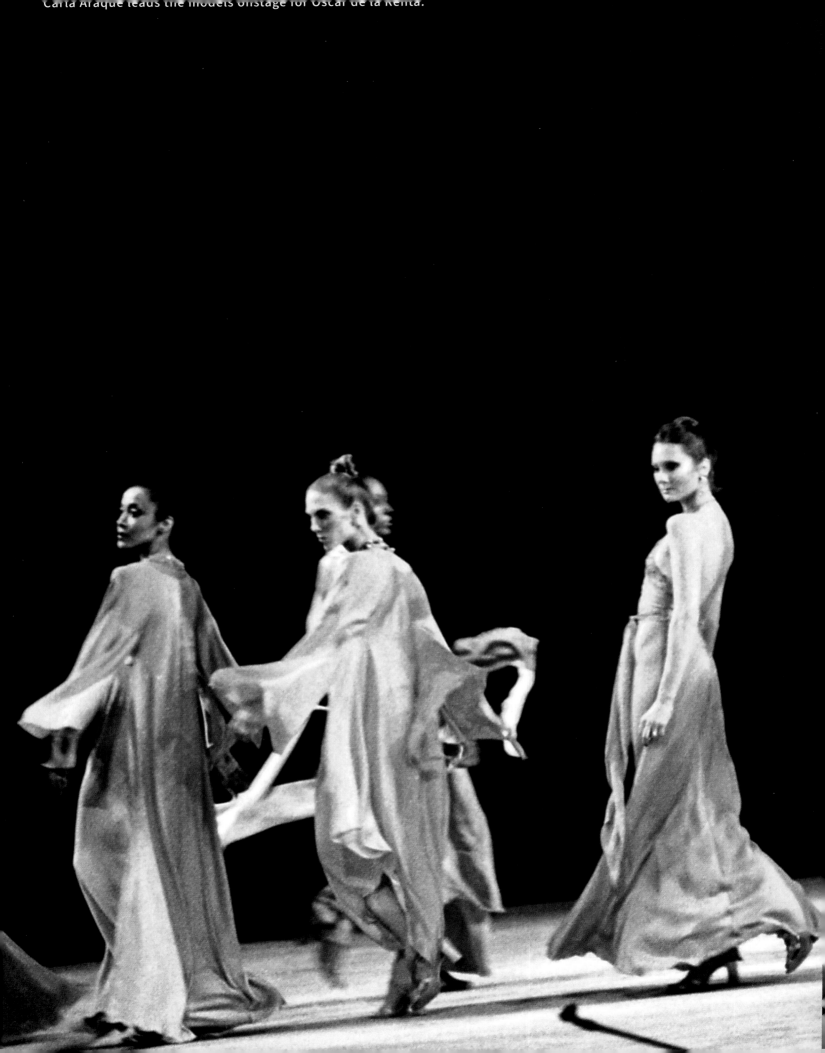

Carla Araque leads the models onstage for Oscar de la Renta.

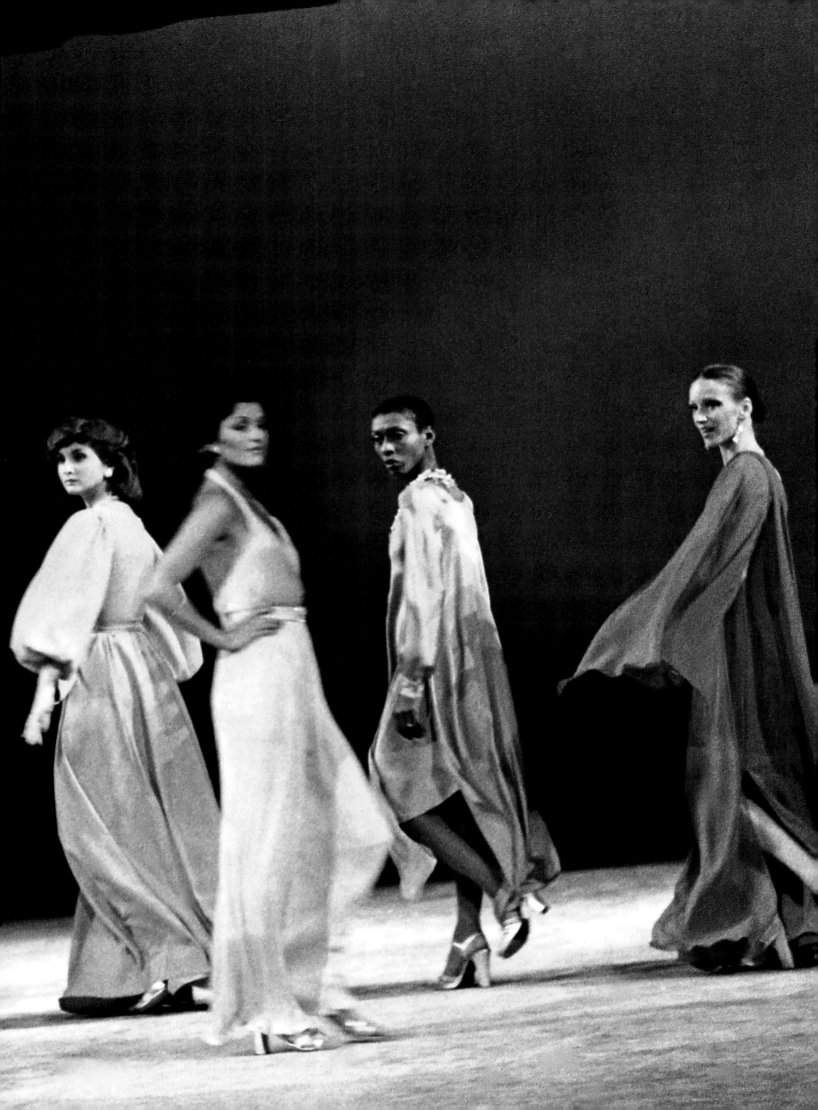

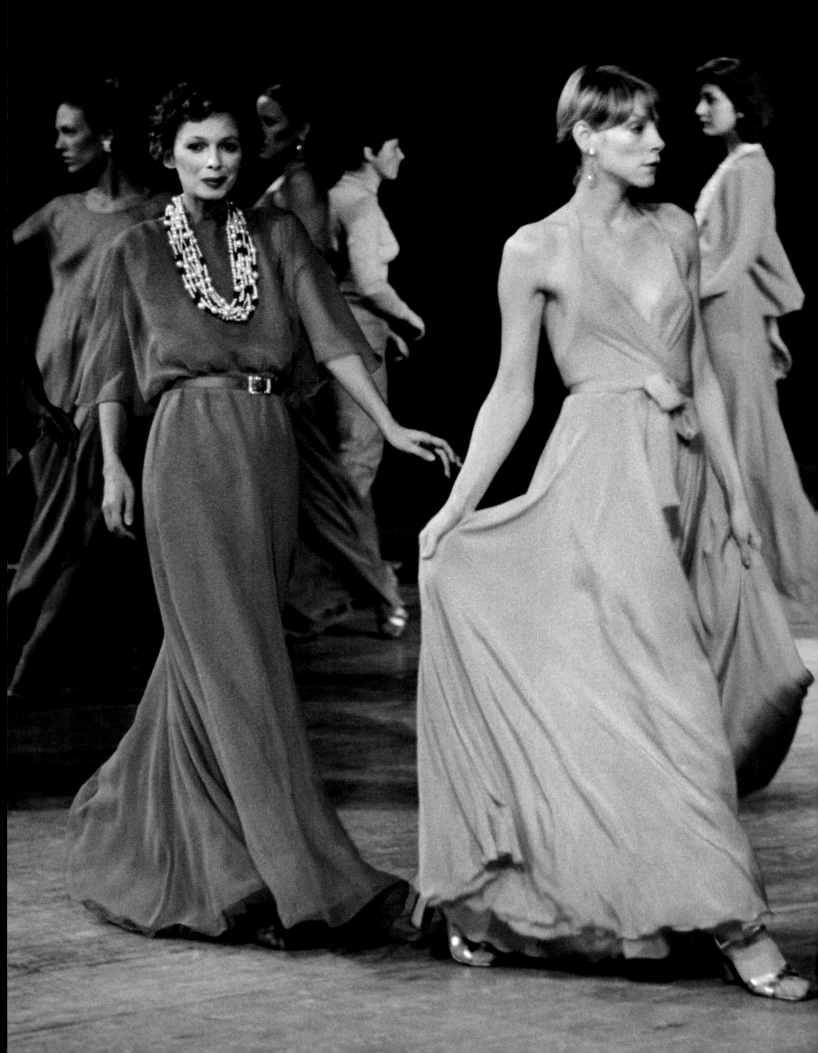

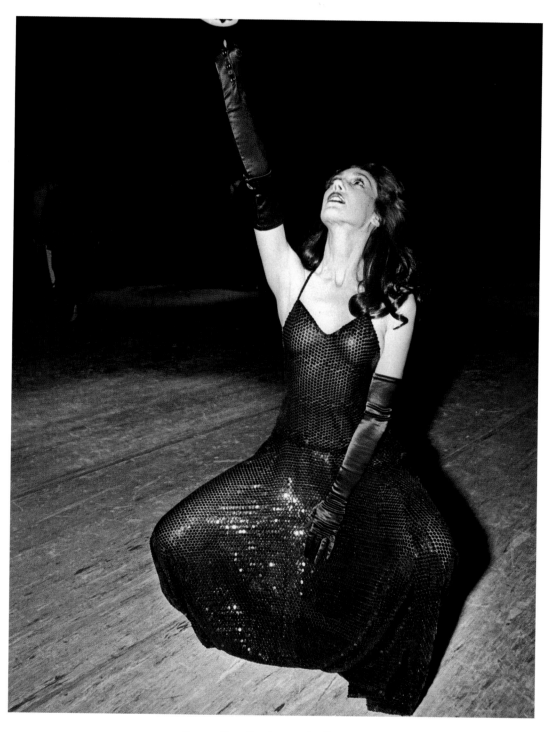

Opposite: Basha and Hilary Beanne in Oscar de la Renta.
Above: Marisa Berenson in Halston.

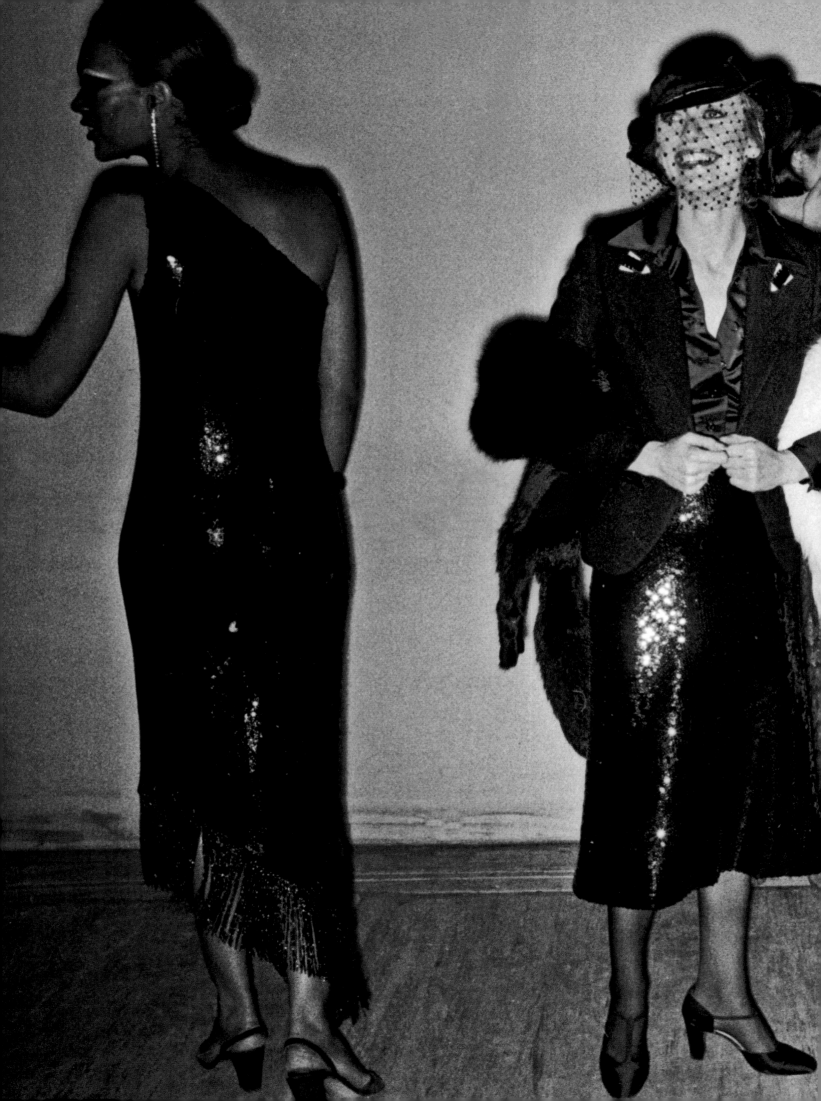

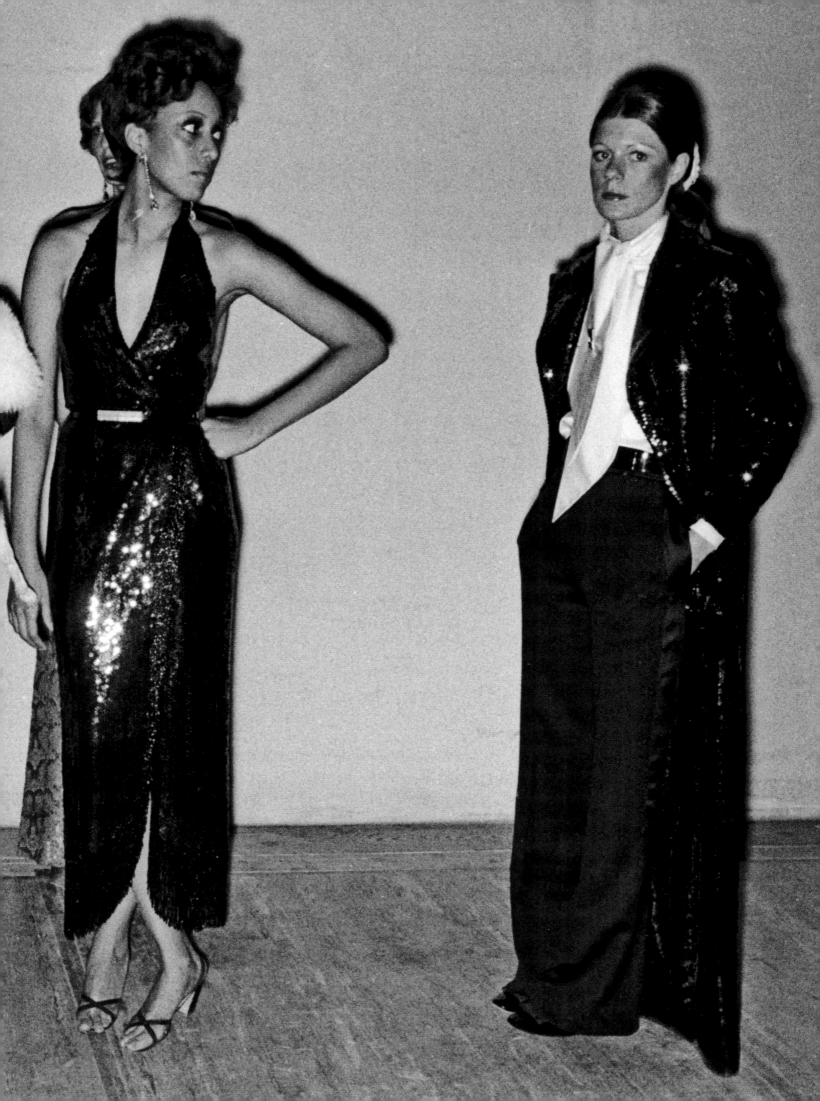

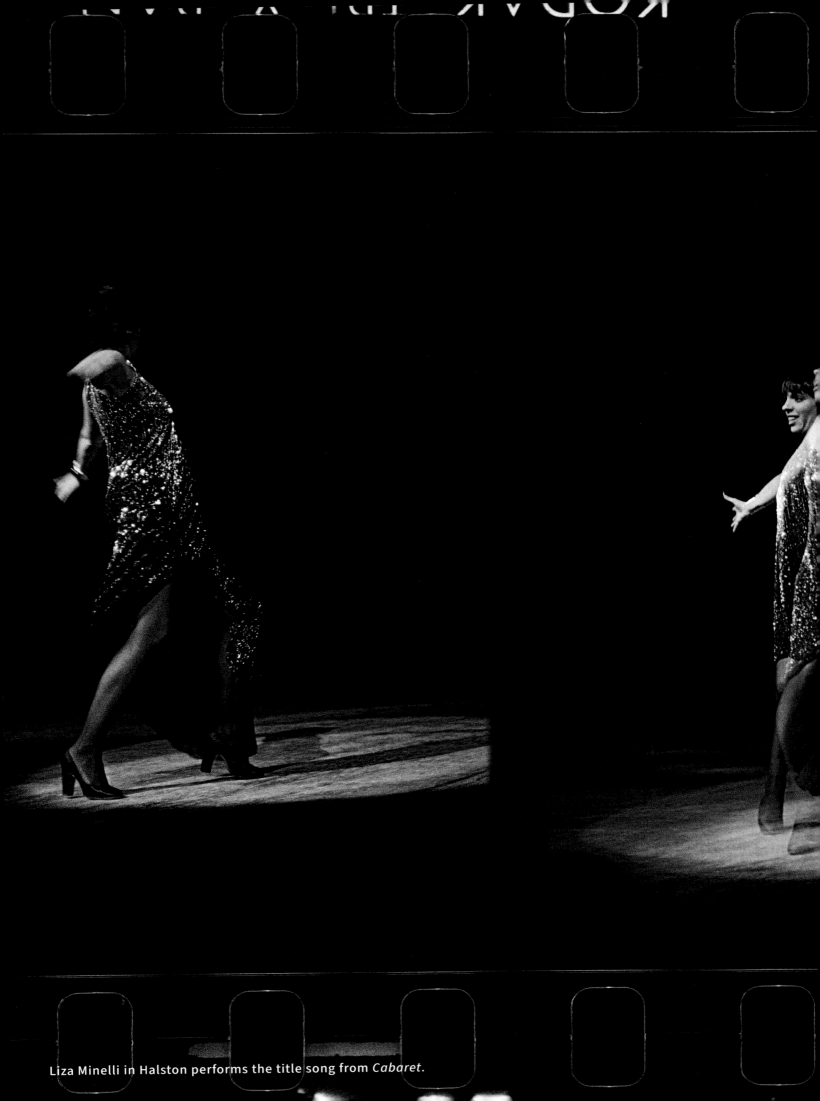

Liza Minelli in Halston performs the title song from *Cabaret*.

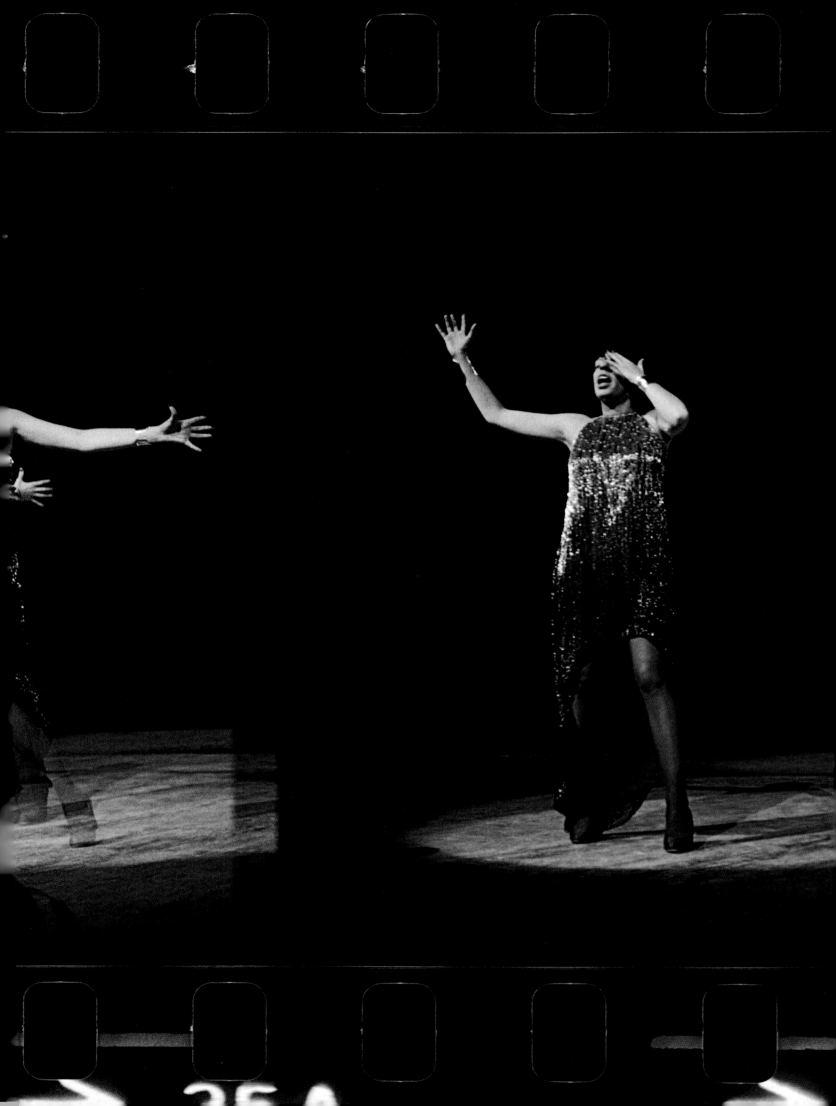

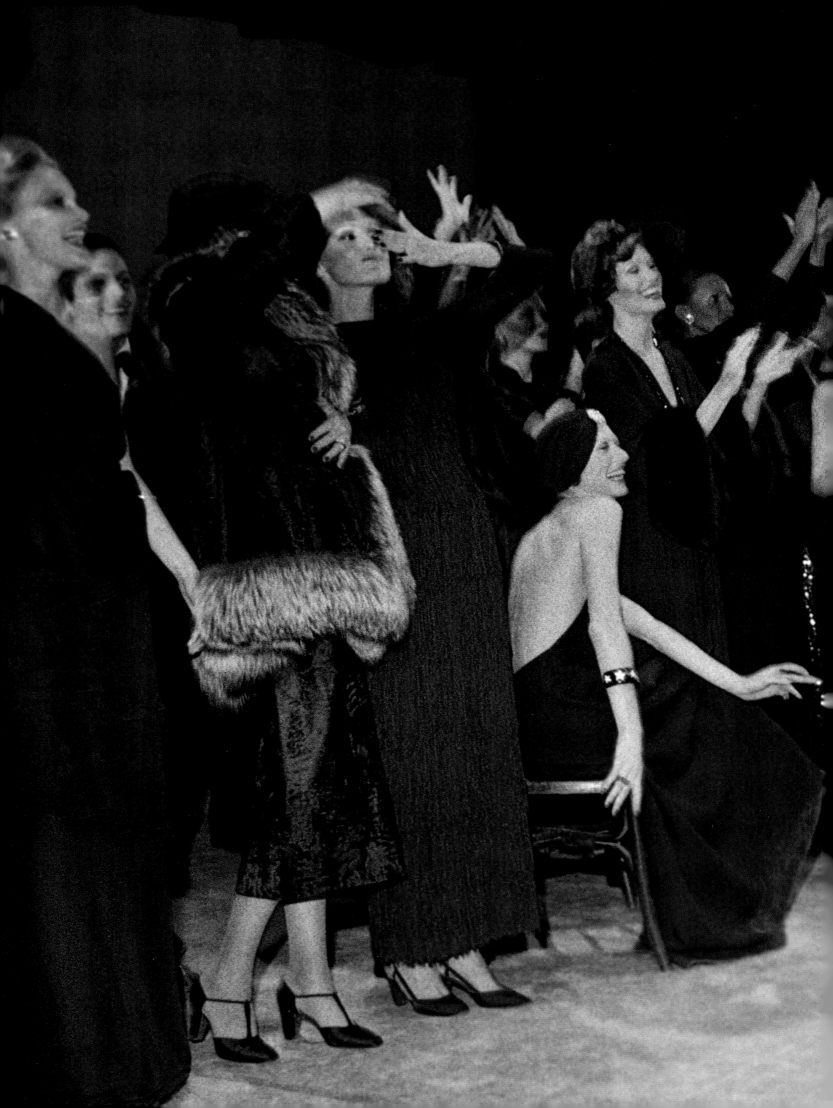

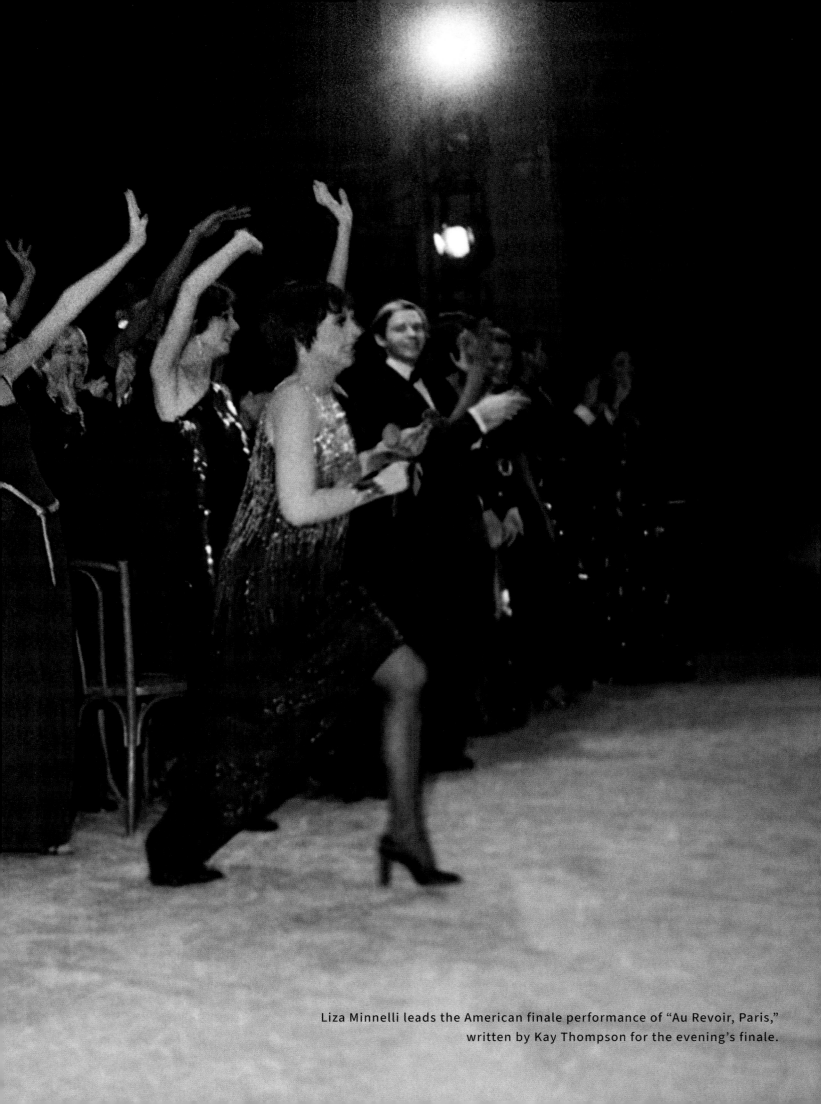

Liza Minnelli leads the American finale performance of "Au Revoir, Paris,"
written by Kay Thompson for the evening's finale.

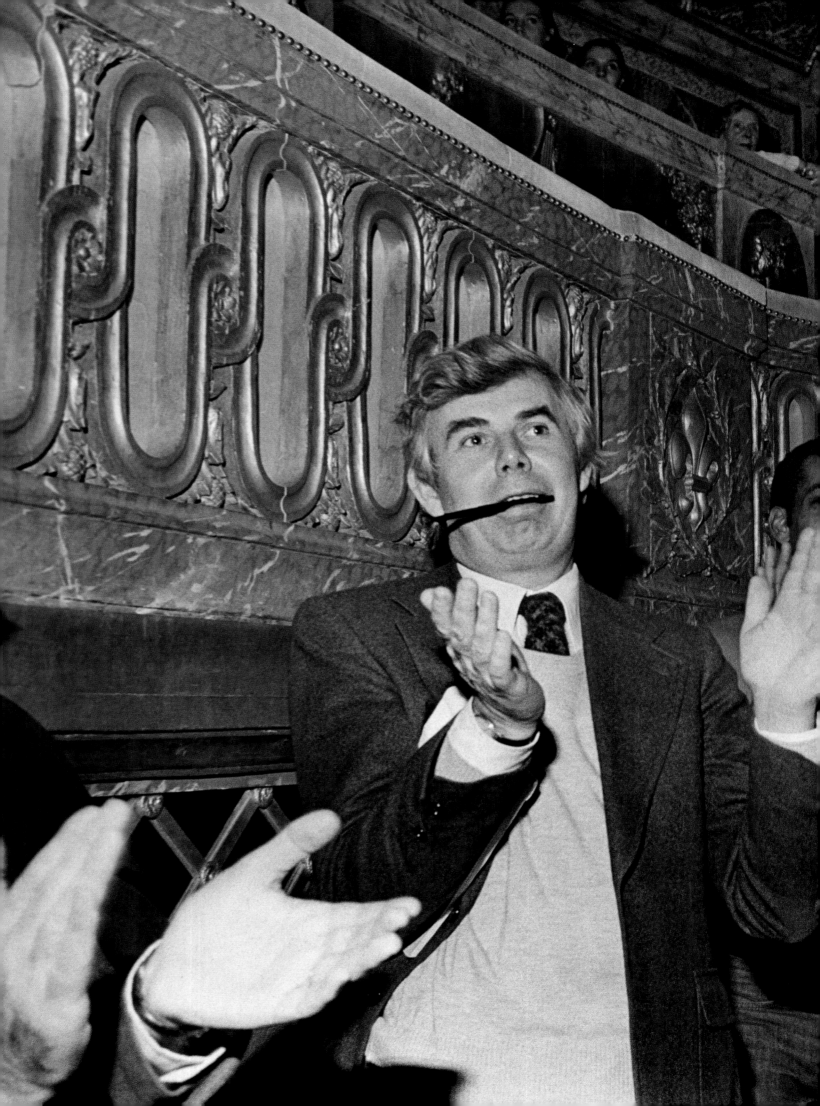

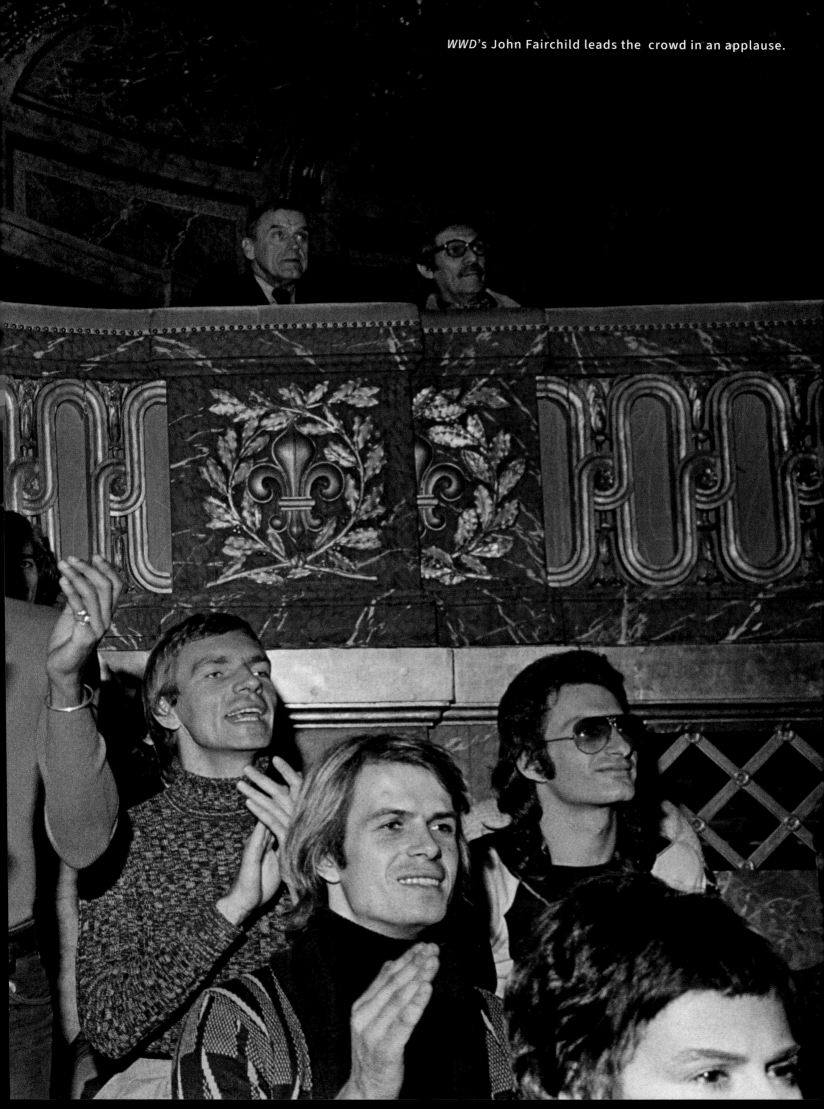

WWD's John Fairchild leads the crowd in an applause.

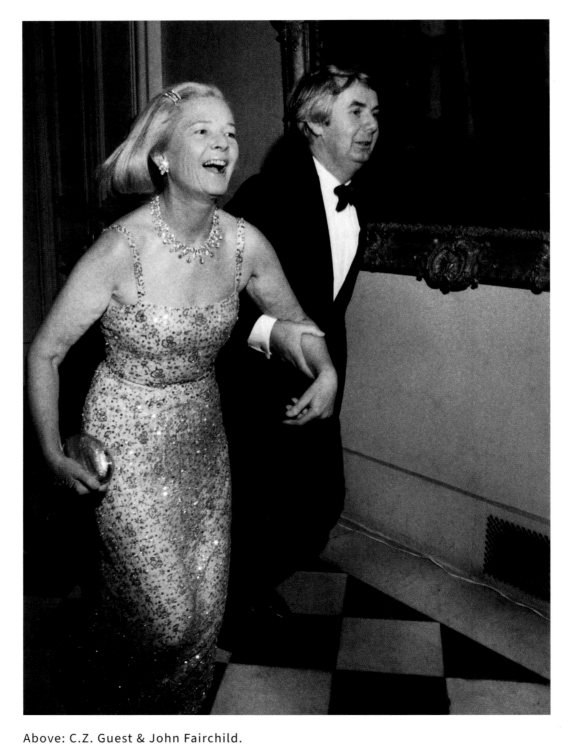

Above: C.Z. Guest & John Fairchild.
Opposite: American models celebrating backstage with Liza Minnelli.

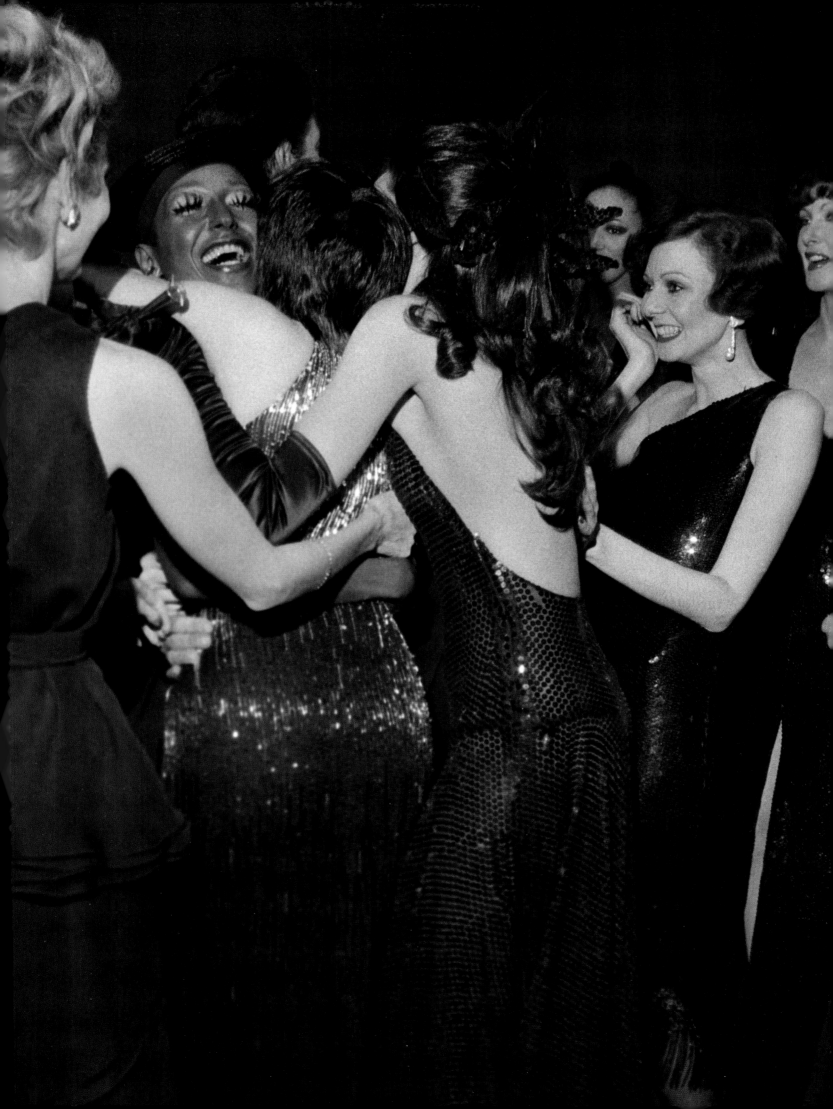

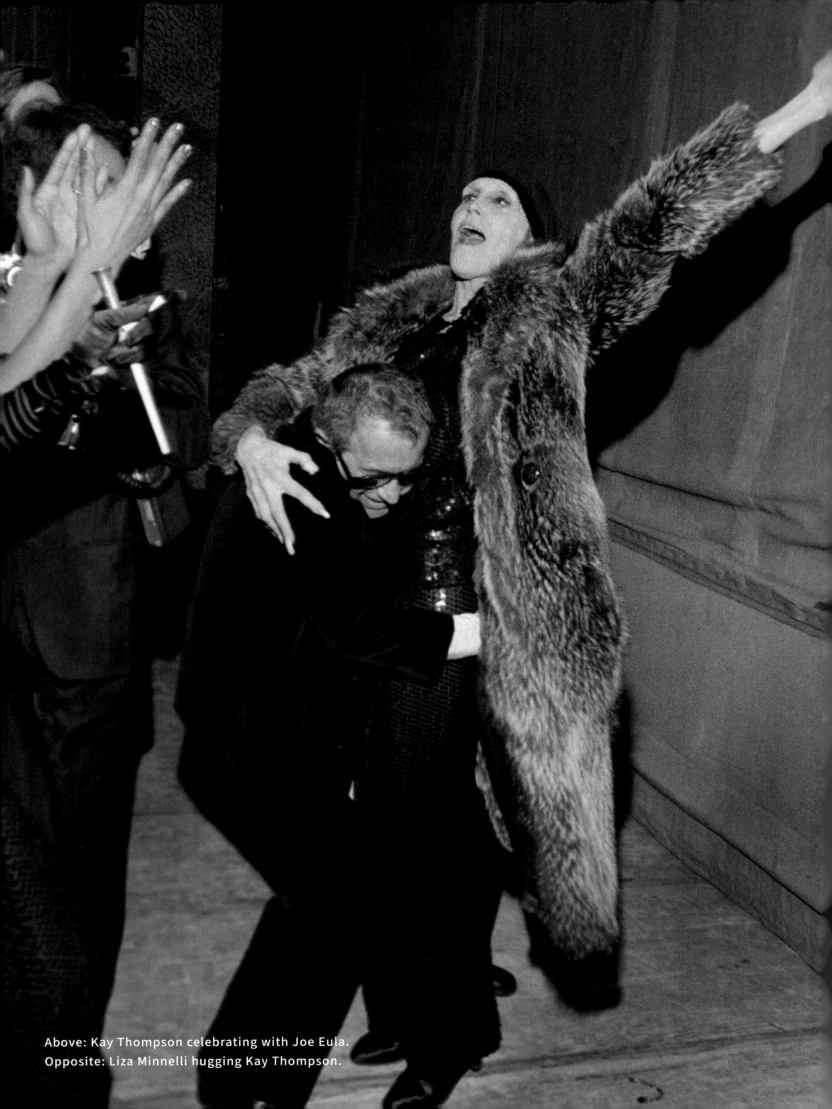

Above: Kay Thompson celebrating with Joe Eula.
Opposite: Liza Minnelli hugging Kay Thompson.

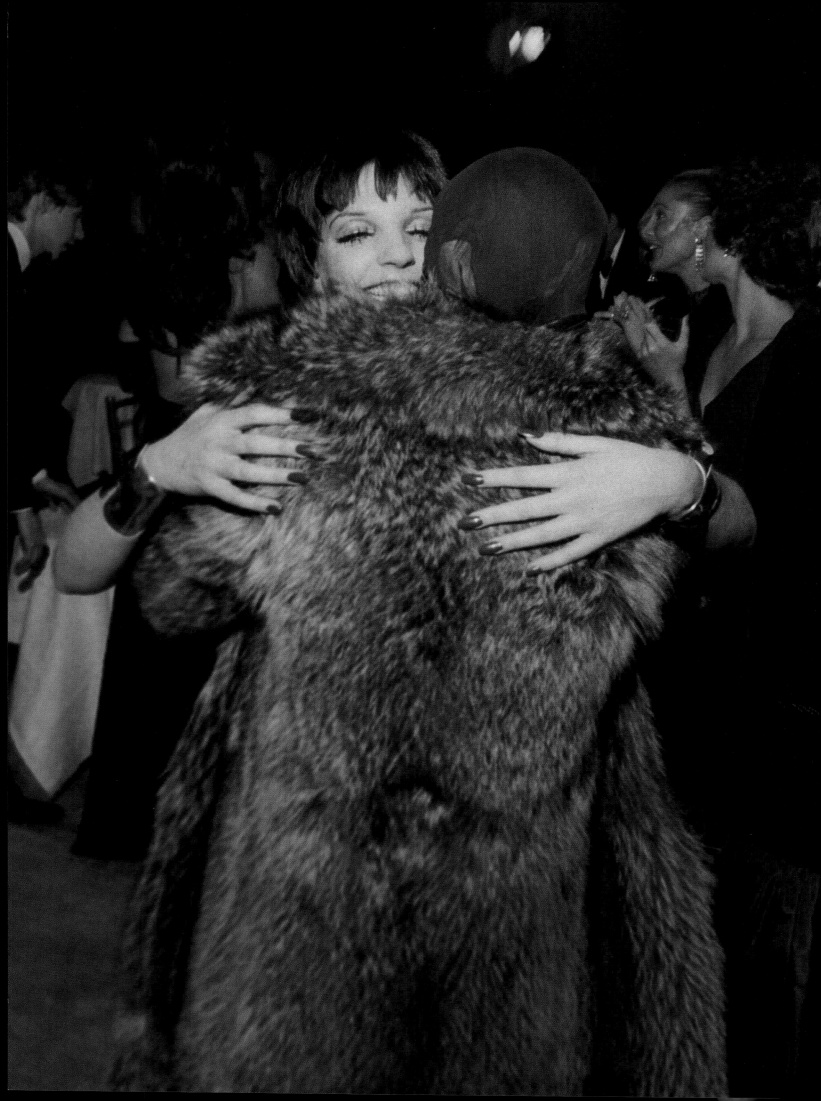

Gala

*"There were a lot of servants - young men dressed
in white tights and white powered wigs
and white gloves, with satin vest jackets,
all in the style of the 1700's.
Everybody was moving around like
they were on a playground.
The kids were wild in there.
The couldn't wait to see each other.
It was like one big, beaded pearl necklace
— everybody getting on the string together
and just being gorgeous."*

- Pat Cleveland

Opposite: Heidi Goldman dancing in the King's Apartment.

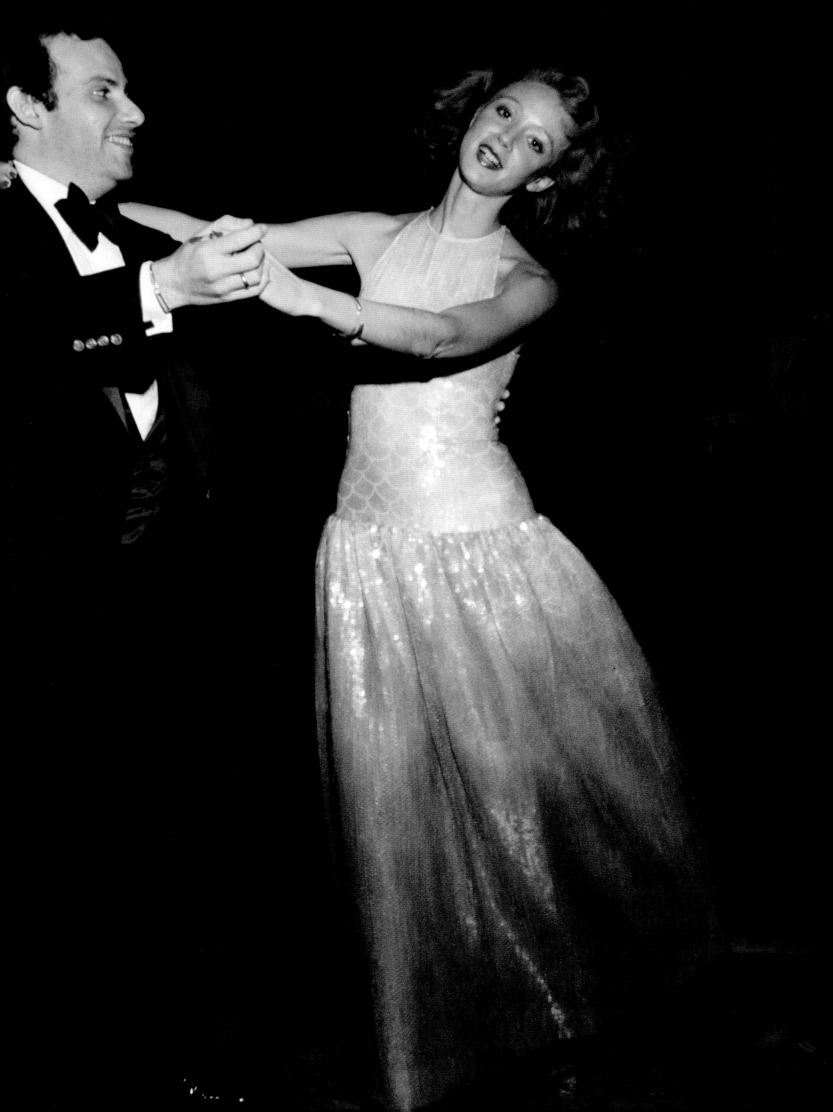

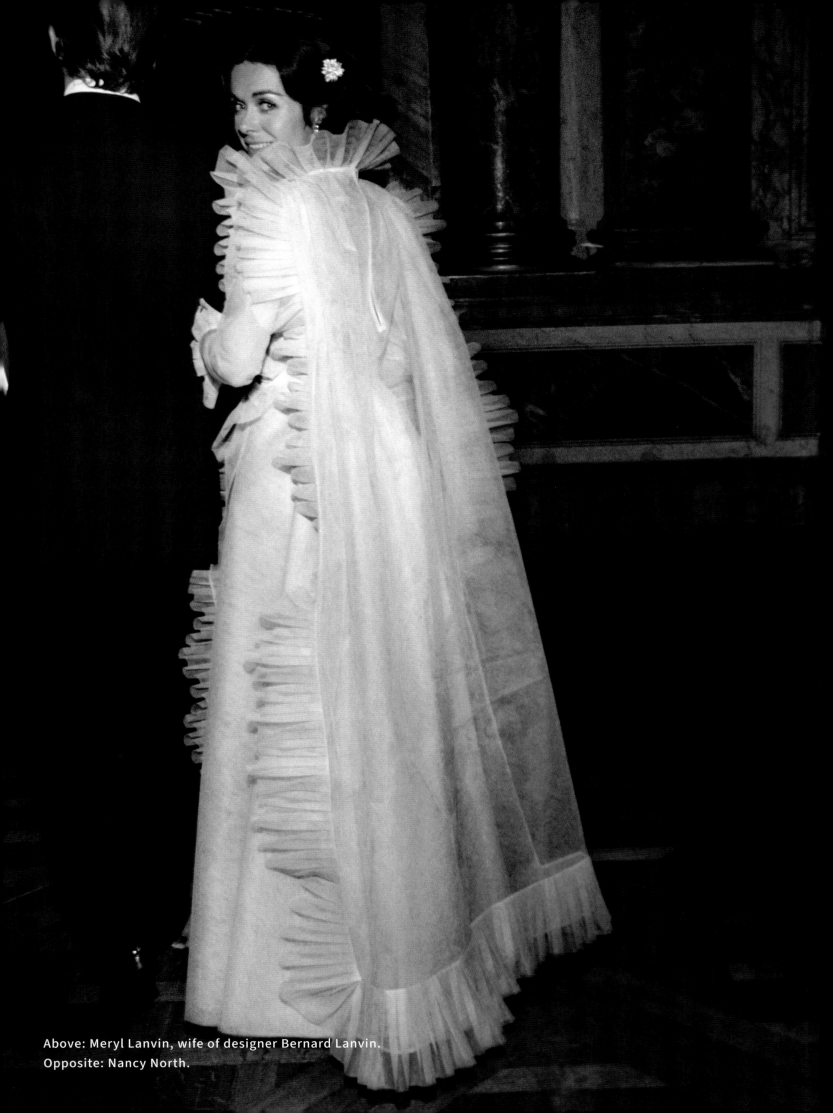

Above: Meryl Lanvin, wife of designer Bernard Lanvin.
Opposite: Nancy North.

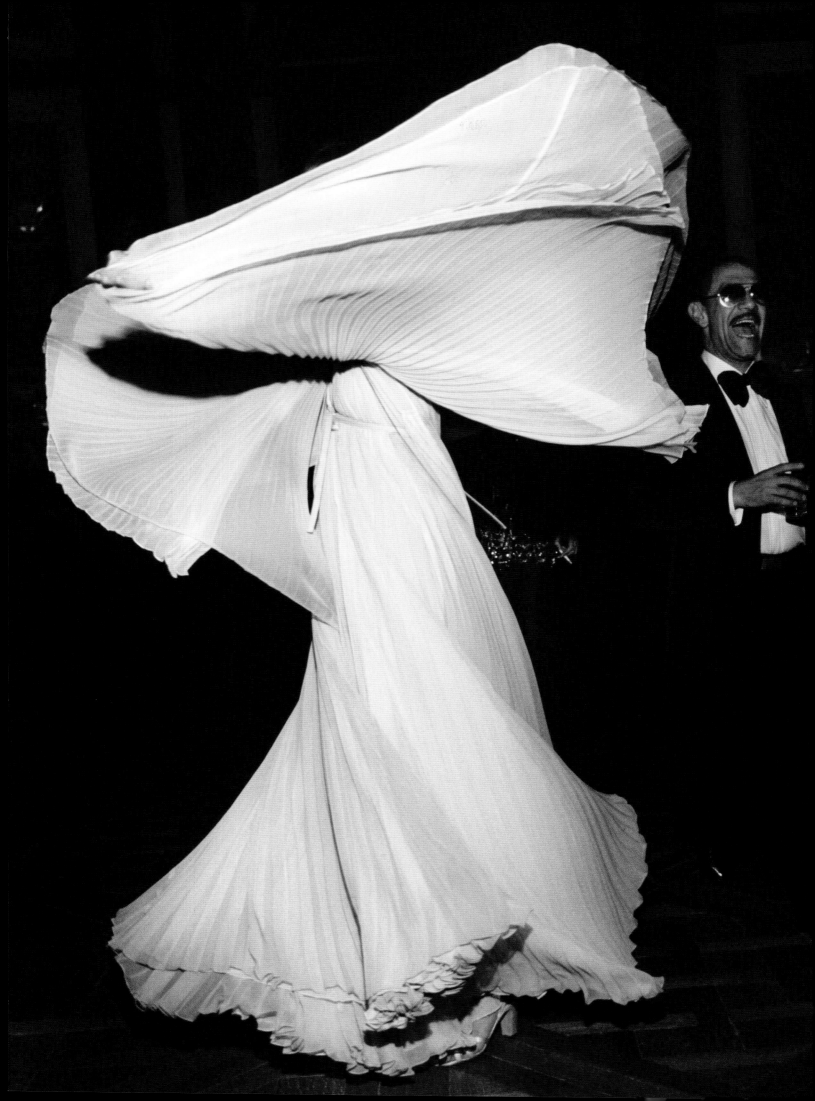

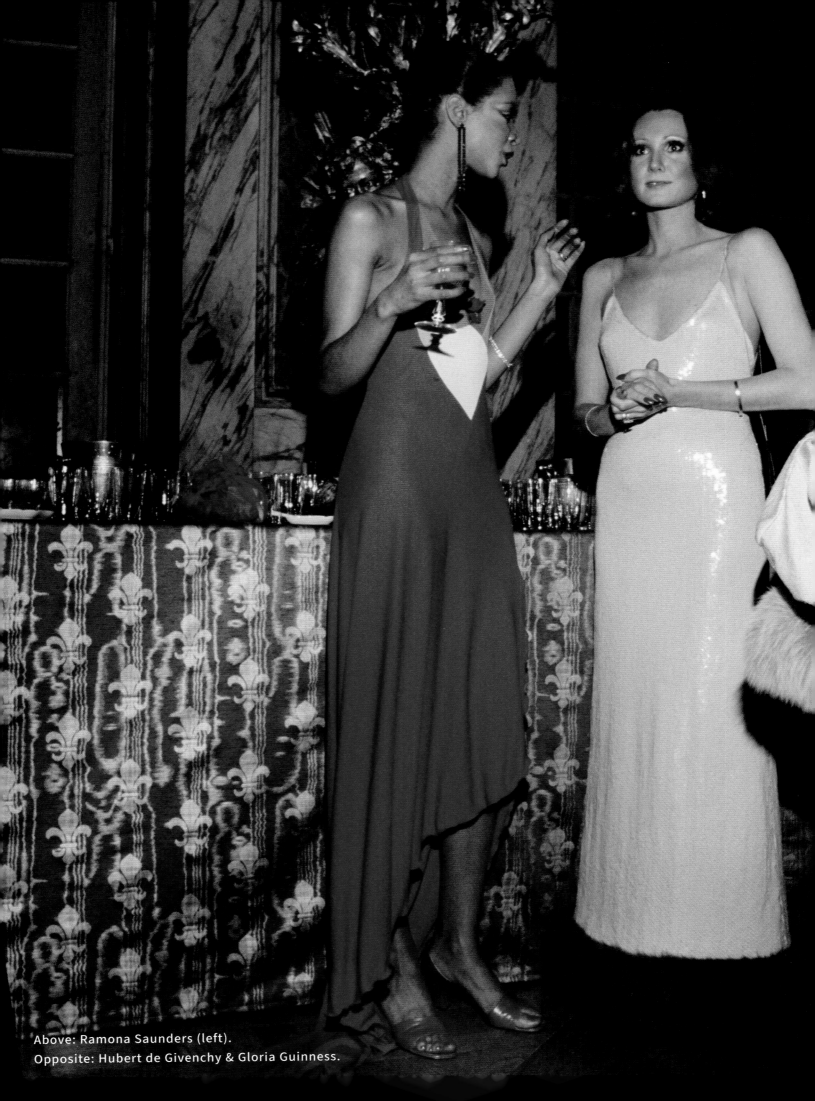

Above: Ramona Saunders (left).
Opposite: Hubert de Givenchy & Gloria Guinness.

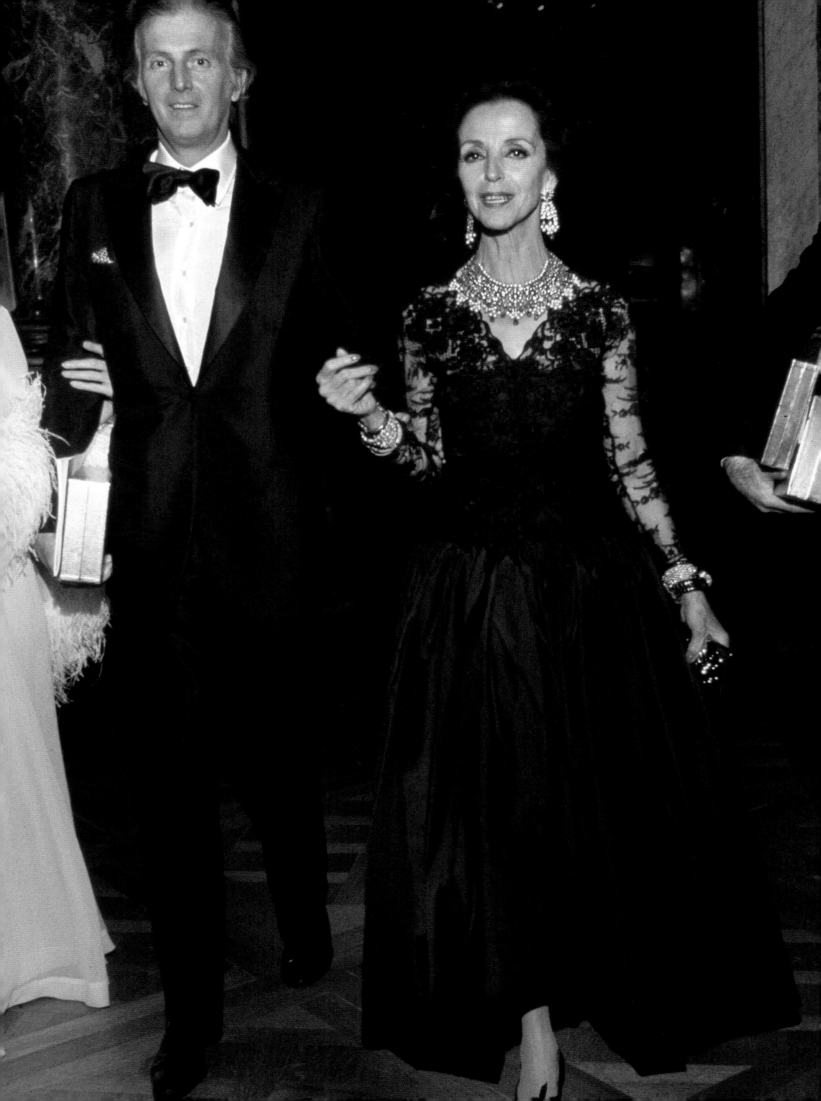

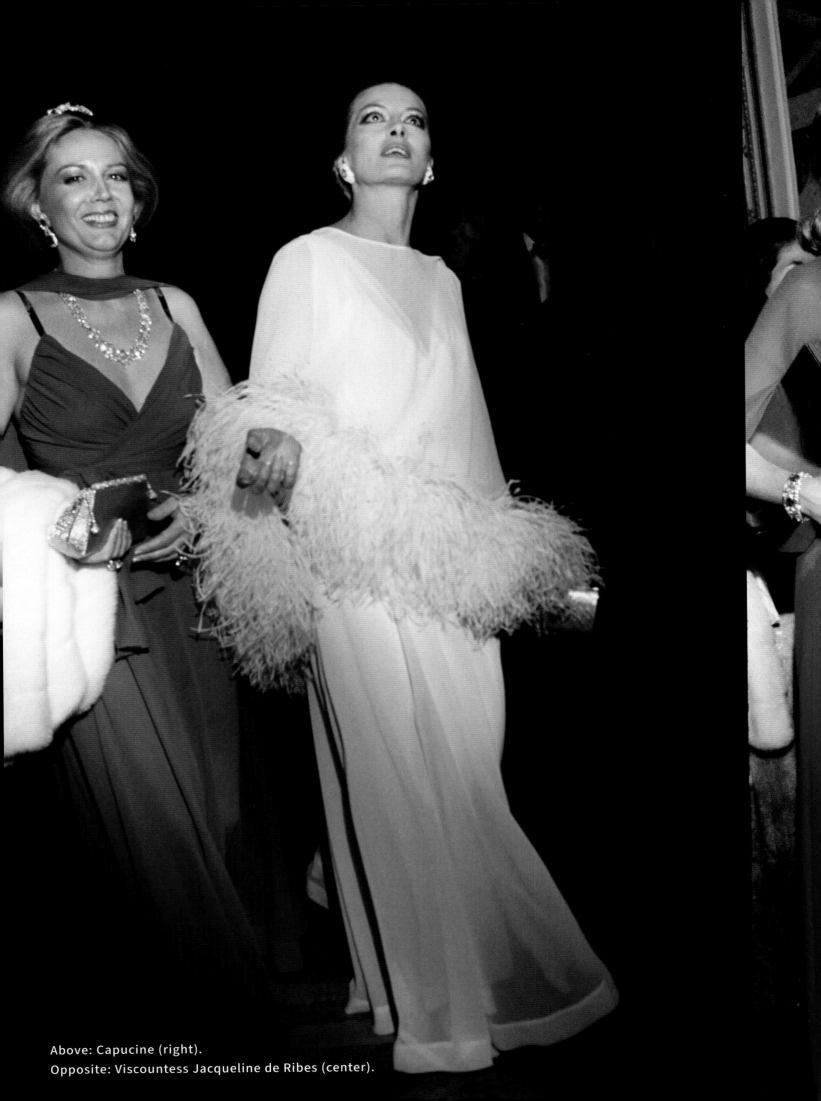

Above: Capucine (right).
Opposite: Viscountess Jacqueline de Ribes (center).

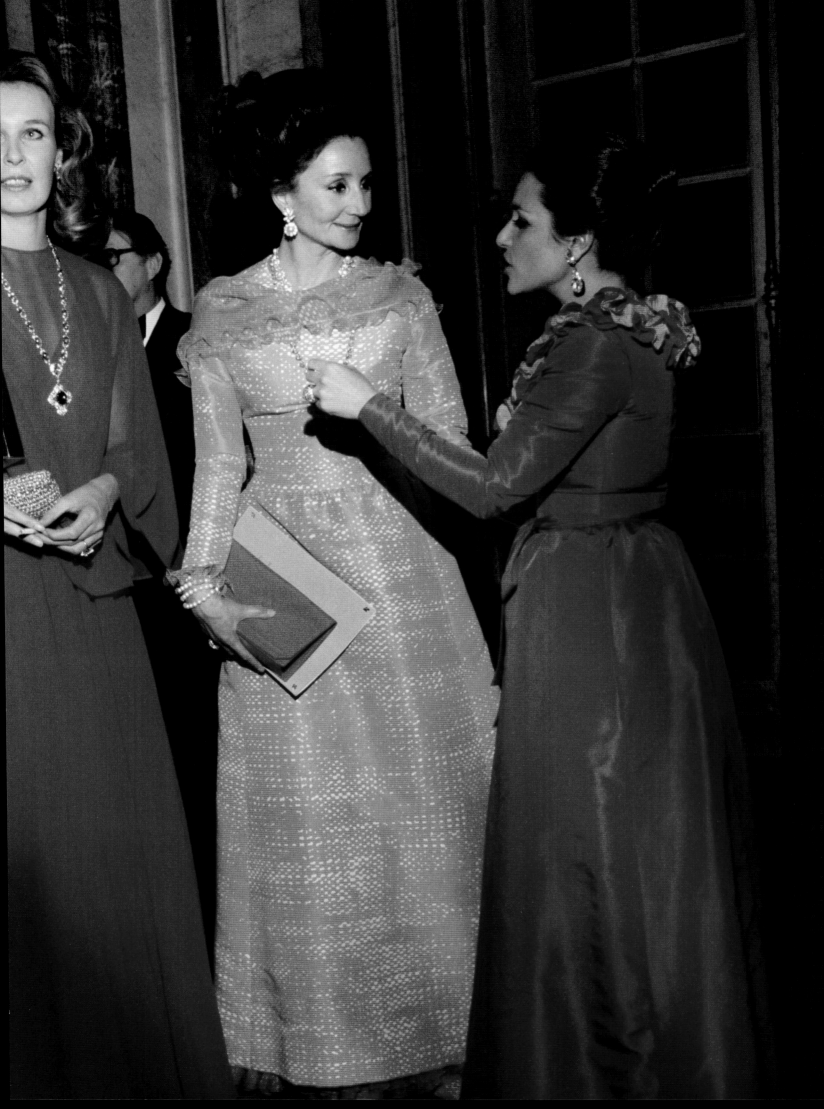

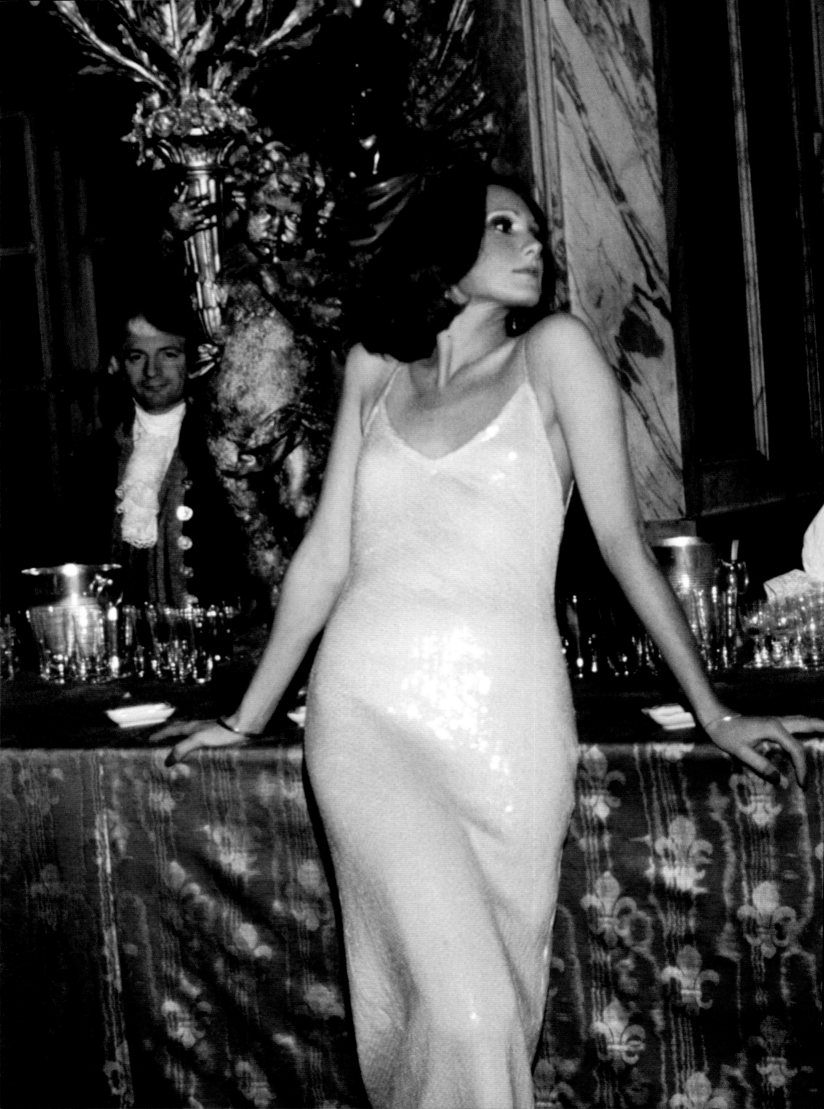

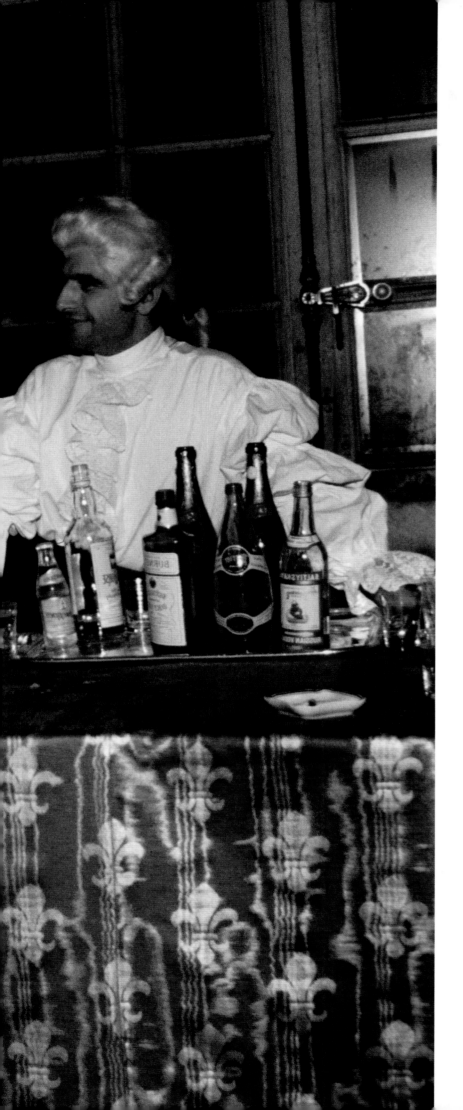

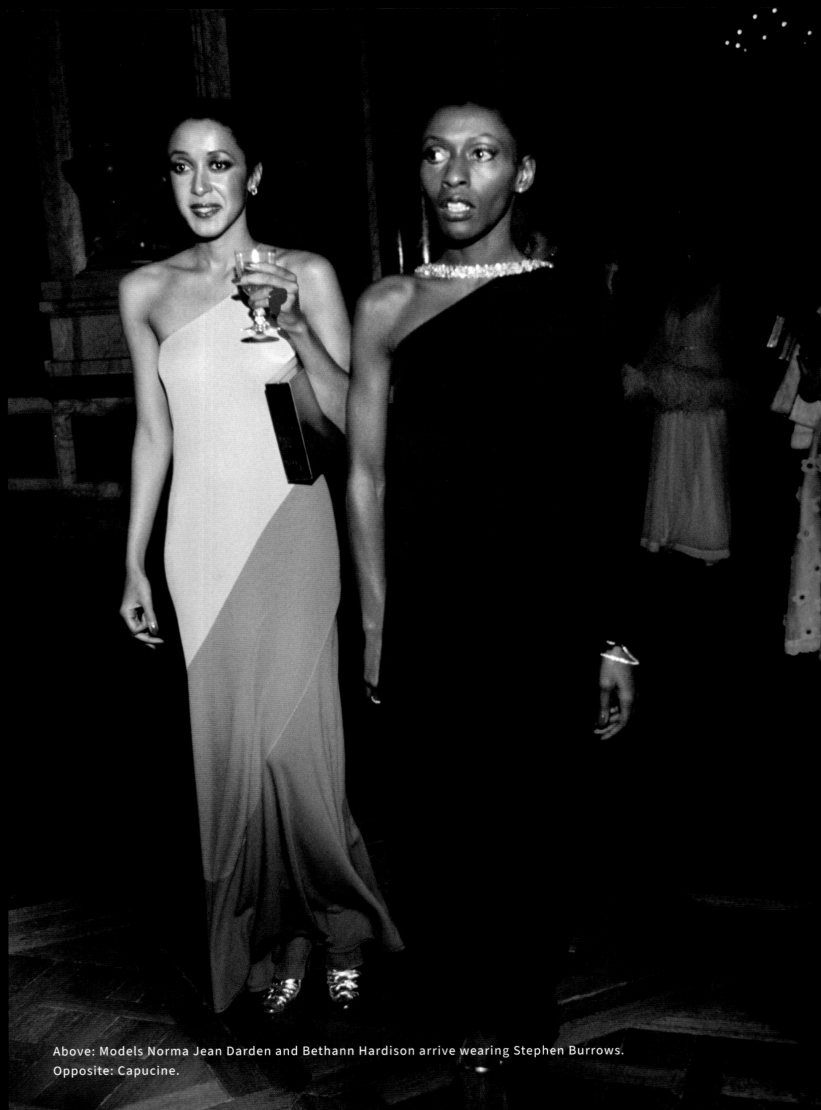

Above: Models Norma Jean Darden and Bethann Hardison arrive wearing Stephen Burrows.
Opposite: Capucine.

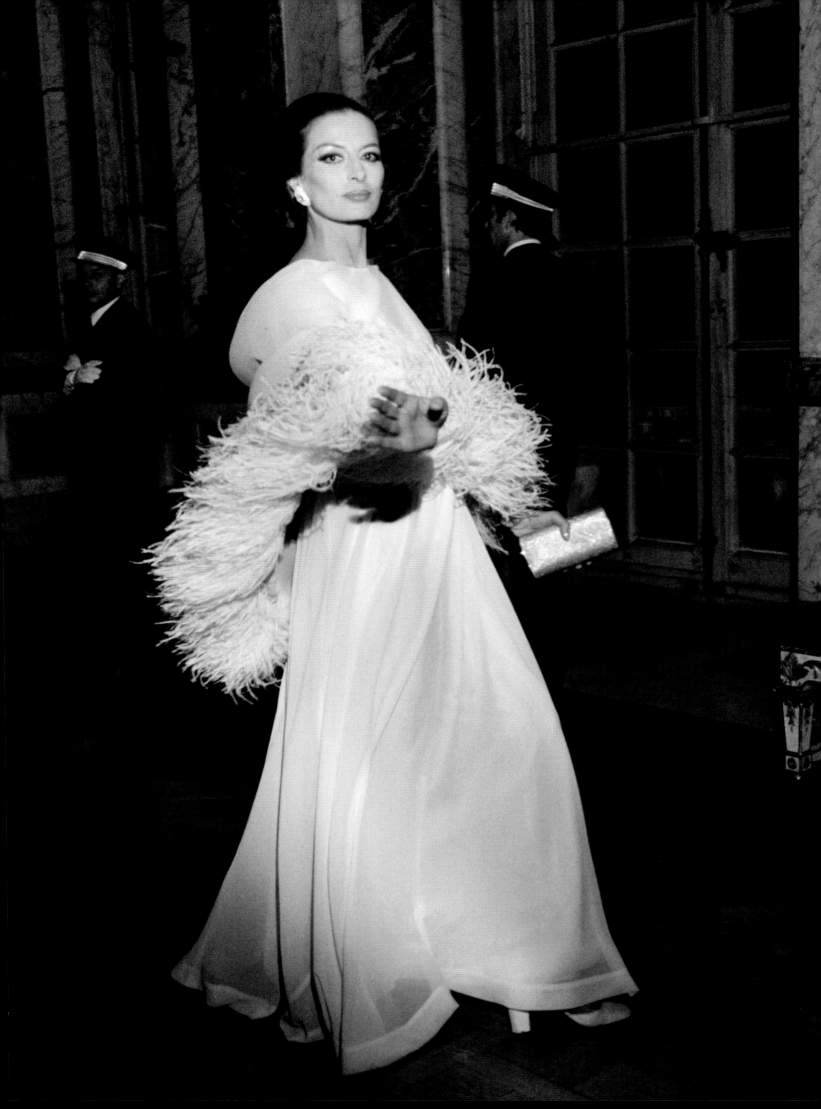

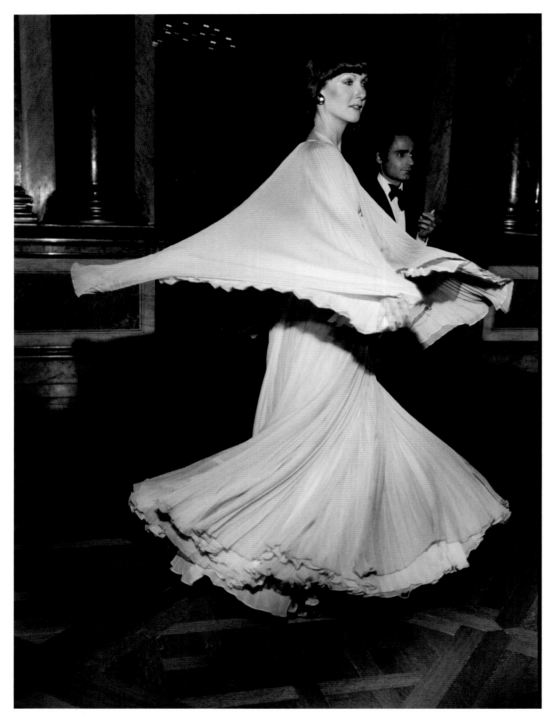

Above: Nancy North.
Opposite: Model Lynn Yaeger.

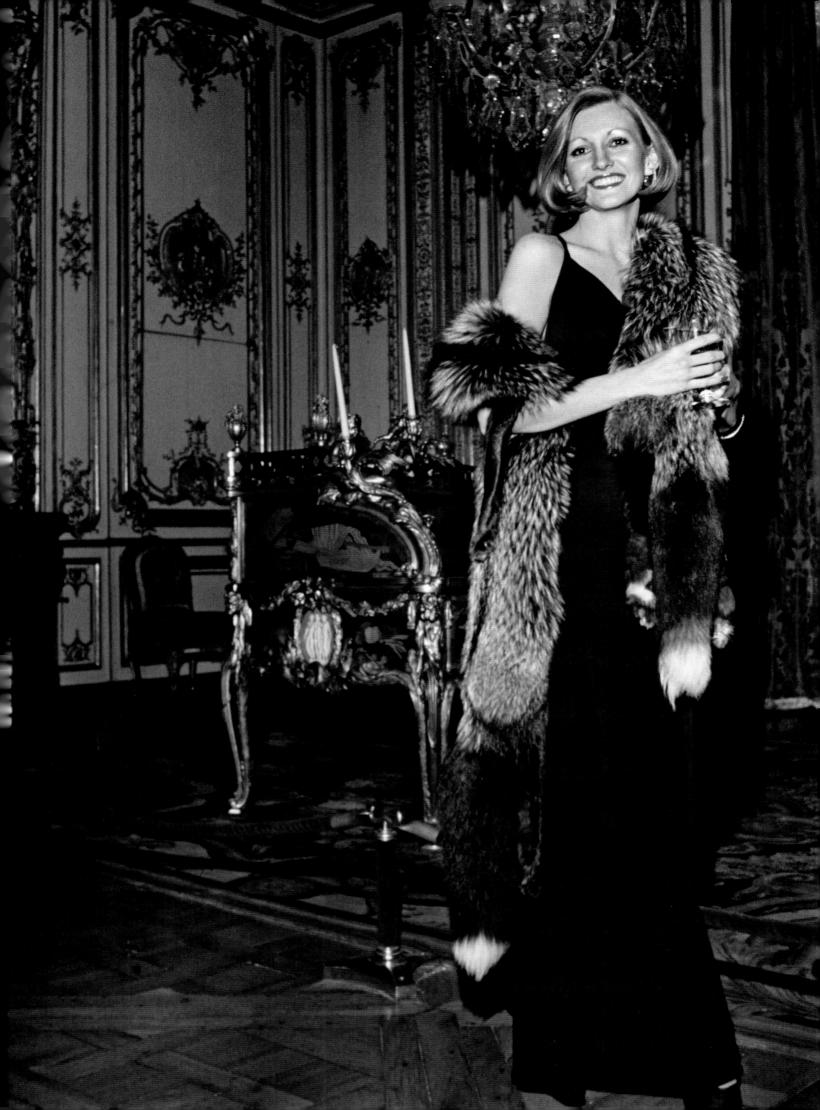

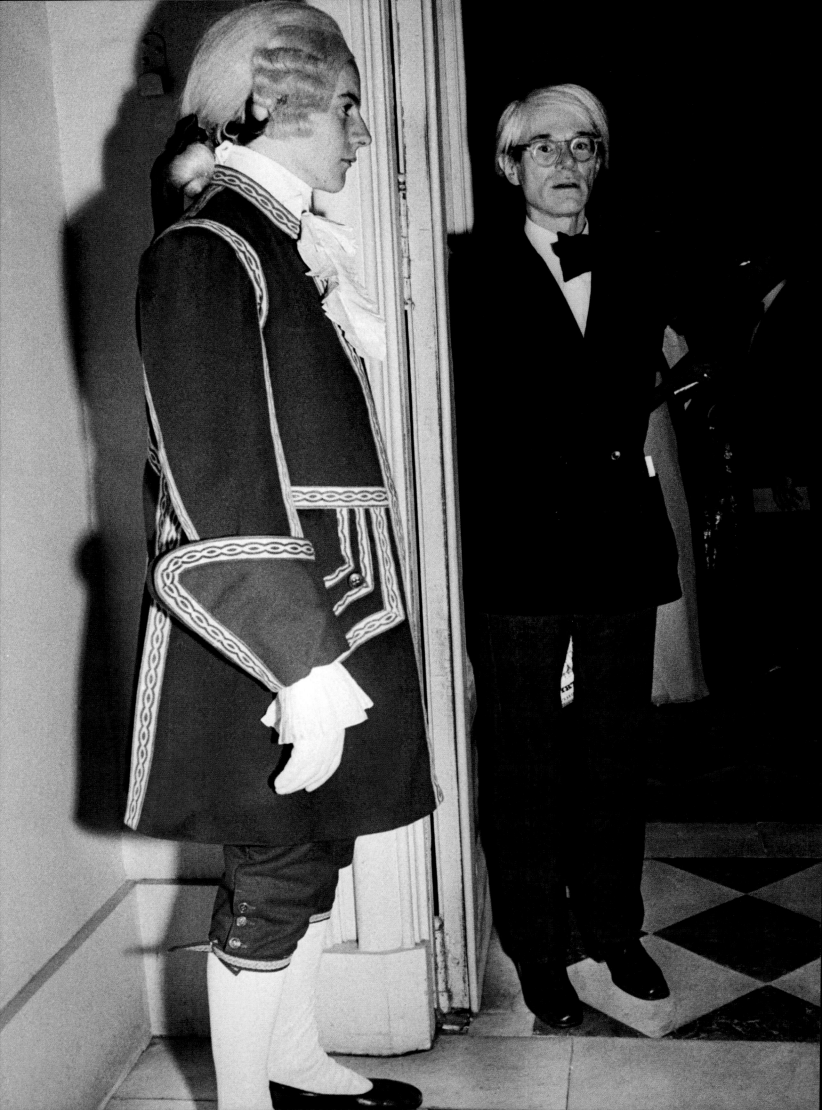

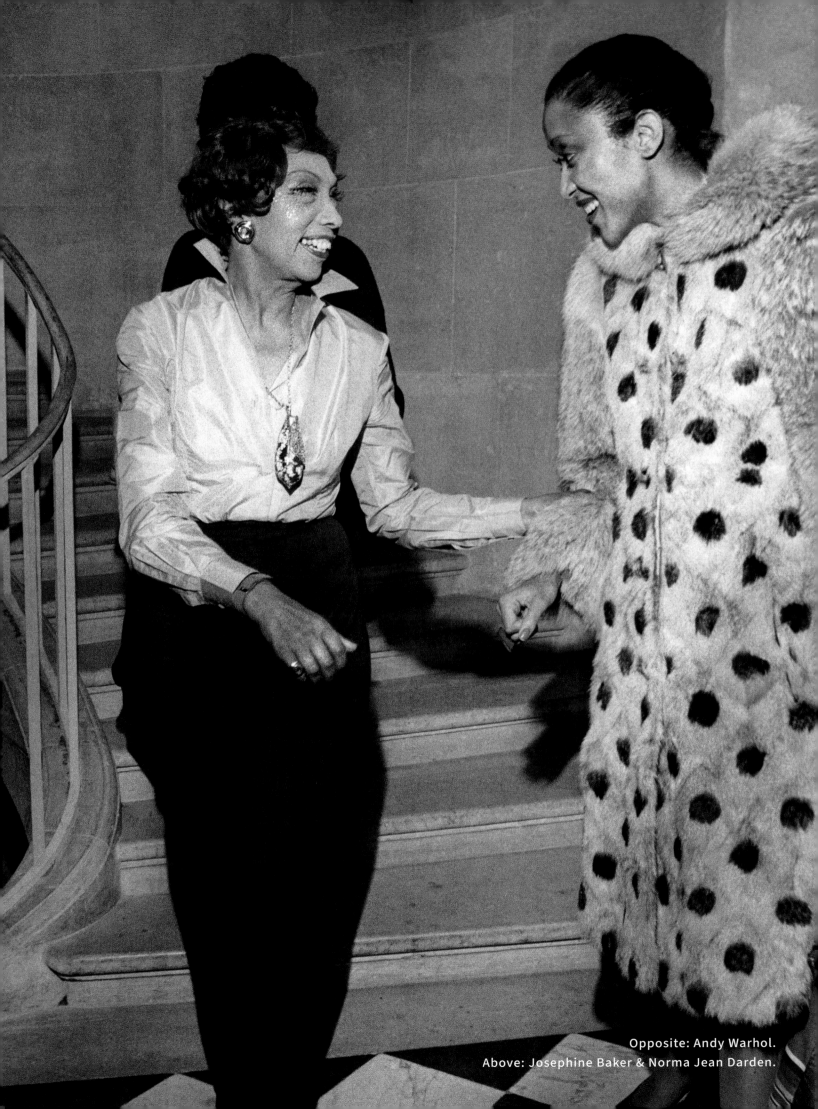

Opposite: Andy Warhol.
Above: Josephine Baker & Norma Jean Darden.

Opposite: Ramona Saunders with footmen.

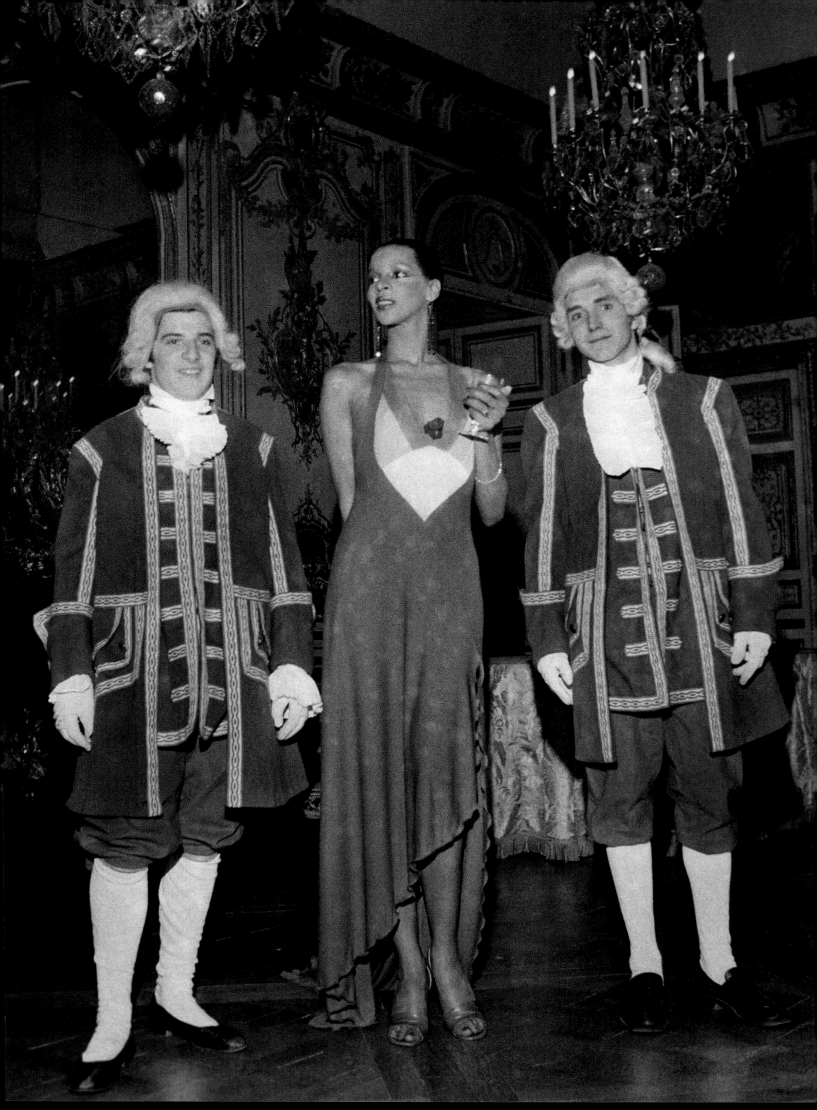

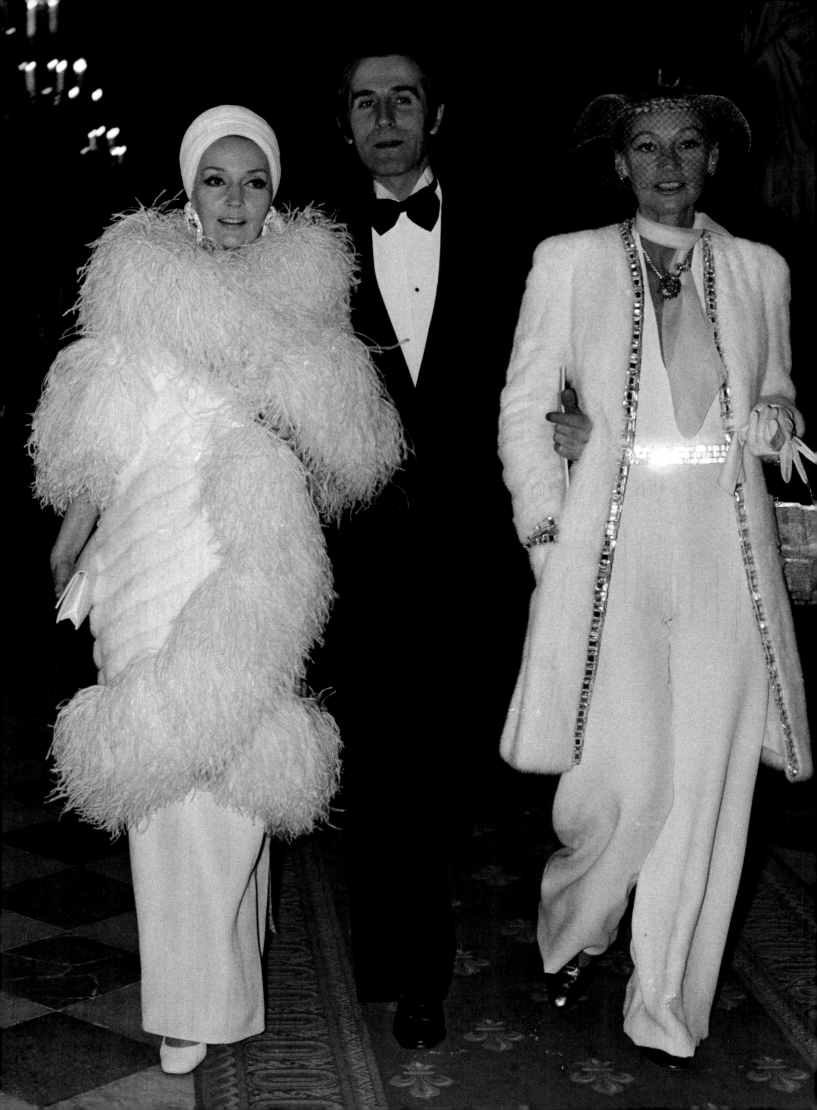

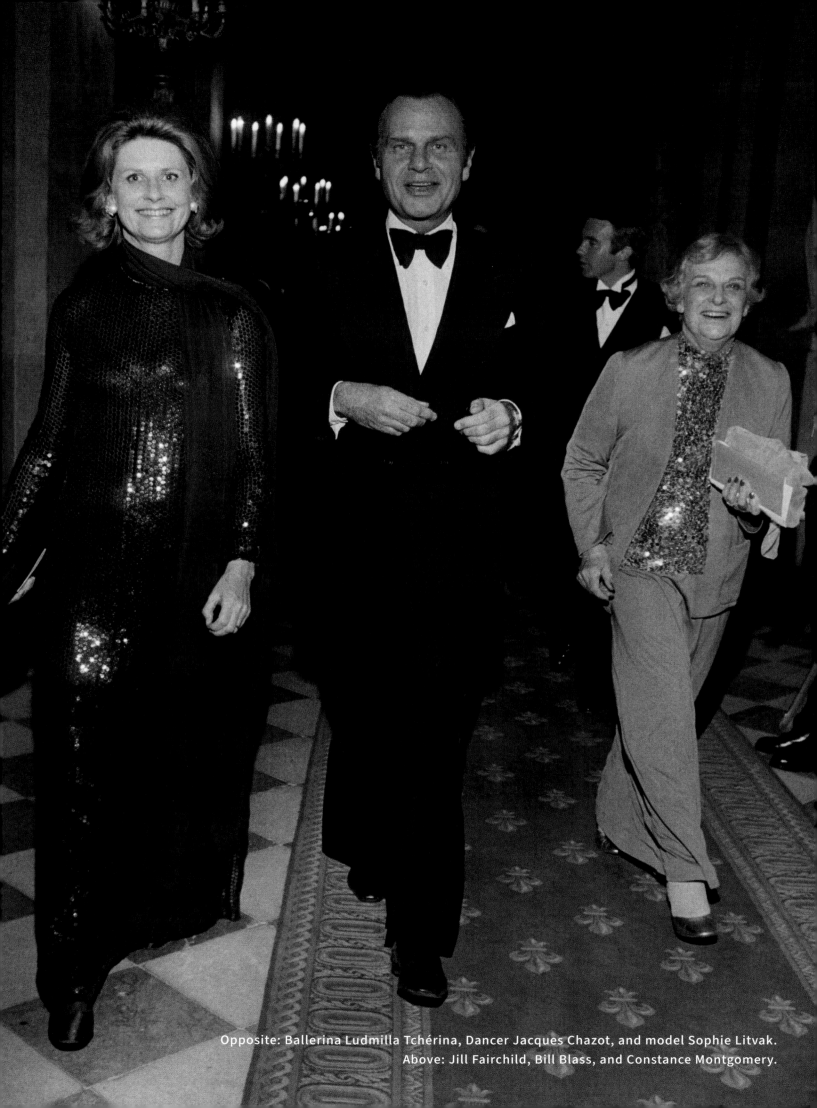

Opposite: Ballerina Ludmilla Tchérina, Dancer Jacques Chazot, and model Sophie Litvak.
Above: Jill Fairchild, Bill Blass, and Constance Montgomery.

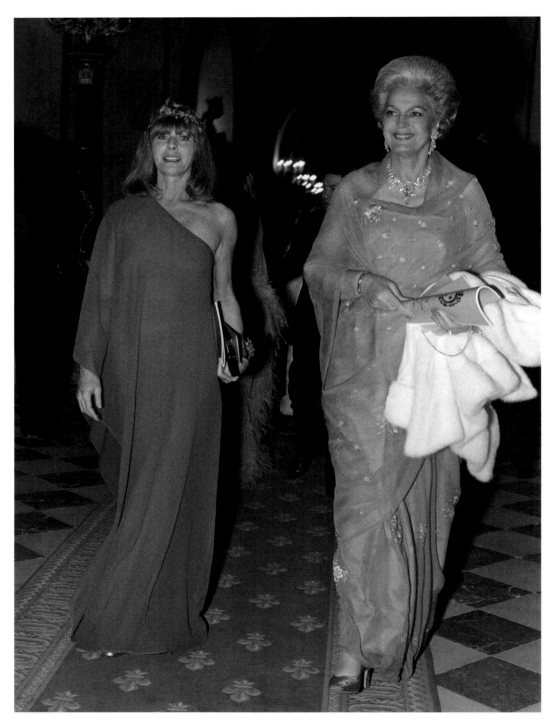

Above: Begum Aga Khan (right).
Opposite: Isabel de Rosnay.

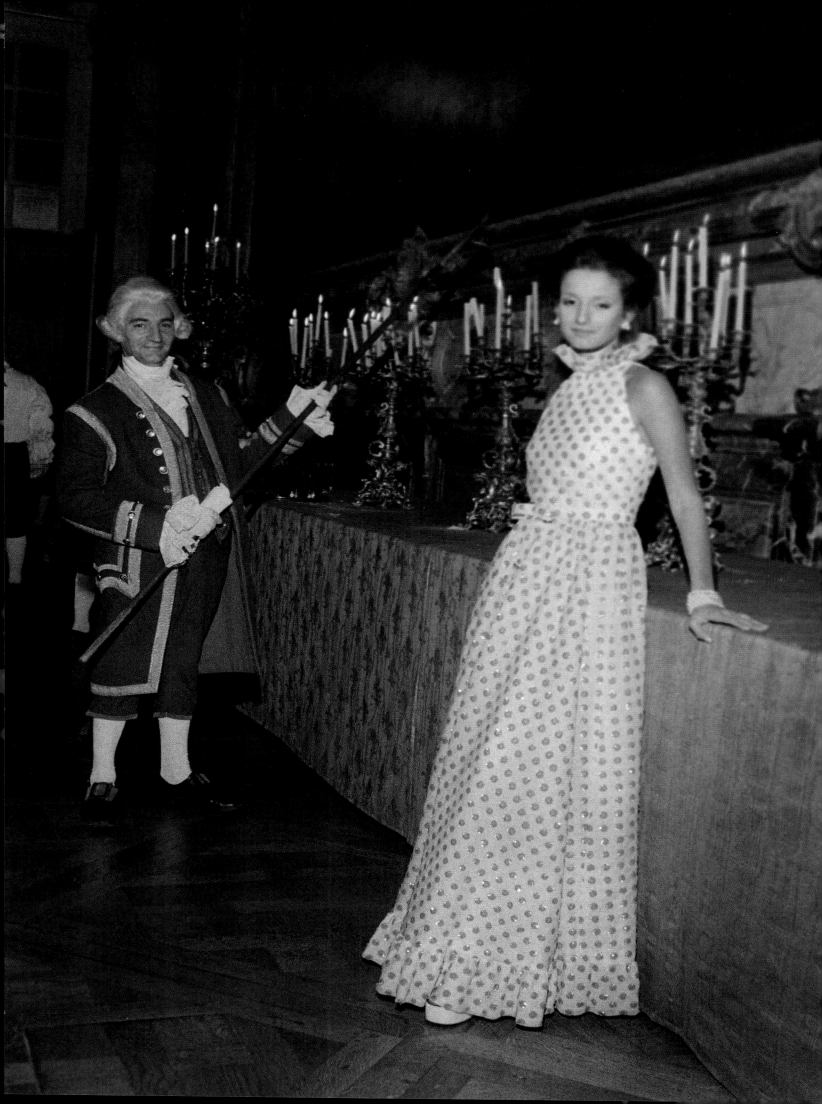

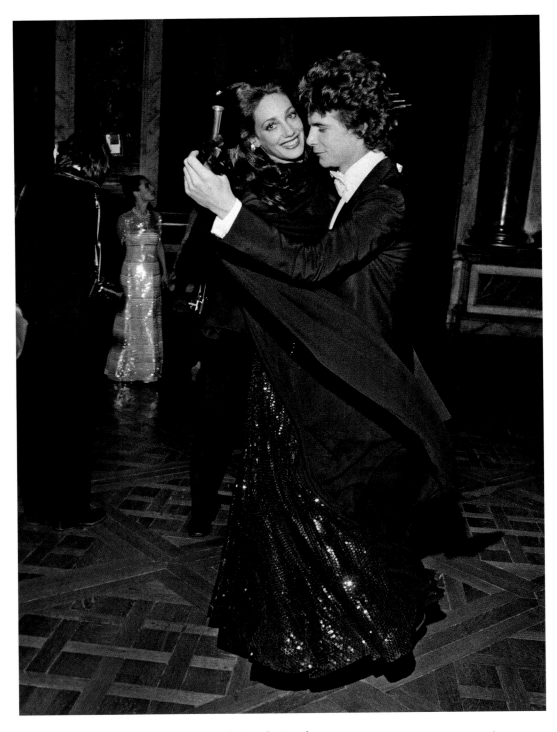

Above: Marisa Berenson & François-Marie Banier.
Opposite: Bernard & Meryl Lanvin.

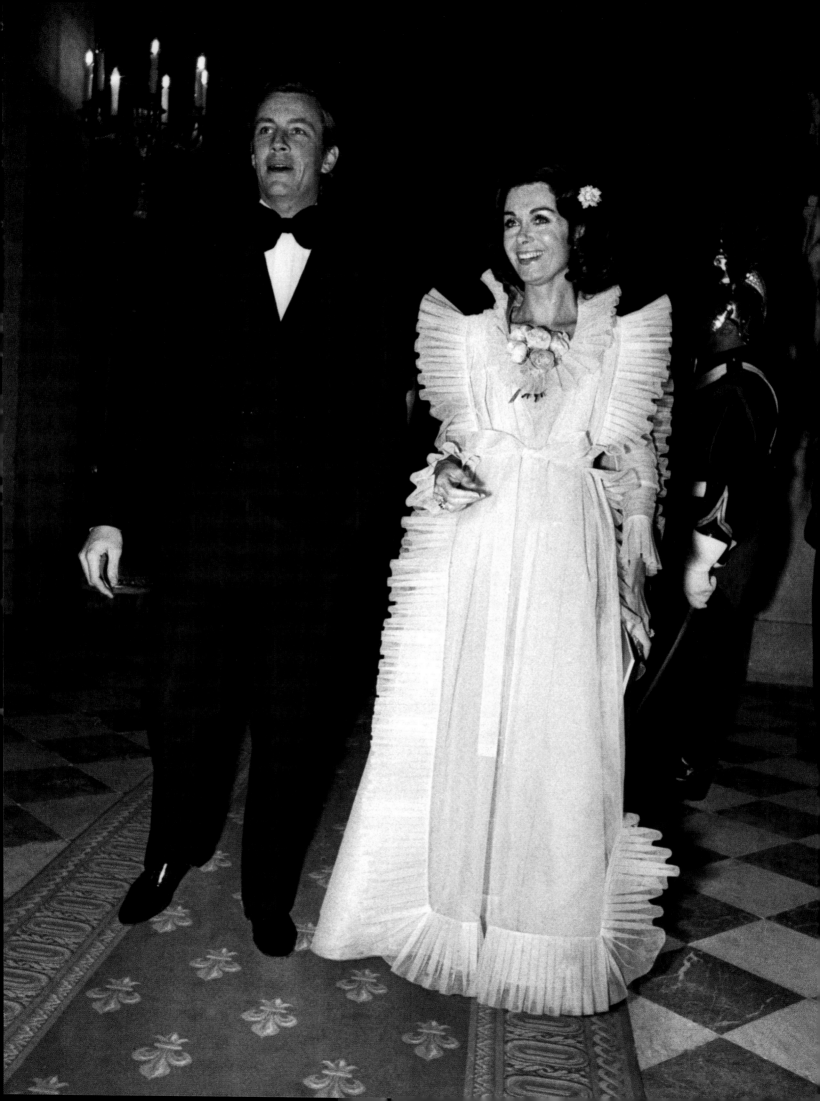

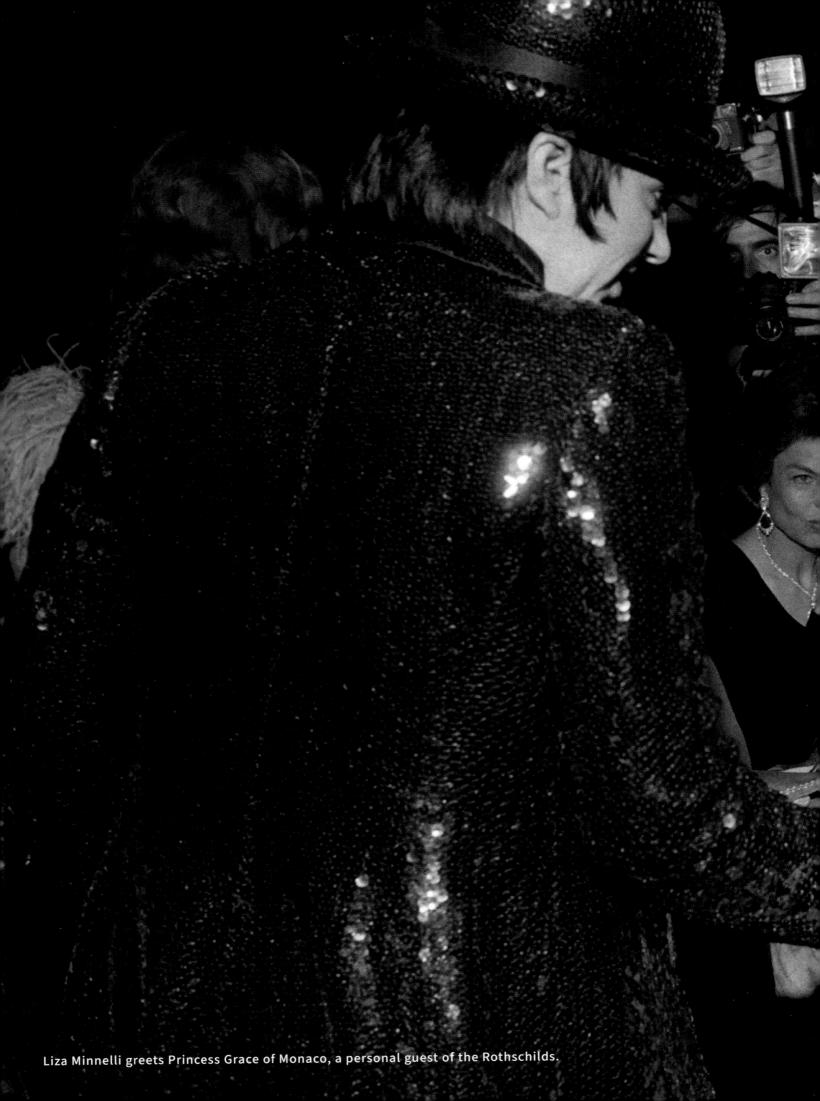

Liza Minnelli greets Princess Grace of Monaco, a personal guest of the Rothschilds.

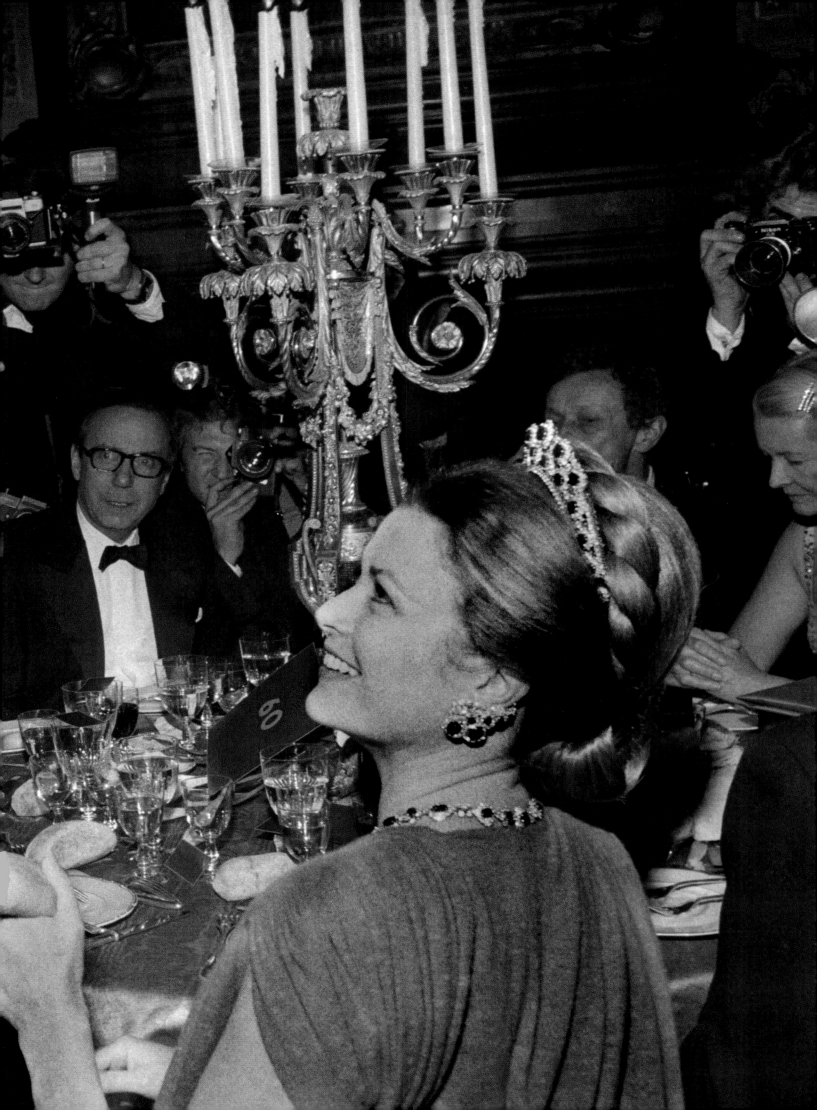

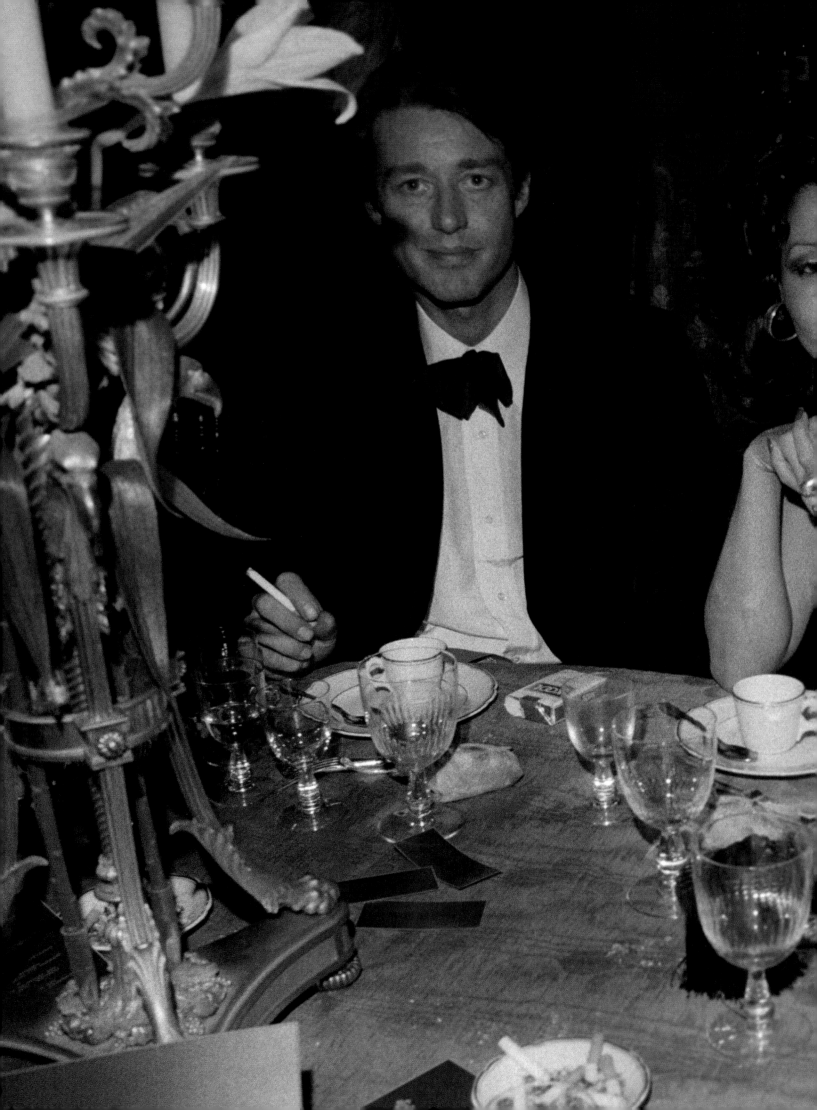

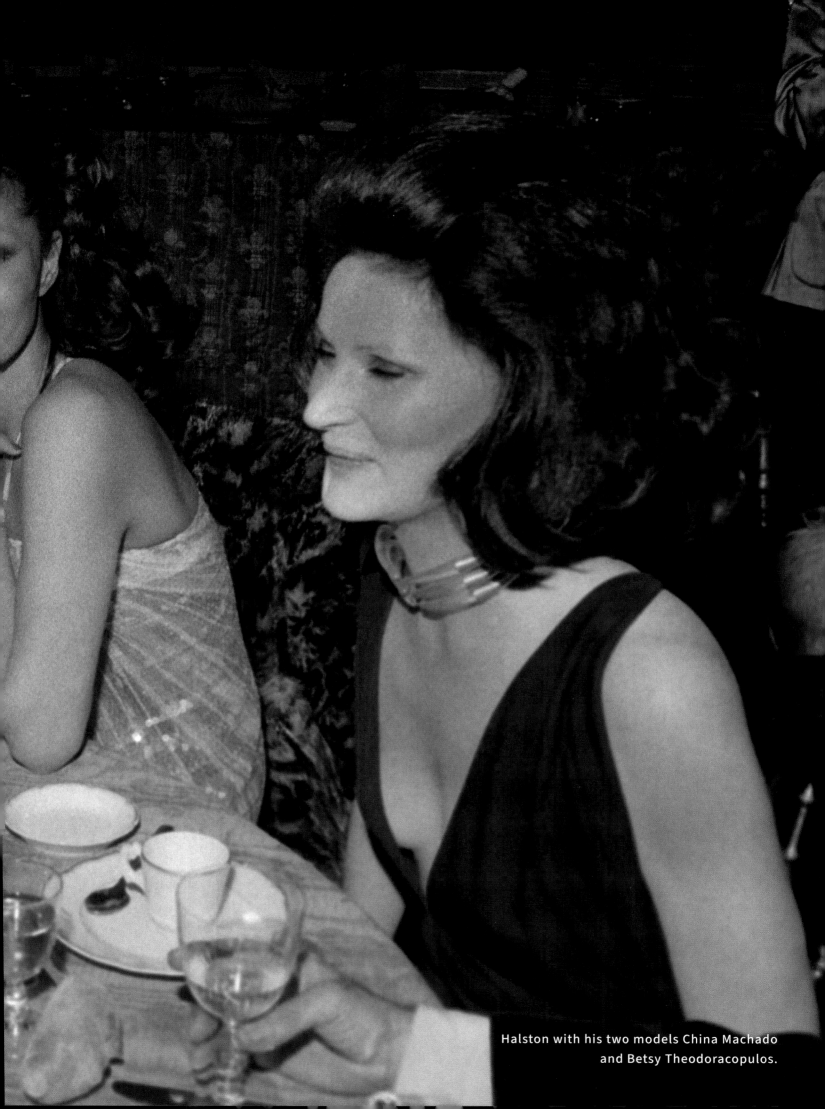

Halston with his two models China Machado
and Betsy Theodoracopulos.

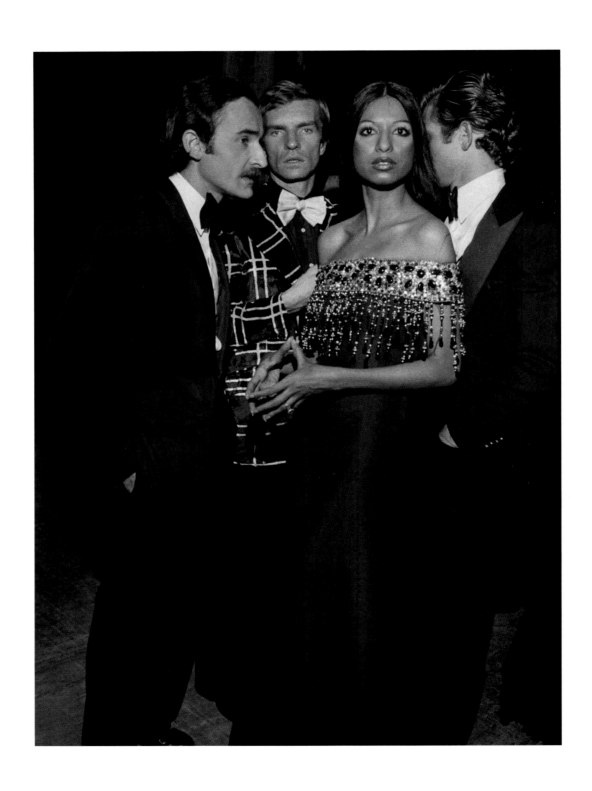

Opposite: Marisa Berenson.

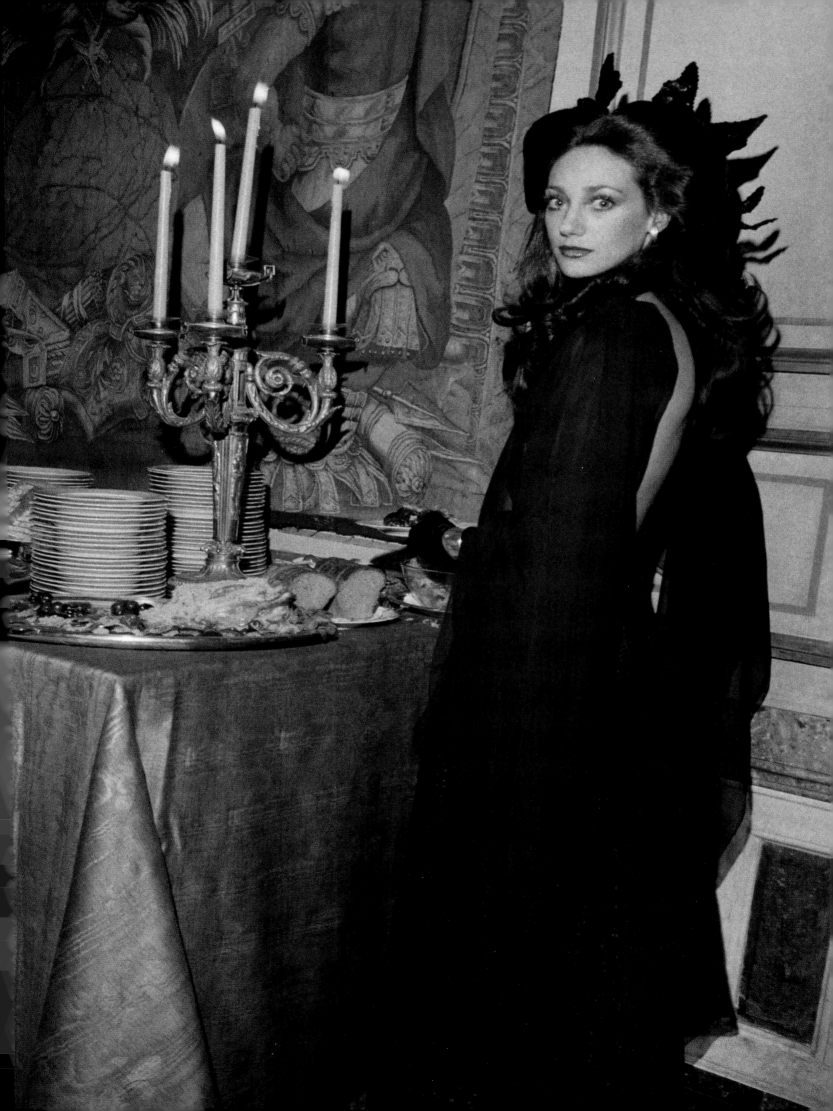

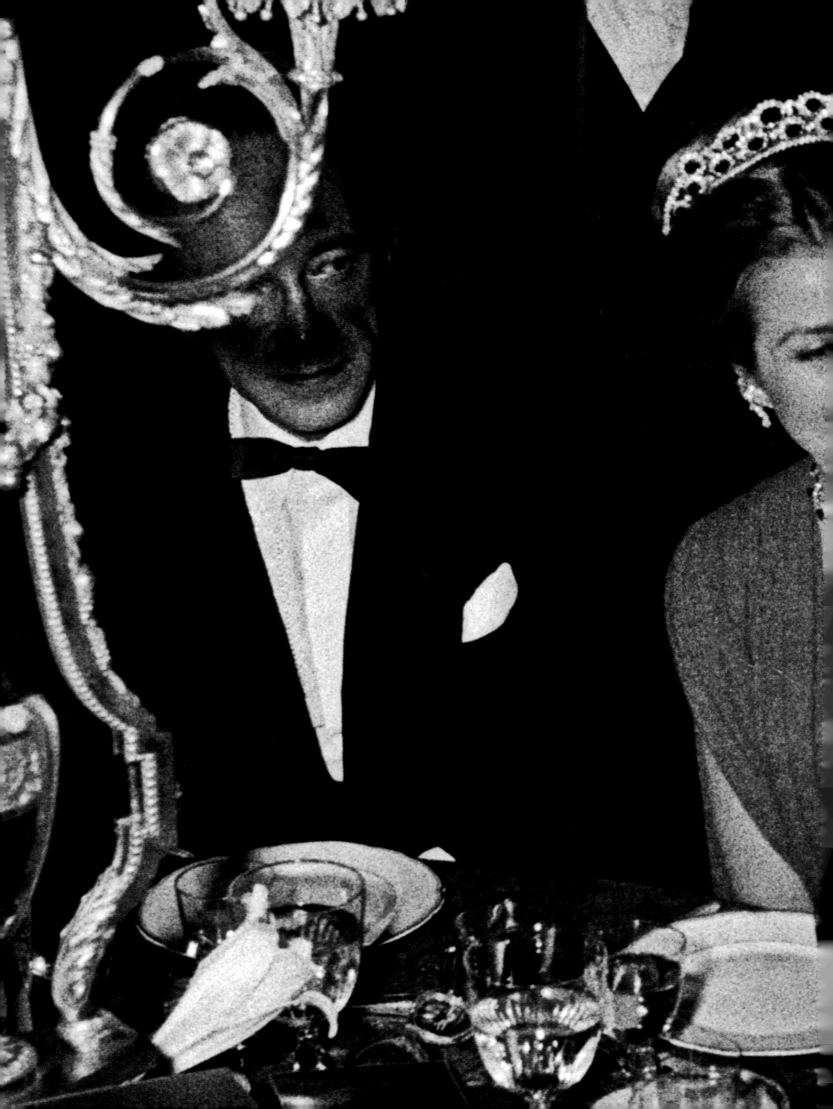

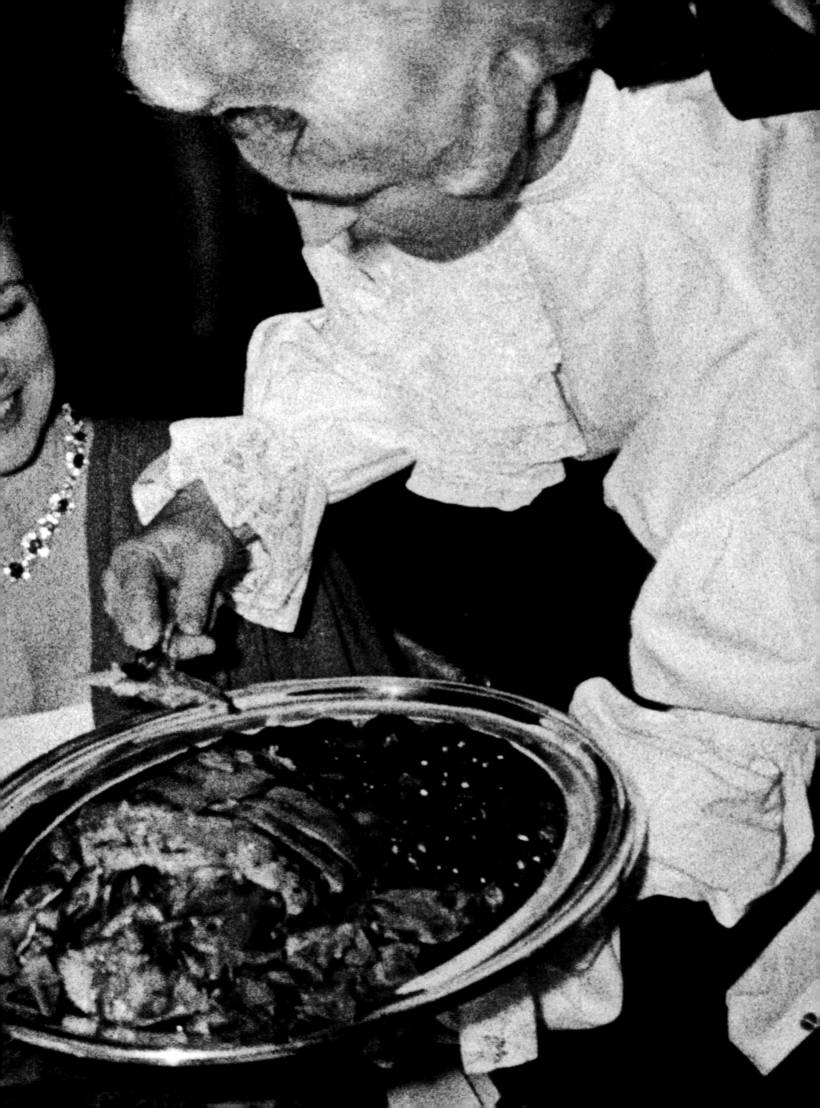

Previous Pages: Princess Grace of Monaco.
Above: Francois & Betty Catroux.
Opposite: Backstage post-show: Pat Cleveland, Ramona Saunders,
Josephine Baker, Bethann Hardison, Billie Blair, and Norma Jean Darden.

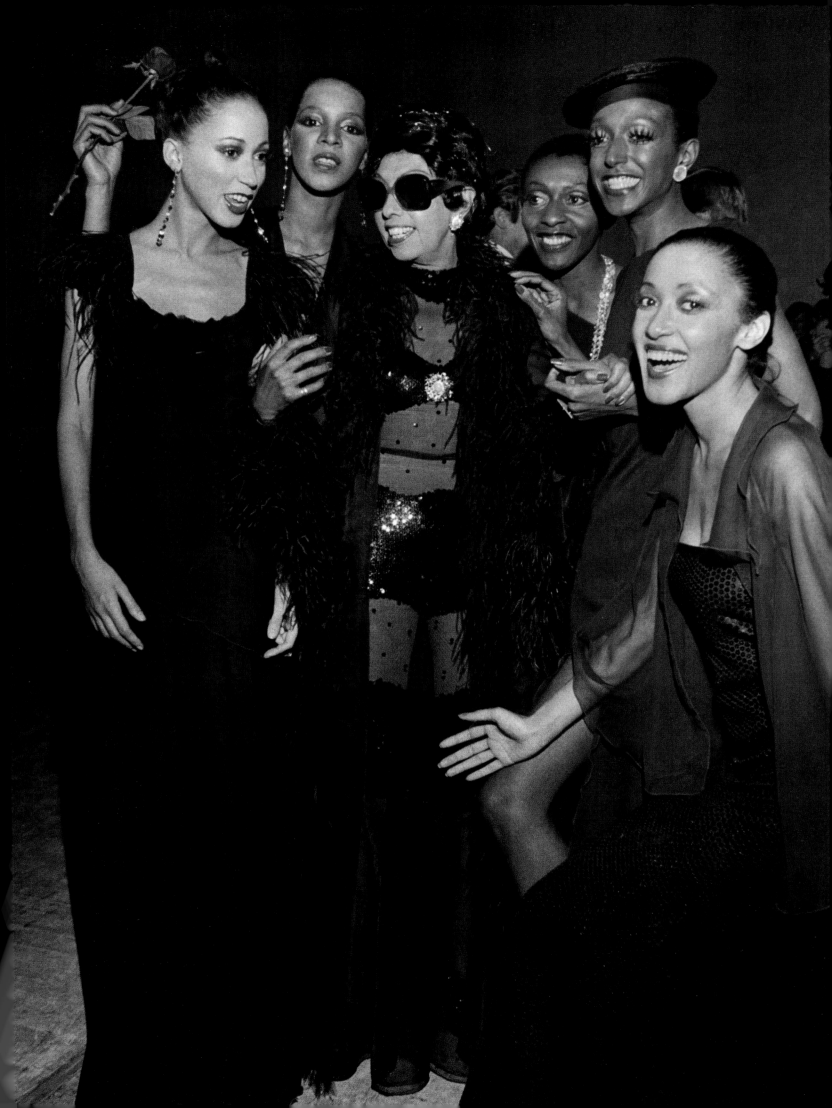

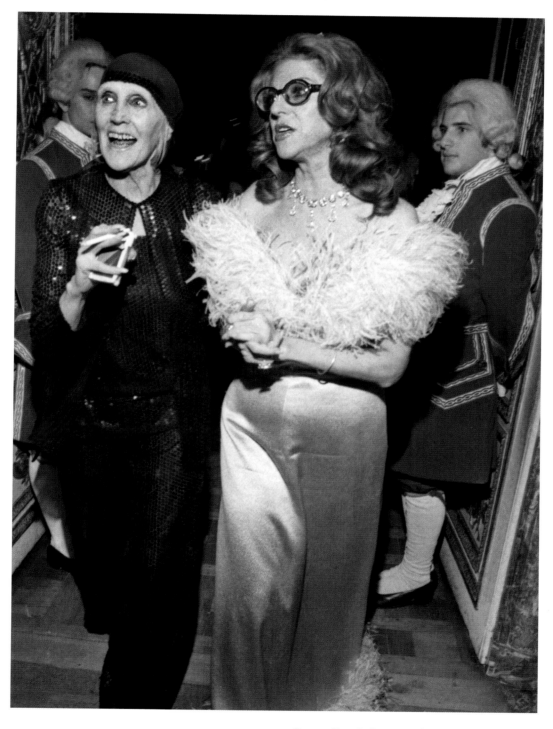

Opposite: Princess Chantal d'Orléans &
husband Baron Francois-Xavier de Sambucy de Sorgues.
Above: Kay Thompson &
the evening's hostess Baroness Marie-Hélène de Rothschild.

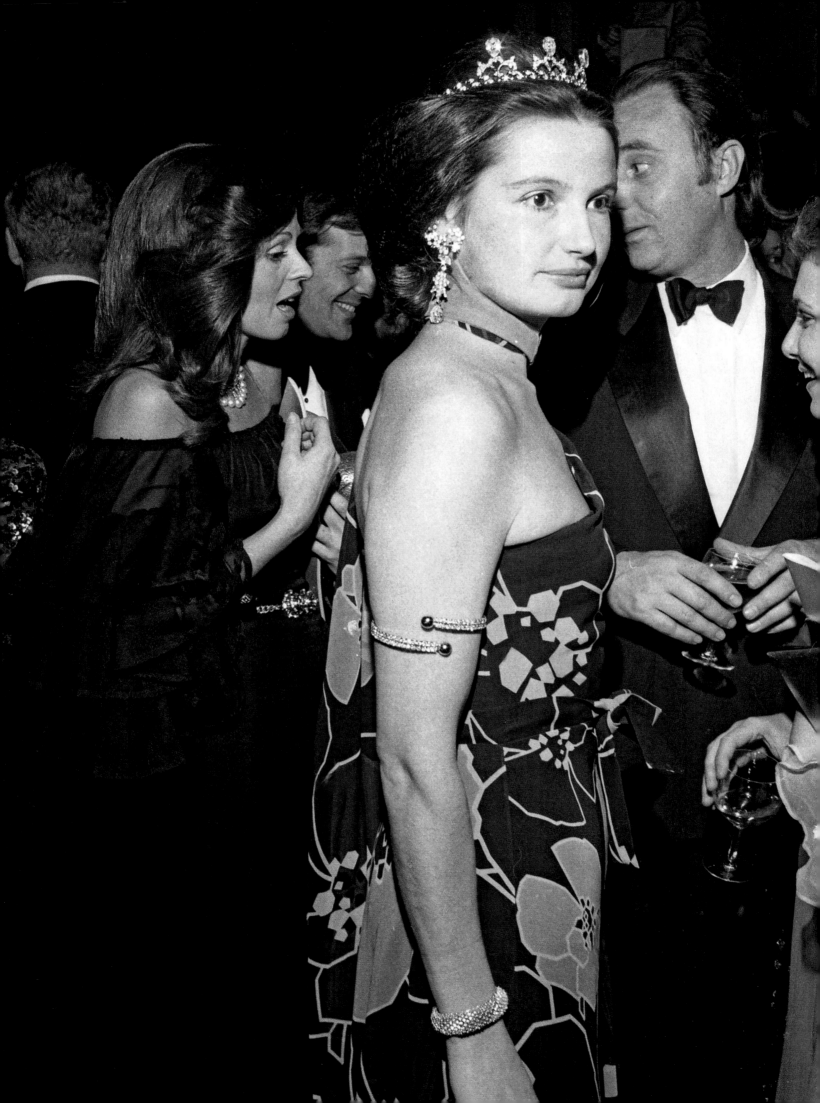

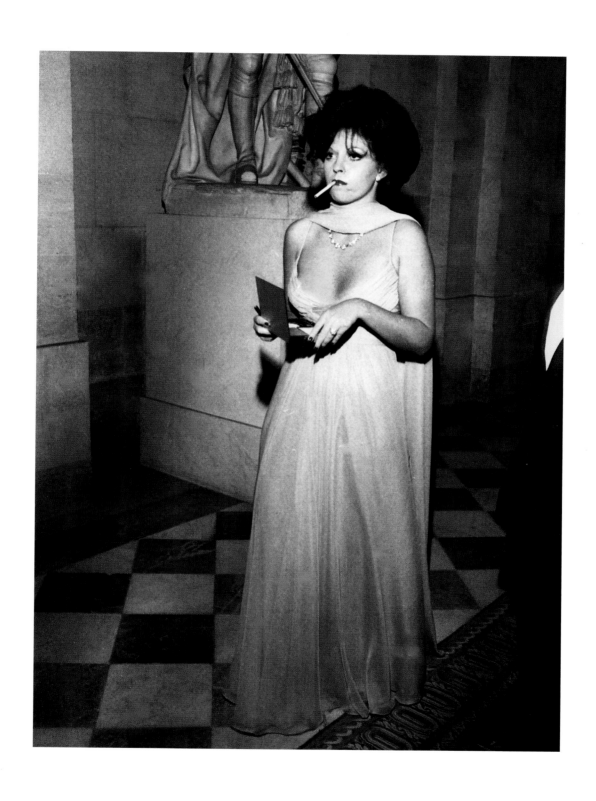

Opposite: Countess Joy de Rohan-Chabot,
David Rothschild (smiling), and Baroness and Baron de Cabrol.

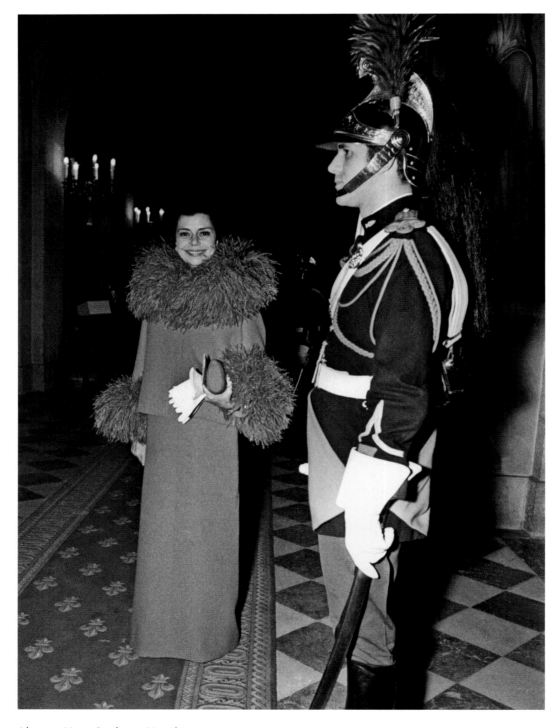

Above: Mrs. Graham Mattison.
Opposite: Oscar de la Renta escorts his wife Françoise de Langlade,
who played a role in leading the Americans' to victory.

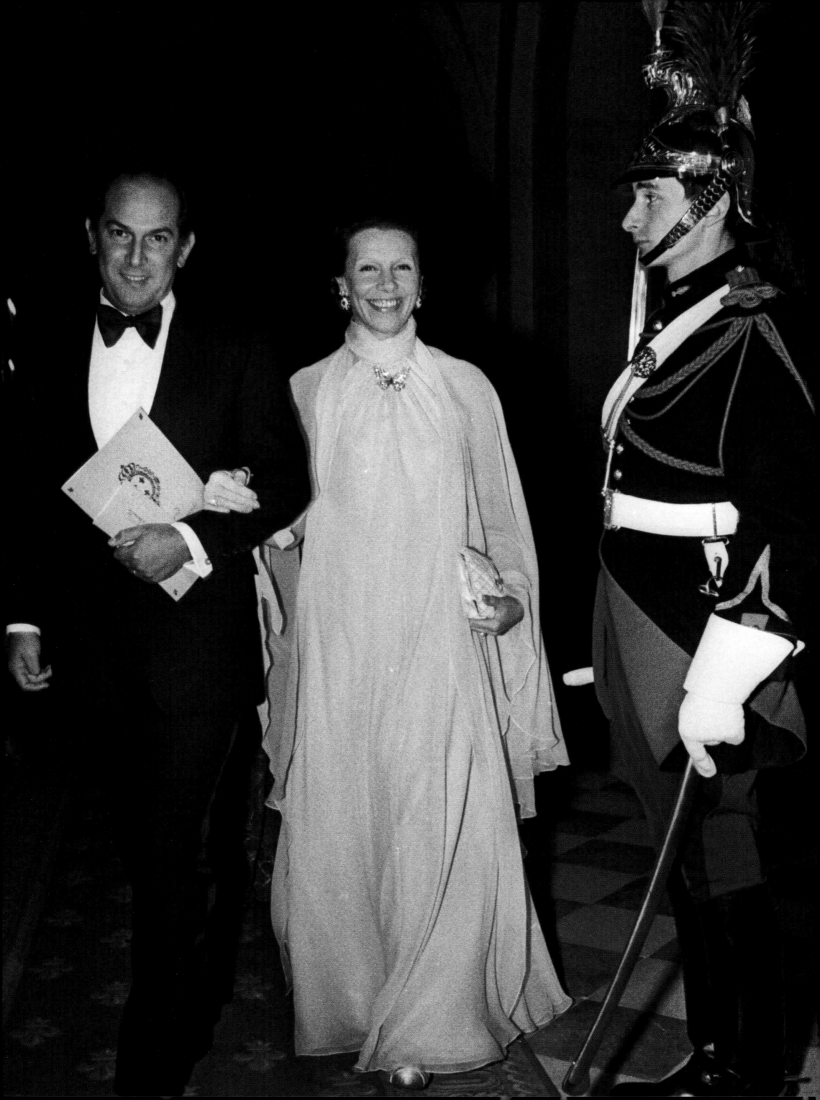

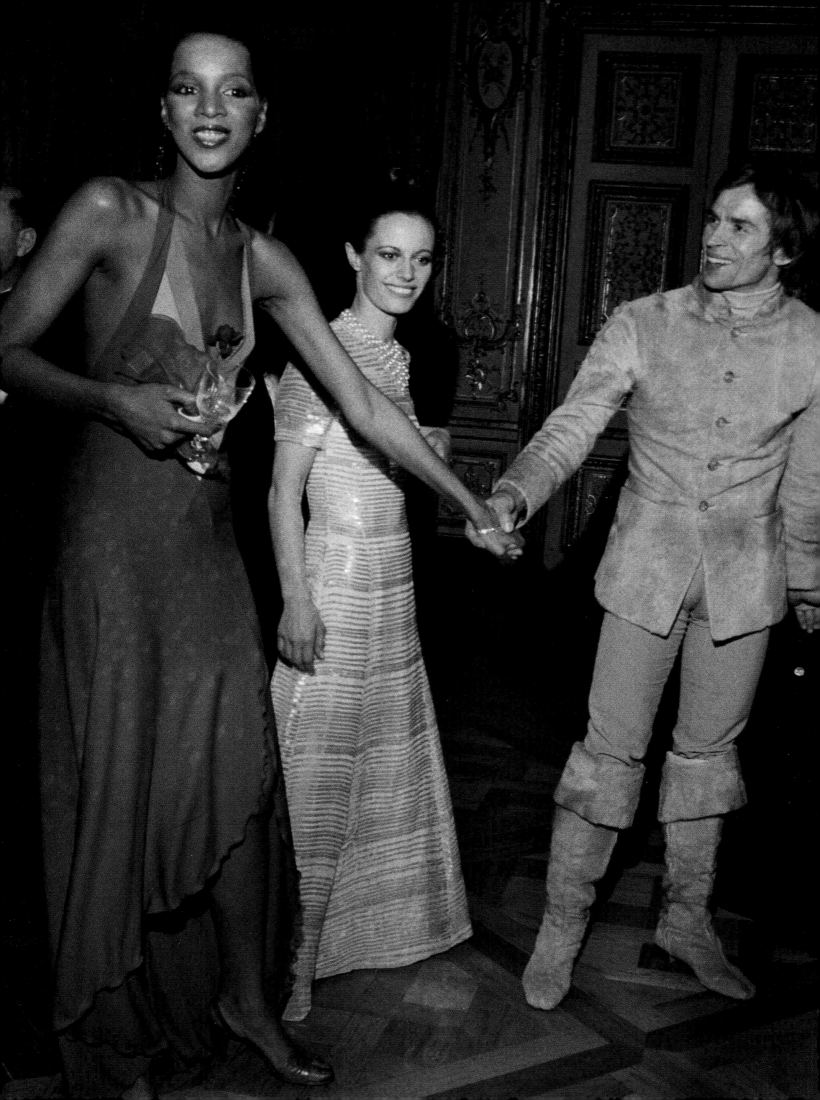

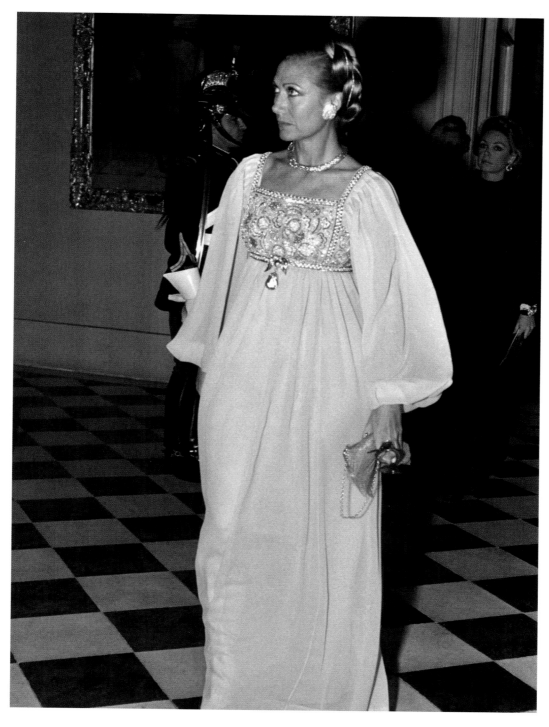

Opposite: Model Ramona Saunders holds hands with
Rudolph Nureyev alongside Douce Francois.
Above: Beauty tycoon Hélène Rochas.

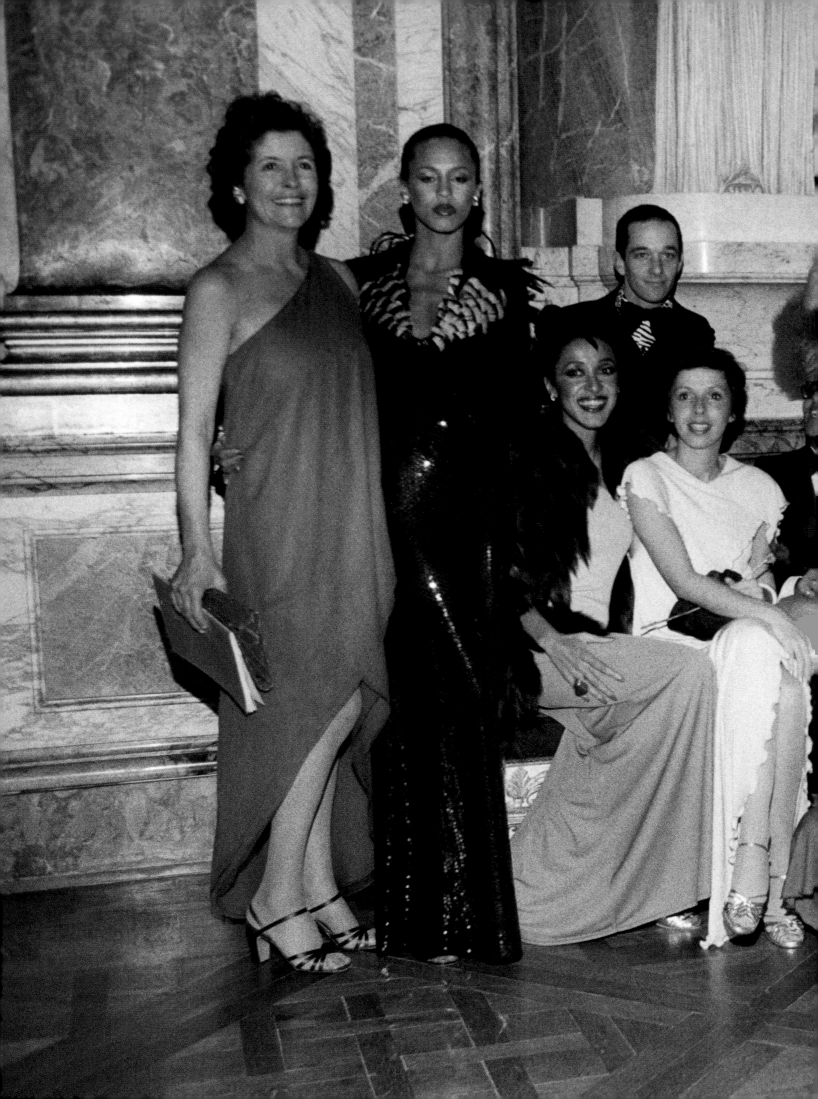

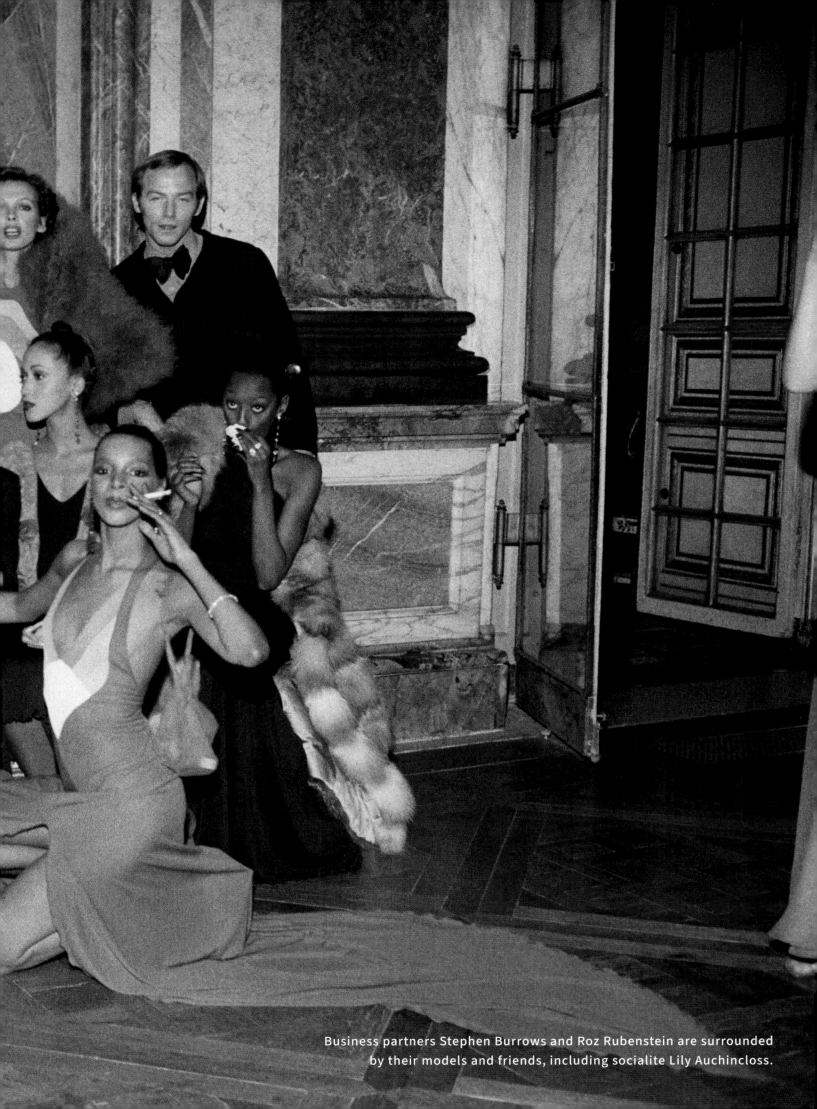

Business partners Stephen Burrows and Roz Rubenstein are surrounded by their models and friends, including socialite Lily Auchincloss.

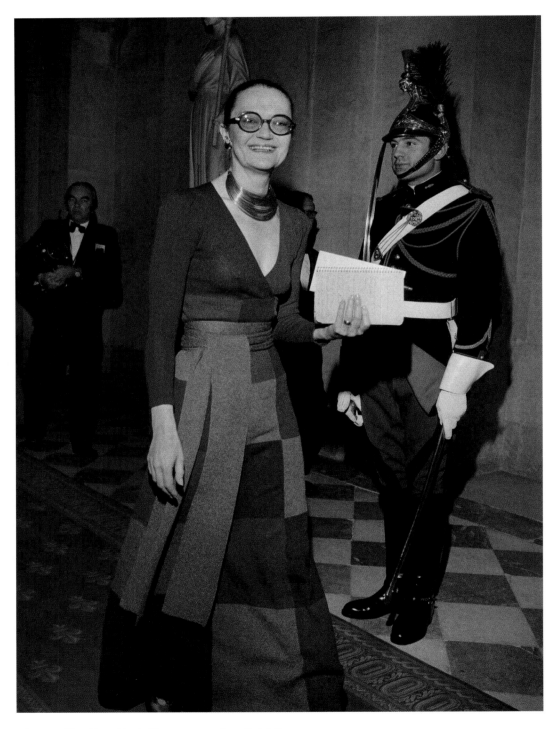

Above: *The New York Times* reporter Enid Nemy.
Opposite: Christina Onassis (right).

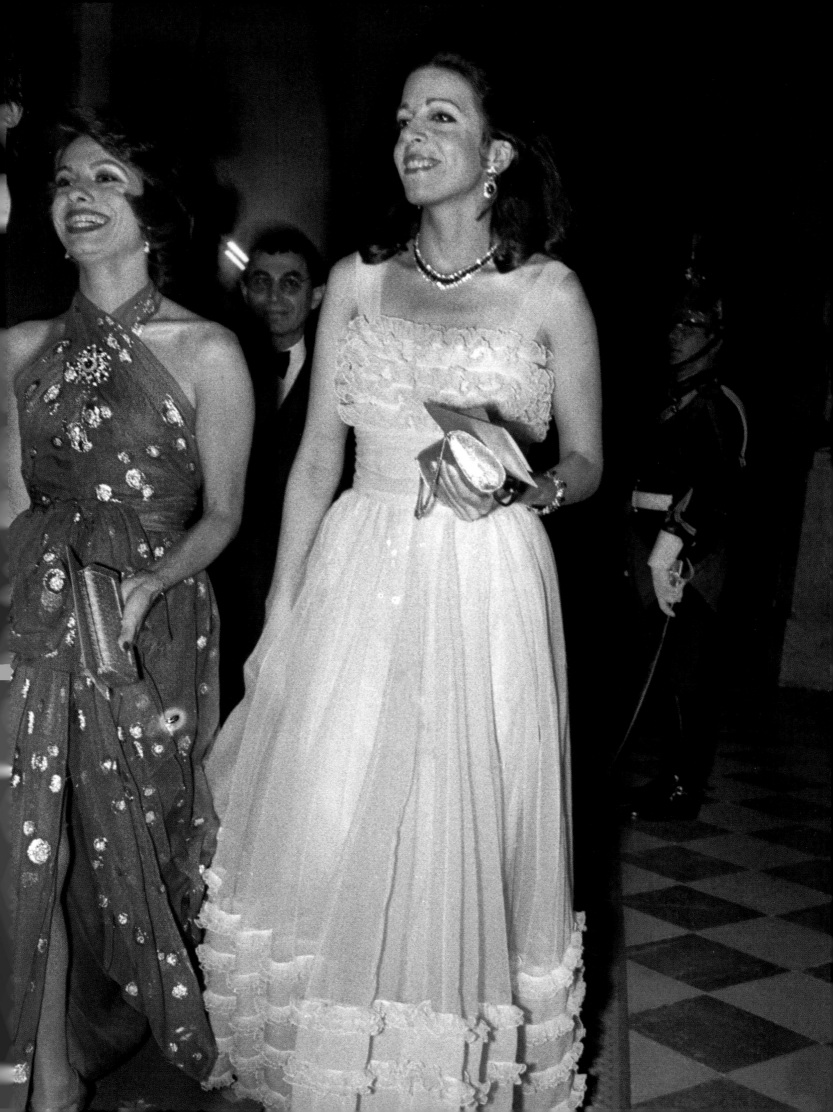

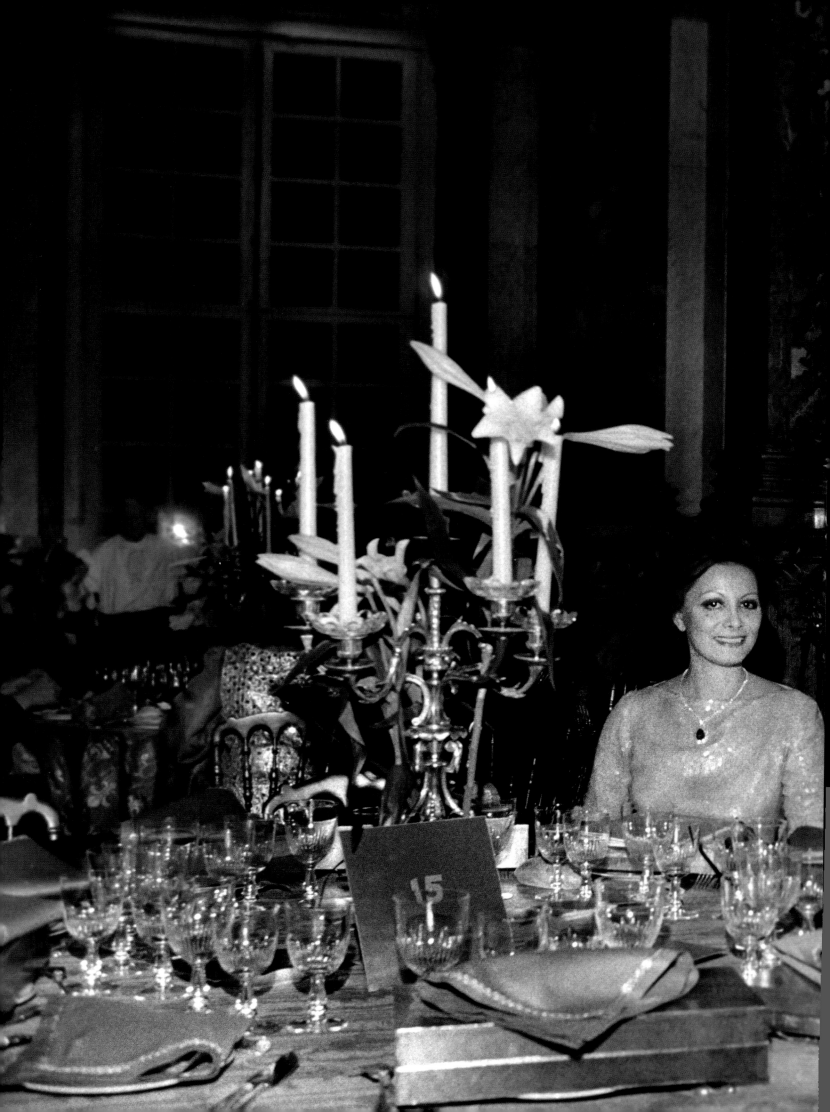

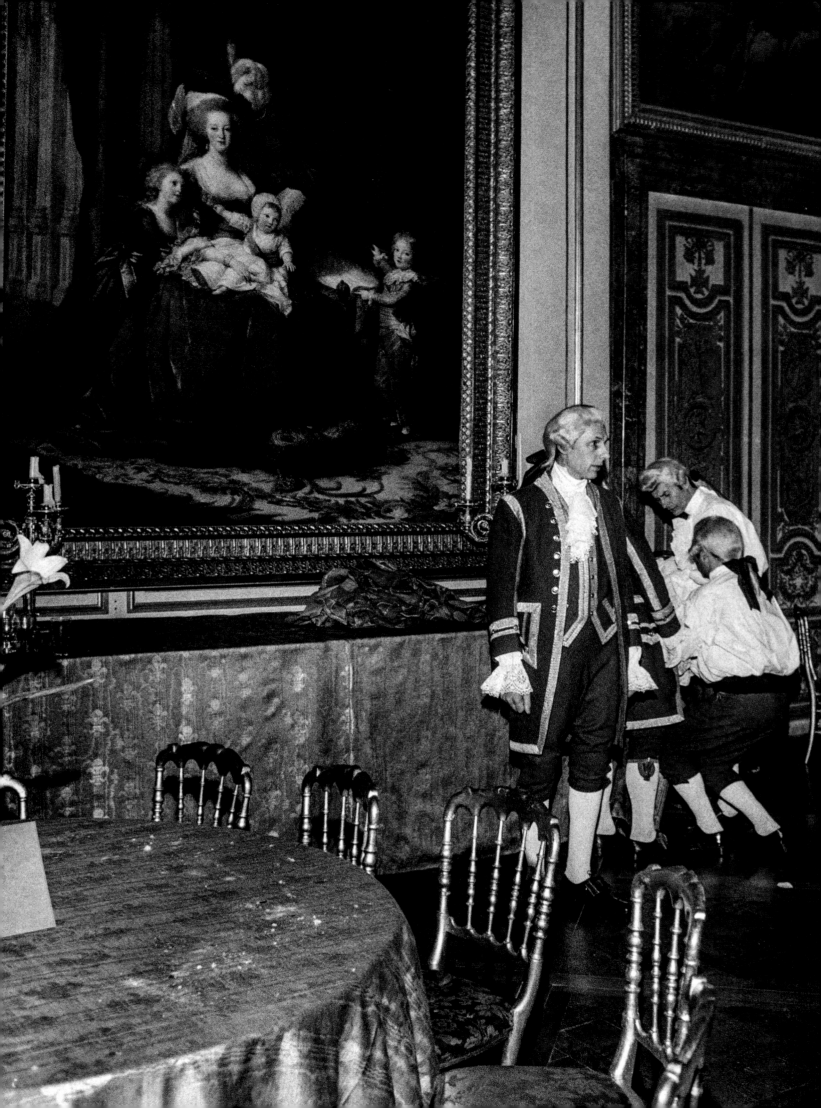

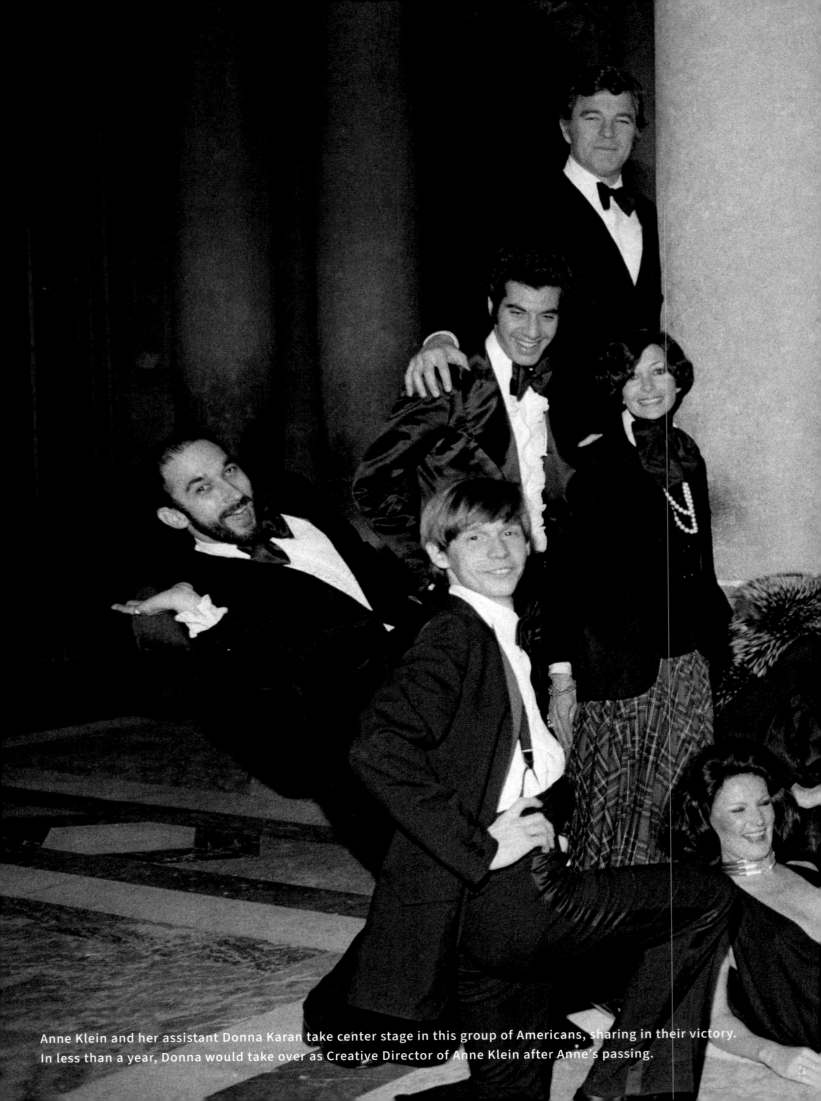

Anne Klein and her assistant Donna Karan take center stage in this group of Americans, sharing in their victory. In less than a year, Donna would take over as Creative Director of Anne Klein after Anne's passing.

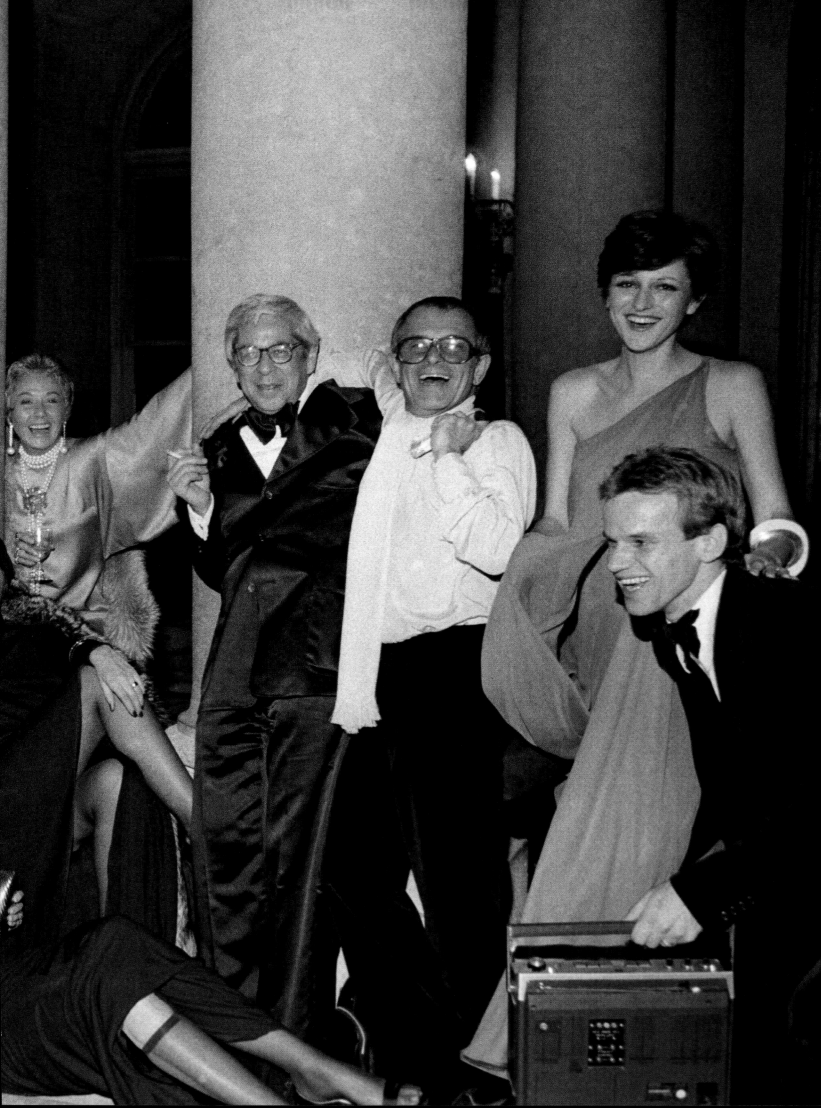

Epilogue

Jean-luce Huré

I first met Bill in the early 1970s while covering the shows in Paris, and we became fast friends almost immediately. Our friendship lasted over fifty years. When Mark called me about the idea for this book, the excitement in his voice—a perfect mix of passion and determination—assured me it would happen: our photos, Bill's and mine, of one of the most amazing events in fashion history. Halfway through our call, I was already zoomed back fifty years and again standing on the stage of Théâtre Gabriel, the palace's opera house, in Versailles.

I had photographed parties at the Château de Versailles before, where the weight of history was an essential part of the fun. And yet, while photographing the French show at Versailles in 1973, I got the feeling our glorious past had somehow kept the couturiers on a short leash. Hadn't I felt more excitement when photographing the haute couture collections in the salons of Paris back in July, without fruit stands, giant pumpkins, and rockets? But also, I had photographed the American rehearsal the day before.

"Vive la différence" (Long live diversity)! I recall whispering to my Nikon. It seemed that while the French had imagined their creations being shown in a chateau, the Americans imagined a stage. An empty one, with a simple black-curtained background and beautiful lighting, with projectors catching every movement, the slightest gesture, from Liza Minnelli wielding her umbrella in the air to the models with their gym-trimmed arms, hips, and legs feeling the groove in Kay Thompson's energized choreography. Simplicity outshining all the gold gilding in Louis XV's Royal Opera House. And making this photographer grateful.

The models danced and twirled, striking poses in flimsy dresses as freely as if we had been in the middle of a heatwave. No one could have guessed they were cold, hungry, and had not been treated well at all. Maybe because there were no prima donnas? Among the models, that is. And they were way too busy being professional and cooperative. I still remember how they greeted me with delicious bonjours. Were they a tiny bit intimidated by the ghost of

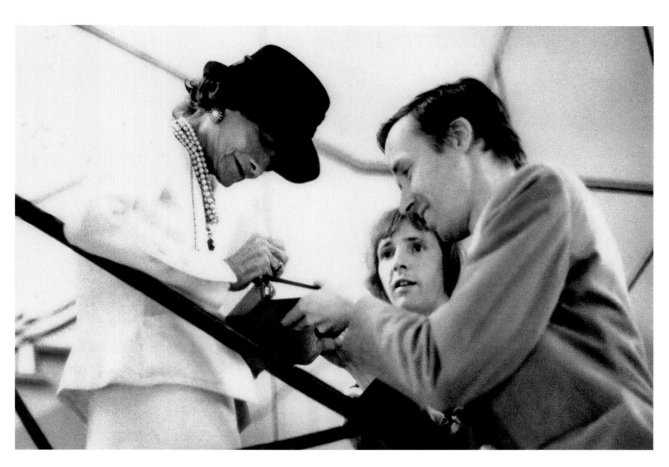

Louis XV? Or an eighteenth-century theater filled with the crème de la crème? No way. On with the rehearsal! The whirlwind left Bill and me a few seconds here and there to say, "Hi, great to see you." Of course, I knew he'd be there. He would not have missed it for the world. A passion such as Bill's never wanes; it only becomes more contagious.

Weeks before the "grand divertissement," as the French called it—more chateau sounding than a fashion show—there was lots of excitement at the thought of a young black American designer being one of the five American designers. Many had already heard of Stephen Burrows; being dans le coup (in the loop) had long become a top priority. And wow, were they in for a surprise. More like a shot of adrenaline, the pleasure I felt photographing the sensual movements of his favorite black models. When they appeared regally crowned with what Bill explained to me were peacock "feather bones," it felt like trumpets were in order. And from the applause, I wasn't the only one. A triumph. And as if to emphasize the regal time warp, there was Andy Warhol looking right at home in jeans with his white-mopped hair alongside one of the Châteaupowder-wigged laquais (lackeys).

February 2024

In a nut shell

Catastry. Scandel. + trumpfer. and Suptoners
sivorld about the Versaille.
fashion spetaula of the century

The Catastrp was the visual
colapeo of the French Couture design.
and the cheep tast of our production
The Scandel touched any area of
the event back stage going treatut of
the Models. The Revlon gift box of perfum
over. Max Factor 25000
cash contributs became Revelar.
Pais Repressentie is the prime departmury.
a friend of the Baron de Rede who chaired
the extrodny
event with the Baheum
M. Helenastield the Trips was the Anne foster
and the Kay trumps Chan Vitel +
serpent sting + 40 Ann woder 30 of them

the Spiral®

STENOGRAPHER'S NOTEBOOK

GREGG RULED | 43-4200

6 IN. x 9 IN. 100 SHEETS

Dayton, Ohio 45402 A Division of THE MEAD CORPORATION MEAD

The Diary of
Bill Cunningham

November 30, 1973 Diary of Versaille

 Catastraphe, scandel, triumphs and assumptuousness,
swirled about Versaille first fashion party. Without doubt one
of the spectacular social events of the century. The castrophy
was the visual sax collapse of the French couture design and
their expensive hideously cheap taste over-production. The
scandel touched every area of the event, back stage gross mis-
treatment of the models. Hideous egostical temperament of th4e
designersthe Revillon gold gift box of perfume succeeding
over Max Factor's $25,000 cash contribution with no gift box
allowed. The point is, Revillon's Paris representative, the
Princess Bx de Polignac, a friend and neighbor of the Baron de
Rede, who conceived the extraordinary event with the Baroness Guy
de Rothschild, better known as Maria Helen. *was allowed to give the*
Revillon comerewal paphge
 The Triumph was the American fashions in their
Kay Thompson directixed show, full of exploding vitality, starkly
clean of any backdrops except a black velvet curtain and surpurb
lighting. It was a case of marvelous taste starring the infectious
Liza Minelli *(10 proffenoal dancers)* and forty gorgeous long-legged American models - 20
of them exotic, tall, sleek Blacks with incredible rythym to their
moving bodies that further heightened the intensity of the bold
colors that staggered, captured and overwhelmed the ~~stounding~~
sophisticated audience, who swelled the magnificant Royal Opera
House with lightening shouts of Bravo and a crescendo of applaude.
In a nutshell - what happened was the Americans capturing the fashion
leadership from the City of Paris where it was born a hundred years
ago. It is not unlike what transpired in the art world at the out-
break of World War II. The American abstract expressionist artists
took control of World art leadership from Paris,

making New York the center of contemporary art movement. Now
the Americans, who have been dominated and servantile to French
fashions have at last overthrown their dictator. The torch of
modern fashion taste now burns in New York.

The sumptuousness was the almost indescribable
beauty of the supper and ball. The Baron and Baroness Guy de
Rohhschild gave in the Royal apartments of Versailles. They
underwrote the expenses of $70,000 for the 750 guests. The
supper was held in ten of the royal salons - one passed through each
candle light room on their way to the great Hall of Mirrors for the after dinner promanad.
ball. All was lit by candle. Outside the drapery hung French
windows the famous gardens and fountains were illuminated while
a light snow fell on the chateau. The bouffet was served by an
army of servants, meticulously wigged and dressed in the 18th
century tradition. The priceless Louis the XIVth furnishings
were removed from the ten salons - each with thirty to forty
foot fresco ceilings. The great parquet floors were set with
tables covered in 2,ooo yards of specially woven royal blue cloth
and gold fleur de lys. The center of each table was dominated by
a two to three foot tall magnificent 18th century gold candelabra
entwined with fresh white Easter Lilies. In each room a long x long
marble bouffet table - on either end three foot tall chrystal
gurendels, sparking with candle light. In each of the windows
a serving table, and more candle lit gurendels. To give you a tiny
idea of the elaborate but tasteful bouffet, the bread in the shape
of a chef's hat was baked with the royal crest of Versailles. The
butter was molded into beehives with Napoleon's signet royal bee
spurting out of the top.

Not in this century has a party of this magnitude
on a level of sumptuous taste been held in Versailles. The
most sophisticated guest, whose memories went back to the great
parties - legendary in recent French history could recall an
equivalent event. Certainly xxixx memories of private balls happen
every decade in Europe, but only the Baron Rothschild has been
able to recapture for one night the splendor of Versailles. After
dinner, the guests - gorgeously gowned - and dripping in jewels,
the likes of which I have never seen in size and beauty -- Real
tiarras, worn by the original owners - were seen by the dozen.
Several women as they swept into the great foyer and through the
doors into the Hall of Mirrors lowered the trains of their gowns
-- one A platinum grey sinuous jersey gown, long tight sleeves, high
neck and a four foot long train encircled in platinum blue fox.
Another of canery yellow, the train a ~~three~~ yards long of rucched
ruffles, looked as if the Empress Josephine had reappeared.

The scene was so inspiring, the most aristrocratic
women were seen swirling over the parquet floors at 3:30 in the
morning, guests were still prominading in awe through the great
Halls while footmen with long handled candle snuffers were dimming
the lights.

The next morning, as one's memory shifted ~~to~~ Through the
extravaçent events, it was the scene of the fashion triumph ~~at~~
~~thexandingxxx~~ that lingered, set in the miniature blue, gold and
pink opera house ~~it carved~~ of CARVed wood, designed by the architect Garbriel
in ~~1769xx~~ 1770 for the marriage of Marie Antoinette to the Dauphin.

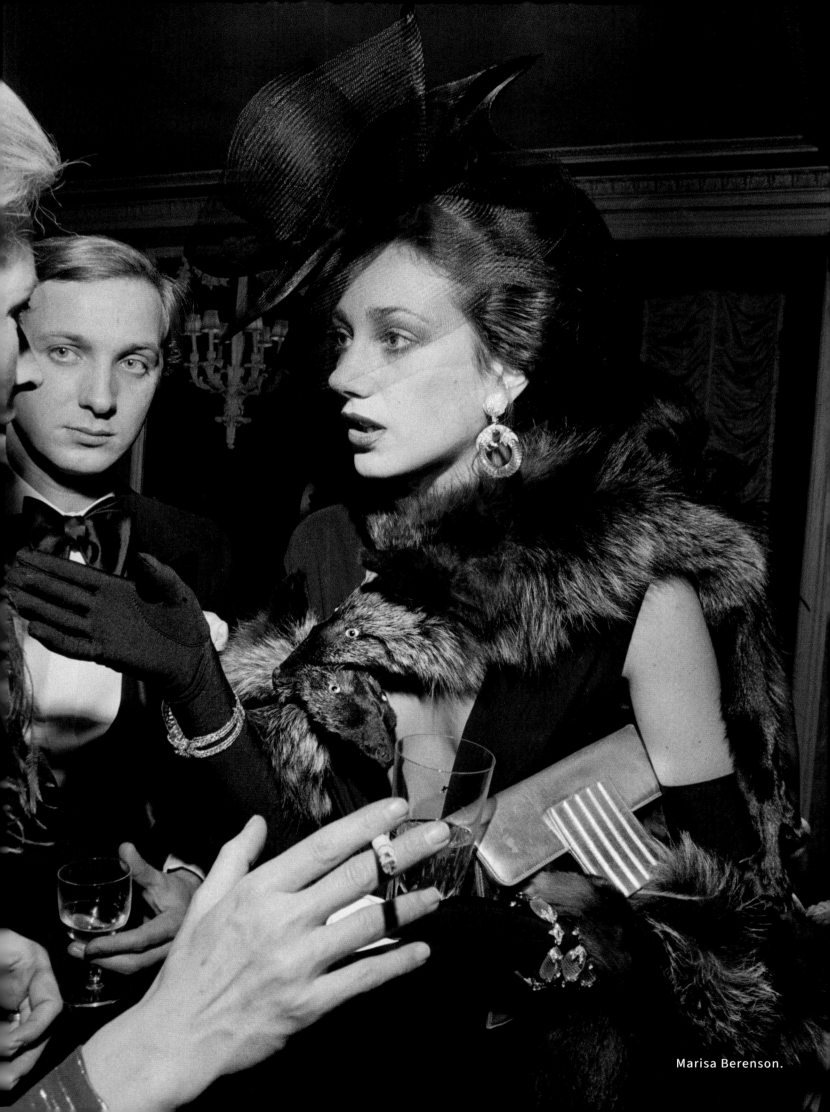

Marisa Berenson.

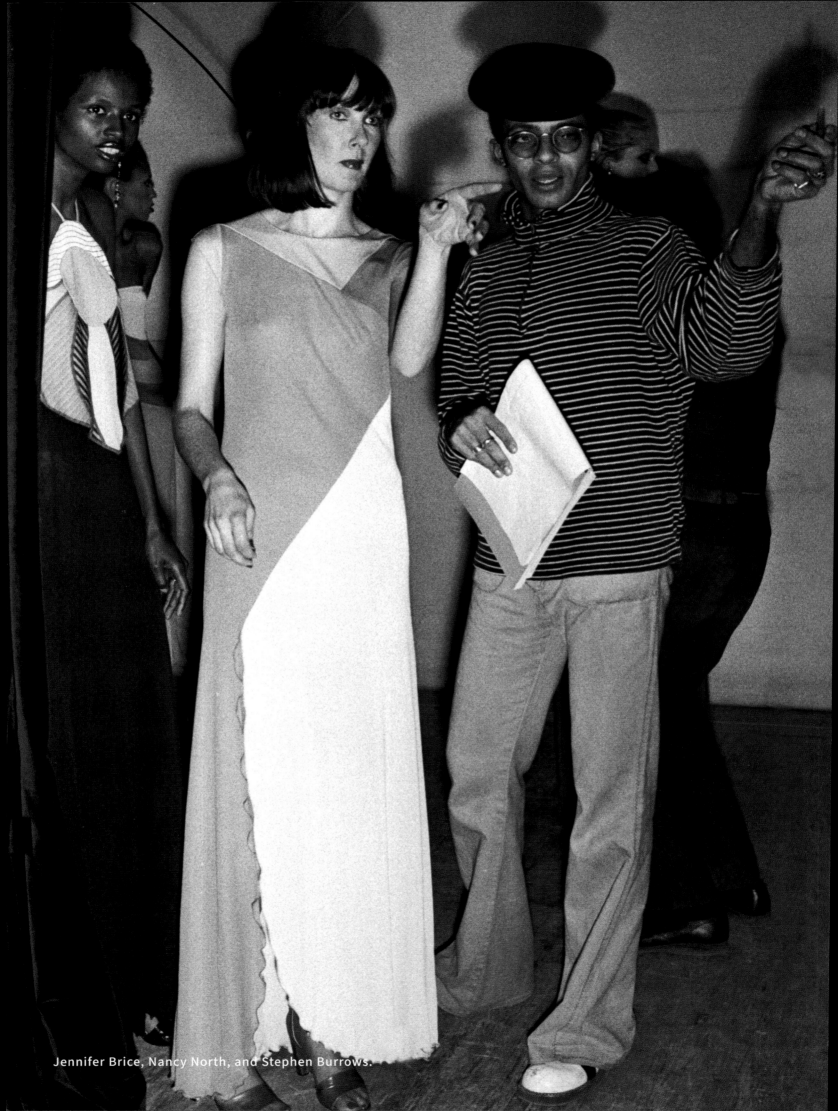

Jennifer Brice, Nancy North, and Stephen Burrows.

The French designers showed first - the Baron ~~ass~~ *Hellane*
de Rothschild had inspired them to create extravagent settings
that were supposed to be fairy tale but turned out to be a poor
imitation of the Macy Thanksgiving Day parade. The French theatre
directors who produced the show placed the couture clothes into
the worst setting and to the ugliest movement. It's inconceivable
how the French designers allowed this to happen without speaking
up. Givonchy came out best with a fantasy 18th century flower
basker background and a ~~beaxx~~ group of beautiful chiffon gowns, *unfortunately*
marred by the ugly dance steps of the coreographer. The Saint
 less contrived
Laurent tableaux was ~~better~~ than the other three - but still
did little for the clothes. The backdrop was a wheeled in 20 foot long
black enamel Boughette car which the models stepped out of, followed
by Zizi Jemere in white tie and tails, while she danced and sang
with two grotesque Saint Laurent costumed transvestites. The Dior
segment were a group of uninspired models marching out of Cinderella's
pumpkin while Ungaro's models climbed out of a fantesy medieval
wagon drawn by a rhinoserous - a complete contradiction to his most
modern clothes. In the corner of the stage~~xxxyoungxhippie~~xxxx two
flower children needlepointed and bass viol played. The Cardin
tableaux was the worst, employ**A**ing space rocket through which models
in five year old Cardin space clothes walked down to the stage.

 The finale was the rocket taking off into the ceiling
with clouds of sparks and smoke, filling the beautiful auditorium
and causing many of the exquisite to gag. ~~Faxintexmixsxionx~~xx The
house lights up and the stunning, if depressed, audience moved into
the Grand Foyer and block long torchierre lit corridors to drown
their sorrows in champaigne. Most people had given up hope, thinking

the Americand could never triumph over the French. As the

bejewelled guests moved back to that exquisite auditorium, the

lights dimmed and a miracle took place. Liza Minelli's voice -

vibrant, young and enthusiastic singing Bon Jour Paris - ~~filled~~

~~the house while it~~x forty American models and ten professional

dancers all dressed in shades of beige and brown/clothes from
 day

each of the five designers danced, sang and displayed their ward-

robe. The scene was so fresh, so wholesome, and the clothes so

realistic they captured the hearts of the French women. One could

feel a love affair racing back and forth from the stage to the

audience. The first models off the scene, ran back stage crying

-- They Love us - They love us!!!. From that second a spirit of

family cooperation kept the show on its split second schedule.
 la Renta
Oscar de ~~Larenso~~ who had been fighting with Anne Klein was now

helping to dress her models. Halston who had walked out of the show,

was now helping to dress the models of designers whom he thought

competitors a few hours before. After the three days of scandel

ridden rehearsals, this, indeed was a revelation. Liza's songs

continued to dazzle her audience, then Anne Klein's four minute

presentation of sportswear day clothes to African inspired resort

play clothes showed on the long slender black models had the

Dutchesses nearly falling ~~anxthaix~~x out of their boxes. When the

black model, Pat Cleveland, shook her hips down the center of the

stage, crescendo of Bravos and $20.00 programs flew into the air.

As Anne Klein said later, I knew we had ~~ana~~ won the Olympics.

The audience had hardly settled when the thundering music - all tape

recorded for theAmerican segment in contrast to the full orchestra

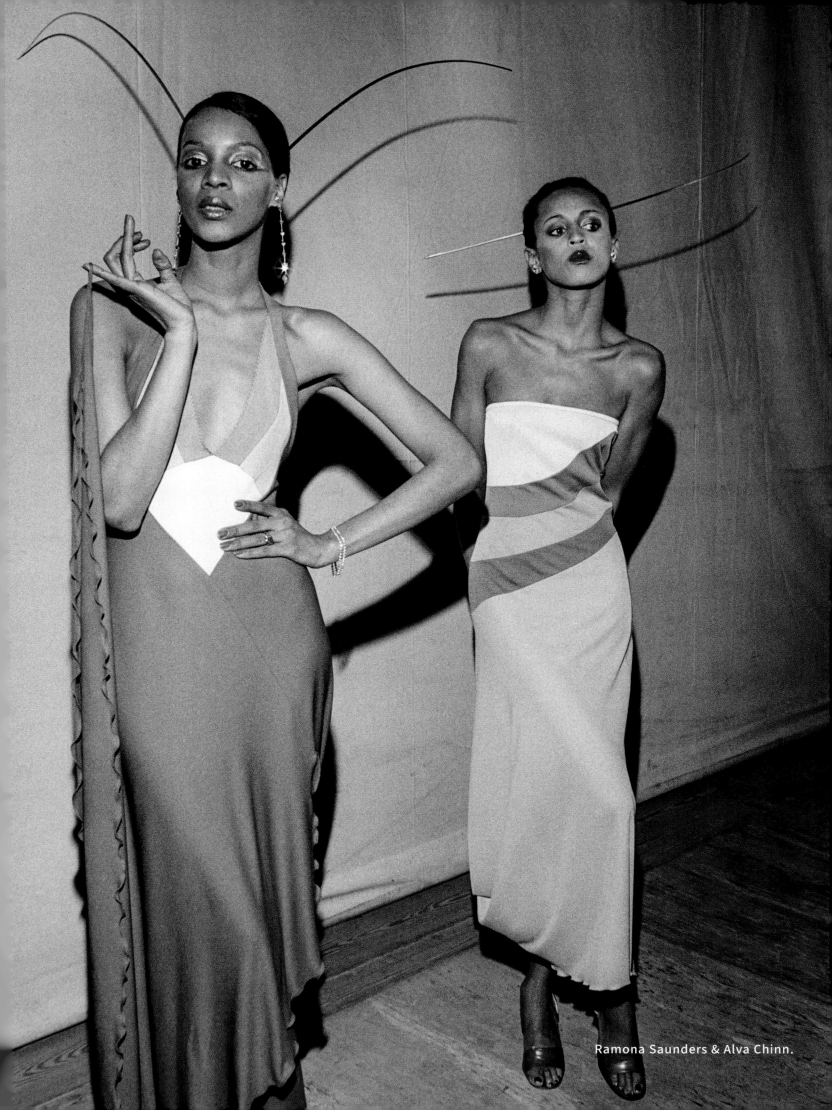

Ramona Saunders & Alva Chinn.

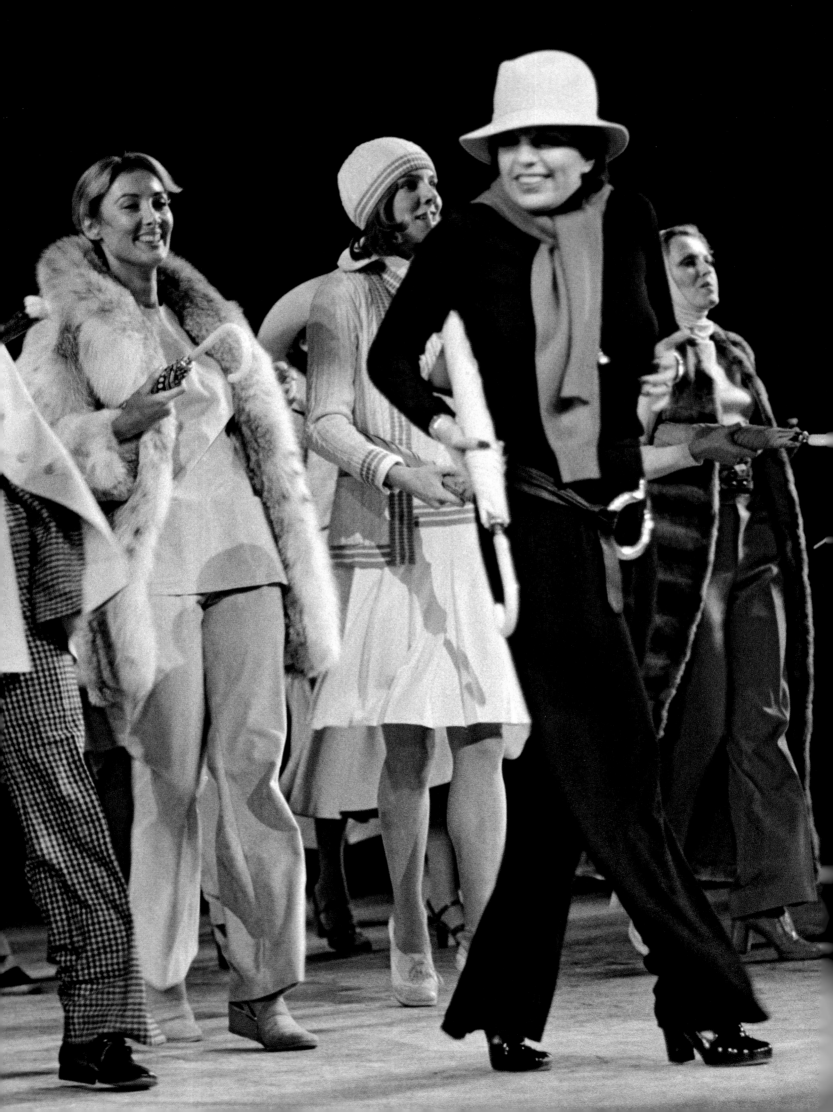

AND FOUR CONDUCTORS on the French side, a yellow spot light
illuminated the back drop to silhouetting the heads of Steven
Burrows models. As predicted his tableaux was to tear down
the house. The models appeared in jersey dresses that skimmed
over their bodies revealing every muscle of the female form -
cut open in front to show the legs and trailing - dragging like dragon
trains. The models, mostly black, had their hair sleekly shaped to
the head pierced with a peacockxfeaxxx center bone of the peacock
feather stripped of all its feathered flues. Eah Each girl more
exotic than the other. Midway, the model Bethanne, with the blackest
skin and the least amount of hair with the feather bone looking like
a Brontuzi sculpture forming aw a yard long arc through her scalp.
Her dress was a saffron yellow jersey. She moved across the stage
like a panther = looking out at the audience with large, fierce eyes
coupled with supreme elegance of body and dress. At this moment
the American show struck its most prophetic blow. Everyone in the
audience realized they were seeing something they had never seen
before.

Okx Other models followed with the same regal
African attribute and the audacious color palette of Burrows.
The French were heard to exclaim "This one's a genius"..

tape
Bill Blass followed with his own/music and a luxury
turn of the century 1920 inspired Newport and Palm Beach elegance. This
was faskixx followed by the Halston segment. A slow motion
tableaux set to waltz music from the film "The Damned". The Halston
group received less applause due to the fact that many of the

7.

creations had ~~an awxxxxx~~ A Ballanciaga feeling, even though Halston
had strippped the old idea's ~~catalogue~~ to a new severity and
economy of line, the mood remained /familiar to theF rench.
 Oscar de ~~Lorento~~ la Renter followed with the model Billie
Blair acting as a Genie, a tiny spotlight focuſed on her
fingers only - while she was hidden in the blackness of the stage.
~~As~~ her fingers ~~seemingly~~ unfurled a green silk scarf from an
imaginary Aladdin's lamp and at the instant the scarf ȼame loose
in a puff, the music swelled to a ~~xx~~ crescendo and there was Billie
in grass green satiᴺ faced crepe georgette long tunic over pajamas.
She ran to the other side of the stage and from the wings pulled ~~more~~
pink scarfs, followed by three models in pink gowns. She ~~xxxxxxd~~x
danced over to the other side of the stage and repeated the scarf
trick - this time twelve models in a rainbow of colors followed
the scarfs. More scarfs were pulled and more models in beautiful
colors. Each of the gowns in this unusual fabric which both clings
and floats about the body, brought a stunning reaction from the
audience. The stage darkened for the ~~fixx~~ closing tableaux. Liza
in a beaded Halston gown cut out in front in a "U" shape above the
knees proceed to sing Aux Revoire Paris. The backdrop raised and
there behind the scrim was the troop of American models all dressed
in black gowns sitting around cafe tables signing and waving
Aux Revoire, Paris.

 I realized something big was going to happen when
the curtain came down. The audience was screaming for more. They
could scarcely believe what had happened. I dashed back stage
and got my camera set just as the curtain fell, and all the models

Above: "20th Century Look of Versailles" created by Kenneth.
Following Page: Marisa Berenson.

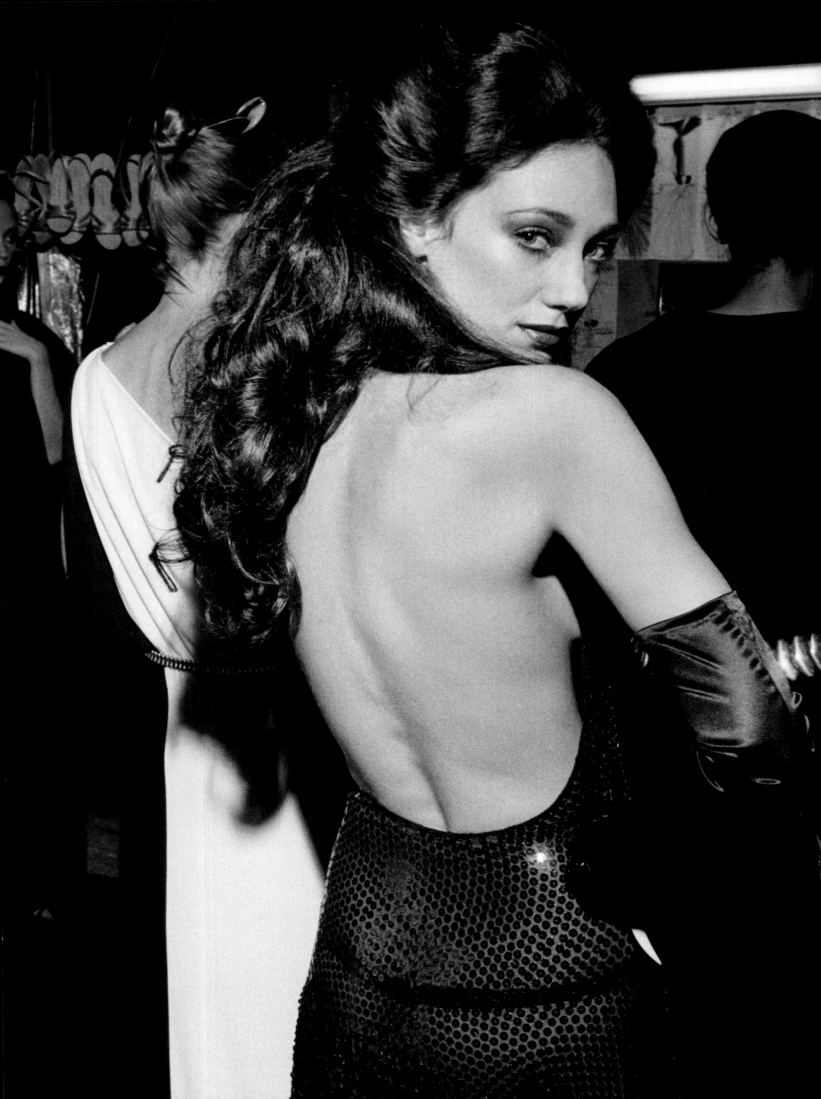

made a beeline for Kay Thompson - the ~~knox~~ heroine of the night.
Liza hugged her for a full minute, burying her head on Kay's shoulder.
Everyone was crying and hugging each other, flushed with success.
Then the ~~impxx~~ celebrities rushed back stage to congratulate the
conquering heroes.

The Viscountess Jacqueline *de Ribes*
the legendary fashion beauty of Europe, dressed in sweeping pink
Dior gown and dripping jewels swept into Kay Thompson's arms,
then grabbed Oscar De ~~Renato~~ *la Renta* by the ~~had~~ hand and rushed to the
dressing room where she proceeded to buy half a dozen designs.
This scene of triumph and congratulations was repeated over and
over until everyone finally left for the supper and ball. The
French with their ~~minizz~~ many entertainers from Rudolph ~~Nurx~~ ~~Nourov~~ *Noureev*
to Josephine Baker were not able to capture the audience as Liza
Minelli had done for the Americans.

Afterword

Diet Prada

Bill Cunningham was many things, depending on who you ask, but he often considered himself a fashion historian first and foremost, and his camera was his instrument to document how fashion reflected the times. Much has been written about him, and the Battle of Versailles, but we will attempt to do what he would have done with these photographs, which is to provide some context to what this moment means in fashion history, and why it still matters today.

It might seem that Paris has always been the capital of fashion, but there are some distinct moments in 20th century fashion history where that wasn't the case. In the 1930s, the renowned costume designer Adrian shifted the center of fashion from Paris to Los Angeles with his designs for Hollywood's biggest starlets. Coupled with the massive international influence of his silver screen sirens, he created a look that reverberated through the entire industry, from as high as Chanel to as mass-market as Macy's—and it continues to define glamour today.

It wasn't until 1947 when Carmel Snow, then editor of Harper's Bazaar, declared Christian Dior's rounded shoulders, nipped waist, and full skirts as the "New Look," effectively rendering the efficient, wartime-influenced designs of Adrian's own label as passé. Paris continued to dominate fashion from this point on, so much so that some American couture houses like Chez Ninon were established to solely copy Dior, Yves Saint Laurent, Givenchy, and other French designers.

What the Americans showed at the Battle of Versailles was so powerful, not only because they were unburdened by the weighty legacy and traditions of Parisian haute couture, but because it came to define pillars of modern American fashion on its own merits. In addition to a cadre of stunning Black models and the ease and wearability of the clothes, the Americans were not afraid to weaponize their greatest asset: star power via a dazzling performance by Liza Minnelli.

This was "fashion-tainment" before it became an industry buzzword as the worlds of entertainment and fashion became increasingly intertwined to create a new type of experience. This was preceding John Galliano's poetic theatrics, and way before Coperni's redux of Alexander McQueen's seminal Spring/Summer 1999 collection and its finale of spray-painting robot arms.

This was a moment before collections were designed by merchandising teams and concepts were conceived to cut through social media algorithms—a spectacle to be taken in before smartphones turned fashion show coverage into a rat race to virality.

People were finally leaving behind the fussy post-war fashions in favor of ready-to-wear, and it was the birth of a new type of wardrobe that allowed for self-expression through personal style—something that truly excited Bill. The pared down American designs felt sophisticated and relaxed, especially against the overwrought presentation of the French fashions. The fact that some of them showed old collections, like Pierre Cardin with his Space Age extravaganza, was a delight to see called out in Bill's diary.

The Americans' collections seemed to highlight the person wearing them, not the other way around. Stephen Burrows' proposition of slinky, color-blocked gowns in novel, casual jersey could still top today's best-dressed lists. The same goes for Oscar de la Renta's swirling chiffon confections. It's easy to imagine department store buyers frothing at the mouth for Anne Klein and Bill Blass's retro-tinged modern wardrobes, even now. Though just over half a century ago, everything somehow still feels timeless—the mark of good design.

In particular, a two-piece plaid halter set by Anne Klein clearly references iconic Claire McCardell styles, which would have already been vintage at the time. The same sets were recently revived by Tory Burch, reinforcing the desirability of practicality that runs through American sportswear.

Bill believed fashion had the power to lift people's spirits, and you can feel that through his photos. All the models have an air of confidence in their looks, and as they take their final turns, there are shots of a standing ovation followed by shots of the victors celebrating with hugs and the wide-mouthed smiles of success.

The shots outside the event are just as enjoyable to view as the ones captured at the fashion show. In a frame snapped at the airport baggage claim, the models coming in from New York wait for their luggage while sporting fur coats, their nerves and excitement almost palpable. In a shot from the pre-party at Paris's famous restaurant Maxim's, Bill's reflection can be spotted above the subjects seated at a mirrored booth—a rare autoportrait of a photographer who, despite becoming quite recognizable, always tried to make himself invisible to capture the best moments.

In the after after-party images, it's clear that it was one of the great parties in modern history. A vibe, in the modern parlance. Whether they're actively posing or not, the models are modeling. The champagne is flowing, and the ambiance is the kind that even the best party photographers can only hope to capture.

What Bill did with his camera was offer a portal into other worlds, be it the humble streets of New York City, or the gilded halls of the Palace of Versailles. In addition to being one of the most insightful fashion historians who witnessed major paradigm shifts across two different centuries, he was truly one of fashion's biggest fans. Always in service to the "dream factory" that he believed the industry was, his perspective remains unmatched in its sheer earnestnessy, and that's what makes his photos a rarity to be treasured.

Acknowledgments

I am very grateful to the following people, without whom this book would not be possible:

To Bill Cunningham—how lucky I was that Bill asked me into his life for just one day in 1994 and told me, on camera, things he'd never shared with anyone, in ways that neither of us ever anticipated. My faith was, and is, the same as Bill's; I have called upon it many times, knowing and hoping, in my own soul, that he was guiding us every step of the process.

To the Rizzoli team, including Anthony Petrillose, Charles Miers, and Lucie Bisbee—thank you for taking on this rookie author with such immense care. A true and pure collaboration that every first author should be so lucky to have. Huge thanks to Carol Dietz. She is a most passionate and talented art director and friend. To my French friend, Jean-luce Huré, whose eyes and history with Bill Cunningham I have learned so much from, and whose photos and written text are so much a part of this book. To Patricia Jarvis-Simonson, Bill Cunningham's niece and the ruthlessly protective owner of his remarkable archive of over three-million photographs and documents. I am grateful for her trust in me in presenting her uncle's unparalleled knowledge and documentation of the worlds of fashion, art and society. To Carol Dietz's art directing assistant Hiewon Sohn and photo scanning artist extraordinaire, Michael Berman.

To Liza Minnelli—how very treasured and lucky we were that Ms. Minnelli agreed to and then wrote a truly compassionate and knowing foreword for this book. To Pat Cleveland—there is no one else I know with such pure passion and unpretentiousness in a time where there's plenty of that already to go around. Huge thanks to Lindsey Schuyler and Tony Liu from Diet Prada for their terrific and insightful afterword for this book. As two of popular culture's most enduring and on-point voices working today, they know their history and they take no prisoners.

To Tonne, and Wendy Goodman—I offer my sincerest gratitude to their immense knowledge (and spelling) of the history of fashion, art, and society, which helped me at all hours of the day and night. Thank you to Ivan Shaw—my longtime friend, advisor, and true fashion warrior and survivor—for introducing me to Anthony Petrillose. And

to Susan and David Rockefeller—Susan's encouragement and support is unwavering. Both she and David shared a love for Bill Cunningham that enabled our friendship and collaborations to continue, I hope, forever. Mickey Boardman—I've learned much from "Asking Mr. Mickey" about life and honesty and insane knowledge and storytelling. Ruben and Isabel Toledo—the Toledo's were among Bill Cunningham's closest friends since the mid 1980's. If not for their trust and encouragement when I first showed them my interview, I would have never taken on a documentary and now this book. Bethann Hardison—to a forty-year friendship of ups and downs but a never wavering love and truth, always. And for her much-needed stewardship in engaging with... André Leon Talley, a tour-de-force who was an immense help to me in identifying people in photographs and stories that I had never heard of. He knew them all. And when I got it wrong, he let me know in ways only André could. And Ryan Murphy—while I've never met Mr. Murphy, I would like him to know that his FX series, *FEUD: Capote vs The Swans*, which aired while I was finishing this book, made me, I hope, much smarter and relentlessly keen, to get the history right and true. And Nicolas de Riviere, my dear friend for over twenty-years. His relentless support of me and my family is something we will always treasure.

To Eleanor Lambert and Baroness Helene de Rothschilds, two powerful forces in fashion and society without whom there would be no such event and all that followed. And for Susan and Jack Bozek, the two people I love more than anything in the world.

Special thank you to PC Chandra for his amazing knowledge of fashion history, including and especially The Battle of Versailles. And to Alva Chinn, Norma Jean Darden, Karen Bjornson Macdonald, and Nancy North who remembered most everyone on the stage. Cecilia Dean, Tom Fallon, Jonathon Gray, Kim Hastreiter, James Kaliardos, Warren and Arlene Katz, Tony Longoria, Laurie Mallet, Stephené Marsil, Todd Oldham, Peter Orlowsky, Betsey Pierce, Kareen Rispal, Chris Smart, and Fr. Marc Vicari.

- M.B.

Photo Credits

Photographs © Bill Cunningham:

Pages 20, 22, 23, 24/25, 26, 27, 28, 29, 30/31, 32, 33, 34/35, 36/37, 38, 39, 43, 44, 45, 46/47, 48, 49, 50/51, 52, 53, 54, 55, 58/59, 60/61, 63, 64, 65, 66/67, 74/75, 80/81. 82/83, 84/85, 86/87, 88, 90, 92/93, 94, 95, 96, 97, 98/99, 100/101, 104/105, 106/107, 108/109, 110, 111, 116/117, 124, 126, 127, 128/129, 132/133, 136/137, 142, 144, 145/146, 147/148, 151, 158, 159, 162, 164/165, 171, 172, 173, 174, 178/179, 180/181, 183, 184, 185, 186, 187, 188, 189, 190, 191, 192/193, 196/197, 198/199, 200, 202/203, 204/205, 206/207, 208/209, 210, 211, 212, 213, 215, 216, 217, 218, 219, 220, 221, 222/223, 224, 225, 226, 227, 229, 230, 231, 233, 235, 236, 238/239, 240/241, 242, 243, 248, 249, 250, 251, 254, 256/257, 258, 260/261, 262, 263, 264/265, 273, 278, 281, 282

Photographs © Jean-luce Huré - Courtesy of Bridgeman Images:

Cover, Pages 4-5, 16, 20, 57, 68-69, 70, 72-73, 76-77, 78-79, 102, 113, 119, 121, 122, 123, 130, 135, 139, 140-141, 143, 152-153, 154-155, 156-157, 160, 167, 169, 170, 201, 228, 274

Photographs © Jean-luce Huré:

Pages 13, 40, 91, 120, 131, 134, 145, 161, 168, 175, 176, 194, 195, 202-203, 232, 234, 237, 244-245, 246, 252, 253, 255, 259, Back Cover

First published in the United States of America in 2024 by Rizzoli International Publications, Inc.
300 Park Avenue South
New York, NY 10010
www.rizzoliusa.com

Copyright © 2024 Mark Bozek
Foreword: Liza Minnelli
Afterword: Diet Prada
Epilogue: Jean-luce Huré
Introduction: Pat Cleveland
Art Direction and Design: Carol Dietz
Design: Hiewon Sohn

Publisher: Charles Miers
Associate Publisher: Anthony Petrillose
Editors: Gisela Aguilar, Lucie Bisbee
Production Manager: Kaija Markoe
Managing Editor: Lynn Scrabis
Design Coordinator: Tim Biddick

Printed in Hong Kong

2024 2025 2026 2027 2028/ 10 9 8 7 6 5 4 3 2 1

ISBN: 9780847835607
Library of Congress Control Number: 2024933821

Visit us online:
Facebook.com/RizzoliNewYork
X: @Rizzoli_Books
Instagram.com/RizzoliBooks
Pinterest.com/RizzoliBooks
Youtube.com/user/RizzoliNY
Issuu.com/Rizzoli

MIX
Paper | Supporting responsible forestry
FSC
www.fsc.org
FSC™ C023053